THE GALLERY OF MIRACLES AND MADNESS

CHARLIE ENGLISH

WILLIAM
COLLINS

William Collins
An imprint of HarperCollins*Publishers*
1 London Bridge Street
London SE1 9GF

WilliamCollinsBooks.com

HarperCollins*Publishers*
1st Floor, Watermarque Building, Ringsend Road
Dublin 4, Ireland

First published in Great Britain in 2021 by William Collins
First published in the United States by Random House in 2021

1

A catalogue record for this book is
available from the British Library

HB ISBN 978-0-00-829962-0
TPB ISBN 978-0-00-829963-7

Maps by Mapping Specialists Limited
Title-page art by Franz Karl Bühler, *Das Selbst*, 1919.
© Prinzhorn Collection, University Hospital Heidelberg, Inv. No. 3018
Book design by Barbara M. Bachman

Typeset in Requiem Text
Printed and Bound in the UK using 100%
Renewable Electricity at CPI Group (UK) Ltd

MIX
Paper from
responsible sources
FSC™ C007454

For Doris Noell-Rumpeltes

1949−2021

THE

GALLERY OF

MIRACLES

AND

MADNESS

BY

CHARLIE ENGLISH

THE

GALLERY OF

MIRACLES

AND

MADNESS

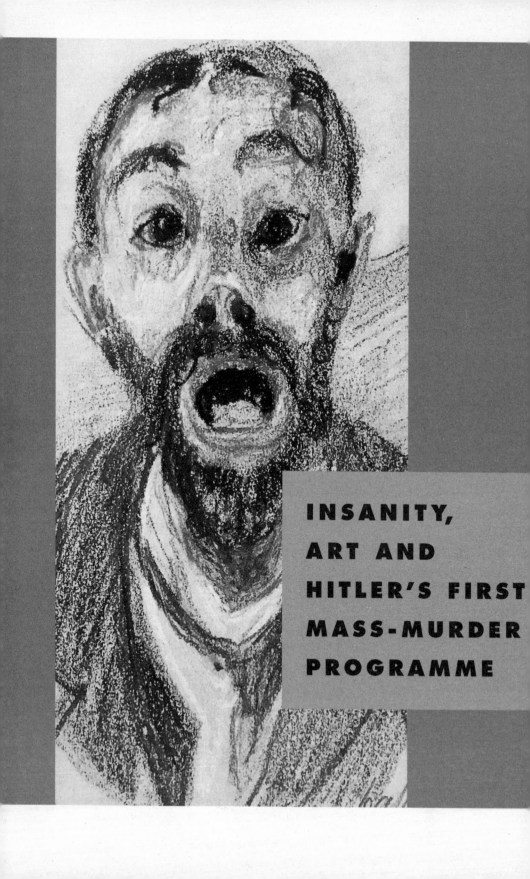

INSANITY,
ART AND
HITLER'S FIRST
MASS-MURDER
PROGRAMME

CONTENTS

PART FOUR: EUTHANASIE

PRINCIPAL
ARTISTS

Franz Karl Bühler

Else Blankenhorn

Karl Genzel

August Natterer

Hyazinth von Wieser

Paul Goesch

Carl Lange

Katharina Detzel

Joseph Schneller

Gustav Sievers

Agnes Richter

August Klett

Frau von Zinowiew

Josef Forster

Wilhelm Werner

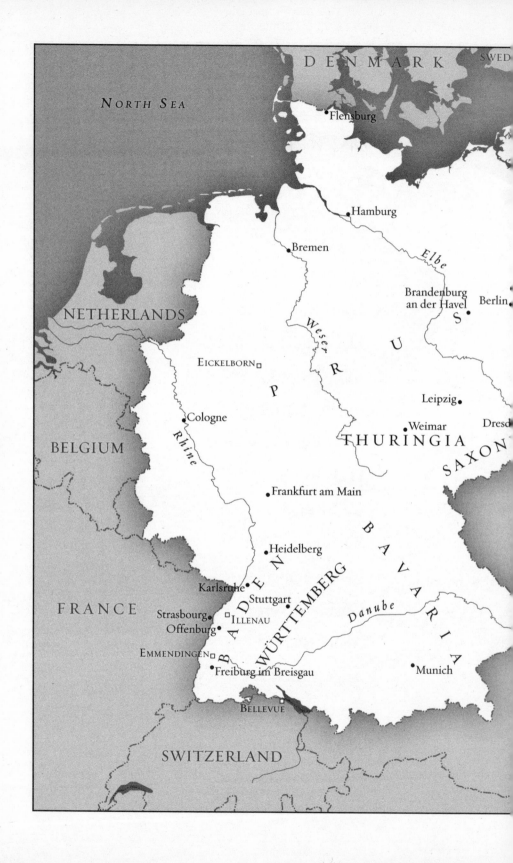

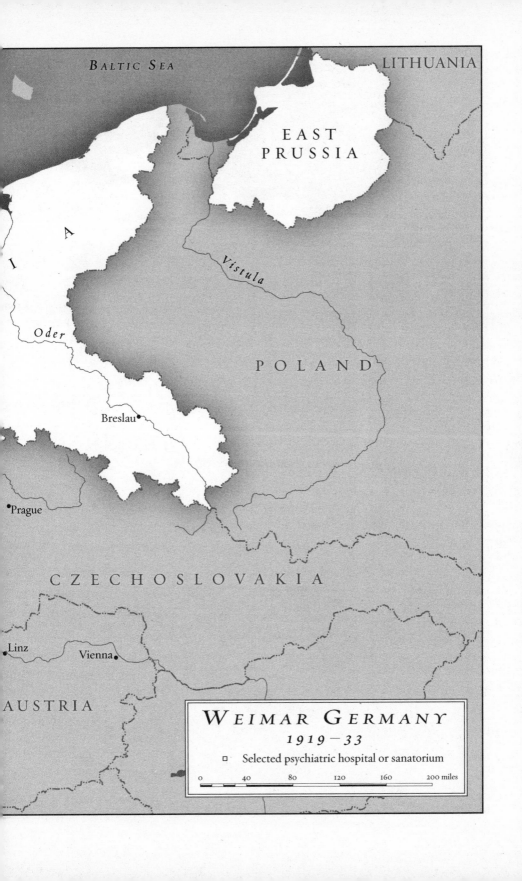

BALTIC SEA

LITHUANIA

EAST
PRUSSIA

A

I

Oder

Vistula

POLAND

Breslau•

•Prague

CZECHOSLOVAKIA

Linz

Vienna•

AUSTRIA

WEIMAR GERMANY
1919 – 33

□ Selected psychiatric hospital or sanatorium

0 40 80 120 160 200 miles

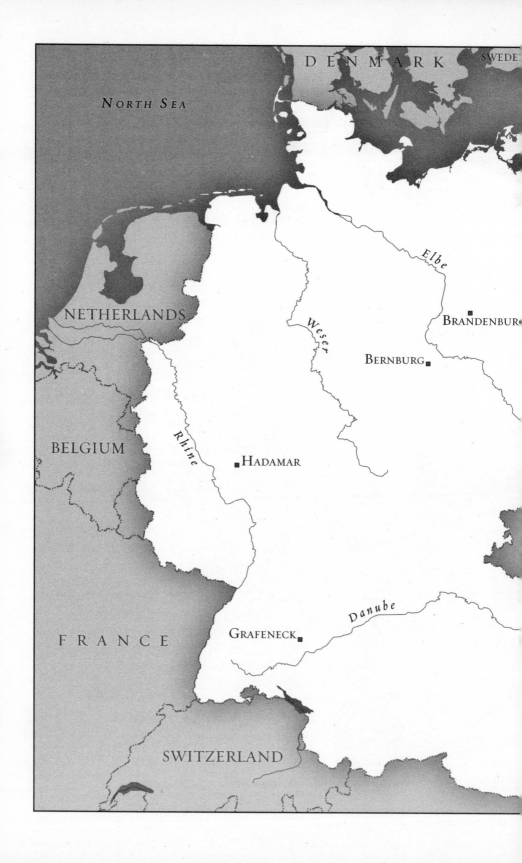

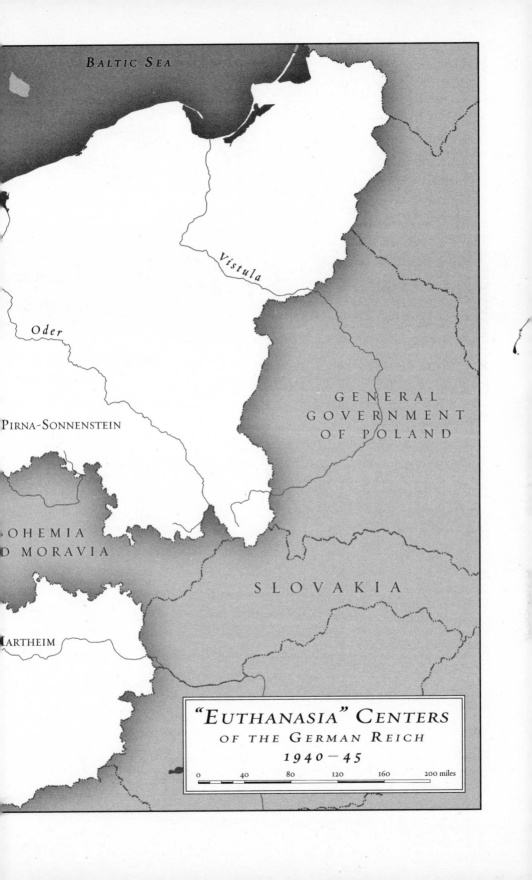

BALTIC SEA

Vistula

Oder

PIRNA-SONNENSTEIN

GENERAL
GOVERNMENT
OF POLAND

OHEMIA
D MORAVIA

SLOVAKIA

ARTHEIM

"EUTHANASIA" CENTERS
OF THE GERMAN REICH
1940 – 45

| 0 | 40 | 80 | 120 | 160 | 200 miles |

PREFACE

—

A LETTER FROM BERLIN

ON OCTOBER 9, 1939, WHEN THE SECOND WORLD WAR WAS barely a month old, the German Ministry of the Interior issued a directive to mental health institutions throughout the Reich, signed on behalf of Berlin's top medical official, Dr. Leonardo Conti. As part of new wartime economic measures, Conti required asylum doctors to register every patient in their care who suffered from certain psychiatric illnesses, including schizophrenia, epilepsy, senile dementia, syphilis, "feeblemindedness," encephalitis, and Huntington's disease. They were also to register anyone without these conditions who had spent five years or more in an institution, or who was classed as criminally insane, or who did not possess either German nationality or "German or related blood." In unclear cases, medical staff were to err on the side of registration, since it would be better for Berlin to have too many rather than too few patients on its lists.

Conti's letter was followed by registration forms: one copy was to be filled out for each patient. Besides logging their racial category (picking from a menu that included "Jew," "Jewish half-breed, first or second degree," "Negro," "Negro mongrel," "Gypsy," and "Gypsy mongrel"), doctors were to provide details of each individual's ability to work, the nature of his or her illness, and whether they received visitors and how

often. The forms had to be completed by typewriter where possible and returned to Berlin within a tight deadline.

As the directive landed in psychiatric institutions across the country, medical staff tried to guess at what it meant. Was the government going to relocate these patients? If so, to where? Were they looking for laborers to dig trenches at the front, or trying to free up beds for wounded soldiers? The registration form itself was scoured for clues. As the bureaucrats hadn't left much room for a detailed medical opinion, at least one doctor concluded that it couldn't signify anything too drastic. Others found the question about visitors highly suspicious. Why would Berlin need to know that?

The secret purpose of the Conti letter would unfold over the following weeks. Once the paperwork was returned, it was copied and sent out to a panel of psychiatrists, all ardent National Socialists, who were instructed to mark each case in pencil with a red "+" or a blue "−". The few patients who received a blue minus sign were left alone. The red "+" was a death sentence. These people would be collected from their clinics and asylums in groups, loaded onto buses, and taken to specially converted nursing homes, where they were undressed, weighed, and pushed into airtight chambers, which were then flooded with lethal carbon monoxide. When they were all dead, their corpses were burned and their ashes dumped on the fields. Aktion T4, as this program was known, represented the first time a government had organized the industrialized extermination of a section of its population. For the Nazis, it would serve as the prototype for the greater mass murder to come.

Among the hundreds of thousands of mentally ill and disabled people killed in the so-called euthanasia actions were two dozen whose artwork had been collected by the psychiatrist Hans Prinzhorn in the aftermath of the First World War. The way in which these artist-patients found themselves on a collision course with the Nazi government is the story I've tried to tell in this book

Exploring art in the context of National Socialism may seem counterintuitive, even distasteful. What relevance can painting or sculpture have when measured against so many deaths? Aren't Hitler's ideas about culture a distraction from his far more pressing crimes, to which

so many words have already been devoted? In fact, the following narrative shows that the opposite is true. Hitler's mass murder programs and his views on art were intimately connected through a network of pseudoscientific theories about race, modernism, the concept of "degeneracy," and the people he deemed to be *lebensunwertes Leben,* "life unworthy of life."

THE ART COLLECTION HANS PRINZHORN gathered at Heidelberg consists exclusively of work by the inpatients of mental hospitals. Though at one time it was envisaged as a research archive for the University of Heidelberg Psychiatric Clinic, Prinzhorn soon became far more interested in its artistic value than in its potential to help diagnose mental illness. This was in large part due to the extraordinary qualities of the material he discovered.

The men and women who created these works spent their lives cut off from the outside world, often forgotten by their peers and even by their families. Diagnosed mostly with schizophrenia, they didn't always intend to make "art." They used sketches, sculpture, and writing to chart aspects of their psychotic reality, or to communicate messages from an isolated interior. The collection includes all kinds of products, from paintings, drawings, and collages to doodles, poems, and music, executed on or with whatever came to hand: discarded nursing rosters, menus, sugar bags, used envelopes, even toilet tissue. Sculptures sit alongside designs for great inventions, diaries, and letters—none of which seems to have ever been sent. One woman repeated the same penciled phrase—"Sweetheart come"—on hundreds of sheets of paper, until each was dark with longing. Some drew pornography. Others worked with needle and thread, creating stuffed mannequins or embroidering clothing with words and phrases that they wore next to the skin. Viewing this often strange material is a moving and sometimes transcendent experience. Visitors remark that it's as if it "bubbled up from the depths of the human psyche" or "opened windows on a different reality." One former curator compared her encounter with the collection to the moment a dam bursts: "Remarkable worlds opened

up before me," she wrote, "drew me into their power; open spaces took away my equilibrium and made me dizzy."

Prinzhorn's achievement was to liberate this art from the psychiatric clinics and nursing institutions where it had been made, and release it into the wider world. He showed it to a new generation of artists who were seeking to explore the madness they had experienced in the First World War. These painters, sculptors, and writers—Paul Klee, Max Ernst, André Breton, and Salvador Dalí among them—saw Prinzhorn's collection as a direct expression of the human interior, untainted by bourgeois education and training. The result was that, for a few giddy years in the 1920s and 1930s, art inspired by insanity stood at the forefront of the avant-garde. But it was never less than provocative, and in Germany, as the Weimar Republic crumbled, modern art came under attack from the far right.

National Socialism peddled the dream of a future based on a mythical past, a time of "blood and soil," when the land was worked by a race of ethnically pure Aryan *Volk*. The messiah of this movement, Adolf Hitler, had more in common with the Prinzhorn artists than he would have liked to admit. Though few ever examined him, his hysterical, psychopathic personality has produced reams of diagnoses from psychiatrists and mental health experts. He also saw himself as a man of culture. His most unconscionable actions sprang from a belief that he was the "artist-Führer," a recurring figure in German history who had both the vision to conjure his people's path and the will to send them on it, no matter what the cost. He presented his politics as a cultural enterprise, and saw modern art, with its borrowings from psychiatry, its abstractions, and its raw emotional expressiveness—so different from his own tepid watercolors—as a symptom of the "insane" malaise that had polluted the community of ethnic Germans, the *Volksgemeinschaft*. True Aryan art, he believed, made the German spirit visible, and this spirit would recover only when *Entartung* (degeneracy) had been eradicated. The cultural cleansing was a precursor to racial cleansing. Uniquely, the Prinzhorn artists would be caught up in both.

Prinzhorn was aware that his collecting project was controversial, and that by treating schizophrenic art as something more than a symp-

tom he was challenging the conventional psychiatric and artistic think-
ing of the time. But he could never have guessed the extreme nature of
the confrontation that lay ahead, the danger for his artists, or the de-
structive purpose to which their work would eventually be put.

—CHARLIE ENGLISH
LONDON

PART ONE

—

BILDNEREI

I could spend my life prying loose the secrets of the insane. These people are honest to a fault, and their naiveté has no peer but my own. Christopher Columbus should have set out to discover America with a boatload of madmen.

— ANDRÉ BRETON,
Manifesto of Surrealism, 1924

1.

THE MAN WHO JUMPED
IN THE CANAL

O N A WINTER'S DAY IN 1898, A STOCKY YOUNG MAN WITH a handlebar mustache was hurrying along the banks of a canal in Hamburg, north Germany. Pohl, as the world would come to know him, was in his early thirties then, a dapper individual who liked to carry a cane or umbrella and to wear a stovepipe hat over his oiled, ink-dark hair. At this particular instant, though, such considerations were far from Pohl's mind. He moved along in a private cloud of fear, rushing to escape the mysterious agents who tormented him. He didn't know who these men were—they could pop up in any guise, anywhere, at almost any time— but he did have a pretty good idea who sent them.

It had begun in Strasbourg, a German city at this time, at a moment of great professional humiliation: his sacking from the city's School of Arts and Crafts. The school's director, not content with ruining a brilliant career, had sent spies to snoop on Pohl, to listen at his keyhole, forcing him to change lodgings again and again. In the end there had been nothing for it but to leave town altogether. Pohl moved to Hamburg, at the other end of the country, and tried to lose himself in the louche entertainments of the city's vast red-light district, spending heavily on prostitutes and peep shows. Somehow his enemies tracked him down even here. Strangers threatened him in the street. He was accosted on the horse-drawn tram, singled out by the conductor, who

yelled "He's crazy!" in front of the other passengers. Pimps shouted "Rascal!," "Thug!," "Kill him!," and the like. Even at the theater, he noticed the actors onstage delivering odd, barbed messages, targeted directly at him.

On this March day, he knew they were closing in.

Hamburg, the great port city on the river Elbe, the "Gateway to the World," home to the fleet of oceangoing liners that carried Germans to Boston and Baltimore, Hoboken and Hong Kong, was a latticework of inlets and lakes, channels and streams. Pohl now found his escape route barred by water. There was only one option: He must swim. At the end of winter, the canal was close to freezing, but he plunged in anyway. The dark liquid engulfed him in its shocking embrace, then he was splashing out for the far bank.

When, at length, he was hauled out onto dry land, soaked and shivering, it was clear to passersby that not everything was well with the strange swimmer. There was no sign of a chasing pack. No one, in fact, seemed to be following him at all. He was disturbed, confused, perhaps insane. So he was brought to the gates of the Friedrichsberg "madhouse," the giant institution that stood on a hill in the northeast of the city, and taken inside. He would remain in the dubious care of the psychiatric system for the next forty-two years, one of hundreds of thousands of inmates who lived precarious, near-invisible lives behind the walls of Germany's asylums.

"POHL" WAS THE ALIAS used to spare his family the taint of mental illness. The man's real name was Franz Karl Bühler. He was a blacksmith by profession, though that word hardly does him justice. In fact, Bühler was one of the world's leading metalworkers at a time when the Arts and Crafts movement had pushed the form to unprecedented heights. Working with the 2,500-degree heat of the furnace, he could transform coarse pig iron into something malleable and delicate. By drawing it and bending it, upsetting, punching, and welding it, he was able to mimic flowers, grasses, and reed stalks so perfectly you had to touch them to know they weren't real. But something had happened to

Bühler, an inner derailment of sorts, which interfered with his sense of reality and put him at the mercy of his own fictions and delusions. Doctors examining him over the following months and years would attach different labels to his condition, but the one that would stick was "schizophrenia."

Schizophrenia, the most severe of mental illnesses, remains the hardest to understand. Even articulate people with the condition find it difficult to explain the condition, beyond a sense of strangeness, alienation, or uncanniness. It is "a country, opposed to Reality, where reigned an implacable light," according to one account, where "people turned weirdly about," making nonsensical gestures and movements. Others describe it as a feeling of disintegration, or like looking at the world through a telescope backward. Some psychiatrists believe that where most people organize their perceptions into an overall picture of the world which they then act upon, those with schizophrenia combine unrelated pieces of sensory data that can only be understood by making irrational intellectual leaps. Hence Bühler, obsessed with his persecutors in Strasbourg, might hear a tram conductor shouting "He's crazy!" when he was just calling out the next stop. But not all manifestations are alike, and not everyone affected finds the condition debilitating. Some view it as an "enhancement" that gives them unusually deep insight. Only around a third of cases are now considered progressive, and most people with schizophrenia live full and active lives. When Bühler was hospitalized, however, the diagnosis was brand-new, and was thought to herald an irreversible decline. There was nothing to be done, his doctors believed. It was just a matter of time.

BÜHLER HAD ALWAYS BEEN UNUSUAL. He was born on August 28, 1864, at Offenburg, a picturesque town of chiming clocks and steep-pitched roofs in the valley of the Upper Rhine. His mother, Euphrosyne, died young, and his father, who ran a blacksmith's shop from their house on Glaserstraße, married a second time, to Theresia. Where Bühler senior was calm and polite, Franz Karl was boisterous and eccentric, and heard voices from the age of sixteen. He was also intelligent

and well-liked, and performed well at school. He enjoyed music and played the violin in a chamber ensemble. But it was at the forge that he would make his reputation. There he was a virtuoso.

In 1871, the Grand Duchy of Baden was incorporated into the new, unified Germany, ruled over by Kaiser Wilhelm I, and Offenburg went with it. The bold imperial nation demanded bold imperial architecture, and Bühler & Son became leading suppliers of ironwork for the castles and grand buildings that were being thrown up all around the region. At the schools of applied arts in Karlsruhe and Munich, Bühler learned to create the most elaborate and fashionable rococo forms. He had a subversive side, too. When the kaiser commissioned a great palace to be built at Strasbourg, in territory conquered from France, Bühler incorporated a caricature of the emperor's face into every handrail, with a mighty nose and Don Quixote mustache. His creative flair soon won him craftsmanship competitions around the country, and in 1893, when he was still in his twenties, his career hit a double high: He was appointed head of the workshop at the Strasbourg School of Arts and Crafts and chosen to represent Germany at the Chicago World's Fair. That summer, as he boarded a liner bound for the United States, this entertaining, brilliant, and somewhat overbearing young man was on course to become one of the most highly regarded artisans in Europe.

 The industrial world at that moment was in the midst of transformation, and nowhere in 1893 embodied the change more fully than Chicago. As one contemporary writer put it, the world had changed less since the time of Jesus Christ than it did in the decades before the First World War. In 1870, most people in Western Europe and the United States lived and worked on the land; by 1910, most lived in the cities, drawn in by a raft of new urban professions. London, Paris, and Vienna doubled in size; Munich tripled; Berlin quadrupled; New York grew by a factor of six. Chicago was the most supercharged of them all, expanding faster than any town in history. Barely sixty years old, it was already laying claim to the title of America's second city, and beating out New York to host that showcase of technological and cultural prowess, the World's Fair.

The World's Columbian Exposition, as the 1893 event was officially billed, was the latest of a series of world's fairs that had begun with the

1851 Great Exhibition in London. As Bühler discovered, Chicago's show would be bigger and brasher than all the rest. A seven-hundred-acre site on the shore of Lake Michigan was filled with the fruits of humanity's most technologically advanced era. Twenty-seven million people would visit, the equivalent of almost half the U.S. population at the time. In Paris four years earlier, fairgoers had been astonished by Gustave Eiffel's tower, an ironwork lattice that pierced the sky to the height of a thousand feet. The American riposte, the first Ferris wheel, was also vast—as high as the tallest of the new skyscrapers—but this construction *moved.* Powered by thousand-horsepower steam engines, it could lift up thirty-eight thousand visitors each day for a view few had ever seen: that of the human world from above. The shift of perspective in itself was a radical discovery, but down there, in the halls and gardens of the "White City," were a host of others: the first paying cinema, the first moving walkway, the first zipper-style fastener, the first Shredded Wheat, Mr. Wrigley's prototype chewing gum. At night, the Chicago sky was lit up with a display of alternating current so spectacular one visitor felt sorry for the moon: "How poor and pale she seemed in comparison!" The futuristic playground contained warnings for the coming century, too: At the southern edge of the site, the million-dollar Krupp artillery pavilion showed off the machines that would one day lay waste to the fields of Flanders.

Bühler's contribution to the fair stood in the largest man-made structure on earth, the Manufactures and Liberal Arts Building. It was one of his finest and grandest achievements, a triptych of neo-Baroque gates a dozen yards long, each of which erupted from the ground in a jungle of floral scrolls, a secret garden frozen in iron. Witty, playful, technically superb, it showed that Germany "was far and away at the forefront of blacksmithing," as the official report to Berlin stated. Bühler was awarded the medal for the highest distinction in his discipline and helped Germany to win first prize overall. It was the greatest honor his profession could bestow.

He spent six weeks in Chicago. The intoxicating atmosphere seems to have put him in an experimental frame of mind, since he began to dabble in the occult, falling in with a group of spiritualists who believed or pretended they could communicate with the dead. For years after-

ward he would describe his voices and visions in spiritualist terms. He likely explored the city's vice districts, too, including the Levee, where prostitutes lounged naked in doorways and junkies shot each other up with hypodermics in the aisles of the drugstores. The following year, he would be treated for syphilis, a disease associated with schizophrenia. By the time he returned to Europe, his personality was a dangerous blend of psychotic risk factors. One more heave would push him over the edge.

He arrived back at his new job in Strasbourg stoked with pride, a world-beating exponent of his craft. But it remained just that, a craft, a poor and socially inferior cousin to fine art. To advance himself further, Bühler decided he must elevate his entire profession. It would be his life's project. He would start by bringing "true modernity and efficiency" to the Strasbourg workshop.

He set about this task with a vigor that surprised his new colleagues, and which soon brought him into conflict with the school's director, Anton Seder. Bühler had ambitions to open the workshop to students from all over the world, but Seder felt a responsibility to the city. Bühler wanted to travel, to learn the techniques of other master blacksmiths in Budapest, Berlin, Stuttgart, Nuremberg, and Dresden, but Seder wanted him to stay in Strasbourg and teach. At every level, Bühler's plans were resisted. Compared with classless Chicago, Strasbourg was a maze of invisible social barriers, and at the Café Broglie, where the *Kunstmeisters* gathered after work, the impudent artisan became the subject of gossip. He started to skip his own lessons. At the end of 1896, after three years at the school, he was fired for unreliability, unauthorized action, and lack of compliance with working hours.

The firing was a public failure that Bühler knew would stain his career forever. He tried to justify his actions in a rambling, thirty-one-page "letter of defense" to the mayor and the city council, filled with puns and alliterations, in which he outlined his vision for the workshop and blamed Seder for blocking it. He never received a reply. There was only silence, into which paranoia crept.

"I am between Scylla and Charybdis," he wrote, "and I do not know on which rock my rudder should break."

He began to think Seder's spies were listening at his keyhole, and

moved apartments several times before leaving for Hamburg in the au-
tumn of 1897. More and more he lived in the alternate, paranoid reality
in his head. Early in 1898, in a state of mental collapse, he leapt into the
canal.

THE FRIEDRICHSBERG ASYLUM HELD more than thirteen hundred
patients and had a poor reputation even by the standards of the day. Its
nursing staff were suspected of violence, and its new accommodation
blocks were fitted with iron gratings that reminded visitors of the ele-
phant house at a zoo. Still, the institution fulfilled its function of quietly
keeping "deviants" off the streets in as economic a fashion as possible. It
was a convenient place to dump inconvenient people.

Bühler did not stay long. Eight days after his admission, he was re-
leased into the care of his father, but on the train south he stuck his
tongue out at a guard, convinced the guard had done the same to him,
and when he reached Offenburg he became a "nuisance" and argued
with everyone, especially his stepmother. The family decided to send
Bühler to the Breitenau sanatorium in Switzerland for a rest cure, but
after two weeks he escaped through a window and sneaked aboard a
train bound for Germany, hiding under a bench because he didn't have
a ticket. Police caught him in a post office: He had been trying to wire
for money but heard a voice calling him a crook and became upset. He
was brought back to Breitenau and put in the secure wing. He thought
the doctors, caretakers, and patients were plotting against him. He hal-
lucinated, seeing strange dogs at night.

Two months later, he returned to Germany, arriving at the Illenau
clinic in Achern in the company of a pair of male orderlies. He cut an
elegant figure even now: Admissions staff noted that he wore a top hat
and was extremely well-mannered. He told them he was not mentally
ill but had come simply because his father wanted him to have a thor-
ough checkup, and he would also like them to sort out his digestive
problems if possible. That night he slept excellently, and the following
morning he sang a hymn to the staff because he liked the Illenau so
much. He didn't know that the doctors were writing in his file that he
was probably a "constitutional psychopath" and that his condition had

gradually developed "on the basis of an abnormal character." On June 4, he wrote to the institution's director, thanking him for his stay and announcing that he was now ready to leave: He intended to go to a spa. He was astonished to be told he would not be allowed out. He consoled himself by asking for a violin and drawing materials.

Over the following weeks, Bühler grew desperate. He wrote six to ten letters a day, threatening, demanding, begging to be set free. He examined the locks to see if he could pick them. He climbed a tree in the garden to look for an escape route; when challenged, he said he was just trying to get some exercise. As it dawned on him that he had lost his liberty, he became frustrated and angry. He smashed a chamber pot, argued with staff and with other patients, and got into a fight. Despite the collapse of his rational sense, he worked with the same intensity he had shown on the outside, writing, drawing, and practicing his painting in anticipation of returning to his artistic program. At last, in the autumn of 1899, after a year and a half of incarceration, he appeared to find some resolution to his inner conflicts.

A key principle of psychiatry at that time was observation. Patients at the Illenau were kept in large, open "surveillance wards," where they were confined to bed and their behavior was monitored around the clock. Realizing he couldn't escape, Bühler began to side with his keepers. From now on, he would be "Doctor" Franz Bühler, a "medical police officer" who had been asked to conduct a study of patients by the ministry in Karlsruhe. This involved sketching every inmate in the asylum, noting biographical information about each case, diligently documenting, numbering, cataloguing, and critiquing every aspect of their existence.

The careful chronicles Bühler produced did not have the medical purpose he intended—the doctors paid little attention to his drawings—but they did capture the atmosphere of life inside. The Canadian sociologist Erving Goffmann would later describe the disturbing psychological effects of "total institutions" such as asylums on their inhabitants. Unlike prisoners, who could return to the world after serving their time, many psychiatric patients were never released. Their lives were a succession of steps in an endless routine: sleeping, sitting in bed, waiting for food, smoking, queuing for the barber's chair. Robbed

of all purpose, the sanest inmate could be driven to despair. Bühler documented it all: the blank faces, the bowed heads, the quizzical, uncomprehending eyes. His self-appointed task had another effect, too: As he produced sketch after sketch of individuals and groups, he was training himself to draw, growing into a figurative fine artist of considerable skill.

After two years in the Illenau, with no sign of improvement, the self-styled "medical police officer" was chosen for transfer to an asylum for long-term incurables at Emmendingen, in the region of Freiburg im Breisgau. He was happy to go, he told his doctors, since the Baden ministry had given him the task of observing and cataloguing an entirely different group of inmates. He arrived at the new institution on April 17, 1900. And that was pretty much all the world would ever have known about Franz Karl Bühler, if it hadn't been for the man who, twenty years later, came to pay him a visit.

2.

THE HYPNOSIS IN
THE WOOD

B Y THE AGE OF THIRTY-TWO, HANS PRINZHORN WAS AT ONCE A qualified physician, an art history Ph.D., a decorated combat veteran, and a professionally trained singer with an expressive baritone voice that could move his audience to tears. In later years, he would add psychotherapist, writer, lecturer, champion of the Navajo nation, and translator of the works of D. H. Lawrence and André Gide to his impressive résumé. But it was his work on the art of the insane, conducted at Heidelberg, that would stand as his greatest and longest-lived achievement. With Prinzhorn's help, madness would become a lens through which to view the horror of the First World War, and a vehicle to explore the newfound psychological territory Sigmund Freud had identified in every human mind.

Prinzhorn arrived at University of Heidelberg Psychiatric Clinic in January 1919, two months after the armistice was signed. He and his young family—Ursula was a toddler, and his wife, Erna, was pregnant with their second child, Marianne—moved into a house on Neue Schloßstraße, a steep street of switchbacks that climbed past mock-baronial mansions adorned with battlements, coats of arms, and even a knight in full armor, all carved from the local red sandstone. From their windows, the Prinzhorns could look out over the town, a picturesque mile of red-tiled roofs and church spires, squeezed between the fast-

flowing river Neckar and the shoulder of the Königstuhl mountain. Writers and artists had flocked to this center of the German Romantic movement for more than a century, to clamber among the green hills and hunt the perfect view of the ruined castle, the verdant Odenwald, and the sun-dappled river. This was a student city, a place for philosophy and poetry, for messing about in boats, for lovers, and for long walks in the fairy-tale forests. Mark Twain, who spent a year here struggling with *The Adventures of Huckleberry Finn*, described it as "the last possibility of the beautiful."

The university hospital lay a brisk thirty-minute walk away, a campus of stern imperial buildings set out on the flat land between the railway station and the river. The four-story psychiatry clinic looked a little run-down in those days: It had been short of investment even before the war, and now it needed several million marks' worth of repairs. Even so, it retained its global reputation as the birthplace of modern psychiatry. It was here in 1898 that a former director, Emil Kraepelin, had revised the old taxonomies of mental illness down to just two: manic-depressive psychosis and dementia praecox, later known as schizophrenia. It was here, too, that Karl Jaspers had written the seminal work of theoretical psychiatry, *Allgemeine Psychopathologie (General psychopathology)*. If it hadn't been for the atmosphere at the clinic and his colleagues there, Jaspers declared, this volume would simply "never have arisen."

Prinzhorn entered the clinic via the botanical gardens, through a double-height portico, and climbed a short flight of steps to the reception hall, which reverberated with the sounds of a mental hospital in the era before antipsychotic drugs. As elsewhere in the German system, the clinic was zoned according to gender and the state of the inmates. While the *unruhig* (agitated) were held in a separate block far from the entrance, *halbruhig* (semi-calm) and *ruhig* (calm) individuals were kept in the main wing, off the long corridors that stretched away at either side, women to the left, men to the right.

Prinzhorn found his place in the attic, a warren of small rooms and offices divided by heavy wooden rafters, which the junior staff shared with a group of nuns who had been drafted to help out during the war. As he settled in, he began to turn to the problem he had conceived sev-

eral months before: how to put together the greatest collection of psychiatric art the world had ever known.

PRINZHORN WAS A RADICAL in many ways, conservative in others, and sometimes both at the same time: He would later describe himself as a "Revolutionary for Eternal Things." The most dazzling assessment of him comes from the American psychologist David L. Watson, who believed he was "one of the significant literary men of our time," with a nature so noble he could be compared with the poet John Keats. In his profundity, Watson wrote, and with a kindness drawn from strength rather than weakness, Prinzhorn embodied Nietzsche's ideal of the coming twentieth-century man: He would make "outstanding contributions to the spiritual guidance of the race." Those who knew Prinzhorn better pointed out less flattering traits. He had a wild oppositional streak. He could be vain. He was psychologically frail and almost pathologically restless. He would blame these latter characteristics on his parents and on his upbringing in the rural community of Hemer, in Westphalia, where he was born on June 6, 1886.

Prinzhorn's father, Hermann, was a self-made man who had left rural Saxony for the Franco-Prussian War of 1870 and afterward found a job in a paper factory in Hemer, working his way up from the shop floor to become co-owner. Hermann married Julie Varnhagen, the daughter of the local pastor, and together they settled into a bourgeois existence of faith, self-discipline, and financial prudence. Hans would describe Hermann as a tyrant in the home—"dully threatening," a "slinger of absolute lightning"—but he was even harsher on his mother, Julie, who appeared to him as a sort of maternal black hole. He couldn't recall a single moment of friendly emotion ever having emanated from her, he wrote: "I have never experienced or 'had' a mother in the spiritual sense, as the embodiment of all simplicity of being, of all security and the gateway to the universe." The idea that he could ever have turned to her for help was "grotesque."

Even so, his parents did pass on certain advantages to Hans, the third of their five children. One was his mother's musicality. She had a beautiful, ample singing voice, and when he heard it floating through

the house he would slip into the dining room, where the piano stood, pull up a footstool, and listen in happy excitement. Another was the gift of good looks. Prinzhorn would grow up tall and fine-featured, with wavy blond hair swept back from a high forehead and pale, intelligent eyes; though his relationships were often disastrous, he would never be alone for long. Sex for Hans began at ten, with an equally precocious girl in a forest glade, and continued through his teenage years with a long list of boys who gathered after school for mutual masturbation. He developed an obsession with death, which drew him to the village slaughterhouse. Here he would crouch among vats of foaming blood to watch animals being dispatched amid the penetrating stink of their own spilled intestines. It was an eerie premonition of his war service. "Killing . . . gained a horrible power over me," he remembered.

The Prinzhorns were an educated family, and Hans found school easy, "like a game." After rebuffing his father's attempts to push him into business, he was allowed to pursue his cultural interests at Germany's best universities. He began at Tübingen, majoring in art history and philosophy, but left after a term for Leipzig, where he was taught by the celebrated art historian August Schmarsow. After three semesters he was on the move again, to Munich, to study under Theodor Lipps, the philosopher of aesthetics. He reached the Bavarian capital in the spring of 1906, age nineteen, ready to begin the most vibrant period of his life.

Munich stood at that time with Paris and Vienna as one of the most splendid cultural centers in Europe. Above all it was a city of art. As Thomas Mann described it: "Art is flourishing, art rules the day, art with its rose-entwined sceptre holds smiling sway over the city." Beneath its famous vault of shining cobalt sky, great painters drove with their mistresses in open carriages, drawing the salutes of passersby and the admiration of policemen. Young men with round artists' hats and loose cravats went out strolling, whistling Wagner motifs, seeking love and sex and inspiration, while the sound of cellos and violins drifted from open windows. The artistic quarter of this artistic city was the Schwabing, a hotbed of Bohemian experimentation, where every fifth house had an atelier. Dramatists, avant-gardists, socialists, and conservative revolutionaries stalked the drawing rooms here, gathering in

circles around the most charismatic personalities—the poet Stefan George, the mystic Alfred Schuler, the philosopher Ludwig Klages—to hammer out theories and ideologies. These ideas were not universally welcomed—as the painter Lovis Corinth noted, "In no city in Germany did old and new clash so forcefully"—but they flourished nevertheless. It wasn't an accident that this city gave birth to a host of modernist art movements, including the Munich Secession, the Phalanx, the Neue Künstlervereinigung München (Munich New Artists' Association), and Der Blaue Reiter (The Blue Rider).

As Prinzhorn wrote to his father, in Munich there was more of what he desired than he had thought possible. He formed an art association with friends, putting on festivals and shows in which he sometimes performed. He reviewed exhibitions for the Vienna papers and went to the theater and the opera, hoovering up new productions of Ibsen and Wagner. He was introduced to Nietzsche's philosophy ("dangerous" was how Hermann described it) and made dozens of friends in the cultural world, from the musician Wilhelm Fürtwangler to the artist Hans Schwegerle. Schwegerle captured Prinzhorn's youthful euphoria in a portrait. Naked beneath a long coat, he wears a hat and holds a lyre, half Apollo, half Orpheus.

"Tübingen gave me freshness, Leipzig new ways, Munich the necessary courage," Prinzhorn wrote home. Later, looking back at those years, he would state simply: "A richer time can hardly come."

In 1908, he completed his Ph.D., on the architect Gottfried Semper. Around this time, he met and married Eva Jonas, the daughter of a wealthy Jewish lawyer from Berlin, and began five years of training to be a professional baritone. It was while he was studying at the Conservatoire in Leipzig that serious mental illness encroached on his life for the first time.

In the spring of 1910, one of the Conservatoire's singing teachers killed himself three days before he was due to marry Prinzhorn's fellow student, Erna Hoffmann. The bride-to-be was pitched into such a severe depression she had to be hospitalized, and for the next two years, as Prinzhorn tried to rescue her from a succession of crises, he and Hoffmann grew increasingly close. In 1912, he divorced Eva to marry Erna. A few weeks after the wedding, Erna suffered a relapse and had to

return to full-time care. Prinzhorn now abandoned all hope of a singing career. Instead, as he told his sister, Käthe, he had decided to "tackle a righteous profession in which one must undoubtedly do something good": He would become a doctor. He took Erna to the exclusive Bellevue sanatorium in Switzerland, then moved to Freiburg, in the county of Breisgau, to begin his medical degree.

He was still there in the summer of 1914 when the war broke out, and he was drafted as a medic. It was a chance wartime encounter that led Prinzhorn to the task that would secure his place in art history.

KARL WILMANNS WAS A senior army doctor charged with reorganizing more than forty thousand beds in hospitals across southwest Germany for the war effort. In civilian life, he was a psychiatrist and had trained at the Heidelberg clinic under Kraepelin. He was fascinated by a small collection of patient art Kraepelin used for teaching, and had been thinking about ways to exploit it further. His initial idea was for a number of researchers to study individual cases, probably with the aim of drawing diagnostic conclusions from their paintings and drawings. When, in late 1917, Wilmanns met Prinzhorn in a military hospital near Strasbourg, the conversation turned to the images and objects produced by the mentally ill, and the thought processes behind them. With his medical and art history training, this was an area Prinzhorn was unusually qualified to research: He had briefly investigated the psychology of creativity in his doctoral thesis, and had discussed similar material with artist friends and with Ludwig Binswanger, the director of the Bellevue asylum. Wilmanns, who had a knack for spotting talent, asked if the young medic would care to explore the Heidelberg works. Prinzhorn initially said no, believing the collection was "too little" and "too insignificant." Yet the seed of an idea was planted that he would carry with him to the front.

In the summer of 1918, Prinzhorn was sent to the Marne Valley to command a mobile dressing station in the last major German offensive of the war. The early hours of Monday, July 15, found him in a forest west of Reims, hunkered down in a foxhole among fifty-two divisions of German troops preparing for the assault. Shortly after midnight, the

artillery around him opened up with a deafening roar; the enemy responded, and soon the scene around him began to resemble a "feast of hell." At 3:00 A.M., his unit began to advance through the pitch-dark wood in ankle-deep mud. Prinzhorn picked his way among the gun emplacements, which flared in spasmodic eruptions. As he reached the edge of the trees, a vision opened up of the river and the battlefield lit by the stars and colored flares:

> In the misty valley floor, flames from the village of Dormans licked the sky, where moments before a thousand mines had just detonated in a single explosion, the glow of the fire illuminating the meandering river. All around you could clearly now see the shape of the slopes and countless muzzle flashes.

With the dull light of dawn spreading in the east, Prinzhorn and his unit pressed forward toward the Marne under a continuous barrage. Suddenly, a "substantial bugger" landed barely ten yards behind him; he felt his left leg fly up, and he let out a scream of pain. Lying in the mud, feeling for the wound, he found only a bruise, and struggled on to the next scrap of cover. There, almost overcome with dizziness, he examined the leg again and found that "the red juice flows." He hobbled back through the roaring howitzers with his arm around a stretcher bearer. Six days later, he was lying in crisp sheets at the Victoria Hotel in Wiesbaden, his war effectively over. He would be awarded the Iron Cross, first class.

Since their meeting, Prinzhorn had continued to mull over his conversation with Wilmanns. Eventually he wrote to the psychiatrist to suggest that they attack the problem "on the broadest possible front" by trying to persuade other asylums and clinics to provide material. Wilmanns agreed. That winter, as the conflict sputtered to an inconclusive end, the psychiatrist was appointed director of the Heidelberg clinic, and he wasted little time in offering his junior acquaintance a job expanding the art collection. In January 1919, just weeks after being demobilized, Prinzhorn moved to the university town on the Neckar to take up his post as a psychiatric assistant.

IN THE SPRING OF 1919—the fifth spring of the war, as the young Bertolt Brecht dubbed it—Germany was defeated, humiliated, broke. Above all, it was hungry. The Allied food blockade continued for eight months after the armistice was signed, leaving the country in a state of famine that would last until the following summer. Difficult decisions had to be made about who ate and who did not, and psychiatric patients were at the back of the queue. What food they were given was indigestible, lacking cereal, meat, and fat, and the patients' poor nutrition turned everyday infections into killers. Thirty percent of Germany's asylum population, more than seventy thousand people, died between 1914 and 1919 from starvation, disease, or neglect. The deliberate prioritizing of the healthy over the sick would have far-reaching consequences. As Karl Bonhoeffer, the chairman of the German national psychiatric association, put it, it was almost as if the country had witnessed a change in its concept of humanity:

> We were forced by the terrible exigencies of war to ascribe a different value to the life of the individual . . . we had to get used to watching our patients die of malnutrition in vast numbers, almost approving this, in the knowledge that perhaps the healthy could be kept alive through these sacrifices.

While Bonhoeffer warned that there was a danger of the situation "going too far," others saw it as an opportunity, a chance to remove an economic burden from the defeated and impoverished state. In their pamphlet *Die Freigabe der Vernichtung lebensunwerten Lebens* (Permission for the destruction of life unworthy of life), Karl Binding and Alfred Hoche set out a scheme to extend the attrition of certain types of psychiatric patient through "involuntary euthanasia." For Binding, a retired legal expert, these "incurable idiots" were "not merely worthless, but actually existences of negative value," a "travesty of real human beings" who occasioned disgust in anyone who encountered them. Hoche, a professor of psychiatry at Freiburg, gave the treatise a medical gloss,

describing inmates who existed "on an intellectual level which we only encounter way down in the animal kingdom." It cost the state 1,300 reichsmarks a year to keep each "idiot," the two men argued, which thereby sucked up "massive capital" from the national product. It was only right, given Germany's dire position, that such "ballast existences" be thrown overboard.

Binding and Hoche introduced the term *lebensunwertes Leben* or "life unworthy of life" into the discourse over mental health care and sparked a debate among psychiatrists, theological experts, and lawyers that would last for more than a decade. Some supported Binding and Hoche's idea and suggested ways to flesh out the details; many did not. For the time being, at least, the pamphlet's recommendations were not implemented.

The mentally ill weren't the only ones on short rations. Across the nation, German daydreams were filled with food. Carl Zuckmayer, a war veteran and poet who moved in the same Heidelberg circles as Prinzhorn, remembered a "crazy hunger" in the spring of 1919, a chemical craving for sweets and alcohol. He and his friends longed for the cans of gluey condensed milk that came in foreign aid packages, while the quintessence of nutrition was a tin of corned beef. Any alcohol they could lay their hands on—including sour wine, and schnapps made by state distilleries from potato peels—was consumed until their "skulls smoked." Clothes were in short supply, too: The only material that existed in abundance was gray-green uniform cloth, which they cut up to make suits. Yet all the deprivation could not dampen the veterans' elation, since they awoke each morning knowing they would not be shot, and went to bed each night knowing that no alarm would tear them from their beds. "We had life," Zuckmayer remembered, "and we wanted to use it and savor it to the limit, with all our power."

Prinzhorn was in a similarly liberated frame of mind. A generation of young men had been forced to walk into the jaws of the guns, and for what? Germany's defeat showed that their deaths had been futile, and everything was now open to question, from faith in human progress to reason itself. Prinzhorn felt "the deepest nihilism" for all forms of culture, he wrote. No religion or ideology could offer him a connection, or even support; he was "as free of all such bonds as is possible for present-

day man to be." Determined to discover the real purpose of life, seeking "the vibrancy of other living things, of nature and the work of men," he threw himself into his job.

THE COLLECTION PRINZHORN FOUND in the Heidelberg clinic was small, probably consisting of no more than a few dozen pieces, arranged by diagnosis. Wilmanns had already picked out a few drawings for him to study, and the professor's authority and reputation would help him gain access to other asylums. It was Prinzhorn, though, who defined the problem. This was spelled out in a first round-robin letter to the directors of psychiatric institutions, two brisk paragraphs typed on a single sheet of A4 letter-size paper. It began:

> Dear colleague,
>
> The pictorial arts of the mentally ill have repeatedly been the subject of scientific investigation. However, the material from which previous results were obtained has been limited.

If institutions would be prepared to send in paintings, drawings, and sculpture by their schizophrenic and paranoid patients, he continued, it was near certain that an "unusually rich and instructive body of material" would result. The Heidelberg clinic would bear any costs and would only require the works for a short time, after which they would be returned undamaged. It would be extremely useful if the medical files of the creators could be sent along, too. Finally, if any of the material was to be published, Prinzhorn would first seek the relevant permissions.

Copies of the letter were signed by Wilmanns in his neat hand, and sent out in the middle of February to psychiatric institutions across Germany. The response was swift, almost overwhelming. Psychiatric patients had been making art in hospitals across the country, and the fruits of their labor now came flooding into Prinzhorn's attic. As time went by, he would expand his search, sourcing material from all over

Europe, even from Latin America and Japan, but the earliest and rich-
est seams were asylums in the German-speaking world. The works they
sent in were of every conceivable type, executed with every available
variety of media. Alongside drawings and paintings, there were collages,
pieces of music, and handmade books. The better-off patients had filled
sketchpads, diaries, and canvases. Others used scraps of newspaper, tis-
sue, old sugar bags, toilet paper, and the contents of wastepaper
baskets—meal plans and nursing rosters, used envelopes and pages torn
from newspapers. Sculptures were molded from chewed bread or
carved from bits of old wooden furniture. The most common drawing
implement was the indelible pencil issued to hospital staff, which wrote
in purple when licked, but there were also watercolors, pastels, vegeta-
ble dyes, and India ink. Some pieces had been varnished, washed with
chalk, or overpainted to obscure their meanings. There were self-
portraits, landscapes, interior designs, texts, and tattoos.

As material poured in, Prinzhorn catalogued it according to content
and form. He gave each artist a case number, and protected the works
as far as his meager budget would allow, mounting and framing the pic-
tures. The growing collection's enormous variety was matched by its
surprising quality: It wasn't just medically interesting, Prinzhorn real-
ized, it was interesting as art. He maintained a busy correspondence
with the asylums, offering encouragement and support where he could.

His exchanges with Dr. Carl Hermkes, director of the Eickelborn
institution in Westphalia, were typical. On March 1, Hermkes sent a
selection of patient drawings and sculptures, including work by a for-
mer publican, Peter Meyer, and an ex-builder named Karl Genzel.
Prinzhorn was impressed with the work and wrote back to Hermkes
asking if he might be so kind as to encourage Genzel and Meyer to do
more. Another Genzel sculpture arrived in May, a small, bulbous
wooden effigy who wore armor, a crown, and an officer's mustache,
which reminded Prinzhorn of ancestor carvings from New Guinea, but
was also recognizable as the German field marshal and war hero Paul
von Hindenburg. Genzel had drawn attention to Hindenburg's "fat
cheeks," and had given the figure "large ears because he must hear ev-
erything" and a protuberant nose "because he must smell everything." It
wasn't always easy to follow what Genzel said about his work, Prinzhorn

realized, but one remark stood out: "When I have a piece of wood in front of me, a hypnosis is in it. If I follow it, something comes out. Otherwise there is going to be a fight."

Meyer, meanwhile, was engaged on a painting called *The Ten Commandments*, Hermkes wrote: At present he would only make religious pieces. It would be "desirable to have some clay and paints" for Genzel, he added, as he was unable to get hold of them.

Were oils or watercolors wanted? asked Prinzhorn, before inquiring about the artists' inspiration. Had Genzel seen any "so-called Negro sculptures"? Had Meyer, who had lived in the cathedral cities of Cologne and Münster, seen stained-glass windows, which his work resembled? Even if he had, his independent achievement was astonishing. Again, the Heidelberg men asked Hermkes to encourage productivity, adding that they were "more than willing to give a small gift of money." Hermkes suggested that chewing tobacco for Genzel, and a letter of acknowledgment for Meyer, would "probably stimulate the productivity of both men."

Around three-quarters of Prinzhorn's artist-patients were diagnosed with schizophrenia. The rest shared a range of conditions from "manic-depressive" to "paralytic," "imbecile," and "epileptic." Though more than half the patients living in German asylums were female, fewer than 20 percent of the works Prinzhorn received were by women, a reflection both of their status in society and of a narrow definition of art, which excluded many traditionally female handicrafts. An exception to this trend was Agnes Richter's jacket. Richter, a Dresden seamstress, had been committed in 1893 after being arrested for disturbing the peace. In the asylum at Hubertusberg, she began work on an institutional garment made of gray linen, re-stitching the arms on backward, and embroidering it all over with expressions of her plight. "I am not big," read one; others spelled out "my jacket," "I am," "I have," "I miss today," and "you do not have to." Her asylum laundry number, 583, appeared again and again. The writing was mainly stitched to the inside, where it would have lain next to her body—an attempt to reinforce her sense of self, perhaps, in a place where that was easily lost. The jacket was Richter's only item in the collection.

Katharina Detzel, too, was represented by very few works. Detzel

was a powerful character in the asylum at Klingenmünster: Institution-
alized after sabotaging a railway line in an act of political protest in
1907, she resisted the doctors' punitive "treatments," and frequently
tried to escape. She wrote a book and a play, and began to create tiny
figures from chewed bread before graduating to more substantial mate-
rials. Her most striking piece was a life-sized mannequin with male
genitalia, which she called "man." When she was angry, she would beat
"man" with her fists; when she was happy, she would dance with him.

Clear themes began to emerge from the work. One concerned the
near-supernatural power of machines. Jakob Mohr, a farmer with
schizophrenia, drew a diabolical device that emitted invisible "influenc-
ing" waves, which he thought were producing his strange visions and
sensations. Gustav Sievers, a weaver, designed a "flying weaving loom,"
which he said would transform life on earth for three thousand years;
he even applied for a patent. Sievers also spent time exploring the erotic
potential of bicycles, depicting large-bosomed ladies pedaling to and
fro: In institutions where men and women were not allowed to meet,
sexual fantasies provided another rich vein. Joseph Schneller, a para-
noid former draftsman for the Bavarian railways, depicted various por-
nographic "chicaneries," as he described them, and produced a magnum
opus titled *Sadistisches Lebenswerk* (Sadistic life's work), which included
vast, detailed plans of establishments in which sex was to take place and
the specialist equipment that was required.

Other artists exhibited royal delusions. Else Blankenhorn, the
daughter of a wealthy Karlsruhe family, had lived for many years in the
Bellevue sanatorium, where she developed an elaborate fantasy life in
which she was Else von Hohenzollern, the spiritual wife of Kaiser Wil-
helm II. This imagined role required her to help deceased couples in
need of redemption, an expensive business which she paid for by paint-
ing high-denomination banknotes. She also produced large quantities
of beautiful, brightly colored oil paintings, influenced by Van Gogh and
Edvard Munch, which often show a young woman floating, untethered,
in an Expressionist landscape.

At a time when the church still governed most people's lives, reli-
gious subjects were strongly represented in the collection. Carl Lange,
a salesman, believed he had seen a divine face in a piece of meat while

traveling in America in 1883. After plotting to assassinate the president of Mexico, he had been taken to the Bloomingdale asylum in New York before being deported and placed in the institution at Schwetz. There, he noticed overlapping heads, figures, and religious symbols that appeared in the sweat-stained insoles of his shoes. He drew more than a hundred such "miracles" in finely detailed pencil sketches, each of which was contained within the outline of a footprint. Josef Forster, a patient at the Karthaus-Prüll institution in Regensburg, believed he could actually become a god by only eating his own bodily excretions. When he achieved the holy state, he would be weightless and able to run through the air at great speed. He envisioned this moment in a magical, thickly painted portrait of a flying man, held to the earth only by the weights he suspended from each hand. In the corner of this work he wrote:

This is to show
That if one's body no longer has any mass,
One must weigh oneself down.
And you can go
With great speed
Through the air

By summer, Prinzhorn realized it had been a mistake to promise to return the works. In an updated circular letter in June 1919, he wrote that it would be "extremely unfortunate" if this unique collection were to be dispersed and returned to asylum archives, where only a small number of people would have access. Instead, he wanted to keep it together as a "museum of pathological art." The most interesting pieces would be hung in an exhibition room, while others would be archived and made available for future research.

That autumn, when artwork by around 130 patients had reached the clinic, Prinzhorn published his first article on the subject, in a German psychiatric journal. "The Artistic Work of the Mentally Ill" contained no details about the collection. Instead, it was an overview of the existing literature on the subject, including *L'Art chez les fous* (The art of the mad) by the French psychiatrist Paul Meunier and *Genio e follia* (Genius and madness) by the Italian criminologist Cesare Lombroso, who ar-

gued that great artistic ability was akin to insanity. Prinzhorn also sum-
marized shorter treatises by Freud, Kraepelin, and Jaspers. What shone
through his analysis was a growing distaste for the diagnostic approach,
when few people seemed to have examined the material's relationship
to "normal" art. How was it possible that an "insane" person could cre-
ate works of undeniable artistic quality? A theory of configuration was
required, he concluded, to explain the psychic processes behind artistic
creation. Only then could "mad" and "sane" art be directly compared
and light be shed on the problem of art's relationship to insanity. This
was the task that lay ahead. He would present his findings in a substan-
tial volume which would showcase the abundant material that was pil-
ing up at the clinic.

For Prinzhorn, examining the immense variety of works within his
collection was a transcendent experience. He realized he had uncov-
ered an untapped source of schizophrenic creativity that matched or
even surpassed professional art in its expressive power. Medical records
could give him only a basic understanding of these strange creations,
however, and he asked doctors to include the artists' own explanations
of certain pieces, recorded verbatim. Then even that wasn't enough. To
understand this art properly, he needed to interview the artists them-
selves. He began to travel around Germany, meeting and speaking with
patients whose work he found particularly engaging.

There was one individual in his cohort of newly discovered talent
who seemed to surpass all the rest for sheer ability. One day in 1920,
Prinzhorn set out to pay him a visit.

3.

A MEETING
AT EMMENDINGEN

THE ASYLUM AT EMMENDINGEN STOOD IN THE BROAD VALLEY of the river Elz, a stretch of rich agricultural land framed by the foothills of the Black Forest, in the southwesternmost corner of Germany. The best way to reach it, then as now, was on the railway line that ran along the Rhine, from Mannheim to Basel via Heidelberg, Karlsruhe, and Offenburg. Beyond the carriage windows, vineyards and picturesque villages ticked by as the engine hauled south across the floodplain. Ten miles before Freiburg, the track turned east toward the station at Emmendingen, a town of four thousand souls. At the time of Prinzhorn's arrival, the asylum had its own rail stop, a mile farther down the line. It was a pleasant walk from here, along an avenue flanked with trees, to the bridge across a mountain stream that led to the asylum gates.

In Germany's two-speed psychiatric system, Emmendingen's inmates were in the slow lane. The rural *Heil- und Pflegeanstalten* (sanatoria and nursing homes), as they were known, were dumping grounds for those who failed to respond to treatment at the university clinics. But anyone expecting to find a Bedlam or a Colditz here would have been pleasantly surprised. Emmendingen was in effect a giant agricultural colony, constructed with a key therapeutic principle in mind: the restorative power of nature. Spread over 160 acres of land, it was mostly given over to fields, orchards, and vegetable gardens, where the patients

were encouraged to work. At its heart lay a fifty-acre residential zone, set out like a city park, and in this warmest, most humid part of Germany, tropical vegetation sprouted at every side. In spring, clattering storks would nest on the roof of the refectory, and on summer evenings, the chorus of frogs outside the administration block grew so loud the duty manager had to shut the window to hear himself think.

As at Heidelberg, the campus was segregated by gender, and designed with a geometric balance that aimed to nurture harmony in the residents. From the gatehouses at the bridge, a central axis led north, bisecting the concert hall and the chapel. Women were kept to the east of this invisible line, men to the west. "Agitated" and dangerous patients were locked in the secure buildings of the large central block, which contained the surveillance wards, bath facilities, and isolation cells, as well as day rooms, sculleries, and toilets. Separate, closed areas on either side of the campus were designated for epileptics. The rest of the inmates, those in the "calm" or "semi-calm" categories, were housed a few dozen at a time in the two-story pavilions that dotted the park. The most trusted patients could walk directly from their verandas out into the gardens, then into the surrounding fields. Bühler, whose surviving medical records show no sign of violent behavior, would likely have lived in one of these "calm" or "semi-calm" houses on the male, western side of the campus.

Prinzhorn found the metalsmith to be a small man with a large head. Bühler was in his mid-fifties by this time, though his hair and beard were still black, and his eyes in particular were luminous—"darkly glowing," the doctor recorded. He had a friendly smile and moved about quietly, though Prinzhorn found his actions "highly mannered." The main difficulty was that no one understood much of what he said. The doctor had hoped that the excitement of seeing someone from the outside would rouse him from his confused state, but it soon became clear that this would not happen. Bühler looked at his visitor with "lively, mousy eyes" and evident distrust. With precise hand gestures, he prevented any attempt to start a conversation. Still, he was aware of the purpose of the meeting. He had a package wrapped in newspaper and bound with string, which he turned over and over in his hands.

Asked if he would open it, Bühler mumbled something about

"unready things" and cast shy, sidelong glances. He tried to divert Prinzhorn's attention by jumping to his feet and running to the window to signal to a friend, and when an asylum physician entered, he shouted a warning and withdrew to a corner, where he mumbled and made conjuring motions. After the physician had gone, Bühler checked the door carefully, listening for a long time in all directions, before returning to the bundle and shrugging. At one point, he loosened the string and took out a sheet of paper before suddenly reaching to his head in recognition and repacking it. He searched in his vest pockets for the butt of a cigarette, which he sniffed lovingly and lit, then stood up and began to walk back and forth, smoking, gesturing for Prinzhorn to be quiet. After a third of the butt was gone, he carefully put it out, rewrapped it, and returned to the table with a friendly smile.

Prinzhorn felt he was being teased. It was only after a "prolonged struggle with these whims," he reported, that he finally persuaded Bühler to show a few of his treasured drawings from the package. As the visitor looked through the works, Bühler became coherent for the first time. "Yes, that's quite good," he said, and "There should be more red in it."

Unlike most artists in the collection, Bühler was pedantic enough to have dated his drawings, either directly or in the writing he often included on the reverse side. This meant they acted as a record of the patient's ability over more than two decades. Though Prinzhorn judged Bühler's illness to have progressed substantially in the twenty-two years since he had entered the asylum system and believed him now to be in "the final schizophrenic stage," his skills as an artist had not deteriorated. In fact, they seemed to have greatly improved.

The early, observational sketches of his "medical police officer" period at Illenau showed little evidence of the extraordinary psychic events occurring within him. At this point he was still able to write "comprehensible sentences containing his desires, communications, and general speculations," and charming, evocative poetry:

Fairies, brushing
Avoid, bend in the dance
See turn enjoy envy

Go stand ride stride around all
Escaped from waving heights
Departing sufferings come here
Consecrated earthly bodies guess
Tricky clever smart women's tears
Dancing round humming howl
Trembling grasses pining odors
Climb embracing the pairing urges
Up within us a breath of love.

By 1903, however, his writing had become less coherent, overtaken by the urge to systematize. Everything was pressed into some scheme or category, such as:

I.	Dissolution of state M.
II.	Stopping s Dem.
III	Victim h soz.
N IV.	Index externally send away P.
III.	well unified story
II.	enjoyment moves geogr.
I.	satis. need language
God I.	Clam World Citizen +

Bühler's art had begun to change around this time, too. Many of the works were still realistic, but others depicted strange "new organisms," as Prinzhorn described them. Some of these resembled mythical animals—a creature that was half tapir and half dolphin; a plump monster that combined a dog, a boar, and a man, which seemed to threaten the viewer. In one sketch he added a body to a head-and-shoulders portrait that hung on a wall, and which magically sprang to life. Prinzhorn believed Bühler had drawn these scenes from the "fantastic intermediate realm" of his hallucinations and observed that his style had become increasingly natural and expressive as his illness progressed.

In more recent years, Bühler had approached what Prinzhorn considered the pinnacle of his achievement. He had begun to turn his gaze inward, producing a number of searing self-portraits. One of these,

drawn in colored pencil with loose but pregnant strokes, had such burning tension that, in Prinzhorn's eyes, it bore comparison to the works of Van Gogh. "For once," he decided, "we are allowed to speak unqualified of art in the fullest sense of the word, of the pictorial confession of an artist who has long used speech only for confused games." But Bühler had attained his greatest heights with a different subject altogether. *Der Würgengel* (The choking angel) showed one of God's messengers with a shining crown of light, a sword, and a blank, torturer's face, standing with its foot on the throat of a man who was attempting to wriggle free. At the right-hand side of the painting, the victim kicked up his legs, which were twisted and seen from the back. For Prinzhorn, all the "valuable intensifying impulses" of the schizophrenic mind reached their peak in this image. The artist had composed the confusion of limbs expertly, giving a clear overview without losing the feeling of colossal tension. The work showed such "sovereign mastery" that it would compare favorably with the work of the most famous German masters of all: "It is certainly not blasphemous to speak of Grünewald and Dürer in relation to this work. All the features we found characteristic in analyzing [Bühler's art] are mirrored in this, his masterpiece."

There was no question in Prinzhorn's mind that Bühler was seriously ill, yet his late output led the art historian to a revolutionary conclusion. No one with any knowledge of culture could look at these works and continue to explain schizophrenic change merely as a deterioration. Instead, viewers must cast aside their prejudices about the image's creator and judge the work only on what they saw in front of them. Psychiatric art, Bühler proved, was just as much an aesthetic occurrence, and just as valid, as any other form of configuration.

4.

DANGEROUS TO
LOOK AT!

T HE AVANT-GARDE WAS ALIVE TO PRINZHORN'S COLLECTION
even as he accumulated it. It helped that he was an energetic letter-
writer and self-promoter, with a growing range of contacts in Weimar
Germany, from the painter Emil Nolde to the architect Ludwig Mies
van der Rohe and the Nobel Prize–winning novelist Gerhart Haupt-
mann. Some of these people were friends he had made during his pro-
longed student days. Others he had met through his wives, particularly
Eva, whose father was well connected in Berlin. Two of his most valu-
able supporters at this time were the philosopher Ludwig Klages and
the art historian Wilhelm Fraenger.

Klages was fourteen years older than Prinzhorn. Handsome and
peevish, he had once been a fixture of the Munich scene, a member of
the "Cosmic Circle," and a lover of the Bohemian queen of the
Schwabing, Fanny zu Reventlow. His philosophy, dubbed "biocen-
trism," was built on Nietzsche's ideas about humanity's place in nature.
Humans, like all animals, were inescapably connected to the natural
world and could experience a harmonious inner life by living at one
with their environment. But civilization had caged the "wild," animal
part of humankind, Klages proposed, making people neurotic and un-
happy. Furthermore, all attempts to rediscover the spiritual beauty of
humanity-in-nature were destined to fail, blocked by our species's de-

velopment of self-awareness, command of language, and ability to think in the abstract. The human condition, therefore, was a perpetual conflict between the unconscious animal drive to regain equilibrium with nature and the self-conscious desire to assert uniquely human traits.

After visiting him at his home outside Zurich, Prinzhorn became a zealous follower of Klages, convinced that he was the natural heir to Goethe and Nietzsche and the antidote to the disarray in German philosophy. Prinzhorn would build Klages's ideas into his interpretation of the art collection. More than that, Klages would become a father figure and lodestar for the younger man, one of the few fixed points in an often chaotic life.

Fraenger was a very different creature—a flamboyant character who liked to combine suede trousers and a burgundy frock coat with matching slippers. He had quit his academic job in the art history faculty at Heidelberg for a more free-form career, and in university circles he was seen as a Rasputin, a corrupter of youth, and a devil. In early 1919 he had founded a society of modern-minded associates called the Gemeinschaft (Community), which included Prinzhorn, the artist Oskar Kokoschka, and Carl Zuckmayer. The Gemeinschaft organized lively debates, banquets, long walks in the forest, musical performances, and outings to exhibitions, and Prinzhorn and Fraenger struck up an intense relationship over their shared interests in art and psychology. On long summer evenings, the group of friends would head out to one of the taverns in the hills behind the castle. A favorite venue was the Wolfsbrunnen, a secluded glade in the dense forest, with a tavern and a fishpond fed by a natural spring. Here, far from the disapproval of the town, they sang and performed, flirted and drank, late into the night.

Prinzhorn excelled on these occasions. Zuckmayer recalled him wearing the same wine-red frock coat as Fraenger and singing a medieval French fable in his beautiful voice. Another time he played the lead in Kokoschka's *Der brennende Dornbusch* (The burning bush), opposite an attractive young female doctor. The play was a sequel to the artist's *Mörder, Hoffnung der Frauen* (Murderer, hope of womankind), which had come close to causing a massacre on its opening night in Vienna after the audience rioted and a group of soldiers entered the theater with swords drawn. This was exactly the sort of modernist provocation of

which the Gemeinschaft approved: if Fraenger was their prophet, Zuckmayer pronounced, Kokoschka was their god. Many of Prinzhorn's artistic reference points, from Breugel to Bosch to Der Blaue Reiter, could be traced to Fraenger. Fraenger invited Prinzhorn to talk to the Gemeinschaft about psychiatric art, borrowed works from the collection to present in his apartment, and helped spread word of it among his contacts in the art world.

Anyone who knew about modern art who saw Prinzhorn's images in those days couldn't fail to notice their astonishing resemblance to contemporary professional painting. This wasn't a coincidence. A surprising number of avant-garde artists had been pursuing their own investigations of madness for years, a consequence of the tremendous changes that had given rise to modernism in the first place.

Alongside the technological revolution, the late nineteenth century had seen a revolution in Western thought, which had overthrown many of the old assumptions about religion, society, and humanity's place in the world. Darwin's theories had demolished the Garden of Eden, Nietzsche had announced the death of God, and Freud had uncovered vast unsuspected depths inside every man, woman, and child. In light of these ideas, the art that had been taught for so long in the academies, with its classical subject matter and its strict ideas of proportion and beauty, seemed irrelevant. The avant-garde instead began to dig for inspiration in sources they believed to be untainted by so-called civilization, such as the art of "primitive" people, of children, and of the insane.

There was no better template for the "mad artist" in the early years of the twentieth century than Vincent van Gogh. The "red-headed lunatic," as he was known in the southern French town where he lived, had created radically stylized views of the world, including the asylum he entered in 1889. Instead of producing a mutually agreed, art-school account of reality, Van Gogh's works appeared to have been distorted by the lens of his own inner turmoil. The emotional power of his painting was a revelation to a new generation of artists who called themselves Expressionists and was so vital to the Dresden group Die Brücke (The Bridge) that one member suggested they change their name to "Van Goghiana." An idea of the excitement the Dutchman provoked can be read in the response of Paul Klee, who saw Van Gogh's paintings

for the first time in Munich in 1908. He was certainly a genius, Klee
decided:

> Pathetic to the point of being pathological, this endangered man
> can endanger one who does not see through him. Here a brain is
> consumed by the fire of a star. It frees itself in its work just before
> the catastrophe. Deepest tragedy takes place here, real tragedy,
> natural tragedy, exemplary tragedy. Permit me to be terrified!

Three years later, Klee wrote a review of a show by Der Blaue Reiter,
the Munich-based Expressionist group he would soon join, noting that
"Neither childish behaviour nor madness are insulting words here, as
they commonly are. All this is to be taken very seriously, more seriously
than all the public galleries, when it comes to reforming today's art."

Just as Klee and his colleagues had begun to investigate madness, the
First World War broke out, bringing psychological trauma into almost
every household in Europe. Twenty million were killed and the same
number left mutilated. Every village had its roll call of dead, its blind
and its limbless, its begging veterans and its matchbook sellers. Added
to the veterans' physical suffering was a less visible mental toll, mani-
fested in a host of symptoms, from tics to mutism to unexplained pa-
ralysis and temporary blindness. Post-traumatic stress was not yet
understood, but it affected soldiers, civilians, refugees, children, and
parents alike. There was little sympathy for these psychological condi-
tions, and many were left untreated or diagnosed as neurotics, "mental
cases," shell-shock victims, and cowards.

Artists were as devastated by the war as everyone else. Two of the
leading lights of Der Blaue Reiter, Franz Marc and August Macke, were
killed in the fighting. The Expressionist sculptor Käthe Kollwitz lost
her eighteen-year-old son, Peter, in Belgium: she would pour her grief
into her work for the rest of her life. "Made a drawing," she wrote in
1916. "The mother letting her dead son slide into her arms . . . I feel
obscurely . . . that Peter is somewhere in the work and I might find
him." Several of those who survived the combat suffered nervous break-
downs, as Max Beckmann, Ernst Ludwig Kirchner, and George Grosz
did. Others, such as Otto Dix, would spend years afterward reproduc-

ing the visions of insane, grinning soldiers and gas-mask-wearing aliens that had been seared into their minds at the front. Max Ernst was so traumatized by his war experience that he wrote simply: "On the first of August 1914 M[ax].E[rnst]. died. He was resurrected on the eleventh of November 1918."

Even as the fighting continued, an artistic resistance had sprouted among a group of intellectuals taking refuge in Switzerland. In February 1916, Hugo Ball and Emmy Hennings launched the Cabaret Voltaire nightclub in a Zurich back alley. The young crowd who gathered in this tiny venue shared a belief in the power of art to save humanity and a disgust at the rationalism that had led to the carnage. "Repelled by the slaughterhouses of the world war, we turned to art," wrote Hans Arp. "We searched for an elementary art that would, we thought, save mankind from the furious madness of these times." Ball, Hennings, Arp, and their friends chose a deliberately nonsensical name for their deliberately irrational movement: Dada.

By the war's end, insanity was a central theme for art. On top of its pre-1914 significance as an authentic route to the Freudian interior and a weapon in the struggle against the bourgeoisie and the academy system, it was now also a badge of experience and suffering, and an emblem of resistance against the generation of warmongers who had been so careless with human life. The schizophrenic postwar age required a schizophrenic postwar art. Madness had never been in such vogue.

PRINZHORN TRAVELED WIDELY IN 1920, visiting patients, presenting his discoveries in lectures, and building an appetite for the book he intended to write. He carried with him a portfolio of patient art that left a profound impression wherever he went, and he noticed that the material deeply affected people of all ages, characters, and walks of life: It seemed to force them to confront fundamental questions about schizophrenia and the zeitgeist in an era that appeared to have lost touch with reality. Professional artists who saw the images fell into a handful of distinct groups. There were those who admired or dismissed the pictures without differentiating "healthy" from "sick" work, and those who renounced it all as "non-art" but were fascinated by it nevertheless. A

third category were "shaken to their foundations" by the material, Prinzhorn wrote, and believed they had discovered "the original process of all configuration, pure inspiration, for which . . . after all, every artist thirsts." Some individuals in this latter group were so overwhelmed that they found themselves forced to reconsider their entire oeuvre. This was precisely what happened on the evening of Saturday, June 19, when Prinzhorn presented his material to the artist Adolf Hölzel and his circle.

At the age of sixty-seven, Hölzel was an eminent figure in the modern art world, a founding member of both the Munich and Vienna Secessions, and a progressive and influential teacher who had recently retired from the Stuttgart academy. That evening, he and around thirty followers and ex-pupils gathered at a friend's villa outside Stuttgart to hear Prinzhorn talk and to view highlights from the collection. Hölzel was "shaken to pieces" by what he saw, Prinzhorn observed. Over the following days, the artist repeatedly asked a friend to visit him to help examine drawings of his own that he thought were strikingly similar to those in the Heidelberg collection. Hölzel's combinations of images and handwriting bore an especially close resemblance to the work of August Klett, a former traveling salesman from Swabia who believed himself to be Christ. But the patient who struck Hölzel most deeply was a woman known only as Frau von Zinowiew, an inmate at the Berlin Zehlendorf asylum. Zinowiew drew connected, kaleidoscopic shapes in crayon, adding realistic human heads that popped up strangely at prominent points. For years afterward, Hölzel would create very similar images. In general, he admired the unrestrained freedom he saw in the Heidelberg collection. "Undoubtedly, it is a truly artistic path that we find in the more outstanding lunatic drawings," he wrote.

Prinzhorn's slides had an even greater effect that evening on one of Hölzel's former students, Oskar Schlemmer. Schlemmer at that time was at a crossroads in his artistic development, and the experience of seeing the works from Heidelberg sent him into a rapture. "For a whole day I imagined I was going to go mad," he wrote to his fiancée, Helena Tutein, "and was even pleased at the thought, because then I would have everything I have been wanting; I would exist totally in a world of ideas, of introspection—what the mystics seek." The material showed

"surprising similarities to the moderns," he noted, especially to Klee, who "has seen these things and is enthusiastic." He was fascinated by the work of Baron Hyazinth von Wieser, a law graduate from Vienna who lived in a Munich asylum and believed his life was governed by magic and supernatural forces. The baron had invented an abstract system of "ologies"—including willology, ideology, sexology, and jokeology—in which human characteristics were translated into geometric shapes. He had drawn a sheet of delicate symbols representing several of these states, and had written across the top of this chart: "Dangerous to Look At!" Schlemmer couldn't get this idea out of his head.

Of course, Schlemmer told Tutein, Prinzhorn's material would be used as an indictment of modern art—"See, they paint just like the insane!"—and he had to admit it was "a dangerous game" modern artists were playing by exploring mental illness. Even so, he envied the patients, since he believed "the madman lives in the realm of ideas which the sane artist tries to reach; for the madman it is purer, because completely separate from external reality." For months afterward, Schlemmer continued to be "much preoccupied" with the questions that arose from Prinzhorn's talk. Future art historians would make an explicit connection between Wieser's ideas and Schlemmer's change in artistic direction that summer.

But the star witness for the collection's artistic value in these early days was Alfred Kubin. Another veteran of the Schwabing scene and Der Blaue Reiter, and a long-term correspondent of Fraenger's, Kubin was deeply neurotic. His life had been filled with traumas and breakdowns, and he mined the dark side of his personality in his art to the extent that his Munich friends had dubbed him the "High Priest of Horror." In the autumn of 1920, while he was recuperating from a bout of overwork at a sanatorium in Alsbach, his doctor suggested they visit the art collection at Heidelberg together, and on September 24 the two men drove the short distance to the clinic. Prinzhorn was away, but Karl Wilmanns showed them the most important parts of the now substantial trove.

Kubin was ecstatic about the material. He found it "stupendous" and "overwhelming," and he hurried to record his impressions with "a

feeling of most uplifting joy." Most of it could be held up alongside that of the best Expressionists, he decided, but was even more original. He and his doctor friend were enormously touched by the "miracles of the artist's spirit" that had arisen from the patients' subconscious depths, a place that lay "beyond all thoughtful deliberation." He was so enamored that he wanted to keep some of the art for himself, and he offered to exchange five pieces from his own collection for four crayon drawings by Bühler and a watercolor by Klett—a remarkable tribute, since it put the work of stigmatized asylum inmates on an equal footing with that of professionals. As soon as he returned home to Upper Austria, he determined to write an article introducing the collection to a wider audience. His essay "The Art of the Mad," published in the magazine *Das Kunstblatt* in 1922, represented a formidable public endorsement of patient art by a leading modern artist.

Kubin picked out eleven Prinzhorn artists whose work particularly impressed him. Following tradition, he didn't publish their names, though they can all now be identified. Apart from the former architect Paul Goesch, whose work Kubin dismissed because of the artist's "unpleasant" technical training, he understood the rest were self-taught. He found Klett "very stimulating," while the compositions of the ex-naval officer Clemens von Oertzen showed "fragrant, almost refined tones." Oskar Herzberg, a patient in Leipzig, had created "collisions of cosmic bodies" and a "fabulously grotesque Kaiser Wilhelm" that reminded him of Klee's work, while a "mighty lord of the wooden stick"— Genzel—made grotesques similar to idols found in the South Sea islands. But it was Bühler who made the strongest impression. According to Kubin, he was an undoubtedly "brilliant talent" with an "extraordinary power of invention" who created unprecedented symphonies of color.

I remember especially *Der Würgengel,* a truly satanic composition, demonic horses, donkeys in their boldest foreshortenings, dimly bathed in a colorful mist. The glass tureen from which the head of an Adonai or Beelzebub looks at us horribly like the evil spirit of intoxication!

Kubin clutched his head, he wrote, at the thought that these works were supposed to have been done by a "madman," since their primal inventiveness spoke of a "master of the first rank"; he could hardly believe it when Wilmanns described Bühler as just as "crazy" as the others, closed to the outside, incapable of any communication with his fellow humans. It would be a fabulous moment when these outstanding images could be measured against the best achievements of great artists. Sadly, the art trade had no interest in such objects, and the clinic itself had no money to exhibit them regularly, but sooner or later, Kubin felt sure, a benefactor would emerge who would help set up a permanent exhibition space in Heidelberg. "Then," he wrote, "from this place, where the creative output of the insane was collected, spiritual freshness will flow."

ALTHOUGH MOST OF THE select group of artists, art historians, and medical practitioners who encountered the collection before 1922 were enthusiastic, even ecstatic, not everyone liked what they saw. Prinzhorn observed that the culturally conservative were the least enthusiastic about the collection, and in May 1921 a visitor arrived from Hamburg who closely matched that description. With his irritable expression, goatee beard, and heavy-rimmed spectacles, Wilhelm Weygandt made such a perfect foil to the Heidelberg impresario of psychiatric art that he was later dubbed the "anti-Prinzhorn." In addition to his role as director of the Friedrichsberg asylum, where Bühler was once held, Weygandt had recently taken on the duties of professor of psychiatry at the new University of Hamburg. Although a political liberal, he was deeply reactionary when it came to medical and cultural issues. At a meeting of psychiatrists and neurologists in 1910, he had been so outraged to hear Freud's ideas about child sexuality that he had banged his fist on the table and yelled that it was a matter for the police. He had also put a great deal of effort into accumulating a gruesome collection of psychological artefacts, including almost three hundred skulls of psychiatric patients, a large quantity of grotesque case photographs of disabled people, and hundreds of examples of what he called "pathological art

practice," including drawings, paintings, sculptures, and embroidery. In 1922, he would try to procure works by Genzel for his collection, with the aim of "drawing very different conclusions" about the artist than Prinzhorn had done. The staff at Eickelborn did not provide them.

By the time of his Heidelberg visit, Weygandt was at the forefront of a growing band of medical men who were alarmed at modern art's preoccupation with pathology, and when he saw Prinzhorn's work he was livid. He poured his scorn into an article for the Berlin weekly *Die Woche,* in which he decried the obsession of "extreme modern art" with insanity. The pictorial creations of the mentally ill could be "medically interesting," he wrote, and were often useful to the psychiatrist for diagnostic purposes, but there was no such thing as "mad art." The alleged artistic expressions of mental patients were merely the clumsy, technically awkward "congenital nonsense" produced by insane impulses. Reproducing works from his own collection of patient art alongside those of professionals, he subjected artists to a psychiatric "analysis," comparing a landscape by Paul Klee with a "schizophrenic insane image" and conceptual work by Picasso with the "delusional ideas" of paranoid patients. He also described paintings by Cézanne, Kokoschka, Kandinsky, Schwitters, and Van Gogh in pathological terms. The amazing similarity between "mad art" and the "excrescences of modernism" did not mean that modern artists were mentally ill, Weygandt argued, but was symptomatic of an *Entartung,* or "degeneracy," an "aberration from the path of normal thought and feeling" which, "in our sick and troubled times," contributed substantially to lowering the dignity of mankind.

In raising the specter of "degeneration," Weygandt introduced one of the great canards of nineteenth-century thinking into the discussion around Prinzhorn's material. The roots of modern degeneracy theory lay in the racial hierarchy developed by the French diplomat Count Joseph Arthur de Gobineau in the 1850s. In his *Essai sur l'inégalité des races humaines* (Essay on the inequality of the human races), Gobineau organized humanity into a ladder of white, yellow, and black peoples. The whites occupied the top tier, with the mythical Aryans being the noblest and most gifted of all, but their "ruination," as Gobineau put it, rested on the fact that they were less numerous than the lower races

and were thereby forced to mix with them. This mixing caused the superior breeds to lose their purity and become "degenerate," which he defined as follows:

> A nation is degenerate when the blood of its founders no longer flows in its veins, but has been gradually deteriorated by successive foreign admixtures; so that the nation, while retaining its original name, is no longer composed of the same elements.

Gobineau's idea had spawned a host of cultural theories, including those of his friend, the composer Richard Wagner, an established anti-Semite who bemoaned Jewish influence on culture in his essay "Das Judenthum in der Musik" (Jews in music). Gobineau had not referred to the Jews in his theory, but Wagner did. In his version, racial mixing was a one-way process: It worked only to the detriment of the higher race, and conferred no change on the lowest race at all. While the whites could degenerate utterly, it was "an amazing, incomparable phenomenon" that the Jew, the "plastic demon of the decay of humanity," could enjoy "triumphant safety" even as he brought about the demise of his alleged racial superiors.

Several writers besides Wagner took up Gobineau's degeneration baton. One of these was the Jewish Italian criminologist Cesare Lombroso, who borrowed the idea to inform his ruminations on creativity, *Genio e follia* (Genius and madness), in 1864. But it was Lombroso's student Max Nordau, who was also Jewish, who did most to spread the idea at the turn of the century, through his influential 1892 book *Entartung* (Degeneration). Nordau, a physician who claimed to have based his arguments in medical science, warned that:

> Degenerates are not always criminals, prostitutes, anarchists, and pronounced lunatics; they are often authors and artists. These, however, manifest the same mental characteristics, and for the most part the same somatic features, as [those] who satisfy their unhealthy impulses with the knife of the assassin or the bomb of the dynamiter, instead of with pen and pencil.

The whole direction of art and literature of the time showed "insane tendencies" such as moral insanity, imbecility, and dementia, Nordau warned. Artists who produced anything other than realism were clearly physically ill. The Impressionists were afflicted by a "trembling of the eyeball," while those who, like Manet, painted "falsely-coloured pictures" were probably suffering from hysteria or neurasthenia. These degenerate "anti-social vermin" should be jailed or committed to lunatic asylums to prevent them from infecting the population.

Several critics pointed out the problems with Nordau's thesis. George Bernard Shaw wrote a lengthy riposte entitled "The Sanity of Art: An Exposure of the Current Nonsense About Artists Being Degenerate." Oscar Wilde quipped that while he agreed with the author that all geniuses were mad, Nordau had neglected to mention that "all sane people are idiots." *Entartung* sold well nevertheless, and the concept became part of the political dialogue in Germany, particularly for social conservatives such as Weygandt.

The Hamburg psychiatrist's intervention irritated and alarmed Prinzhorn. He addressed it obliquely in a circular letter in July 1921, which stated that the clinic was anxious to avoid any scandal but made it clear that he and Wilmanns would not be cowed. Given the attention the collection was receiving from artists and art lovers of all kinds, they were increasingly being urged to open up the collection to the general public, to allow the widest possible debate.

> The opinions of eminent artists and scholars, from different disciplines, support us in the idea that the collection is called to deliver a contribution to the psychology of artistic creation beyond the field of psychiatric reflection, and that in the end it can have a clarifying effect in the chaos of current art.

This was the last circular letter Prinzhorn sent, as it turned out, and his longed-for museum of pathological art would never come to pass. Tension had been building between him and his colleagues at the clinic for some time, and at the height of the summer, Prinzhorn abruptly resigned.

5.

THE SCHIZOPHRENIC MASTERS

PRINZHORN'S DECISION TO QUIT WAS AS PATHOLOGICAL AS IT was planned. The research for his book was more or less complete, and he was ready to free himself of Wilmanns's influence, but the swooping trajectory of his correspondence in the spring of 1921 suggests he had his own psychological problems in the form of depression, stress, and perhaps even latent war trauma. His long absences from Heidelberg, combined with his growing dislike for psychiatry, made the time he spent at the clinic increasingly unpleasant as the year progressed. He described himself as an "outsider" and suspected his colleagues of plotting against him—if he made the slightest professional misstep, it would provoke a "howl of joy," he told a friend. In his letters, he accused Wilmanns of deliberately undermining him and excluding him from social events, and suspected the professor of "grubby tricks" in his failure to find money for a museum of pathological art. In March, Prinzhorn diagnosed himself as an "unstable psychopath with hysterical traits," and felt he was losing his grip, "floating in the space between heaven and earth, inwardly bound for nowhere, at home nowhere, with no goal."

The task of writing up his conclusions added to his burden. In April he retreated to the small holiday home he and Erna kept in the Black Forest. Snow lay deep on the ground, and he was alone. He worked fifteen hours a day, until his head was "thick," and became mentally "help-

less" and "depressed." He hoped to become a psychotherapist when the art project was complete, but had begun to question himself, and even the book now seemed "dubious." The following month he was back in Heidelberg, "a bundle of feelings of insufficiency," and believed Wilmanns was treating him in a disgraceful manner. On July 15, he resigned.

Prinzhorn was thirty-five years old, a respected doctor of medicine and philosophy, a husband, and a father of two, but he celebrated like an undergraduate, hooking up with his friends the Schroeders and a mysterious blond woman he called "the ivory Swede" for a twelve-hour pleasure boat trip on the Neckar. They decked out the small vessel with so many plants and bouquets it looked like a "pile of flowers," and they wore swimsuits, Prinzhorn borrowing Frau Schroeder's. He described their attention-grabbing progress along the river in a letter to his friend Käthe Knobloch:

[Schroeder was] a slender, sinewy young athlete in a black short swimsuit, [Frau Schroeder] in a white robe with a colorful headscarf, the boyish blond Swede in light wine-red raw silk pyjamas with poppy seeds in her hair, me in the Schroeder woman's miniaturized bathing suit, with a cloth around the shoulders and, as a hat, a knotted handkerchief with cornflowers.

Erna did not feature in this reminiscence. She may have been on one of her extended visits to her parents' house in St. Gallen, Switzerland. Quite what her husband's cavorting did to her fragile mental state is not recorded, but the marriage was in difficulty. The Prinzhorns had spent much of their relationship apart: While he was in the army, she had split her time between the Bellevue sanatorium, their home in Freiburg, and St. Gallen. Now, with the added demands of two young children, the atmosphere in the apartment on Neue Schloßstraße was strained. A significant chunk of the blame lay with Prinzhorn, who was indecisive, neurotic, and resisted attachment of any kind—indeed, these were the qualities that had drawn him to psychology in the first place. But the irony was not lost on him that they had fallen in love as he tried to help Erna through her mental illness, and now the tables were turning. He noted bitterly how "this person, in whose schizophre-

nia I have penetrated so deeply and actively that I am somehow com-
plicit in its presence . . . turns majestically away from me."

More and more, Prinzhorn looked to escape Heidelberg. In 1921–
1922 alone he went to Frankfurt, Stuttgart, Cologne, Hanover, Mu-
nich, Zurich, Bern, Leipzig, Berlin, and Vienna, lecturing, training in
psychotherapy, building up his freelance work, and finishing the book.
He secured an introduction to Freud through Binswanger, the director
of the Bellevue. Prinzhorn had "an artistic nature with a strong im-
pulse toward independence and a great opposition to all authority,"
Binswanger wrote, and had curated the Heidelberg collection "very
well." On October 12, 1921, Prinzhorn delivered a guest lecture at the
Wednesday meeting of the Vienna Psychoanalytical Society, with Freud
in the chair. His themes—the special relationship between the work of
mental patients and contemporary art; the idea that the capacity for
artistic configuration is given to everyone—were the major lines of in-
quiry in the book he was close to finishing. Freud gave Prinzhorn a good
review, telling Binswanger that he had "personally made a good impres-
sion," though no lasting relationship was established.

Prinzhorn felt a deeper connection to Carl Jung. In November, he
began a three-month placement at the Burghölzli hospital in Zurich,
where Jung worked as a clinical psychiatrist. The apprentice was im-
pressed. "The profound wisdom and insights I have always felt in this
man are really there," he wrote to Knobloch. "We work hard together. . . .
That he offered me this, so to speak, au pair, or *honoris causa,* naturally
pleases me." Next time they met, he told his friend, he would identify
her "type" in the Jungian manner.

Prinzhorn's travels through the postwar intellectual German world
continued into April 1922 when he visited the Bauhaus art school in
Weimar. Walter Gropius, the Bauhaus's founder, was initially wary of
the whole idea of psychiatric art. "I do not want to let Prinzhorn speak
here," he told his lover, Lily Hildebrandt. "Such border crossings are
dangerous and confusing, and the minds here are already sufficiently
overwhelmed." But Prinzhorn won Gropius around. The images he
showed were "really quite astonishing," Gropius told Hildebrandt af-
terward, and Prinzhorn himself seemed "a fine person."

Throughout this period, Prinzhorn kept up a long and difficult cor-

respondence with his publisher, Julius Springer, over the editing of the book. The text was too long, and he had to trim the number of schizophrenic artists profiled from a dozen to ten, dropping the Swiss watchmaker Hermann Mebes and the only woman, Else Blankenhorn. He decided to produce separate monographs on each at a later date, though these would never materialize. He made great demands of Springer: The book's title had to be printed in a special "runic" font, the cover had to be black, and he wanted lavish quantities of high-quality images. At last, by the end of April, these issues were resolved, and on May 4, 1922, he held a copy in his hands for the first time.

BILDNEREI DER GEISTESKRANKEN (Artistry of the mentally ill) was a monumental achievement, an object of elegance and substance. If he had failed in his ambition to create a physical museum, the book itself was a virtual art gallery. It would be hailed as an "inaugural act" and an "emergence," which gave patient works a worthy presentation for the first time. Weighing almost three pounds, with 361 luxurious pages, it contained 20 plates, many in color, and 167 black-and-white images, the highlights of the five thousand pieces of art by around 450 patients— mostly from Germany, Austria, and Switzerland, but also from the Baltic states, Italy, and Japan—that Prinzhorn had gathered at Heidelberg. Springer was a scientific publisher, but this was an art book from its opening folio, which showed a full-color, near-life-sized reproduction of *Der Würgengel,* one of seven full-page images of Bühler's works. Dozens of Genzel's sculptures were also included, along with copious pieces by Meyer, Schneller, Lange, Wieser, Zinowiew, and many, many more.

Prinzhorn's unusual title addressed the core controversy of whether this material constituted art. The word *Kunst* (art) implied a value judgment and led to the dismissal of everything else as "non-art," the doctor explained, so he had borrowed a word used by Fraenger, *Bildnerei,* which translates as "artistry," but also "imagery" or "pictures," to describe all objects produced by the creative process. *Bildnerei* was the result of the primordial human need for self-expression via configuration, and was therefore equally valid whether it was produced by a schizophrenic mind or a sane one. It could neither be "sick" nor "healthy."

Developing this theme, he turned his considerable skill as a writer against the psychiatric profession and its attempts to use art—the highest manifestation of the human spirit—as diagnostic material. He attacked Cesare Lombroso for reinforcing the idea that geniuses were more or less insane and sparking a wave of attempts to pathologize important cultural figures. Though he didn't name him, Prinzhorn's fury was clearly aimed at Weygandt, who had dismissed the material as "congenital nonsense," and perhaps at Wilmanns, too, who had once hoped to use the Heidelberg collection as a medical tool. Any psychiatrist who attempted to dismiss a controversial work of art by casting the suspicion of mental illness on its author acted "carelessly and stupidly, no matter what his qualifications," Prinzhorn argued. It would simply not do to "explain" artists' works by pathographic investigations of their lives. Even "reputable psychiatrists" were making vulgar and sensational comparisons between professional art and the art of patients in the press, and these served only to "arm the philistines." It was "superficial and wrong" to infer that the authors of two separate paintings shared the same underlying psychic conditions simply because their work bore an external resemblance:

> The conclusion that a painter is mentally ill because he paints like a given mental patient is no more intelligent or convincing than another . . . that [the artists] Pechstein and Heckel are Africans from the Camerouns because they produce wooden figurines like those by Africans from the Camerouns.

A common error of psychiatry, in Prinzhorn's view, was the lazy comparison of schizophrenic configuration with "degeneration," or decadence. There were various problems with the term "degeneration," which was not defined but implied that there was a "norm" from which the artist deviated. There was no norm, Prinzhorn insisted, and he would avoid such value judgments. In fact, since psychiatry had no standing in the cultural field, all its pronouncements in the field of art were irrelevant.

Having dealt with his main enemy, Prinzhorn turned to analyzing the pictures using the knowledge of the philosophy of art that he had

acquired from Lipps, Schmarsow, Freud, Fraenger, Jaspers, and Klages. The works in the collection were direct expressions of the psyches of their authors, all of whom had a fundamental drive to "build a bridge from the self to others": These were compulsive, vital acts of communication. The configurative process itself was an honorable phenomenon, and only someone hostile to it on principle would make cheap fun of the result, however distorted or strange it appeared. The tragedy of contemporary art, he wrote, was that it had lost touch with this primeval purpose. Artists were taught that there was an objective reality, a "correct" photographic version of the world, when there was no such thing. The mental image of a particular scene was interpreted differently by every individual, and its expression could sit anywhere on a scale from the narrowest realism to the broadest abstraction. In fact, the chimera of correctness and completeness, particularly in representations of the human body, had done a great deal of harm to art. It was wrong to judge a work on its correspondence to reality, as such judgments could only be based on the dogma of the moment. Instead, the value of a work lay in its author's ability to relate whatever moved them, so that the observer could empathically participate in the experience as closely as possible. Expressive power, rather than technical ability, was what made this possible. Children, "primitive" people, and the insane all demonstrated expressive talent in their art.

At the center of the book lay Prinzhorn's pièce de résistance, his all-important, lavishly illustrated profiles of the ten "schizophrenic masters" he had found in the collection, each of whom had been given a pseudonym to protect their families' reputations. He began with Genzel (whom he called "Brendel") and followed with Klett ("Klotz"), Meyer ("Moog"), August Natterer (Neter), Joseph Knopf ("Knüpfer"), Clemens von Oertzen ("Orth"), Hermann Behle ("Beil"), Wieser ("Welz"), and Schneller ("Sell"). His greatest artistic find, Bühler ("Pohl"), was saved for last, with *Der Würgengel* picked out as his crowning glory. Some of the pieces here were so clearly artistic, Prinzhorn wrote, that many an average "healthy" work was left far behind. Indeed, professional artists' attempts to mimic the work of schizophrenics appeared ersatz when compared with genuine examples of "mad" configuration, which were the epitome of artistic authenticity. The patients

with schizophrenia in his collection were "in contact, in a totally irra-
tional way, with the most profound truths." Unbound from the repres-
sive customs of civilization, they had reproduced, unconsciously,
pictures of transcendence as they perceived it.

FOR PRINZHORN TO COMPLETE such a project in little more than two
and a half years was astonishing. A courageous psychological explorer,
he had wandered into the little-charted borderlands between art and
madness and returned with a schizophrenic treasure trove that mir-
rored the spirit of the age. It was true that he had romanticized the idea
of the autonomous schizophrenic and glossed over the fact that several
of his artists were formally trained, but his book would still be hailed as
the standard work of his field many decades later. He had rescued art
from the diagnostic clutches of psychiatry and placed the previously
despised output of the mentally ill on a pedestal, equal to or higher than
that of some of the most vaunted artists in German history.

His ideas would infuriate cultural conservatives, as he must have
known they would. He had provoked the psychiatric establishment by
ordering it out of the cultural sphere altogether, and by batting away its
favored concept of degeneracy. He had also demolished the value sys-
tem of the academies—of realism, objectivity, and years of training in
technique, color, perspective, and anatomy—and held up individual ex-
pression and raw configurative power as the key ingredients for art, just
as the avant-garde did. There would be consequences, for art and for
his artists, as the nationalists and reactionaries sought their revenge. In
the coming Germany, only one individual's expression would matter:
that of Adolf Hitler. Painting, sculpture, and design would be placed at
the service of his vision of a pure ethnic community, marching in unison
to the National Socialist drum. There would be no room in these ranks
for Prinzhorn's schizophrenic acts of configuration, or for the people
who produced them.

6.

ADVENTURES IN NO-MAN'S-LAND

IN THE DEPTHS OF HIS DIFFICULT DIVORCE, THE ACHIEVEMENT of *Bildnerei der Geisteskranken* provided some solace for Prinzhorn. The book "goes well," he wrote to his friend Käthe Knobloch in August 1922. It had doubled in price, and a reprint would soon be ordered. Reviews were positive. For the art journal *Kunstwart und Kulturwart,* it was an incomparable textbook on the psychology of creation; in different times, when there was less stigma attached to mental illness, *Der Würg-engel* should have adorned the magazine's cover. Emil Ludwig in the *Prager Presse* called it "a new, groundbreaking study" that "reveals so much with tact and sensitivity." Anyone who opened it would find "the breath gets heavier, the eye glazes, the heart rises in the throat . . . gentle souls beware!" Oskar Pfister, writing in Freud's journal *Imago,* described it as "highly commendable." It was not surprising that the book "conquered the interest not only of psychologists and psychiatrists, but also of art lovers, indeed the educated world." Karl Jaspers noted that its "quite outstanding and numerous illustrations" made it the authoritative book on the subject.

That summer, Prinzhorn's art gallery in book form became part of the German cultural landscape. The Paris-based writer Clara Malraux, holidaying with her husband, André, in Berlin, described the context in which it landed: The cinemas were screening the Expressionist horror

film *Das Cabinet des Dr. Caligari* (The cabinet of Doctor Caligari), the galleries were hosting shows by Dix and Rembrandt, and in the bookstores she found volumes of Expressionist poetry, the early works of Freud, and Prinzhorn's book on "the art of lunatics." Needless to say, she bought a copy. The Dadaist dancer Sophie Taeuber wrote to her collaborator and future husband, Hans Arp, to tell him it had finally been published and that he absolutely had to obtain it. He did.

At the Bauhaus in Weimar, the book was "going the rounds" of the staff and students, according to Lothar Schreyer, the head of the Bauhaus stagecraft workshop. Schreyer remembered dropping in on Paul Klee in his studio at the school, a "wizard's kitchen" that smelled strongly of coffee, tobacco, French varnish, lacquer, and alcohol. Klee, one of the leading young artists in Germany at this time, launched into a diatribe about "their lordships, the critics," who dismissed his art as being like children's scribbles or "the product of a diseased brain." He was in mid-flow when a mood of gaiety took hold of him, and he reached up to pluck *Bildnerei* from a shelf. "You know this excellent piece of work by Prinzhorn, don't you," he said, flipping through it. "Let's see for ourselves. This picture is a fine Klee. So is this, and this one too. Look at these religious paintings. There's a depth and power of expression that I never achieve in religious subjects. Really sublime art. Direct spiritual vision."

The new generation of artists was experiencing a "shift of consciousness," Klee told Schreyer: Territories were opening up that lay beyond the range of normal human senses, and only children, madmen, and primitive people had access to this "in-between world." Klee's art, like that of the insane, was an attempt to make that place visible, he explained, and Prinzhorn's book acted as a "confirmation" that this difficult task was valid.

In fact, *Bildnerei* was more than simply a confirmation for Klee; it was a sourcebook. The artist adapted numerous devices from it for use in his own work. Like Oskar Schlemmer, he felt a particular affinity with the paranoid schizophrenic law graduate Baron Hyazinth von Wieser. Prinzhorn reported that Wieser thought he was connected to the world by invisible, supernatural forces: He believed he could "change the position of the stars by an act of will" and would recklessly turn somersaults

in order to overcome the effects of magnetic polarization on his body. In the garden of the Neufriedenheim asylum near Munich he had given trees the names of his relatives, or of sociological terms, and by viewing them from different standpoints had discovered surprising alignments that he considered new and real knowledge. Klee to an extent shared Wieser's belief in humanity's invisible connections with the universe and in "forces that defy terrestrial bonds." If the artist knew how to let go, these could carry him "onward and upward, up to the celestial Orbits," Klee stated, where he would "soar beyond the tempestuous, sentimental style to the kind of romanticism that merges with the universe." This sense of cosmic connection was what separated Klee's work from realism or photography: "The artist of today is more than an improved camera; he is more complex, richer and wider," he wrote. "He is a creature within the whole, that is to say, a creature on a star among stars."

Six drawings by Wieser appeared in *Bildnerei der Geisteskranken*. Klee appears to have taken direct inspiration from a work Prinzhorn captioned "*Circle of Ideas of a Man*," which showed a bearded gentleman whose skull had a hatch in the top, out of which had popped a palace, a tournament, a lion, some women, and two antennae transmitting radio waves: Thoughts were literally springing from his head. A second drawing by Wieser, "*Geometrical Portrait*," showed a figure in profile within a complex network of precisely ruled lines of varying thickness. From 1922 on, Klee produced numerous similar figures, including *Abenteuer zwischen Kurl und Kamen* (An adventure between Kurl and Kamen, 1925) and *Grenzen des Verstandes* (Limits of the intellect, 1927). Various versions of Klee's *Der Seiltänzer* (The tightrope walker, 1923) also incorporated forms that appear to derive from Wieser's "*Circle of Ideas*." Though Klee was able to function effectively in the everyday world and Wieser was not, both artists loved to develop highly abstract systems and present their ideas as diagrams.

But however much Klee, Kubin, Schlemmer, and Hölzel admired the Heidelberg art collection and borrowed from it, Prinzhorn's greatest impact would not be felt in German-speaking Europe at all, but in France. In August 1922, *Bildnerei* arrived in Paris, the capital of world art, where it was to play a central role in one of the most spectacular and celebrated art movements of the century: Surrealism.

INSANITY WAS ALREADY IN vogue with the Paris avant-garde, thanks
in large part to the Dadaist writer and poet André Breton. Breton had
studied medicine before 1914 and spent much of his war service work-
ing with shell-shock victims in French military hospitals, where he was
introduced to Freud's techniques and occasionally used them on pa-
tients. At the Second Army's neuropsychiatric center in Saint-Dizier,
he became fascinated by a soldier who was convinced the entire conflict
had been faked in order to drive him insane, and who therefore sub-
jected himself to the most dangerous situations in order to expose the
conspiracy. Breton saw the man's denial of reality as a great achieve-
ment, since it gave him moral distance from the ongoing atrocities.
Madness was not simply a psychological condition to be cured, the
young medic decided, but a valid philosophical response to the apoca-
lyptic results of rational thinking. "The art of those grouped today
under the category of the mentally ill [is] a reservoir of moral health,"
he would state.

After the war, Breton tried to emulate insanity in his writing, but
ran into the problem every sane artist encountered: He was not actually
mad. Instead, he realized he would have to devise techniques to intro-
duce non-rational effects. His breakthrough came one evening in the
spring of 1919. Obsessed at the time with Freud, he decided he would
apply psychoanalysis to the process of composing a short story, hur-
riedly jotting down whatever came to his pen without engaging any
critical faculties in the hope of producing the sort of rapid, uninhibited
monologue he had extracted from patients in the war. The result, "Les
Champs magnétiques" (The magnetic fields), was nonsensical and oc-
casionally comic, but it seemed to Breton to have emerged from a direct
dialogue with the unconscious. He named the process "automatic writ-
ing" and claimed that it cast light "upon the unrevealed and yet reveal-
able portion of our being wherein all beauty, all love, all virtue . . . shine
with great intensity." He would spend the next five years honing his
ideas before officially launching a new artistic movement, Surrealism
(meaning "super-realism"), in the summer of 1924. It was while Breton

was in the midst of these deliberations that *Bildnerei* arrived in Paris, in the suitcase of the philandering Dadaist Max Ernst.

Ernst had been just as fascinated with psychoanalysis and insanity as Breton. He had studied psychology, psychiatry, and Freud at the University of Bonn before the war. Several of his seminars took place in the city's asylum—"a frightful place," as he remembered it, though it did contain a small collection of patient art. While many of the students and doctors made fun of the works' clumsiness and absurdities, Ernst was profoundly moved by what he saw, and even planned his own Prinzhorn-style book to bring the artworks to a wider audience. The war got in the way of that project, and instead he launched a radical and chaotic branch of Dada in his home city, Cologne, with his wife, the art historian Luise Strauss, and the painter and poet Johannes Baargeld. In one infamous Cologne Dada show, held in a pub courtyard in April 1920, visitors entered via the men's toilets, where a young woman in communion robes read obscene poetry aloud. Afterward, they were invited to destroy one of Ernst's sculptures with an axe the artist provided: This work is often identified as the first piece of conceptual art.

Ernst's interest in psychiatry probably led him to visit the collection at Heidelberg around this time. In seeking to follow the transcendent path of insanity, however, he hit the same barrier as Breton: He was not, strictly speaking, insane. So he began to experiment with his own processes to penetrate this "no-man's-land," as he called it. The most successful of these was collage. By combining unrelated images from teaching aids, clothing catalogues, and science books, he discovered he could create absurd clashes that provoked a sudden and intense response in viewers and made them think of hallucinations.

Breton was delighted by Ernst's collages, and in 1921 he staged a one-man show of the artist's work in Paris, which caused a sensation. Ernst couldn't attend himself since he was German and wasn't allowed a passport. Instead, two members of Breton's circle, the poet Paul Éluard and his Russian-born wife, Gala, came to visit him in Cologne. The two men struck up an immediate rapport over their war experience— "Max and I were at Verdun together," Paul Éluard would say, "and used to shoot at each other"—while Max and Gala felt a powerful sexual at-

traction. Ernst was movie-star handsome, with bright blue eyes and the physique, it was said, of an international tennis player, while Éluard was an enthusiastic wife-swapper who kept a nude photo of Gala in his wallet to show to male acquaintances. In the summer of 1922, Ernst left his wife and young child in Cologne and traveled to Paris illegally on Éluard's passport. On arrival in France he presented his new friends with a copy of *Bildnerei der Geisteskranken* as a token of thanks.

The gift enraptured Éluard. It was "the most beautiful book of images there is," he wrote, "better than any painting." Soon it was being shared among the group around Breton. It wasn't the first or only publication on the art of the insane available in Paris: Paul Meunier's *L'Art chez les fous* had been available since 1907, but it didn't carry many illustrations and was not widely read. Prinzhorn's book, on the other hand, came to occupy such a central position in Breton's circle that it was routinely referred to as the "Surrealists' bible." "All the Surrealists had [Prinzhorn's] book on the art of the mentally ill in their hands," the painter André Masson remembered; it was the "revelation" which helped them to conquer the irrational and reject the values of classicism. Breton himself would write that Prinzhorn had given the artist-patients a "presentation worthy of their talents" for the first time. In doing so, he had "called for a direct comparison of their work with that created by other contemporary artists, a comparison which in many respects turns to the disadvantage of the latter."

Bildnerei was particularly useful for visual artists struggling to adapt Breton's technique of "automatic writing" to painting. This problem was summarized in the first volume of the group's magazine, *La révolution surréaliste,* in 1924: "What was required by the Surrealist artist was a 'wonder drug' which would put him or her in a position to achieve similar results to madmen and mediums." The "wonder drug" Masson developed appears to have derived from the process of an anonymous sixty-two-year-old female patient in Prinzhorn's book, who found relief from her erotic conflicts by drawing motifs of fish and birds. She would fall "into a dreamlike condition," whereupon her hand would "move automatically with the pencil across the paper. From time to time the pencil came tremblingly to rest." Prinzhorn's description of the sleepwalking hand, combined with the resulting rhythmic, streaky

illustration reproduced in *Bildnerei,* provided a perfect blueprint for Masson's own technique, which he called "automatic drawing."

The Prinzhorn artist most favored by the Surrealists was August Natterer, an electrical engineer from Upper Swabia with a catastrophic sex life, whom Prinzhorn included among his "schizophrenic masters." In 1906, as his business started to fail, Natterer had visited a prostitute and asked her to satisfy him in a particular, undisclosed manner, at which point he heard a voice telling him that if he went ahead he would be "lost." They performed the act anyway, and in that moment he felt a lightning strike, followed by the sensation that he was "falling into hell." At noon on April 1 the following year, he was standing outside a barracks in Stuttgart when he noticed a spot in a cloud. As he watched, the spot slowly grew into a screen, sixty-five feet high, on which appeared a vision so vivid he would be able to recall it for the rest of his life:

> On this board or screen or stage, pictures followed one another like lightning, maybe 10,000 in half an hour . . . [and] the Lord himself appeared, the witch who created the world—in between there were worldly scenes: war pictures, parts of the earth, monuments, battle scenes from the Wars of Liberation, palaces, marvelous palaces, in short the beauties of the whole world.

Six months later, Natterer was brought to the asylum at Rottenmünster, where he came to believe he was "Août I," a direct descendant of Napoleon and the true successor to the French throne. His vision, he said, was God's revelation of the Last Judgment, "for the completion of the redemption."

The engineer was unusual in Prinzhorn's collection in that he didn't use the Expressionist technique of transferring his emotional crises to paper, but saw his drawing as a technical project in which he was trying to record aspects of his strange visions as accurately as possible: He appeared to treat his hallucinations as something outside his own psyche, and by depicting them he may have hoped to disassociate them from himself. This coincided with Breton's idea of trying to report on the "other world" in a realistic, documentary fashion. In essence, the Surrealists would utilize Natterer's creative way of coping with a personal

collapse of meaning to answer the more general collapse of meaning caused by the First World War.

Ernst drew direct inspiration from several Prinzhorn artists, including Genzel and Gustav Sievers, but no one had more influence on him than Natterer. Obvious parallels can be seen between the patient's *Der Wunderhirte* (The miracle shepherd) and Ernst's 1931 collage *Oedipus:* Both show sitting, free-floating figures, along with an animal, and emphasize the legs and feet. *Oedipus* was so important to Ernst that his biographer Werner Spies described it as "programmatic" for his entire oeuvre. Natterer's principles can also be found in a host of other Ernst creations, including his 1923 painting *Der Sturz der Engel* (The fall of the angel).

Breton and the Surrealists would push their cult of insanity to absurd heights, romanticizing mental illness far beyond the often grim reality. In the first *Manifesto of Surrealism,* published in October 1924, Breton wrote: "Their profound indifference to the way in which we judge them, and even to the various punishments meted out to them, allows us to supose that they derive a great deal of comfort and consolation from their imagination, that they enjoy their madness." Éluard would pronounce that it was those outside the asylum who were imprisoned and that liberty could only be found inside, while Antonin Artaud's 1925 "Letter to the Medical Directors of Lunatic Asylums" compared asylums to slave colonies and identified psychiatrists as a public enemy. Artaud protested against "any interference in the free development of delirium," proclaiming that a patient's concept of reality was "absolutely legitimate," as were all the acts resulting from it.

No Surrealist would achieve more fame and notoriety than the Catalan painter Salvador Dalí. Ten years after the Éluards had won over Ernst, they dropped in on Dalí, who was similarly captivated by Gala. This time, however, Gala would leave her husband for the artist, becoming his wife and muse. It was said that Dalí spent most of the 1920s trying by every means possible to go insane, and when he failed, he developed his own insanity-emulation processes, including the "paranoiac-critical method." Using this technique, he sought to bypass the brain's systems for ordering the world by invoking a state of delusional paranoia, projecting his own interpretations onto objects around him, much

as a child might spot a face or an animal in an oddly shaped cloud. The result was a series of visual double meanings that replicated insanity perfectly, Dalí claimed. "The only difference between myself and a madman," he declared, is that "I am not mad."

At least two Prinzhorn artists are known to have influenced Dalí. The first was Carl Lange, the former salesman who saw miraculous figures in the sweat-stained insoles of his shoes; products of Dalí's paranoiac-critical method such as *L'homme invisible* (1929–1932) closely resemble the visual double meanings identified by Lange in his *Holy Sweat Miracle on the Insole,* dating from around 1900. The second was the sadomasochistic former Bavarian railways employee Joseph Schneller. In his essay "The Tragic Myth of Millet's *The Angelus:* 'Paranoiac-Critical' Interpretation," Dalí refers twice to an erotic image by Schneller, showing two women in fetish boots in a prison or reform school setting. Dalí contrasts them with the pious figures in Millet's painting, who pray with their heads bowed, and concludes that the real subject of *The Angelus* is the couple's repressed sexual desire.

CLAIMS OF ONE ARTIST's influence on another are not always easy to verify. Art historians do not agree, for instance, on the existence of a connection between a series of heads by Picasso, including *Tête de femme* (1926), and the work of the Prinzhorn patient Heinrich Anton Müller, though the images bear a strong superficial resemblance. But there were numerous other artists working in the 1920s who paid direct tribute to the collection in their writing or in interviews and acknowledged its tremendous influence on their work.

One of these was Jean Dubuffet, who was a young art school graduate in Paris when he first saw *Bildnerei der Geisteskranken* in the 1920s. Like so many others, the images liberated him and moved him to reexamine his artistic identity. "Prinzhorn's book struck me very strongly," he remembered. "I realized that all was permitted, all was possible." He was not the only artist he knew to be similarly affected: Prinzhorn's lecture tours had led to an upsurge in public interest in the art of the insane, Dubuffet explained, which "strongly influenced the minds of many contemporary professional artists and their style." After the war, he

would make a pilgrimage to Heidelberg to see the collection in person, and join with Breton in creating a new movement based on psychiatric work, which he dubbed Art Brut (raw art). Prinzhorn's impact on modern art was simply "enormous," Dubuffet said.

Richard Lindner, the German American painter sometimes described as the "father of Pop Art," discovered Prinzhorn's work in 1925. Years later, he would pay tribute to the influence the collection had on him, calling his encounter with it "the most important artistic experience of my life." Joseph Schneller was one of several Prinzhorn artists whose work Lindner reinterpreted. The Surrealist Hans Bellmer, who devised a series of hybrid female bodies he dubbed "cephalopods" after Prinzhorn, regarded *Bildnerei* as "incomparable" and "one of the most important spiritual events of this entire century." Late in the decade Prinzhorn's influence would even reach Japan, where Koga Harue was developing a "pure art" based on Breton's principles. One of the first works of Japanese Surrealism was Harue's painting *Endless Flight* (1930), which, he told a friend, had been inspired by a "German madman": August Natterer.

Perhaps the greatest written tribute to the Prinzhorn collection in the 1920s came from the founder of Dada, Hugo Ball. In 1926, Ball proclaimed that *Bildnerei* marked nothing less than "the turning point of two epochs." He found particular comfort in the revelation that intellectual catastrophes such as the one that had befallen Bühler promoted rather than disturbed the configurative process. If the world situation were ever to deteriorate to the point where artists were committed to sanatoriums, he wrote, "the last torch of humanity, art, would not be extinguished."

What neither he nor anyone else knew then was how seriously this theory was about to be tested.

PART TWO

ENTARTUNG

A statesman is also an artist.
For him, the people are merely what
stone is to the sculptor. The masses
pose no more of a problem for the
Führer than color does for the painter.

— JOSEPH GOEBBELS,
Michael, 1929

7.

PLEASANT LITTLE PICTURES

THE *CLACK-CLACK* OF HITLER'S REMINGTON TYPEWRITER COULD be heard from his cell in Landsberg prison as early as 5:00 A.M. in the summer of 1924. This was a highly unusual state of affairs. The National Socialist leader was a notoriously late riser, yet the excitement of writing his political memoirs lured him to the small typing table every day at dawn. He would spend hours there, composing, dictating, and discussing, and when he wasn't writing he liked to read. He described the time he spent in jail as his "university paid for by the state."

Hitler had entered the prison a suicidal failure. In November 1923, he and two thousand Nazi storm troopers had tried to seize control of Munich, the first step in a plan to topple the Weimar Republic. But the Beer Hall Putsch, as the coup attempt would be called, had been a disaster: Sixteen Nazis and four state police officers were killed, and Hitler was caught and charged with high treason. On arrival at Landsberg he was convinced he would be shot, raging at the prison psychologist, Alois Maria Ott, "If I had a revolver, I'd use it!," flecks of spittle showing at his lips. Ott assessed the new inmate as "a morbid psychopath . . . prone to hysteria . . . with an inclination toward a magical-mystical mindset." But during the subsequent trial, which gave Hitler a high public profile, his confidence returned. Later, surrounded in jail by forty sycophantic co-conspirators, with piles of expensive gifts sent by

admirers, and with even guards whispering "Heil Hitler!" in his ear, he became convinced that he was the messiah for the German people, their Führer.

It was essential to support this destiny in the story he pecked out on the Remington, which he intended to call *Viereinhalb Jahre (des Kampfes) gegen Lüge, Dummheit und Feigheit* (Four and a half years [of struggle] against lies, stupidity, and cowardice) but which would be published under the snappier title *Mein Kampf*. He began the book with his birth on April 20, 1889, at Braunau am Inn on the Austria-Bavaria border, a fortuitous spot for the man who intended to unite the Germans, and followed with an account of his vocation. He had been barely eleven years old when his domineering father, Alois, decided to force him into a life of pen-pushing drudgery in the customs service. Even as a young boy, the very thought of sitting caged in an office, wasting his life and liberty filling out forms, made Adolf sick to his stomach. Quietly, he developed a different plan: He would become an artist. One day, he blurted this out, almost by accident, and for a moment the old man was struck speechless:

> "Painter? Artist?"
> He doubted my sanity, or perhaps he thought he had heard wrong or misunderstood me. But when he was clear on the subject, and particularly after he felt the seriousness of my intention, he opposed it with all the determination of his nature ...
> "Artist, No, never as long as I live!"

For the next two years, the predestined child collided with the imperious father. Alois was violent and alcoholic, the son implied, and relentless in enforcing his will: Adolf was forbidden from nourishing the slightest hope of an artistic career. The boy responded by refusing to study at all. After years of bitter struggle, the standoff came to an end on January 3, 1903, when Alois collapsed and died over his usual morning glass of wine. Adolf was now free to pursue his artistic dream.

Exactly how this confrontation played out in reality is impossible to say. Hitler twisted aspects of his biography for propaganda purposes, and was always secretive about his family background, with some rea-

son: Alois was illegitimate, his surname was the deeply rustic Schickl-
gruber until he changed it, and Adolf's mother, Klara, was Alois's cousin
as well as his third wife. But the parable of the Führer-child does deliver
an important symbolic message for Hitler: that he knew from an early
age he was an artist, and that in pursuit of this ambition he had taken
on the most powerful forces and won. By promoting this side of his
biography, Hitler was tapping into a fundamental concept of Romantic
philosophy, which he had read about in Schopenhauer, Nietzsche, and
Kant: that of the artist-genius. The individual endowed with a "talent
for art" was a "favorite of nature," as Kant explained it, a dynamic spirit
who existed outside the rules that bound humanity. The brilliant po-
litical leaders in German history were exclusively drawn from this fra-
ternity. Only such an individual could be endowed with the eternal
qualities of *Idee und Gestalt*—the creative vision of the seer and the ruth-
less execution of the politician. Again and again, Hitler would present
himself to the German people as the artist-Führer, the "artist-in-chief."
Like his idol, Richard Wagner, he believed it was his destiny initially to
be misunderstood and then to be recognized as the redeemer, the one
who could lift up broken German hearts and despairing German souls.

He would continue to portray himself as an artist long after he had
stopped painting for a living. Diplomats, generals, and visitors would
recall moments when Hitler would break off vital discussions about the
war to hold forth about art, or to claim improbably that he would rather
give up politics to wander Italy as an unknown painter. Many of his
personality traits—his indifference to bureaucratic routine, his insis-
tence on higher truth, and his preference for intuition over reason—
have been linked to his idea of artistic behavior. Even Thomas Mann
could not help but recognize the artist in him: "Must I not, however
much it hurts, regard the man as an artist-phenomenon?" he wrote
from exile in 1938. And after two decades of postwar reflection in
Spandau prison, Hitler's architect and armaments minister, Albert
Speer, concluded that the Nazi leader was always and with his whole
heart an artist. Art lay at the heart of Hitler's personality and at the
center of his ideas about politics and race. Art, Hitler came to believe,
was an eternal value that could be passed on through the *Volkskörper*, the
body of the pure race, over the generations. The German people would

be genetically healthy when they produced "good" art, while "bad" art was a symptom of their malaise.

Never in modern history would the leader of a powerful country shape the nation's cultural life so closely around his own predilections. Yet, even as he wore his artist's mantle, Hitler was a static figure, unable or unwilling to change the positions he had formed growing up in provincial Austria. As Speer put it, he remained arrested in the time of his youth, in the world of 1880 to 1910, which stamped its imprint on his artistic taste and on his political and ideological conceptions for the rest of his life.

HE WAS A REMOTE CHILD, socially inept, bossy, inclined to outbursts of extreme temper, and such a poor student in math and physics at the Realschule in Linz that he was forced to repeat a year, then moved to a less academic institution twenty miles away. It was true that he showed an enthusiasm for drawing, however, an activity at which Klara encouraged him after Alois's death. In 1905, at age sixteen, he developed a convenient long-term illness, which meant he never had to return to education. He used his time to read, learn the piano, and fill reams of paper with his sketches.

Linz, the provincial capital of Upper Austria, was home to a vibrant theater at that time, and Adolf would spend many evenings in the cheap standing-room section known as the Promenade, watching Schiller plays and listening to the music of Mozart and Liszt. It was Wagner, though, who became his obsession. "My youthful enthusiasm for the master of Bayreuth knew no bounds," he wrote. "Again and again I was drawn to his works." He was "captivated at once" by *Lohengrin,* and went to see *Die Götterdämmerung* thirteen times. His only real childhood friend was another Wagner aficionado whom he met at the theater, August "Gustl" Kubizek.

Kubizek was an upholsterer's son, nine months older than Adolf and just as awkward. His main role in their friendship was as the audience for Hitler's lectures on every subject under the Linz sun, from the rate of excise duty levied at the Danube bridge to the shortcomings of the city museum. Kubizek responded to his friend with a mix of fear

and awe, and put Adolf's volcanic personality and work-shy tendencies down to an artistic temperament: "He belonged to that particular species of people of which I had dreamed myself in my more expansive moments," Kubizek remembered, "an artist, who despised the mere bread-and-butter job and devoted himself to writing poetry, to drawing, painting and to going to the theatre."

The first time Kubizek visited Hitler at home, he found his bedroom littered with sketches, drawings, and blueprints, "like an architect's office." He always carried various types of paper, on which he would sketch or note his grand plans. Although rigid in his thinking, Hitler had a "mania" for reinventing the world around him, imagining vast and detailed visual schemes. But even as a teenager, Kubizek could tell there was something absent from his friend's paintings. They lacked artistic revelation and emotion. "The rapid catching of an atmosphere, of a certain mood, which is so typical of a water color and which, with its delicate touch, imparts to it freshness and liveliness—this was missing completely in Adolf's work," Kubizek recalled. Though Hitler worked with "painstaking precision," his ambition was only ever to paint "pleasant little pictures."

In 1906, Hitler sketched a vision of their shared future, designing a grand villa where they would live when he was a great artist and Gustl a famous musician. Soon, a new occupant was assigned to the fantasy house: a young blond woman, identified by Kubizek only as "Stefanie," whom Hitler much admired during their evening strolls on the Landstraße. He was too shy to exchange a single word with her, yet the daydream of their shared future drove Hitler on. Before asking for her hand in marriage, he decided, he should first take a step toward his chosen career by attending art school in Vienna. It would be "child's play" for someone with his talent to win a place. He wrote Stefanie an anonymous letter—she didn't have a clue who it was from, and in any case was about to marry a captain from the Hessian command—then took the road east, toward Vienna and his luminous, imagined future.

The capital of the Austro-Hungarian Empire was an epiphany for Hitler. He had visited Vienna briefly before, wandering the city from morning until after dark. He had stood for hours in front of the giant Opera and Parliament buildings, while the wide boulevard of the Ring-

straße seemed to him "like an enchantment out of the Thousand-and-One-Nights." This time he intended to stay, to stitch himself into the glorious cultural fabric of the metropolis.

He arrived in the autumn of 1907, when the modernist Vienna Se-cession and Wiener Werkstätte were close to their peaks, when Gustav Klimt was in his "golden phase," building toward his sensuous master-piece *Der Kuss* (The kiss), and when Egon Schiele and Oskar Kokoschka were setting out on their own famous careers. Hitler avoided all of this. He chose to apply to a bastion of artistic conservatism, the Academy of Fine Arts, a pompous, old-fashioned, irrelevant institution according to Kokoschka, whose all-male student body still wore velvet robes and berets, the better "to be considered artists." He sat for an admissions test at the academy in early September and was allowed to proceed to the drawing assessments, which were held over two days at the start of October. The examiners required eight compositions on such well-worn themes as "Expulsion from Paradise," "Hunting," "Spring," and "Death," and he waited for his result with "confident self-assurance," convinced he would be successful. The verdict when it came was un-equivocal. "Drawing exam unsatisfactory," the professors recorded, be-fore hinting at the reason: He had sketched "few heads."

It shouldn't have been a surprise. Of the 113 candidates who showed up, only 28 were accepted, and as Kubizek had noticed, Hitler's work was lacking in a fundamental way. He was particularly poor at people: The figures in his paintings stand about like self-conscious extras, un-certain of their roles. For Hitler, though, the rejection was "a bolt from the blue." He asked the rector for an explanation and was told his exams "incontrovertibly showed [his] unfitness for painting." Admission to the school was "out of the question," though he did have some ability in the field of architecture, and perhaps he should try that instead. Having flunked math and physics, Hitler knew he didn't have the qualifications to attend the architecture school. The fulfillment of his artistic dreams now looked impossible. He left the academy downcast, "for the first time in my young life at odds with myself."

Nothing more terrible could have happened to his friend, Kubizek recorded, but he was unable to console him, as Hitler didn't share the news with anyone, not even his mother. Instead, he withdrew into him-

self, resolving to cope alone and always to press on along his chosen path, since "obstacles do not exist to be surrendered to, but only to be broken."

He soon had a more urgent crisis to deal with. On a return visit to Linz that month, Hitler was told by the family's Jewish doctor, Eduard Bloch, that Klara was in the terminal stages of cancer. Adolf nursed her through the final, excruciating weeks of her life with "loving, sympathetic affection," according to Bloch. She passed away in the early hours of December 21, age forty-seven, and when the doctor reached the house that morning, he found the grief-stricken young man sitting by his mother's body. Bloch had witnessed many such scenes in his career, but he had never seen anyone as hard hit by bereavement as Hitler. To preserve a last impression, the eighteen-year-old sketched her on her deathbed.

In the space of two months, Hitler's dreams of becoming an artist had been shattered, and he had lost the only person on earth he had really loved and who had loved him in return. This might have been a moment to compromise, to take a regular job, to consolidate the family's money and property and take care of his eleven-year-old sister, Paula. But that was not Hitler's way. When a neighbor suggested he find work with the postal service, he replied that he was intent on becoming "a great artist." The neighbor questioned whether he had the necessary means or connections, to which Hitler retorted: "Makart and Rubens too worked themselves up from impoverished conditions!" Soon after Klara's funeral, he hurried back to Vienna, this time with Kubizek in tow.

The city that had once seemed so lustrous now showed Hitler its darker side. Vienna's dramatic growth meant it was home to some of the worst poverty and poorest housing in Europe. At least half the city's residents were immigrants, mostly from the eastern part of the empire. In this "Babylon of Peoples," Germans mixed with Czechs, Slovaks, Poles, Ruthenians, Hungarians, Croats, Italians, Rumanians, and a large minority of Jews. Whatever the architectural glories of the Ringstraße, the real story of the capital was one of overcrowding, of back alleys threading shoddily built slums, of prostitution and criminality, hunger, disease, and homelessness. When Hitler took Kubizek to the

digs he had arranged in the overbuilt Mariahilf neighborhood, the younger man was horrified to be led across a dark courtyard and down a stairwell to a small basement room riddled with vermin and rank with the smell of kerosene.

In this tiny, sunless space, Kubizek observed his bereaved friend with increasing alarm. Hitler still harbored the secret of his failed exam and pretended to attend the academy each day, a bizarre situation made worse by Kubizek's easy acceptance to the Conservatoire to study music. Hitler, always high-strung, achieved new heights of apoplexy. Kubizek remembered him "choking with a catalogue of hates." He would "pour his fury over everything, against mankind in general who did not understand him, who did not appreciate him and by whom he was persecuted." After Kubizek bought a piano, there was so little space left in the room that when Hitler launched a tirade, Gustl had to get into bed. He would lie there as Adolf ranted and cried and gesticulated, and if Kubizek fell asleep Hitler would shake him awake to shout at him some more. On top of his grief and humiliation, Hitler was sexually repressed, afraid of women and masturbation. His anger was "boundless," Kubizek recalled, his "mania" growing; he was a "crazed young man" with a "hymn of hate." When at length Kubizek discovered the truth about the exam, Hitler began to fire "salvoes of abuse" at the academy, which was "old fashioned, fossilized," and had "no understanding for true artistry." There was a great conspiracy against him: Trip wires had been "cunningly laid" for the purpose of ruining his career. He would show the "incompetent, senile fools" that he could get along without them! On the day that Hitler renounced Stefanie, Kubizek knew the crisis had passed into a new and difficult phase: Without the dream of young love to sustain him, what, he wondered, would become of Adolf?

In July 1908, when the Conservatoire's term had ended, Kubizek left for Linz. When he returned to their room later in the year, he found that Hitler had cleared out, leaving no explanation or forwarding address.

Hitler drifted from one rented room to another, refusing work, frittering away his small inheritance. He tried again for the academy and

this time didn't even get through the preliminary test. He became a down-and-out, sleeping outdoors or queueing for hours for a place in the city's filthy, overcrowded homeless shelters. The chemicals the shelters used to delouse their residents turned the blue-checked fabric of his only suit lilac, and he went without food for days at a time. At last, toward the end of 1909, he found a way to live through art.

Shortly before Christmas, he met an ex-convict and grifter named Reinhold Hanisch in the Meidling homeless shelter. When Hanisch discovered Hitler could paint, he suggested he copy postcards of famous Viennese views, which Hanisch would try to sell. The plan worked: Soon there were enough orders for them to move into the safer environment of the men's hostel in Brigittenau. Hitler would live there for the next three years, copying tourist scenes in watercolor from a spot in the corner of the reading room. The paintings were not good— even he later admitted, "I painted that stuff only to make a living"—and he was infuriating to work with: Lazy and easily distracted, he sometimes disappeared for days at a stretch. When conversation in the hostel turned to politics, he tended to leap up from his bench and start shouting his half-informed opinions. The partnership fell apart when Hitler accused Hanisch of fraud. Even so, the most difficult phase of Hitler's early life was behind him, and when he was forced to leave Vienna, he would continue to paint for money.

IN MAY 1913, Hitler caught the train to Munich, carrying a portfolio of watercolors that he would keep for the rest of his life. He later claimed that he felt an immediate connection as he stood on German soil for the first time: "The city itself was as familiar to me as if I had lived for years within its walls," he wrote. "[My artistic study] at every step had led me to this metropolis of German art." In fact, he had moved to Bavaria to escape the Linz authorities, who were pursuing him for evasion of military service. He rented a room above a tailor's shop on the edge of the Schwabing and continued to knock out copies of postcards—of the Theatinerkirche, the Hofbräuhaus, the Alter Hof, the Altes Rathaus—touting his work around the cafés and bars. As in

Vienna, he showed little interest in the thriving avant-garde, preferring the late Romantic works that hung in the Neue Pinakothek and the Schack collection.

When war broke out the following summer, he joined a Bavarian regiment in a rush of pan-German enthusiasm. His comrades in arms called him "the artist" and found him strange and aloof. He didn't drink, visit brothels, or ever speak of his relatives, but he loved the army as a replacement for the family he had lost. He was brave, winning the Iron Cross first class, a rare achievement for a corporal, and he continued to paint: farm buildings, shell-damaged villages, soldiers moving along a railway cutting under fire. At the start of 1916, he was sketching Fournes-en-Weppes, on the French-Belgian border, just across the front line from a British lieutenant colonel, Winston Churchill, who was painting another village, Ploegsteert, in a far freer, more impressionistic style.

The early hours of October 14, 1918, found Hitler on the heights near Wervik, in western Flanders, when mustard gas filled his trench. He was seized with pain, and he and his comrades retreated, half blind, clinging to one another to find the way out of the line. He was evacuated to a hospital at Pasewalk, with eyes that were "glowing coals."

Hitler's account of what happened next is one of *Mein Kampf*'s most exalted passages. The damage to his sight was so severe, he wrote, that he believed his painting career was over. He could "distinguish the broad outlines of the things," but could never hope to be able to draw again. On November 10, an elderly pastor arrived at the hospital with news of Germany's capitulation. Revolutionaries had taken control of the country, he told the men, "sobbing gently": the kaiser had abdicated, and a parliamentary government had been installed. Not an eye was dry, Hitler remembered, and he himself was distraught:

> I could stand it no longer. It became impossible for me to sit still one minute more. Again, everything went black before my eyes; I tottered and groped my way back to the dormitory, threw myself on my back, and dug my burning head into my blanket and pillow.

He had not wept since the day when he had stood at his mother's grave, he wrote. Now, as he contemplated the ruin of his artistic career, as he considered the brave soldiers who had died in their millions and the wretched civilian politicians who had betrayed their sacrifice in an act of the greatest villainy, and as the tears began to flow, the blinded artist realized his destiny: to save the German people.

Most of this version of events was untrue. The German high command had tried to hide its failings, and when the hopeless military situation was revealed, the generals left politicians to clean up the mess, even as they spread the word that they had been "stabbed in the back" by Bolsheviks and Jews in the new republican government. If Hitler did suffer a second episode of "blindness," it didn't last long, since he was soon back on full duties. Karl Wilmanns, who read Hitler's case file before it mysteriously disappeared, diagnosed a mental breakdown, telling his Heidelberg students years later that even "a strong man like Herr Hitler" could suffer from a hysterical symptom. Hitler's decision to follow his "destiny," meanwhile, came months later, after the army had sent him to spy on the Deutsche Arbeiterpartei, the group he would infiltrate and turn into the Nationalsozialistische Deutsche Arbeiterpartei (NSDAP), or Nazi party.

For the Hitler myth, though, it was vital to connect the moment of national humiliation with the political awakening of the artist-Führer. As his chief propagandist, Joseph Goebbels, would later state: "He comes from architecture and painting, and only the nameless misfortune of the German people, which began on November 9, 1918, called him into politics."

8.

DINNER WITH
THE BRUCKMANNS

ITLER WALKED FREE OF LANDSBERG FIVE DAYS BEFORE
Christmas 1924, having served little more than a year of his lenient
term. He was transformed. The rabble-rousing street fighter of the
previous year was intent on becoming a respectable politician, or at
least looking like one. He moved back to his small room in Munich, at
41 Thierschstraße, and began to "start again, from the beginning," as he
told his photographer, Heinrich Hoffmann. Three days after his re-
lease, he visited a woman who would be instrumental in his reinven-
tion, Elsa Bruckmann.

Bruckmann was fifty-nine years old, a Romanian princess, the
daughter of an ancient family of Byzantine aristocrats. She and her
wealthy husband, the publisher Hugo Bruckmann, had been linchpins
of the Munich intellectual scene for two decades and lived at one of the
city's most prestigious addresses, the Prinz-Georg-Palais on Karolinen-
platz. Every Friday night, Elsa held a salon in these airy, art-filled rooms,
which in earlier times had echoed with the conversation of Rainer
Maria Rilke, Stefan George, Thomas Mann, Hugo von Hofmannsthal,
and Ludwig Klages, to name a few. In recent years, the salon had taken
a turn to the far right. The Bruckmanns had always been close to the
Wagner family, and Hugo published Wagner's son-in-law, the racist
English historian Houston Stewart Chamberlain. In his influential

1899 book, *Die Grundlagen des neunzehnten Jahrhunderts* (The foundations of the nineteenth century), Chamberlain built on Gobineau's race theory to portray the story of humanity as a chronicle of conflict between the Aryan "founders of culture" and the Jewish "destroyers of culture." Everything good in the world was due to the former group—in which Gobineau conveniently included the ancient Greeks—while everything evil was the fault of the latter. Although he was old and paralyzed by the early 1920s, Chamberlain had become an early promoter of the Nazi leader, writing to him in an open letter that it was "a testament to Germany's vibrancy that in the hour of its greatest need it gives birth to a Hitler."

That May, Elsa Bruckmann had visited Hitler in Landsberg, carrying Chamberlain's greetings. For her, the meeting was a quasi-religious experience: The NSDAP leader wore lederhosen and a yellow linen jacket, and was "plain and chivalrous and bright-eyed," she gushed. Standing close to him, she had felt his "simple greatness," the "authenticity" of a life that flowed "directly from the root." Now that he was at liberty, she was determined to help his cause by inviting him to the salon and introducing him to her elite sphere of influential right-wing friends.

With his riding crop and velour hat, and with a pistol at his belt, Hitler cut an odd figure at the Karolinenplatz apartment. The snobbier guests saw him as a curiosity, the Bruckmanns' "house boy," while he himself felt "like a monkey being shown off at the zoo." But the wealthy couple and their contacts were critical to his new, law-abiding strategy. Soon after first visiting Elsa, he accepted the Bruckmanns' invitation to an intimate dinner with their friend, the architect and cultural theorist Paul Schultze-Naumburg.

Schultze-Naumburg would become one of the most widely read German writers of the early twentieth century. His many race-based polemics included a rant against the flat roof as being essentially Arab in character, and thereby "un-German" and inferior, and his ideas about the ethnic German *Volk* and their homeland would be used to help formulate the anti-Semitic, anti-urban "blood and soil" rhetoric of National Socialist cultural policy. At this first meeting, the architect knew almost nothing of Hitler, only vaguely associating him with the Beer

Hall Putsch. He found the party leader to be unimpressive, a "slight figure" with a boyish nature, and for much of the meal, he recalled, Hitler wore a thousand-yard stare and remained silent, perhaps out of shyness. But later, after Schultze-Naumburg had put forward his hypothesis that the height of an artistic epoch could be gauged from the racial "type" that had shaped it, Hitler grew animated. Here was a topic that he had spent much of the past year deliberating for the cultural passages of his book. He began to spout his theories with such vehemence that he didn't stop talking for the rest of the evening.

ART HAD SUSTAINED HITLER through his social and academic failings, through the horrors of the Viennese homeless shelters and the terror of the trenches, and he carried it with him into politics. It continued to provide a fantasy world into which he could escape, and it gave him a sophisticated skin in which to negotiate the elevated social circles he now sought. It delivered a Nazi aesthetic, too, in the party emblems, badges, uniforms, and monuments he designed, the stage sets he oversaw, and the propaganda he sponsored. His theories about art also provided a bridge to the public, many of whom shared his dislike of the avant-garde. Most significantly, art gave Hitler a higher political purpose. In millennia to come, he told his audiences again and again, the Germans would be judged by the quality of their cultural achievements and their monuments, just as the great civilizations of the past were now judged by theirs. To restore German culture was to restore the community of ethnic Germans, the *Volksgemeinschaft*; to see it decline was to witness Germany decline. And contemporary art, as he and Schultze-Naumburg could agree, represented a decline of epic proportions.

Like so much of his worldview, the cultural critique that poured out of Hitler that evening was cherry-picked from nineteenth-century pseudoscience. At its heart lay a doctrine of victimhood and racial despair based on the concept of degeneracy promoted by Gobineau, Wagner, and Nordau: Everything that had once been noble, glorious, and pure was threatened by genetic degradation and Jewish pollution. By the time he was composing *Mein Kampf,* this paranoid reading of history

had been extended by a host of latter-day conservative thinkers, so that Hitler and the ideologues around him had a library of degeneration-based texts from which to borrow. The result was incoherent—his technique in the early days was to hurl out any argument that came to him to see what stuck—but it was highly emotional, and it resonated with a certain type of audience.

"Blood" was the key to his manifesto. The sole purpose of sex and marriage, Hitler wrote, was to increase the genetic strength of future generations. The depravity of the modern era, the unregulated coupling of Aryans and Jews, and the assumption that "every creature, regardless how miserable, must be preserved" meant the *Volk* were now suffering a "complete degeneration." There was a "general weakening," a "Jewification of our spiritual life," a "poisoning of the blood," as any visitor to the lunatic asylums could observe. Nowhere was this more evident than in art. He had seen it for himself in Vienna, once a great bastion of German culture, which had become the embodiment of "racial desecration," overtaken by "the eternal mushroom of humanity," the Jew. In the old German Reich, too, political collapse had been foreshadowed by a degradation of art: An "entirely foreign and unknown" element had intruded into painting, signaling the advent of a "spiritual degeneration" that would prove fatal to national identity.

Hitler held up the avant-garde's interest in insanity as clear evidence of degeneration in action. Though there is no direct proof that he had read *Bildnerei der Geisteskranken* by this time, he would have been exposed to its ideas through reviews and polemics in a wide range of newspapers, including those of the far right, and it could well have served as a catalyst for his views. Even before *Bildnerei*'s publication, he had attacked the "inner feeling" modern artists aspired to find: The sole purpose of this quest was the eradication of "healthy attitudes," and the whipping of people into a state "in which no one knows whether the environment is mad or he is." Afterward, in *Mein Kampf,* he railed against the "half-wits" and "scoundrels" who had attempted to stultify the "healthy artistic feeling" of the high Romantic genre painters he loved. Modernist attempts to dish up all sorts of "nonsense" and "obviously crazy" stuff as "so-called inner experience" were a cynical ploy to stave

off criticism by their horrified fellow citizens, while movements such as
Cubism and Dada were "the morbid excrescences of insane and degen-
erate men." Sixty years earlier, he wrote, anyone who had tried to orga-
nize a show of Dadaistic "experiences" would have "ended up in the
madhouse," but now such people presided over the art associations.
Art's insane direction was not mere coincidence, but a deliberate plot
by the Jewish-Bolshevik nexus to destroy Germany. He synthesized
these straw enemies with doom-laden compound nouns such as *Kultur-
bolschewismus* (cultural Bolshevism), *Kunstbolschewismus* (art Bolshevism),
and *Verfallskunst* (art of decay), all of which became powerful vectors in
the spreading of his new religion.

Art wasn't the only area where degeneration was visible. "Parasitic
growths" could be found in almost every field of culture over the previ-
ous twenty-five years, the symptoms of a "slowly rotting world." The
Weimar Republic was hastening Germans "toward the abyss." Sooner
or later, they would be ruined, he warned: "Woe to the peoples who can
no longer master this disease!"

Having painted this dystopian vision, Hitler put forward his radical
solution: a merciless purge of *Kulturbolschewismus*, combined with a new
social model that would promote conservative morality and "Aryan"
values. To combat the decadence of the intelligentsia, the whole educa-
tion system would be reorganized and geared toward the military-style
training of boys, since a fit young man was less inclined to "sexual ideas"
than a lazy stay-at-home. Big-city "civilization" would be cleansed of its
current filth, and art, theater, literature, cinema, the press, and even
window displays would be placed in the service of his campaign for cul-
tural renewal. Most drastically—and here he echoed Binding and
Hoche's argument for the killing of "life unworthy of life"—Hitler
called for a "medical struggle" to preserve the genetic strength of the
race. Individual rights were irrelevant in the face of this most important
task, and the gravest decisions would have to be made. Future genera-
tions, however, would thank them, since

the demand that defective people be prevented from propa-
gating equally defective offspring is a demand of the clearest
reason.... [I]f necessary, the incurably sick will be pitilessly

segregated—a barbaric measure for the unfortunate who is struck by it, but a blessing for his fellow men and posterity.

If Germans did not swallow this bitter medicine, the consequences would be severe: They would simply die out, to be replaced by healthier, tougher peoples, more resistant to degeneracy.

Schultze-Naumburg was astonished by Hitler's tirade. He came away from the Bruckmanns' dinner with the impression that he had met a "very peculiar man." Later he would describe him as a "monomaniac" and as a "pressure cooker overheated to the point of bursting," filled with "enormous forces" that were "tamed only with difficulty." Even so, he was impressed by his companion's rhetorical dexterity and found him impossible to forget. The two men would meet many times after that, sometimes at the Bruckmanns', sometimes at the large house and extensive gardens Schultze-Naumburg had built near Weimar. The architect would come to see Hitler as "almost clairvoyant," possessing the "highest wisdom of a statesman," and turn their conversations into some of the first tangible Nazi arts policies.

Hugo Bruckmann published the first volume of *Mein Kampf* in July 1925, with a second part to appear the following year. In most ways it was a terrible book, a mishmash of scientific and historical misunderstandings, conspiracy theories, fantasies, and downright lies, which managed also to be badly written and difficult to follow. Even some of Hitler's allies were appalled. His friend Ernst "Putzi" Hanfstaengl, who looked over an early draft, described it as "really frightful stuff . . . the style filled me with horror." Mussolini said it was "a boring tome," which he had never been able to get through. The Nazi dissident Otto Strasser called it "a veritable chaos of banalities, schoolboy reminiscences, subjective judgements, and personal hatred." Some reviewers attacked the author's mental stability; few thought he meant it all literally. But in the febrile, violent interwar atmosphere, its logical and stylistic shortcomings wouldn't matter. Hitler worked in the mediums of emotion and prejudice, and after four years of addressing the beer hall mobs, he understood what worked, which buttons to push, which scapegoats to pick. He mined his personal history of intensely felt humiliations—at the hands of his father, the academy professors, civilians during the

war—to paint himself as the German martyr, Jesus-meets-Prometheus, whose suffering could be read in his grim-set features, and who would never give up the fight to restore dignity to his adoptive country.

For one twentysomething reader, at least, *Mein Kampf* was a revelation. "Who is this man?" wrote Joseph Goebbels on finishing the first volume. "Half plebian, half God! Is this really Christ, or just John the Baptist?"

9.

GLIMPSES OF A TRANSCENDENTAL WORLD

FOR THE MOMENT THESE ARGUMENTS LAY ON THE POLITICAL fringes as Germany enjoyed the Golden Twenties, a period of rare prosperity and stability bookended by the inflation crisis of 1923 and the Wall Street crash of 1929. At last, the people had food, work, clothing, even a little luxury in the form of lipstick and whipped cream, silk stockings and automobiles, radios and air travel. Passport restrictions were lifted. Borders reopened. A zeppelin flew to America, and Americans flew to Germany, looking to invest in its industry and infrastructure. German academics were once again invited to international conferences. "The world opened up like an immeasurable blue sea full of golden islands," the historian Konrad Heiden remembered. "Again all water and land routes led into the infinite; again each man was free to go out and search for his horn of plenty."

Prinzhorn, now a famous intellectual, spent these years hurrying through a surprising number of doomed romances and dead-end careers. He left Heidelberg for Dresden to move in with a new lover, the Expressionist dancer Mary Wigman. It took Wigman just a year to realize she couldn't live with him. He ran a private sanatorium in Wiesbaden after that, but hated being surrounded at all hours by "hysterical jellyfish" who robbed him of sleep. Nine months later he was in Frankfurt, where he taught psychoanalysis at the university and founded a

psychotherapy practice, but the business didn't perform well, and he had to return to the lecture circuit. On one of his speaking tours he met a sixteen-year-old girl, Margarethe Hofmann, nicknamed "Lychee." At the start of 1926, despite the twenty-two-year age gap, Margarethe agreed to become his third wife.

Prinzhorn returned from their honeymoon to embark on a feverish round of literary activity, which included a second book, *Bildnerei der Gefangenen* (Artistry of the prison inmates), an attempt to replicate his initial success by exploring the art of convicted criminals. But he failed to find the same transcendent insight in Germany's jails that he had found in its asylums, and admitted in a preface that "the problems raised here are not that important." The experience does seem to have rekindled interest in his original study, however, since at the end of that year he wrote to a friend who worked at Emmendingen to ask after the great find of his former project:

> The patient Bühler, who plays an important role in my *Bildnerei,* died some time ago. I would now like to know if his drawings, which at that time included several large packages (mainly with soft crayon on newsprint), are still preserved.

If that was the case, he would try to stop by after Christmas when he was driving to the Black Forest with Margarethe. Though he had no need for more material relating to *Bildnerei der Geisteskranken,* he would be fascinated to find the artist's last works, he explained. Bühler had fallen into "a phase of disintegration" after the heights of *Der Würgengel,* Prinzhorn believed, and these works would help "round off the overall picture."

There is no evidence that the doctor did return to Emmendingen that winter, but if he had, he would have discovered that Bühler was very much alive, and that conditions at the Breisgau asylum had improved dramatically since 1920. Every part of the institution had been upgraded. The cells in the secure central block, once filled with agitated, confused, dirty patients, had been converted into light-filled day- and workrooms, well-ventilated halls, and staff accommodation. The isolation unit had been abolished. Builders had given the pavilions a

makeover, chopping down trees that overshadowed them, painting the walls in bright colors, and hanging artists' prints. Gardeners were now tending the parkland so that it resembled a "most beautiful jewel," as the asylum supervisor Otto Waßmer remembered, a "magic forest" richly decorated in summer with flowers and blossoms, which filled the air with their scent. Electric lighting had replaced the dangerous old gas system; unhygienic commodes and chamber pots had been swapped for plumbing and sewers; telephones had been installed, bringing instant communication with the outside world; and two tractors and a new Mercedes-Benz had been added to a growing motor pool. Visitors could now be picked up from the station, and patients taken out on drives through the picturesque countryside.

The inmate population was growing, too: By 1927 it would climb to around thirteen hundred, almost double that of 1918, a trend that was repeated across the country. There were so many patients, in fact, that a system of community care had to be devised, in which large numbers were sent home or to host families where they were monitored by teams of health visitors. Those who remained found their days increasingly filled, thanks to a new therapy developed by the director of the Gutersloh asylum, Hermann Simon. Simon understood that inactivity, boredom, and poor living conditions created new pathologies, "bad moods, moroseness, excitability," arguments, and fights, so he devised a system of occupational therapy, looking both to improve the environment and to keep patients busy with purposeful tasks, since "successful activity creates satisfaction, inner and outer calm." He established a hierarchy of jobs to cover all levels of ability, ranging from pushing a wheelbarrow while supervised to overseeing other work parties. Some better-off patients were even encouraged to pursue hobbies such as photography and painting. These reforms produced tangible benefits for inmates and reduced asylum costs, but there would be a downside, in that psychiatrists increasingly came to view health as synonymous with useful economic activity.

There was plenty of work to be done at Emmendingen. As well as sowing and reaping the crops, the asylum had to manage hundreds of pigs, eight horses, a bull, fifty cows, twenty cattle and calves, and more than two hundred chickens. There was a butcher's shop to run, a bakery

that produced 185 tons of bread annually, and a vegetable garden that yielded beans, carrots, lettuce, cucumbers, celery, leeks, radishes, and cauliflower. On the gentle slopes to the north stood 2,500 fruit trees, whose harvest kept the cellars filled with 32,000 gallons of drink. More employment could be found in the kitchens, which had to feed up to 1,500 people three times a day. All this industry meant that by 1930 almost every male inmate and three-quarters of the women were in some form of employment. Even on Sundays and public holidays the patients were encouraged to keep busy with a range of leisure activities. There were outdoor games and board games, card games and parlor games, swimming pools, a bowling alley, and a substantial library. Every month, local and international artists performed in the festival theater, and in summer, an asylum orchestra played in the gardens.

All in all, the Emmendingen and Baden asylums were now exemplary and progressive psychiatric institutions. As Otto Waßmer put it, the staff—whose motto was "Love, serve!"—were there to ease the lot of the patients, to treat them with humanity, and, where possible, to return them recovered to their families. Reflecting on the four decades that had passed since Emmendingen's founding, Waßmer hoped that it would be able to "continue its work in blessing for a long time to come."

THE SUCCESS OF *BILDNEREI DER GEISTESKRANKEN* and the art collection made little difference to the lives of most artist-patients—they were, after all, anonymized—though some were lucky to receive recognition and respect within their institutions. At Wiesloch, Joseph Heinrich Grebing, a former chocolate salesman who had designed a magnificent "Air Ark" ocean liner for the skies, was immensely proud of his inclusion in the book, which he described as "such an intervention in 'human education' that one could almost say that nothing like this had ever existed before." At Eickelborn, Genzel's doctors entirely reassessed their view of his creative output: Sculptures that had been referred to in his medical notes as "shameless" and "nonsensical" were now "artistic productions" or "artistic works." This didn't stop their one-legged creator from trying to escape, and in November 1924 he

succeeded, fleeing a hundred miles cross-country to Mühlhausen, Thuringia, where he was taken in by relatives. But he was difficult to live with, and before long he was brought to the local asylum, where he suffered a stroke; after that he was returned to Eickelborn. He appeared happy to be back at the institution where he had spent most of the past seventeen years. He died there six months later, on August 21, 1925, at the age of fifty-four.

At Rottenmünster, August Natterer's doctors acknowledged his Heidelberg connection by writing "Prinzhorn!" repeatedly in parentheses in his notes. The Surrealists' favorite patient abandoned art around this time and became increasingly overbearing. He was occasionally allowed into nearby Rottweil, until police found him in a seedy quarter of town with young girls. His freedoms were restricted after that. In 1926, doctors noted a "flourishing systematized megalomania," including a declaration that he was the "world saviour and Deputy Lord on Earth," though he "completely lack[ed] his earlier more artistic and cosmological ideas (Prinzhorn!)." The following summer he returned to art, drawing various symbolic images. Overwhelmed now by hallucinations, he developed an irregular heart rhythm, and would die of cardiac failure in October 1933. He was busy with artistic activity to the end, producing "eccentric figures and machines," such as an air-driven heating device, and painting scenes that once again expressed his fantastic visions and experiences.

Paul Goesch, the professionally trained architect, even managed to sell some of his work from the asylum. After 1921 he lived in the Göttingen institution, where he produced more than fifty pictures—helped, no doubt, by his brother-in-law, who worked there—and made sculptures of leftover food, paper, and geranium leaves, which he explained by saying "in the transition to recover, one has joy in flowers." In June 1923, he was paid 70,000 marks when his colored woodcuts were used to accompany twenty luxury copies of a book of biblical texts. By 1926, he was beginning to weaken physically, but he still had an agile mind, and constructed a new language from Greek and Latin. As one physician noted in 1931, he had "an excellent memory for details, productive imagination, and an original way of seeing things."

Bühler was rare in that his contribution to Prinzhorn's book was publicly recognized, thanks in part to the Offenburg printer Franz Huber. When Huber was a boy, Bühler used to come almost daily to visit the Huber family's lodger, a painter and musician named Josef Mandel. Bühler was a "strange gentleman" with black hair and keen eyes, Huber remembered, and though even at a young age he could tell that both he and Mandel were "misfits," the two men had gotten along perfectly. They had practiced music together—Mandel playing the piano, Bühler the violin—and Mandel had kept a photograph above the washstand in his room of them in a music ensemble. After a while, Bühler had stopped visiting, and when Huber asked where he had gone, he was told that he was in an asylum. He sought out the master black-smith's work after that, identifying several wrought-iron pieces in the buildings around Offenburg. In the basement of the School of Applied Arts in Karlsruhe, he discovered the gates Bühler had shown at the Chicago World's Fair.

Years later, Huber was discussing Bühler and his ironwork with a local physician when the doctor pulled out a copy of *Bildnerei der Geistes-kranken,* opening the volume at *Der Würgengel.* Turning to the profile of the work's author, Huber recognized "Franz Pohl" as the man who used to visit their house when he was a boy. It was "one of the strangest dis-coveries and one of the most shocking at the same time," he remem-bered: "The man [I] had so often seen as a boy, who had suddenly vanished . . . still lived and led a sad existence in a lunatic cell." He asked around town to see if he could gather any more information. Mandel was dead by this time, but he found some of Bühler's childhood friends, who told him they had visited Emmendingen, but the artist no longer recognized them.

Prinzhorn was right to pick out Bühler for praise, Huber concluded, since he was "one of the most interesting in the great chapter of the mentally ill." Not only had he been a great artisan as a healthy person, he had confronted the science of psychiatry with "new tasks and insights."

An exhibition of Bühler's ironwork would be shown at the Offen-burg county fair in 1931. Under the headline "Franz Bühler: A True Great," the local *Badische Presse* reported:

A few in Offenburg still remember this man, whom the university professor Dr. Prinzhorn has commemorated in his standard work *Bildnerei*. [Bühler] achieved great successes until his mind was irretrievably transformed.

Many a valuable piece from the healthy days of this "very great craftsman" had been saved and brought to the exhibition, the paper went on, before noting that Bühler "still works today." Though his drawings were "bizarre," "one can see the artistic talent in what he draws and paints, even as a 70-year-old."

PRINZHORN'S MARRIAGE TO MARGARETHE lasted just two years. She fell for a historian her own age and asked her husband to release her, which he did. Once again a "lonely wanderer in the world," he retired to the North Sea island of Sylt to put the finishing touches to *Psychotherapy*, the book he intended to stand as the sum of all his thinking on the subject. He had concluded that the principal problem of therapy was the character of the therapist: To heal humanity's spiritual ills required an uncommonly rare individual who hadn't simply observed life, but had played a full part. The first quest of the psychologist was therefore to develop a "ripe" personality, and he called for a rigorous training program to eliminate the unfit. Some reviewers of the book saw this as refreshing; others were deeply critical of the idea that the practice of psychoanalysis should be restricted to an elite.

In 1929, he was invited to speak at an international congress in New Haven, Connecticut, and he built the invitation into a lecture tour of fifteen American universities, in which he reprised his ideas about the art of the mentally ill, as well as aspects of psychology. Encountering the Navajo people of New Mexico, this student of Nietzsche and Klages wrote that he had never felt so close to another people. The Native Americans' belief that man and nature were bound together in harmony and that a balance of all universal forces was of central importance to human life resonated deeply with Prinzhorn's own view. He became an avid supporter of Navajo rights, and was even invited to

Washington, D.C., for a meeting of representatives of the tribal coun-
cils with the U.S. government.

A glimpse of the impression Prinzhorn left on America was re-
corded by a young psychologist he met at Antioch College, David L.
Watson. Watson was charmed by the cultured, charismatic, freethink-
ing German. One evening, Watson recalled, a group of them were in-
vited to the house of a female friend, who noticed Prinzhorn standing
by the piano, leafing through a collection of Schubert songs. Would he
care to sing one? the hostess asked. He would, and he did, in his expres-
sive, high baritone. Two and a half hours later, he had sung all fifty, and
moved his audience to tears. As Watson recalled:

> Every one of us present had the same experience. He seemed
> to open up a glimpse of an unsuspected transcendental world
> within ourselves—whose beautiful, moist-eyed sadness was
> somehow happier than laughter.

Years later, Watson would remember this impromptu performance
as one of the great musical experiences of his life.

10.

ART AND RACE

THESE WERE LEAN YEARS FOR NATIONAL SOCIALISM. THE PARTY would poll just 2.6 percent of the vote in the elections of May 1928. Hitler spent much of his time reorganizing the movement, growing the membership, expanding the ranks of the paramilitaries, and establishing absolute control. Under the *Führerprinzip* (leadership principle), he was the physical embodiment of National Socialism, its demigod and supreme commander. His personality hadn't much changed since the Vienna days—Kubizek would have recognized the "coffee-house tirades," "distaste for systematic work," and "paranoid outbursts of hatred" Putzi Hanfstaengl described in these years—but his following had. His word within the party was law. No dissent was tolerated.

The Weimar Republic in that time was host to a vibrant, anything-goes cultural scene, in which the generation of war survivors shrugged off convention and gender stereotypes and went exploring. In the theaters, nightclubs, and galleries of 1920s Berlin, burlesque dancers titillated men and women alike, bands played Black American jazz music, and the unflinching artists of the Neue Sachlichkeit (New Objectivity) captured the depraved realities of prostitution, war trauma, and sexual violence. The metropolitan cognoscenti found this uninhibited, hard-partying world liberating, but to the uninitiated and the conservative— to most Germans, in fact—it was alarming, alien, another threat to the

fragile fabric of the defeated nation. Hitler seized it as an opportunity and, holding up Weimar decadence as further evidence of degeneracy, used it to try to bring people over to his extreme politics.

From every platform, he stoked a culture war, exploiting the widespread antipathy Germans felt for modernity and modernism. In speech after speech, he railed against the Jewish-Bolshevik art and music of the present, decrying internationalism and racial dilution, while connecting himself with the Teutonic talents of the past, exalting the anti-Semite Wagner as the peak of Aryan genius. Without the influence of the Teutons, he pronounced, there would be no high art, poetry, or modern technology: "Take away the Nordic Germanic, and all that's left are the monkey dances." The avant-garde's enthusiasm for madness remained a central pillar of his politics. In January 1928, he poured scorn on "the gall of people who belong in a sanatorium, who are sent as 'artists to humanity.'" His party would take on the role of "clearing up this garbage," he announced:

> We will make sure that when fate gives us power in our fists we will use it . . . for the internal education of man. . . . The time will then come to overcome the misery of today and the German people will once again receive German art.

That month, Hitler gave tangible form to his rhetoric of cleansing by creating the Kampfbund für deutsche Kultur (Combat League for German Culture), founded on his behalf by the party ideologue Alfred Rosenberg. As Rosenberg stated, the Kampfbund's mission was "to arouse the conscience of creators and supporters of art against the flood of degeneracy spreading from Berlin" and to "defend natural German values in the midst of today's cultural decline." Its political purpose was to push the narrative that all areas of society, science, and the arts were in a deep crisis, and only an authoritarian state could avert the danger of complete degeneration. The Kampfbund would declare war against the "swamp culture" of the Weimar Republic, whose secret mastermind was the Jewish-Bolshevik nexus.

Local branches were established across the country, tasked with attacking museums and galleries that supported modern artists and nam-

ing and shaming their directors. Founding members of the Kampfbund included Hugo Bruckmann and Wagner's daughter-in-law, Winifred, a long-standing Hitler supporter who had sent him food parcels in Landsberg, as well as high-ranking Nazis such as Philipp Bouhler and Heinrich Himmler. The organization's star attraction, however, was the nationalist architect whom Hitler had astonished with his cultural rant over the Bruckmanns' dinner table, Paul Schultze-Naumburg.

Schultze-Naumburg had spent the years since that meeting working up his racial theories in a number of pamphlets and essays, including *Kunst und Rasse* (Art and race), published in 1928. Like Hitler, he drew his ideas from nineteenth-century degeneration theory, portraying the Weimar era as an Aryan end time, in which "Nordic" art was drowning in a sea of inferior immigrant genes. Art, Schultze-Naumburg wrote, was a direct expression of the race of its creator: As Egyptian artists had depicted Egyptians, and Greek sculpture showed Greeks, truly German art could only portray Germans. It was impossible, in fact, for artists to deviate far from their racial type: their genetic makeup was expressed in their work, which could also be used to examine their ethnic identity and racial "health." The creative agent in art was therefore not the author's personality, but the hereditary body of his or her race. It was a key tenet of Nazi art theory that the uniqueness of the artist faded away in the face of the German racial community.

What was more, a collection of paintings or sculpture did not just express the racial state of the time when it was made, but showed the "spiritual direction" in which a culture was headed, the world to which its creators aspired. The architect had examined medieval European statuary and discovered heroic and beautiful designs that revealed the Nordic genes of the people of the times. Contemporary art, by contrast, showed its creators to be either diseased and degenerate Germans or members of other races entirely. Modern art could thereby be read as evidence that Nordic blood was being tainted by "inferior components," such as the Jews. Racial mixing was producing a "colorless porridge of characterless ugliness," and modernism was a race to the bottom, where beauty was determined by the "mentally lowest."

As arresting as these theories were, they were nothing compared with Schultze-Naumburg's most attention-grabbing ploy in *Kunst und*

Rasse. To illustrate his thesis, he published jaw-dropping photographs of mentally and physically disabled patients alongside works by leading avant-garde artists. Portraits by Kirchner, Modigliani, Nolde, and Heckel were juxtaposed with unflattering shots of medical case studies to illustrate the "tormenting, loathsome, and disgusting feelings" such art evoked in "every healthy person." Schultze-Naumburg had had to search high and low to find real humans sick enough to correspond to these artists' works, he wrote:

> It is not possible to find them in healthy people or in places that attract healthy people. One must descend into the deepest depths of human misery and human scum; into the institutions for idiots, psychiatric clinics, cripple homes, leprosy wards, or in places where the most depraved are hidden.

The medical "horrors" he had discovered were so unspeakable that photography was barely able to reproduce them, yet they were still able only to approximate the awfulness of this type of art.

The disturbing images in Schultze-Naumburg's parade of disability had been supplied by none other than Wilhelm Weygandt, the "anti-Prinzhorn" who had been so infuriated by his visit to the Heidelberg collection in May 1921. Weygandt had ignored Prinzhorn's 1922 conclusions that psychiatry had no cultural standing and devoted himself to scouring paintings for disease, claiming in 1925 to have found evidence of Gustave Courbet's depression, Édouard Manet's paralysis, and Adolph Menzel's hydrocephalus in each artist's work. He had also examined Prinzhorn's material and spotted signs of schizophrenia in three aspects of Bühler's *Der Würgengel:* the "violent" notches of the angel's halo, the "indifference" on the victim's face, and the twisting of his legs. This led him to dismiss Bühler's drawing, which others had held up as a masterpiece, as confused, ugly, and not worth trying to interpret. Furthermore, its pathology meant it would easily fit into a modern art exhibition.

Weygandt—who remained an enthusiastic supporter of Nazi cultural policies long into Hitler's reign, touring the world to give almost ninety "cultural propaganda" lectures on behalf of the regime—supplied

medical opinions along with his photographs, captioning them with such diagnoses as "mongoloid idiotypy," "idiocy," "obesity," and "high-grade harelip." He and Schultze-Naumburg together gave the impression that a growing mass of degenerate goblins was filling German asylums, and that this was reflected in German art. In fact many of the images were decades old. One, showing a young disabled man, had been first used by Weygandt in 1902: at that time, the psychiatrist described the subject as a twenty-four-year-old "cretin" with "characteristic pale yellow skin color," and noted that "while eating, he cradles his head and grunts with satisfaction." Despite their age, the photographs retained their ability to shock. Schultze-Naumburg cropped them and the portraits to make them appear more alike, and accused the artists of deliberately emulating these specimens of degeneracy. It was part of the avant-garde's "subhuman yearning" to be comfortable in a greasy world of "grimaces and bent bodies," he wrote. If it was left to such artists to envision the future, the world would soon come to resemble that of the images they had produced.

Two years later, in *Gestaltung der Landschaft* (Configuring the landscape), the architect would extend this thesis to embrace eugenics, using the analogy of blood sports. Every hunter was indebted to the foxes for a population of strong and healthy rabbits, he wrote, as "Reynard" caught and killed the weakest individuals. This logic was equally applicable to human society, where the weak included not just poor physical specimens, but those who were "intellectually and socially unfit." Of course, this appeared cruel in the moment, but in the long run it would be extremely beneficial for humanity:

> Life necessitates constant extermination. The cruel, yet necessary and philanthropic law that is in effect is called selection, and its result may be discerned by the unfit soon sinking, and the worthy asserting themselves.

Schultze-Naumburg's theory of art was a tapestry of misrepresentations, lies, and half-baked ideas. He made no attempt to engage with the art he criticized, or to explain the artists' intentions in trying to reach beyond academic aspirations. His fury stemmed from the works'

lack of realism and classical beauty, and he constructed a tottering po-
lemic of perverted Darwinism and degeneracy theory to reach a prede-
termined political position. The idea that a work was entirely an
expression of its author's racial type, rather than of the individual's per-
sonality or environment, was preposterous, as was the whole Nazi con-
cept of a German race. Six years earlier, Prinzhorn had pointed out that
attempts to diagnose artists by their work were foolish, but Schultze-
Naumburg had taken this tendency to absurd lengths, arguing that the
extent of disease in a society could be read by its art's resemblance to
the disabled. From there, he had conjured a conspiracy of modern art
and racially inferior *Untermensch*, which was degrading the Germans cul-
turally and biologically. He proposed that this alleged degeneracy should
be rooted out by killing the genetically "unhealthy," in which category
he grouped together the disabled and the avant-garde, just as a fox kills
weak rabbits.

As implausible as his arguments were, they were persuasive for
some, as he succeeded in synthesizing Nazi preconceptions and so-
called *Rassengefühl* (racial feeling)—toward foreigners, Jews, the avant-
garde, and psychiatric patients—into an ethno-nationalist aesthetic
theory. In proposing this theory, he was supporting Hitler's eugenic
stance in *Mein Kampf,* and retooling art into a political weapon for the
far right, as he would assert in 1932:

> The essential element of art, as we understand it, is [. . .] to al-
> ways show a "spiritual direction." The idea of National Socialism
> is based on "giving direction" to the German people and leading
> it to salvation. And since that task is substantially conducted
> with spiritual tools, National Socialism cannot ignore the instru-
> ment of art.

Most mainstream reviewers reacted to *Kunst und Rasse* with horror
or laughter, but those in the nationalist movement applauded. The
völkisch writer Manfred Hausmann compared Schultze-Naumburg with
Leonardo, praising his "excellent illustrations" and noting the immuta-
ble proof that the "moderns . . . aren't of our blood." Another wrote
that by showing the connection between contemporary painting and

the "physical deformities and cretins," he had identified the "explicitly pathological, more than just decadent," in art. Hitler, too, is said to have responded well, appreciating the architect as "highly cultivated" and an "ideal art conservator for the German Reich."

AT THE END OF October 1929, the worsening German economic outlook was pitched into full-blown crisis by the crash on Wall Street. The country's dependence on American loans left it heavily exposed, and the result was a return to the chaos of the immediate postwar years. Before the crash, unemployment stood at 1.3 million; in 1932 it would hit 6 million, with one in four in the German labor force out of work. Voters flocked to the political extremes, and in regional elections on December 8, 1929, the Nazi Party won more than 10 percent of the vote for the first time, in Thuringia. This central state was an important symbol for the nationalists, as its capital, Weimar, had been a focal point of the German Enlightenment, and now represented the entire hated democratic republic. Hitler demanded control of two key ministries in the new regional government: those of education and the interior. The Nazi "old fighter" Wilhelm Frick would occupy both positions, with Schultze-Naumburg as his cultural tsar. For a little over a year, Thuringia became a test bed for National Socialist policies.

On April 5, 1930, four days after Schultze-Naumburg's appointment, Frick signed the first piece of National Socialist cultural legislation, the decree "Wider die Negerkultur für das deutsche Volkstum" (Against Negro culture—for German tradition), vowing that the public authorities would "do their utmost to preserve, promote, and strengthen German art." Certain types of music were banned, including jazz, along with books by Erich Maria Remarque and the films of Eisenstein, Pabst, and Pudowkin. The Bauhaus had been forced out of Weimar by right-wing politicians in 1925, and Frick appointed Schultze-Naumburg to lead the United Art School, which now occupied the same building. The architect fired most of the school's staff before ordering the destruction of paintings, wall reliefs, and frescoes by the Bauhaus artists Oskar Schlemmer, Joost Schmidt, and Herbert Bayer.

That November, Frick and his cultural adviser ordered the first Nazi

art "purge," at the Weimar Schloßmuseum, instructing staff to remove "every Modernist painting." Around seventy works were taken off the walls, including pieces by Kandinsky, Klee, Kokoschka, Barlach, Dix, Kollwitz, Munch, Nolde, Schlemmer, Schmidt-Rottluff, and even the dead war hero Franz Marc. Leading cultural figures protested the "rape of spiritual and artistic freedom" and called for Frick's resignation, while Schlemmer, in shock, tried to work out what it meant. The white-washing of his murals was "barbaric," but he was most astonished by the attacks on works that had no visible political content, created by artists who were deeply German in ethos and sentiment:

> That terrible thing . . . lies in the fact that this is not about the persecution of works of political tendency, but about purely ar-tistic, aesthetic works which, simply because they are novel, dif-ferent, idiosyncratic, are equated with "Bolshevism."

What Schlemmer did not understand was that German art was being redefined. For the *völkisch* wing of the NSDAP, it was no longer sufficient for something to have been created by Germans, in Germany; instead, it had to exhibit the classical signifiers Schultze-Naumburg had identified as race-based, and avoid the gamut of motifs and concepts that had been designated "un-German," "Jewish," "Bolshevik," "exotic," "not of our blood," and "degenerate."

The nationalist media hailed the NSDAP's assault on modernism in Thuringia as a heavy blow and a triumph. The painter and critic Bet-tina Feistel-Rohmeder, a fierce reactionary who in 1920 had founded the anti-modern Deutsche Kunstgesellschaft (German Art Society), of which Schultze-Naumburg was a member, used the moment to call for "a great iconoclasm throughout Germany." "It began in Weimar," she wrote. "Heil Frick!"

The Thuringian experiment did not last long. Frick was ousted by the Social Democrats in April 1931, and Schultze-Naumburg lost his position as the head of the United Art School, at which point he threw himself into battle for the Kampfbund für deutsche Kultur. He was sec-ond only to Alfred Rosenberg in the Munich-based organization and was its main draw, speaking to sell-out crowds in universities and col-

leges across the country. These lectures, which had such titles as "Kampf um die Kunst" (Battle for art), drew heavily on the theories he had set out in *Kunst und Rasse* and used the same technique of juxtaposing images from medical institutions with cropped modernist paintings, in an attempt to prove that contemporary art was leading Germany toward a "true hell of subhuman beings." Asylum inmates were included in this slideshow as evidence of the artists' "mockery of nature." Paul Ortwin Rave, then a curator at the Berlin Nationalgalerie, recalled:

> In his lectures he demonstrated—by his words and a projector— the disturbing similarity of some of the expunged images with physical deformities and cretins from the madhouse, whose photographs he presented alongside the paintings of degenerate artists to facilitate a comparison.

The atmosphere at these gatherings was more akin to Nazi beer hall rallies than academic lectures. They often descended into riots, provoked or encouraged by the whole unit of brown-shirted storm troopers from the Sturmabteilung (SA) that was allocated to provide "security." Rosenberg would kick the proceedings off with a short introduction, whereupon the "itinerant preacher for racially pure German art," as one artist described Schultze-Naumburg, climbed to the podium amid the jubilant cheers of nationalists in the crowd and the whistles and roars of the academics and anti-fascists. The architect proceeded to hurl one accusation after another at the guardians of contemporary German art. The lectures concluded with a chorus of the Nazi anthem "Deutschland Erwache!" (Germany, awake!).

Feistel-Rohmeder described the "most vehemently excited" character of these events, writing, with an almost palpable shiver, that to find oneself in the audience was "luck." Summing up Schultze-Naumburg's influence on the heady spirit of the time, she stated that after him, the German *Volk* would never again forget the criteria for judging art:

> [He had applied] the heavy artillery of his serious scholarship to categorically dismiss all art that is not blood-bound ... It is his conviction that the visual arts of the future will recognize as its

sole ideal the German people, which originates from generations
who bring with them rigor and strength and true heroic disposi-
tion.

Anyone who asked awkward questions of the architect took their
lives in their hands. At one lecture in Munich on March 31, 1931, two
young German painters, Günther Graßmann and Wolf Panizza, found
the courage to interject, asking, "Where is the good modern culture?"
The National Socialist "venue security" responded by beating the two
artists with brass knuckles and throwing them out of the hall. Panizza's
cheekbone and jaw were broken in the process.

THIS COULD HAVE BEEN Prinzhorn's moment, the time when he
brought his unrivaled expertise and considerable intellect to bear on
the debate over modern art and psychiatry. At a minimum, he might
have reiterated his 1922 conclusion that all configuration was a legiti-
mate expression of the human psyche, no matter what the state of the
intellect behind it, and rejected the racial ideas of Hitler and Schultze-
Naumburg. Instead, he remained silent on the subject, and when, in the
early 1930s, he chose to intervene in politics, he sided with the National
Socialists.

He had returned from America more directionless than ever. He
wrote poetry. He translated André Gide's *Les nourritures terrestres* (The
fruits of the Earth) and D. H. Lawrence's *The Man Who Died* into Ger-
man. He embarked on a new relationship with a friend from his student
days, but when she pressed him for marriage, he refused, and she left
to wed a wealthy industrialist. The manner of this breakup pushed
Prinzhorn into a new cycle of despair. He developed speech problems.
His voice became hoarse and almost toneless, and medical specialists
diagnosed a hysterical disorder. Lecturing became painful at a time
when he really needed the money.

If he'd had any political leaning during the time of *Bildnerei der
Geisteskranken,* it was toward the left. An early outline for the book even
proposed a section on "Tolstoy and the socialist sentiment as salvation,"
though this never appeared in print. Since then, he had tried to remain

aloof from "the shallowness of timebound affairs," as he put it, refusing
to read the newspapers, considering himself to be an explorer of long-
standing human truths. By 1930, when he decided, Zarathustra-like, to
come down from the mountain and put his insights at the disposal of
the Germans, he had bought into the right wing narrative of impending
doom. This was an "age threatened in its cultural, sociological and ar-
tistic foundations," he wrote, a "disintegrated and restless time," much
like that of late Rome. The *Zeitkrankheit* (time sickness) presaged the
great reversal, long predicted by German philosophy, when the people
would reject the current "untenable, rotten worldview" and return to
the age-old values that lay deep within them. His desire for cultural
renewal, combined with the theories he had expressed in *Psychotherapy*
about the importance of strong leaders, increasingly drew him toward
the Nazis.

He entered the political arena in December 1930, writing a letter to
the editor of the Berlin conservative weekly *Der Ring* in which he an-
nounced that, after many years of political skepticism, he had come to
"agree . . . in the main lines" with the aims of Hitler's party. He would
write four more articles on the subject of National Socialism for the
publication by 1933, exploring the phenomenon from a psychological
standpoint.

The key to the movement's appeal lay in the response of the young,
he wrote. In intolerable social and economic circumstances, Hitler had
given German youth a cause, a purpose greater than themselves, which
demanded self-sacrifice, and in return for the meaning this brought
them, they showed him "genuine devotion." The weakness of
Prinzhorn's argument was pointed out by his mentor, Ludwig Klages,
who told him: "What you say . . . about National Socialism is in itself
quite correct; but there is one serious snag. The fact that a willing and
uncritical youth is enthusiastic about a so-called idea or person neither
speaks for the quality of this idea nor for any ability of this person to be
a leader." Prinzhorn wasn't put off. After observing Hitler at close quar-
ters at a rally in Weimar in April 1931, he announced that his "interac-
tion with the comrades is free, buoyant, well-rehearsed, carried by
relaxed, well-intentioned discipline," and that the Führer, though a
coarse and clumsy speaker, represented "something like a constitutional

monarch" of the masses and showed a remarkable ability to "hammer a few facts and judgments and guiding principles" into his audience.

He was critical of some Nazi activities, particularly the "unspeakably vulgar" tone of the propaganda sheets. He took Wilhelm Frick to task for his show-off tone and insult-laden style and opposed his attempts to politicize culture in Thuringia. Something like that could only happen, he wrote, "under de facto dictatorship." Attempts to include artistic activities in political propaganda were a "violent coup against the vitality of art," and the Hitlerian idea that the average SA man should be able to understand everything was misguided, since "every good artist has a right to see his work and his personality first judged by experts, whose opinion is then to be respected by politicians." The most deadly atmosphere for artistic blossoming was one in which the grassroots were paralyzed, for fear that their self-expression was illegitimate.

Overall, though, he brushed aside Nazi attacks on civil liberties and Jews with the phrase "not nice but perhaps tactically necessary." While he could admit that there was hardly a field of work in which he hadn't encountered a Jew who had been "exemplary . . . in character, achievement and contribution to German culture," there was clearly a tension between "Nordic" and Semitic peoples, which arose from their instinctive feelings of difference. It was true that a "Jewish spirit" had overtaken Germany during the Weimar period and that it had become "unendurable in many fields." To redress the balance, he suggested a war against "Judaism," rather than individual Jews.

The *Der Ring* articles caught the eye of Hugo Bruckmann, who was keen to position himself as an expert on cultural renewal in Hitler's eyes. He approached Prinzhorn with the idea of a nationalist cultural magazine, and the doctor seized on it, since it promised exactly the sort of spirit-guide role he imagined for himself. On January 6, 1932, he presented Bruckmann with an idea for a German cultural reeducation program, which would run alongside the magazine. At this time, Elsa Bruckmann was still energetically supporting the Nazis through her salon, which was attended by senior party members and, when he had time, by Hitler. Prinzhorn was now also invited. He met Rosenberg there, who became involved with the project. That May, Prinzhorn wrote spontaneously to Hitler himself, offering his services:

I have long wished to place my powers at the disposal of the only national movement which, because of its youthful momentum and impartiality, is perhaps receptive and ready for those teachings . . . that emerge from the triad of Goethe-Nietzsche-Klages as the German worldview of the 20th century.

What Prinzhorn failed to recognize was that there were major points of difference between his own position and that of the Nazis. A measure of how deeply he misjudged the party was his proposal to include Freud's works in his cultural program: soon, Nazi students would be burning these very volumes on ritual bonfires. By the end of 1932, he understood his project could not be realized with Hitler and his followers and abandoned it. His fourth, more critical *Der Ring* article appeared that November, after a summer of unprecedented political violence, when the storm troopers had been allowed to create an atmosphere akin to civil war. "There should no longer be anyone outside the party who wishes Hitler and his people to take over government even from the point of view of the least evil," he wrote. The Nazi leader was not a legitimate Führer, and his rule could lead to a "catastrophic" conclusion. Even now, though, he left room for reconciliation, asking the reader to consider how much easier it had been for Mussolini, whose black-shirted Fascists had simply marched on Rome at the end of 1922 and been handed power by the king of Italy. And he remained close to the Bruckmanns. That Christmas, Elsa sent a copy of Prinzhorn's new book, *Persönlichkeitspsychologie* (Personality psychology), to Hitler as a gift. Judging by the crispness of the pages many decades later, the Nazi leader didn't read it.

Prinzhorn was attacked from many quarters for his dalliance with National Socialism. The Jewish writer Ludwig Marcuse railed against the NSDAP's new "recruit" and accused him of opportunism. More surprising was the welcoming response of the German Jewish newspaper *C.V.-Zeitung*, which asked, "Will they listen to him? A sincere critic of the NSDAP." He never joined the party, and his sensibilities may well have been offended by the crackdowns on dissent and artistic freedom that were soon to come. His interest in National Socialism stemmed from his own despair, narcissism, and naivety. He yearned for

relevance and public acclaim, but his complacency and his belief that he could help steer Hitler's wrecking ball, using his influence to "try hard to avoid the worst," would tarnish his reputation for decades after his death.

AS THE ECONOMIC AND political weather in Germany changed, so, too, did the public reception of Prinzhorn's collection. Between 1929 and 1933, an exhibition of the Heidelberg material toured at least nine cities in Germany and Switzerland, showing between 150 and 330 works at a time. The impetus for this traveling show may have been the inclusion of thirty-six Prinzhorn artworks at the *Exposition des artistes malades* (Exhibition of ill artists) in Paris in the summer of 1929. Buyers here included Paul Éluard and André Breton, who stressed the importance of asylum art as a source of inspiration. Equally, Wilmanns may have been trying to combat misconceptions about the mentally ill in the increasingly febrile climate.

The job of defending the material at this point fell largely to one of Prinzhorn's ex-colleagues, the psychiatrist Hans Gruhle. In an introductory essay in the guide that was printed for the tour, he advised viewers to discard two habitual prejudices about schizophrenic art. The first was that anything produced by a psychiatric patient had no artistic value: that it was neither good nor bad, beautiful nor ugly, but "a curiosity and nothing more." The second was that an esteemed act of literary or artistic creation lost its worth as soon as its author was proven to be "sick": It was a peculiar confusion of standards to elevate the art of an unknown master, only to overthrow it as soon as one became aware that the artist was mentally ill. The only reason such judgments persisted was because of outmoded ways of thinking, which placed psychiatric patients outside human society and barred them from achieving recognition for anything they did. In fact, the Heidelberg collection showed far greater authenticity than much professional art. If spectators approached the works without prejudice, they would not believe that they had come from sanatoria at all, but would be forced to conclude, as many an important artist had, that "these sick people can do more than we can."

This was red meat to the *völkisch* reactionaries. After seeing an exhibition at the Munich Art Association in June 1931, Bettina Feistel-Rohmeder blamed "supporters of the Indian chief and relativity sage Einstein," a regular Nazi hate figure, for launching this traveling show of "madhouse art." Its aim, she claimed, was to prove to "us naive people, who consider a healthy soul in a healthy body a desirable basis for artistic creation," that "nobody knows anything," particularly not "where sanity ends and nonsense begins." She found it most ironic that where two to three thousand artists had once worked in Munich but were now "extinct" thanks to the galleries' pro-modernist buying policies, the art association was forced to turn to the madhouse to fill its rooms, much as the biblical king, despised by his family, had been forced to trawl the streets for beggars to fill his banquet. Feistel-Rohmeder acknowledged the Heidelberg collection's influence with a backhanded compliment, writing that there was little question that this sort of event was to blame for the "schizophrenic characteristics" of modern art. There was an upside to the material being put on display, however, since it did at least allow the viewer to compare how closely the art of the "half-baked Expressionists" resembled that of the "mentally deranged."

In March 1932, when the collection traveled to Kassel, the public conversation around the creative output of the insane was toxic enough that Gruhle was forced to write to the local art association to explain that he could not allow images from the collection to be given to the media. "Reproductions of abnormal pictures (not from our collection, but from that of Weygandt in Hamburg) have mostly given rise to misunderstandings and unpleasant press discussions," he wrote. By January 1933, when the touring exhibition opened for the last time, in Leipzig, the euphoria with which the material was once received had turned to fear and caution. As the liberal *Neue Leipziger Zeitung* put it, the days of the hegemony of radical Expressionism were over, and there were now "widely divergent answers" to the question of whether these works qualified as art. In the new, more rigorous, psychiatry-led atmosphere, it was a mistake to draw conclusions of any sort. In fact, the newspaper's critic pronounced carefully, the Heidelberg material probably did not reveal anything much at all.

11.

A CULTURAL
REVOLUTION

HITLER'S REVOLUTION WAS A CULTURAL UNDERTAKING AS
much as a political one. His aim was to reshape the Germans, eradicat-
ing the *Kulturbolschewismus* of the Weimar Republic, and to forge a com-
munity of ethnically pure Aryans, the *Volksgemeinschaft,* which would
operate in unison in support of the Führer's vision. In 1930, he had as-
sured Joseph Goebbels, the Gauleiter of Berlin, that once in office he
intended to carry through the party provisions of 1920, which called for
a struggle against "tendencies in the arts and literature which exercise a
disintegrating influence on the life of the people." He would not waste
time.

Hitler was appointed chancellor of Germany at noon on January 30,
1933, the head of a coalition with the German National People's Party.
He had not seized power so much as been handed it, and high-ranking
NSDAP officials could scarcely believe their good fortune. "Hitler is
Reich Chancellor," wrote a jubilant Goebbels. "Just like a fairy-tale."
Two other Nazis took key roles in the cabinet: Wilhelm Frick became
interior minister, while Hermann Göring was given control of the po-
lice in the giant state of Prussia, which accounted for more than half of
the country's population. At 7:00 P.M. on the evening of Hitler's ap-
pointment, Goebbels organized a torchlit parade of SA, SS, and "Stahl-
helm" ultra-nationalists around Berlin, declaring that a million men

had taken part, though in fact there were only a few tens of thousands. Göring announced on the radio that the mood in the country "could only be compared with that of August 1914, when a nation . . . rose up to defend everything it possessed." The "shame and disgrace of the last 14 years" had been wiped out, he said.

Within hours of his appointment, Hitler began to consolidate his power. The next day, January 31, President Hindenburg agreed to dissolve the German parliament, the Reichstag, at Hitler's request, pending a new national vote. The day after that, the Nazi leader kicked off an election campaign with his first address to the people. He chose the slogan "Attack on Marxism," and squads of storm troopers now began literally to attack the two parties to which this label applied, the Communists and the Social Democrats, who also happened to be the NSDAP's most powerful opponents in the Reichstag. Party offices were smashed up, newspapers were banned, activists were beaten and tortured, and this was only the beginning. On February 27, the Reichstag building burned, and Hitler used the fire as pretext for an emergency decree that suspended civil liberties, including freedom of speech, freedom of association, freedom of the arts, and freedom of the press. Nazi paramilitaries were authorized to carry firearms to enforce the new strictures and were enrolled as police auxiliaries.

All over Germany, storm troopers now visited bloody, unrestrained horror on their enemies. There was nothing sophisticated about their methods: They worked with jackboots and fists and truncheons, punching men and women alike, forcing Reichstag deputies to drink oil and urine, shooting those who resisted. They smashed their way around the country, robbing victims of cash and valuables and stealing their vehicles, roaring up and down city streets with banners flying and weapons on display. Tens of thousands of Jews, leftists, and liberals were dragged away under "arrest," and even the makeshift jails began to spill over. This overcrowding problem was solved in mid-March, when Himmler established a new facility on the outskirts of Munich: the Dachau concentration camp.

As Germany recoiled, Hitler dissembled. He had long experience of commanding violence without implicating himself, and now he professed mild disapproval of the horrific acts his men were committing,

blaming communist infiltrators or radical elements within the move-
ment, while denouncing his enemies in extreme and violent terms.
Local bands of storm troopers would, he knew, take the hint, and if
specific directions were needed, Göring and other lieutenants could be
relied upon to give them.

The NSDAP won 43.9 percent of the vote in the federal elections
on March 5. Given the scale of the oppression wreaked by his followers,
this was a poor result for Hitler: Of 45 million eligible voters, only 17
million had chosen him. Still, he was able to command a majority in the
new parliament, and there was only one piece of legislation he now
needed. The Enabling Act, which allowed the government to pass laws
without the Reichstag's approval, was put to a vote on March 23. Chant-
ing storm troopers lined the Kroll Opera House, where the deputies
now sat, jeering at those members of the opposition who had not yet
been arrested or scared off. The atmosphere was so threatening that the
leader of the Social Democrats, Otto Wels, carried a cyanide pill in his
pocket in case he was dragged away by brown-shirted SA men. Only
Wels spoke against the legislation, which passed by a large majority. The
Weimar constitution was effectively void.

Over the following months, the SA, Stahlhelmers, and SS cut a
swath through the remaining opposition, beating, murdering, and ter-
rorizing with impunity. By June, Hitler had a near monopoly on power.
"The road to the total state," Goebbels crowed in his diary at the end of
that month. "Our revolution has an uncanny dynamism."

HITLER LAID OUT HIS cultural intentions even as he seized political
control. In one of his first speeches as chancellor, at the Sportpalast on
February 10, he declared that he would "bestow once more upon the
Volk a genuinely German culture with German art, German architec-
ture, and German music." This would "restore to us our soul," he said,
and "evoke deep reverence for the accomplishments of the past, a hum-
ble admiration for the great men of German history." In his Enabling
Act speech of March 23 he announced a "thorough moral purging" of
society, in which the education system, the theater, the cinema, litera-
ture, the press, and the radio would all be bent to the maintenance of

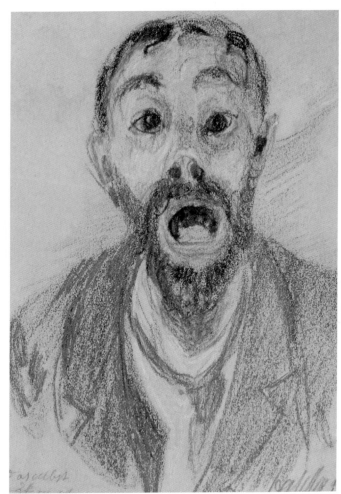

Franz Karl Bühler's self-portrait, *Das Selbst,* dated March 1919. In Prinzhorn's eyes, Bühler's art reached the pinnacle of creativity at this time.

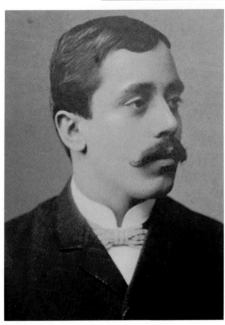

Franz Karl Bühler photographed in Offenburg in the 1890s

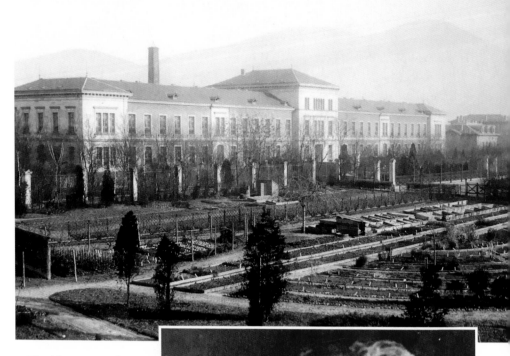

The University of
Heidelberg
Psychiatric Clinic,
1895

Hans Prinzhorn
circa 1922

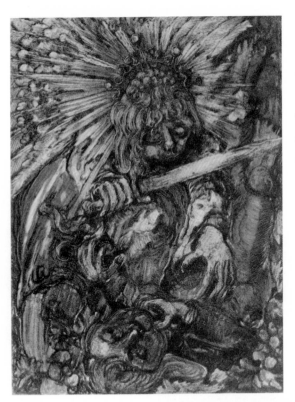

Bühler's *Der Würgengel* (The choking angel), which Prinzhorn compared to work by Grünewald and Dürer

Franz Karl Bühler, *"Untitled"* (Angel playing with dolls)

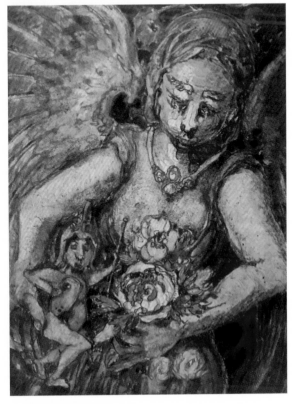

August Natterer, *"Hexenkopf"* (Witch's head), circa 1911–1917

© PRINZHORN COLLECTION, UNIVERSITY HOSPITAL HEIDELBERG, INV. NO. 184

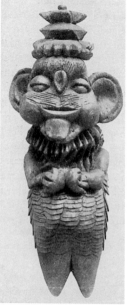

Else Blankenhorn,
"Untitled I," before 1917;
thought to be a
self-portrait

© PRINZHORN
COLLECTION,
UNIVERSITY HOSPITAL
HEIDELBERG,
INV. NO. 4267

Hindenburg, by Karl Genzel,
represents the German field
marshal Paul von Hindenburg.
The artist wished to draw
attention to his fat cheeks, large
ears, and protuberant nose.

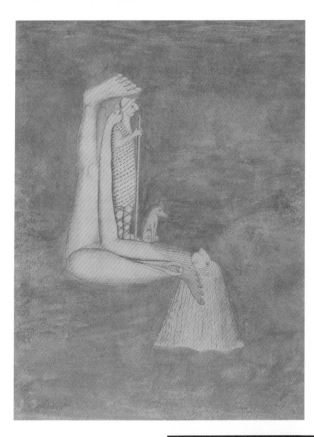

The Prinzhorn artist August Natterer's work was especially popular with the Surrealists, including Max Ernst. Natterer's *Wunder-Hirte II* (Miracle shepherd II), 1911–1917, left, clearly influenced Ernst's *Oedipe* (Oedipus), 1931, below. Ernst borrowed Natterer's vision of a female form floating freely in space.

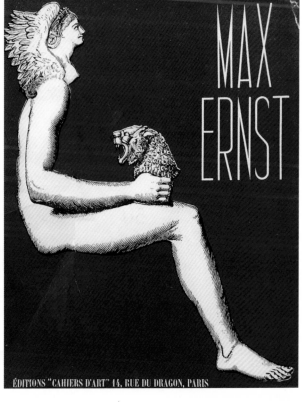

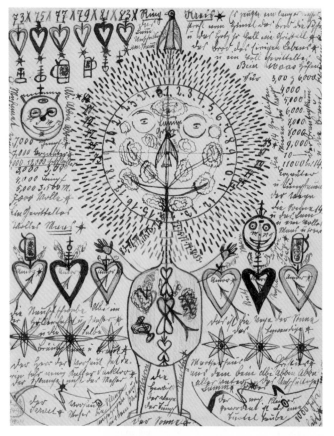

Paul Klee was also entranced by Prinzhorn's book. The artist's 1923 work *Prophetisches Weib* (Prophetic woman), below, may have been inspired by Johann Knopf's *Lamm Gottes* (The lamb of God), left, from the Heidelberg collection.

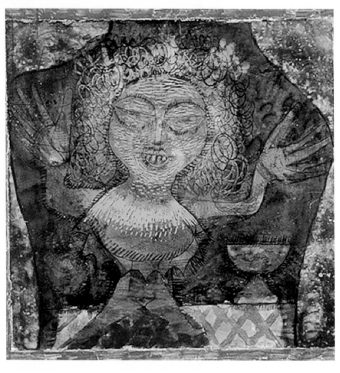

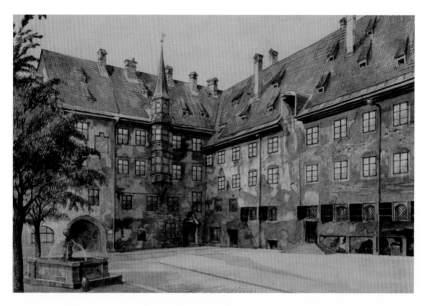

Alter Hof, Munich, Adolf Hitler, 1914. Hitler showed some ability painting buildings but was poor at depicting people. He was rejected from the Vienna Academy for drawing "few heads."

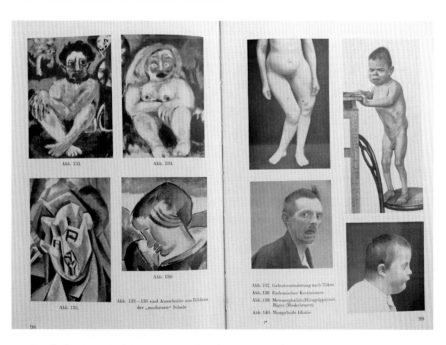

Paul Schultze-Naumburg's 1928 book *Kunst und Rasse* (Art and race) made an explicit link between modern art and disability, juxtaposing paintings with case photographs.

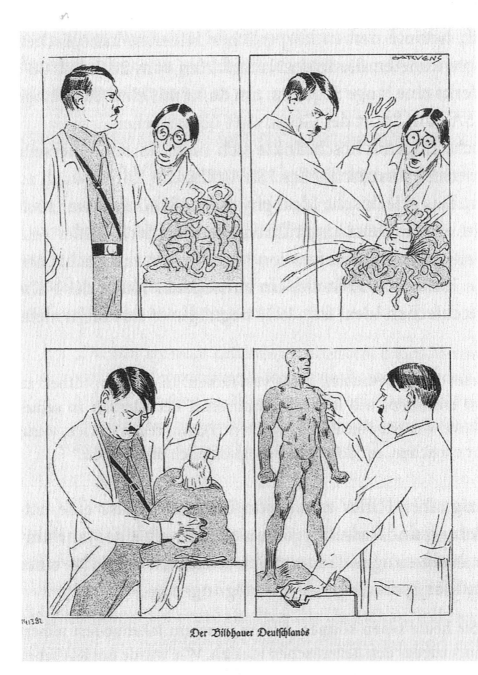

"Der Bildhauer Deutschlands" (The sculptor of Germany), a 1933 cartoon from *Kladderadatsch* magazine, reflected Hitler's plan to genetically reengineer the German people as an artist remodels an artwork.

the "eternal values residing in the essential character of our people." There would also be a new direction for German painting and sculpture, since the heroic, racially hygienic Nazi era called for heroic, racially pure art, free from dirty "cosmopolitan" modernism:

> Art will always remain the expression and mirror of the yearning and the reality of an era. The cosmopolitan contemplative attitude is rapidly disappearing. Heroism is arising passionately as the future shaper and leader of political destinies. The task of art is to give expression to this determining spirit of the age. Blood and race will once more become the source of artistic intuition.

In pursuit of this new art, Hitler commissioned a great new gallery, the Haus der deutschen Kunst (House of German Art), to be constructed in Munich. This first monumental Nazi building was designed by Paul Ludwig Troost, an architect Hitler had met at the Bruckmanns' salon, who was most famous for designing the interiors of ocean liners.

Much as the SA did not need direct orders from the leadership but "worked toward the Führer," state officials, party newspapers, and organizations needed little encouragement to take action in the cultural field. Weeks after Hitler's appointment as chancellor, Alfred Barr, the director of the Museum of Modern Art in New York (MoMA), attended a public meeting of the Kampfbund in Stuttgart, where he heard the leadership announce that since the revolution was "above all cultural," there must be "no remorse and no sentimentality" in "uprooting and crushing" National Socialism's artistic enemies. In mid-March, Barr discovered that a major Oskar Schlemmer retrospective had been shut down by the city authorities after a vitriolic attack in the Nazi press. He bought one of Schlemmer's works for MoMA "just to spite the sons of bitches."

The critique of modern art continued to revolve around the unholy trinity of "Jewish," "Bolshevik," and "mad," as a programmatic article in the *Völkischer Beobachter* made clear on February 25. Under the headline "From the German Artistic Kingdom of the Jewish Nation," the Nazi art historian Wilhelm Rüdiger poured sarcasm over three categories of modern art, including "psychopathic art" and the parallel grouping "art

connected with the degradation of all values." Savaging by name Paul
Klee (a "truly lamentable" artist, who "has Arab blood in him"), Hans
Arp ("once a Dadaist—you know, the oxen are sitting on telephone
wires playing chess"), and Max Ernst (simply "alarming"), as well as
George Grosz, Otto Dix, Max Beckmann, and Marc Chagall, Rüdiger
noted:

> What some call surrealism is what the other (healthy) people
> call having a screw loose. (See Prinzhorn, *Die Bildnerei der Geistes-*
> *kranken*.) In fact, here the "Limits of Reason," as a picture by Klee
> is titled, are not only reached, but far exceeded!

Aware that their moment had arrived at last, a group of *völkisch*
art organizations, including chapters of the Kampfbund and Bettina
Feistel-Rohmeder's Deutsche Kunstgesellschaft, came together in Wei-
mar in early March to form the umbrella organization Führerrat der
Vereinigten Deutschen Kunst- und Kulturverbände (Führer's Council
of the United German Art and Cultural Associations). Immediately
after the March 5 elections, the council published an appeal, "What
German Artists Expect of the New Government," demanding that
the "proven soldiers of the cultural struggle" be given their reward
for the battle with art Bolshevism they had been fighting for a decade
or more. The council, which represented 250,000 members, spelled
out five demands to the new government that would "precisely delin-
eate the stages of the Nazi struggle against the avant-garde." These
were:

> 1. That all art showing "cosmopolitan and Bolshevik signs"
> be removed from German museums and collections. These
> should be put on public display, along with the sums spent on
> them, and the names of the officials responsible. Thereafter, the
> works should be burned, and their heat used "to warm public
> buildings."
> 2. All museum directors guilty of "unscrupulous waste of
> public funds," and who had hidden "truly German" works of art
> in storage, must be immediately suspended.

3. The names of all artists who had been "swept along by Marxism and Bolshevism" should no longer be mentioned in any printed publication.

4. Modernist architecture, including "residential boxes" and "churches that look like greenhouses," should be banned.

5. Statues or sculptures in public spaces that offended public sentiment, including those by the Expressionists Ernst Barlach and Wilhelm Lehmbruck, should be removed as quickly as possible to make room for "German" works.

Almost all of these demands would eventually be met, though in truth, the influence of the Kampfbund and the *völkisch* groups was now on the wane, as the assault on modernism could now be led by the state itself. Under the policy of *Gleichschaltung* (coordination), all aspects of German life were to be brought in line with Hitler's ideas. The principal tool in this reorganization was a powerful new government department charged with centralizing control of German culture and uniting the country behind the idea of national revolution: the Reich Ministry for Popular Enlightenment and Propaganda. The man appointed to run it was the creative Berlin Gauleiter who had already amply demonstrated his love for Hitler, Joseph Goebbels.

AT THIRTY-FIVE, GOEBBELS WAS eight years younger than Hitler and a rare beast in the upper echelons of the party: a physically disabled and highly educated intellectual. Born with a congenitally deformed right foot, he had earned a Ph.D. from Heidelberg and spent much of the 1920s trying to become a novelist. He had long been sympathetic to modernism: In 1923 he penned a fictionalized autobiography, *Michael,* whose eponymous hero described Van Gogh as a "star" and "the most modern of the moderns," brushing off the artist's alleged insanity with "we, really all of us, are mad when we have an idea." Visiting a museum in Cologne in 1924, he had admired the modern sculpture of Ernst Barlach, and described the "wonderful colors" of Emil Nolde. As he grew closer to Hitler, however, he was learning to adjust his views. When Albert Speer remodeled Goebbels's Berlin apartment in the summer of

1933, borrowing some of Nolde's paintings from the National Gallery to hang in it, Joseph and his wife, Magda, were "delighted," Speer recalled—until Hitler paid a visit. Then they were mortified. "The pictures have to go at once," Goebbels told Speer. "They are simply impossible!" In matters of artistic taste, it seemed there was only one opinion that really mattered. "We were all in the same boat," Speer remembered. "I, too, although altogether at home in modern art, tacitly accepted Hitler's pronouncement."

Goebbels was hated by the more reactionary tendency within the Nazi cultural establishment. He would fight a long battle with Rosenberg over the regime's artistic direction, while Schultze-Naumburg despised him almost on sight, calling the limping intellectual an "evil spirit" and an "angry snake." His appointment was not welcomed by the arch-conservatives in the cabinet that spring, but it was one of Hitler's inherent contradictions that he recognized the need for modern methods and technologies to deliver an age of allegedly eternal values, and he knew Goebbels and his propaganda ministry could be relied upon to devise them. The *Volk* had to start "to think as one, to react as one, and to place itself in the service of the government with all its heart," Goebbels explained. "Technology must not be allowed to run ahead of the Reich: The Reich must keep up with technology. Only the latest thing is good enough."

Aided by a slew of new laws, *Gleichschaltung* was applied with swift brutality. Until 1933, Germany had been a cultural powerhouse: Its writers and poets, musicians, filmmakers, and architects were recognized across the world, and its artists were feted most highly of all. This would be swept away in the coming cataclysm. Ernst Barlach wrote to a friend on the eve of Hitler's takeover of power: "We all feel as if we are sitting on a volcano." The radio "hurls rage, hatred and revenge, and snorts murder," and people were fleeing abroad to avoid the rancid ideology, the threat of violence, and the parade-ground bellowing that could be heard from every direction. "The nationalist terror will probably outlast me," he predicted.

Paul Klee was reluctant to recognize Hitler's threat. A professor at the Düsseldorf academy in 1933, he tried not to let the new regime faze him. He "refused to be upset," his son, Felix, recalled, and tried to carry

on as though nothing had happened. But when a swastika was run up over the academy in March, he knew he could no longer continue to show up for work. Storm troopers rifled the family home in Dessau, turning everything upside down and taking whatever they wanted. The most hurtful loss was of their correspondence. A native of Bern, Klee left for Switzerland for a few weeks at that point, remarking: "They say the Bernese are slow moving, but I'd like to see them catch up with this one." His wife, Lily, a stern and energetic Bavarian, went to the SA headquarters with a van and made them return the letters and post-cards, proclaiming her triumph over the "blockheads" to all and sundry. Her victory was short-lived. Klee was declared "degenerate" and "sub-versive," and suspended from the academy on May 1. Lily repeatedly told him: "You must leave Germany, there is nothing left for you to do here," but he hung on until Christmas, when they emigrated to Switzerland for good.

The litany of artists targeted at this time is a roll call of great German names from the early century. Otto Dix was sacked from the Dresden academy, and Max Beckmann from Frankfurt's; Oskar Schlemmer was accused by students at his Berlin art school of being Jewish (he wasn't), then dismissed. Berlin was also the scene of the final demise of the Bauhaus. After relocating from Weimar to Dessau, it had once again fallen afoul of far-right politicians and was shut in 1931. Mies van der Rohe reopened it in a disused factory in Berlin the following year, but in April 1933 it was raided by police and closed permanently. In May, the Prussian Academy of Arts asked ten members to resign, including Dix, Schmidt-Rottluff, Kirchner, Kokoschka, and Mies van der Rohe. Kollwitz, the first woman appointed to the academy, was also the first to be dismissed. Barlach left in protest at Kollwitz's removal. The academy's Jewish president, eighty-six-year-old Max Liebermann, was also pushed out, as was Emil Nolde, whose membership in the Nazi party did not protect him.

Gallery and museum directors were targeted, too: Around thirty were removed from office in 1933. Gustav Hartlaub, an associate of Prinzhorn's from his Heidelberg days, had amassed one of the best collections of nineteenth- and twentieth-century art in Germany at the Mannheim Kunsthalle, including three works by the Prinzhorn artist

Paul Goesch. The Kunsthalle had already been subjected to a long-running attack in the pages of the Nazi propaganda sheet *Hakenkreuzbanner* (Swastika banner) by the Kampfbund's Otto Gebele von Waldstein. No fewer than seven articles had appeared, dismissing Hartlaub's entire buying activity and declaring again and again that he did not collect "genuine German art" at all. In January 1932, Hartlaub had complained to the director of the Nationalgalerie in Berlin, Alfred Hentzen. If such attacks were occurring everywhere, he told Hentzen, "we should think about how to defend ourselves together."

By the spring of 1933, the moment for any such action was long past. Hartlaub was sacked on March 20 and Gebele appointed director instead. It was the new director's job, the Nazis declared, to "uncover and eliminate" the gallery's "Bolshevik art policy." Gebele would put on a show to highlight the errors Hartlaub had made, as well as the role of Jews in the "disappearance of city funds." On April 3, he marched into the gallery with a unit of armed SS and set to work. The following day, he opened the exhibition *Kulturbolschewistische Bilder* (Images of cultural Bolshevism) in two upper rooms. The first show in art history whose sole purpose was defamation, it featured almost a hundred works by Klee, Schlemmer, Chagall, Dix, Nolde, Beckmann, and others. They had been stripped of their frames, of which they were said to be "unworthy," and hung deliberately badly. Captions gave each piece's purchase price (which often dated from the time of hyperinflation, and so was misleadingly high) and, in some cases, information about the race of the artist or dealer. To give the show an illicit air, people under twenty were barred from entry. The propaganda accompanying *Kulturbolschewistische Bilder* encouraged the general public's disapproval of avant-garde art, inviting the people with their "healthy sense" to judge the works themselves. Twenty thousand went to see it.

Not content with shaming modern art in the gallery, Gebele decided that a portrait of a rabbi by Chagall, who was of Jewish origin, should be paraded around town in a vehicle, accompanied by a large photograph of the Hartlaubs and a poster with the painting's purchase price. This procession, reminiscent of the medieval pillory, traveled two miles from the Kunsthalle to the Hartlaubs' family home before continuing to a well-known Mannheim store, where it was installed for

public ridicule in the window, along with a sign that read "Taxpayer, you should know where your money has gone." It remained there for several weeks. "The people gathered in huge crowds," Hartlaub recalled, "and read a poster next to it, which stated that I had acquired this horrible creation for 3,500 reichsmarks of taxpayers' money." At one moment during this affair, Gebele asked Hartlaub how he could possibly have bought a painting of a Jew by a Jew—and an eastern Jew at that. Hartlaub replied that one of Hitler's favorite artists had portrayed the same subject. "Mr. City Councilor," he said, "Rembrandt also painted rabbis and Jews."

The *Hakenkreuzbanner* was euphoric about the show of "shamed" art, pronouncing that it had "opened the eyes of the *Volk* to the way their spiritual values were played down." The conservative newspaper *Neue Mannheimer Zeitung* also generally approved, asking why the gallery had bought the "smut" of Klee and Grosz, but objecting to the inclusion of works by such Nordic artists as Munch and Beckmann. The more liberal *Neues Mannheimer Volksblatt* complained that it was "violence" to take paintings out of their frames and defended "good pictures by Rohlfs, Nolde, Marc, Heckel, [and] Munch," demonstrating that it was still possible to oppose party actions against "cultural Bolshevism" four months into Hitler's rule.

From Mannheim, the "abomination exhibition" was sent on tour, to Munich in early July, where it was given the title *Mannheimer Schreckenskammer* (Mannheim chamber of horrors), and then to Erlangen. In Erlangen, the Nazis experimented for the first time with a new discrediting technique: contrasting the modern works with those of unknown provenance by psychiatric patients. The observer was meant to regard the creations of the professional artists and the patients as similar, and conclude that the artists were also "ill," "broken," or "decomposed," thereby discriminating against both groups. The exhibition was not a success: It ran for just three weeks, and the local chapter of the Kampfbund was disappointed, noting that "participation in cultural life is still quite low" and that there was a large amount of work to do "to hammer the meaning of cultural life into these circles." Nevertheless, the *Völkischer Beobachter* art writer Franz Hofmann was prompted to call for drastic measures to be taken against such art, just as action had been

taken against proscribed books. Evidence of the Mannheim purchases had struck the public suddenly with "what threatened us in Germany," Hofmann wrote, as had the contents of the modern wing of the Nationalgalerie in Berlin. Book burnings had already dealt with "dirt, shame, and decomposition" in literature, yet no such action had taken place against Bolshevik art, even though it was "more dangerous by the immediacy of its effect." Hofmann had no time for those who tried to defend Hartlaub. In fact, anyone who had bought or created modern art deserved to be sent to the new facility outside Munich. "We can only wish them a stay in Dachau, in the concentration camp," he wrote.

Not every party member agreed. In the summer, the National Socialists' Students Association began to mount an exhibition in Berlin, *Dreißig deutsche Künstler* (Thirty German artists)—including Barlach, Macke, Nolde, Marc, and Schmidt-Rottluff—with the aim of reclaiming Expressionism as a truly German art. Naturally, Rosenberg and the Kampfbund protested against the idea, describing it as an "act of sabotage." The exhibition received a favorable critical response on its opening but was shut after only three days on the orders of Frick. The student leaders who had promoted it were expelled from the union.

Visual art was just one target of *Gleichschaltung*. Similar purges and acts of censorship occurred in the music, theater, literature, and film worlds as Goebbels's ministry took German life in its grip. "Cultural chambers" were set up to oversee each industry and to weed out Jews, leftists, and artistic modernists. The result was an extraordinary exodus of national talent: An estimated two thousand Germans active in the arts emigrated after 1933, including many of the most skilled and virtuosic creators of the era. Fritz Lang left after his film *Das Testament des Dr. Mabuse* (*The Testament of Dr. Mabuse*) was banned in the spring of 1933: Coincidentally, the film showed numerous works from the Prinzhorn collection. Lang moved to Hollywood, where he joined a substantial community of German refugees that would include Billy Wilder, Bertolt Brecht, Erich Maria Remarque, and Alfred Döblin. Thomas Mann remained in exile in Switzerland from February 1933 on. "I was expelled [from Germany]," he wrote bitterly. "Abused, pilloried and pillaged by the foreign conquerors of *my* country, for I am an older and better German than they are."

There were cultural figures who stayed and tried to operate within the regime's increasingly draconian restrictions, or even, like Gottfried Benn, to become champions of it. One of Prinzhorn's friends, the dramatist Gerhart Hauptmann, was among the few celebrated writers who remained. He would come to regret his decision. Asked in 1938 why he hadn't left, he shouted: "Because I'm a coward, do you understand? I'm a coward."

IT WAS THE STUDENTS—PRINZHORN'S vaunted German youth—who drove *Gleichschaltung* forward in the universities, leading book burnings and harassing Jewish staff and anyone deemed to represent the "un-German spirit." In Heidelberg, young Nazis marched through the town with flaming torches, flanked by storm troopers, SS, and Stahlhelmers, carrying books to throw on bonfires and singing far-right anthems. Karl Wilmanns was targeted for a lecture he had given at the psychiatric clinic in November 1932 in which he had described Hitler's wartime blindness as "hysterical," provoking the loud disapproval of National Socialist students. Wilmanns wasn't easily silenced, and he continued to criticize Hitler, stating openly that he did not consider him a capable leader. His alleged insults were conflated with other "suspicious" behavior, such as a research trip he had once made to the Soviet Union, and the fact that his wife, Elisabeth, though a Protestant, was classed as 75 percent Jewish under the Nazi system of racial profiling. Wilmanns also employed several Jewish assistants.

The university began to move against him in April 1933, withdrawing various privileges. Storm troopers raided the family house several times in the middle of the night, turning over every room, screaming that he was a friend of the Jews and a communist. During the third such raid they arrested him, and after his release, the family received nightly death threats. He was formally dismissed from his post on June 22 and replaced by a party member, Carl Schneider. Wilmanns's pension was halved, and he and Elisabeth fled Heidelberg, eventually settling in Wiesbaden. He maintained that he was proud of being the first non-Jewish professor of psychiatry to be sacked.

His daughter, Ruth, stayed on in Heidelberg to continue her medi-

cal studies. She was forced to wear a card announcing she was "37.5% Jewish." As she walked to a lecture at the university hospital one day, a staff member tried to run her down with his car: She threw herself out of the way, and he shot past, screaming anti-Semitic threats. Ruth left the country soon afterward. She would complete her medical degree in Switzerland before moving to the United States. There, in 1972, she was appointed clinical professor of psychiatry at the Yale University School of Medicine.

AS GERMANY FELL UNDER Hitler's control, Prinzhorn went on holiday. That spring, he stayed with a twenty-two-year-old girlfriend in a Roman palazzo a friend had rented, and he returned, tanned and healthy, via Perugia and Venice. A few days after arriving back in Munich, he fell ill with typhoid fever and was taken to a hospital. On May 13, struggling with a cloudy "typhus brain," he wrote to Klages. He was still working to promote the philosopher and had arranged a visiting professorship for him at Berlin via his friend Hugo Bruckmann, now an NSDAP deputy in the Reichstag. Klages wished him a speedy recovery. By May 23, writing had become too difficult for Prinzhorn, and he had to dictate his next letter. He had a "penetrating headache," he told Klages, and found it hard to stand. On May 30, he'd "had a setback": His temperature was 103°F, he felt dazed, and he spent much of his time dozing.

Four days later, with the danger of his situation clear, he begged Klages to visit. The philosopher stalled, and then declined: "I have come to the conclusion that we do better to postpone our reunion a few more moons," he wrote. "I am convinced that for the time being you would need the utmost calm for at least fourteen days." Prinzhorn never read this final brush-off. Klages, or perhaps his secretary, mixed up two envelopes, and sent the letter to the wrong person. Prinzhorn waited in vain for a reply from the man to whom he had been devoted for much of his intellectual life, and who, in those last days, meant more to him than anyone. At last he could wait no more. He died on June 14, at the age of forty-seven.

This last scene, with Klages's apparent ambivalence and the muddle

over his final letter, was somehow fitting. Although Prinzhorn pursued life's meaning with all of the great intellect, passion, and energy at his disposal, in crucial decisions—about his relationships, his choice of mentor, politics—he reliably took the wrong turn. These choices left him unhappy, unable to capitalize on his achievements or win the admiration of his peers. Yet he was fortunate in one respect: that his three years of flurried, obsessive activity at Heidelberg produced a legacy that grew far beyond him.

One admirer, at least, was devastated to hear of Prinzhorn's demise. Recalling the strange power of the German's personality and his "noble nature," the American David L. Watson found himself weeping as bitterly as he had at Prinzhorn's rendering of Schubert's "Death and the Maiden":

This was one of the significant literary men of our time. His scientific, philosophic training had been transmuted by his artist mind into novel and beautiful patterns. What he might have told us as a common man, after leaving the platform of the scientist, we shall, alas, never know.

Never before had Watson understood why Shelley had written, on the death of John Keats, "I weep for Adonais—he is dead!" Now he did. Prinzhorn was gone, and only his books remained.

BILDERSTURM

An art which turns to the people,
serves the needs of the crowd, of
the small men . . . is the worst
philistinism, and the death of
the spirit.

—THOMAS MANN,
Doctor Faustus, 1947

12.

THE SCULPTOR
OF GERMANY

By 1933, THE GOLDEN DAYS AT EMMENDINGEN HAD PASSED. The psychiatric system seemed to have fallen through a time warp, slipping back to the immediate postwar years, when food was short and costs were only ever cut. In the general economic emergency, with millions unemployed and mental illness spiking, many destitute families were unable to support relatives who needed care and were forced to send them to institutions. At the same time, budgets were being slashed, nurses laid off, and premises rented out or shut, leaving the asylums that survived overcrowded and understaffed. The more prestigious university clinics could at least argue for funding on the grounds that they would treat and discharge cases more rapidly than before, but this meant long-term-care establishments such as the Heil- und Pflegeanstalten, which housed "incurable" patients, suffered disproportionately. Here, the ambition was simply to spend as little as possible on keeping residents alive.

Whatever pittance was given over to psychiatric care, it was too much for the promoters of racial hygiene. In their rhetoric, Germany was being overwhelmed by a wave of useless individuals "unworthy of life," and caring for such "ballast existences" was a luxury Germany couldn't afford. Psychiatry congresses and academic journals recalled

Binding and Hoche's theories, and explored ways to eradicate the "less valuable" from society, but even some of the most hawkish party members recognized the difficulties "euthanasia" presented. There were legal and ethical challenges, and the reputation of psychiatry, never high, would be tarnished, possibly for good. There was a less radical option, however. Sterilization had been practiced legally in the United States since 1907, and by 1932 the debate around this draconian solution had advanced enough in Germany that the Prussian Health Council had drafted legislation to allow the neutering of certain genetically "defective" individuals, with the subject's consent. In the chaotic political climate of that year, the Prussian law was never passed, but the following summer, as the Nazis moved to turn their racial ideology into government policy, they found the ground well prepared.

The Nazi belief that refashioning the race was an artistic enterprise for Hitler had been clear at least since 1931, when Goebbels had pronounced that "only under the hand of an artist can a people be shaped from the masses, and a nation from the people." In 1933, a cartoonist for the rightwing *Kladderadatsch* magazine precisely captured this idea in a four-panel strip: A Jewish-looking artist is shown molding a squabbling mass of small figures from clay; Hitler moves in to smash it angrily with his fist, then reworks it into a towering Aryan Adonis. The caption reads: "The Sculptor of Germany." Of course, the sculptor-Führer would need someone else to do the actual work, so he handed the project to his regular enforcer, the new interior minister, Wilhelm Frick. Barely four months into Hitler's reign, Frick convened an "Expert Committee on Questions of Population and Racial Policy" to move the eugenic scheme forward. Frick appointed Schultze-Naumburg to the committee, where he would sit alongside the likes of Himmler and the race ideologues Walter Darré and Hans Günther, to advise on the all-important cultural aspects of the Nazi plan. As the architect had written, art made visible both the *Volksgemeinschaft*'s genetic health and its spiritual direction. It fell to art, therefore, to establish what the future race should look like, to define the *Zielbild*, the target image of the pure-blooded supermen who would deliver German salvation.

Every lever of the totalitarian state was thrown into the resculpting project: political speeches, films, posters, magazines, newspapers, and radio. Exhortations for racial hygiene were pushed out on all channels, demonizing Jews, Bolsheviks, and the Weimar Republic, and promoting the spectre of degeneracy. *Rassenkunde,* or racial science, became an essential part of the newly militarized school curriculum, and laws were introduced forbidding marriage between Jews and Aryans. But the first piece of race legislation was aimed at those Hitler had described in *Mein Kampf* as "whoever is not bodily and mentally healthy and worthy": the country's psychiatric patients and the disabled.

Frick set out the committee's aims at their first meeting, in June. He explained that while the country was being swamped by large numbers of immigrant Jews, Germany had seen its birth rate decline and its population age. The result, he said, was a huge rise in "degenerate" offspring. At least 500,000 Germans exhibited genetic defects, and there were probably many more: Some experts considered the true figure to be around 13 million, or 20 percent of the German population. Caring for the "asocial, inferior, and hopelessly genetically diseased" was a drain on the exchequer, he said. They needed a population policy that would eliminate these threats to the health of the *Volk*.

The committee quickly produced the "Law for the Prevention of Genetically Diseased Offspring," which Hitler passed on July 14. The legislation was based on the Prussian government's draft from 1932, but with one crucial difference: The new version stipulated that those it targeted could be *forcibly* sterilized. Nine categories of supposed hereditary afflictions were listed: congenital feeblemindedness, schizophrenia, manic-depressive psychosis, hereditary epilepsy, Huntington's chorea, hereditary blindness, hereditary deafness, severe hereditary physical deformity, and alcoholism. Applications for sterilization could be made either by people with these conditions or by doctors, psychiatrists, and directors of hospitals, nursing homes, and prisons. Cases were to be decided by a network of "hereditary health courts," each made up of a judge and two physicians; the presence of the candidate was not deemed necessary at these hearings. The procedures would take the form of vasectomies for men and tubal ligations for women. If a subject refused,

the police were empowered to use force to bring them to the operating table.

The law came into effect on January 1, 1934, and quickly led to a rush of referrals: 388,400 in 1934–1935 alone, almost three-quarters of which came from the medical profession. The hereditary health courts were overloaded: They processed 259,051 cases in the following three years, and in more than 90 percent of cases they ruled in favor of the procedure. Over the duration of the Third Reich, doctors would sterilize around 400,000 people, most of whom were judged to be "feebleminded," schizophrenic, or epileptic, though the categories were vague enough to sweep up large numbers of people who were simply regarded as antisocial and had no risk of passing on their "defects": moderate drinkers, reformed abstainers, criminals. Complications caused by the operations would kill hundreds of people, mostly women, as their procedure was more invasive. Many found the process traumatic, with some of the most vulnerable individuals attempting suicide rather than face the surgeon. One man was so scared he tried to castrate himself with a bread knife.

Wilhelm Werner, a patient in the Werneck asylum in Bavaria, documented his own sterilization in more than forty pencil drawings that are now in the Prinzhorn collection. He may have been deaf or autistic, but in 1919, at the age of twenty-one, he was given the diagnosis of "idiocy," the lowest form of "congenital feeblemindedness," which in the thinking of the time meant he would only ever reach the intellectual development of a toddler. In 1934, a new director arrived at Werneck who diligently implemented the Law for the Prevention of Genetically Diseased Offspring, overseeing the sterilization of 284 of the asylum's inmates.

Werner had no artistic training, but he developed a sophisticated cartoonist's style, which gives the lie to his diagnosis. He drew marionette-like figures who enacted a series of humiliating medical procedures in a Punch and Judy–style pageant. Like other Prinzhorn artists, he was fascinated by mechanisms, showing whole pages of terrifying medical tools and implements: syringes, drips, saws, catheters, gauges, and strange and sinister machines. He depicted himself as a

friendly but passive clown, sometimes in a dunce's cap. Stripped naked in the drawings, he submits meekly as his genitals are manipulated or pulled out with sharp hooks by scowling nurses wearing swastika armbands. Some of his cartoons show an expensively dressed man with a monocle, a mustache, and a bow tie: This is "Director Weinzierl," Werner tells us, a reference to the chief surgeon of a hospital where many sterilizations took place. Another drawing shows patients sitting on a double-decker Nazi propaganda bus. A banner along the side reads "Sterelation"—Werner's own word for the procedure. A nurse sits on the roof of the bus with a gramophone and a plate bearing two testicles, while people are shown smoking and chatting on the lower deck: such is the new normal in Germany, the artist seems to say.

Werner is the only victim known to have recorded the procedure visually. His pathos-filled drawings capture the helplessness and bafflement hundreds of thousands must have felt in the hands of the medical practitioners who robbed them of their fertility.

THE HEREDITARY HEALTH COURT for the town of Emmendingen ordered 216 sterilizations in 1934, mostly on inpatients at the asylum, and by 1939, doctors would operate on 2,500 people in the local area. Bühler, who was in his early seventies, was probably too old and isolated to be targeted, but a rare correspondence at the end of 1935 gives us a glimpse of the precariousness of his situation. His father had passed away some years before, and the courts had made him the ward of an Offenburg councilor, Ferdinand Friedmann. Friedmann's role came with few responsibilities, it seems, since after the councilor's death in 1931 the city didn't bother to replace him until November 1935. The new guardian, Wilfried Seitz, at least showed some interest, because the following month Emmendingen's director, Viktor Mathes, wrote him a brief note explaining Bühler's situation:

Franz Karl Bühler has been in the local institution since April 17, 1900. Since the death of his parents, no relatives have cared for him. His board is paid for by Freiburg County Council.

Any inheritance that had come to Bühler, in other words, had already been spent on his care; his living costs were now paid by the state, and the only person with an interest in his welfare was Seitz, a civil servant who likely had never met him. This was a dangerous situation in Nazi Germany.

Two years later, another exchange of letters sheds light on Bühler's growing peril. In 1936, the regime launched a program to create a database of genetic information on everyone in the Reich. Psychiatric institutions were ordered to sweep their geographic catchment areas for the relatives of those designated *erbkrank* (genetically ill) in the expectation of finding more "defective people" to send before the sterilization courts. Eugenicist doctors and psychiatrists prioritized this "weeding out" over medical care, and the quality of treatment plummeted, particularly in outpatient departments. Hermann Pfannmüller, who ran the outpatient provision at Kaufbeuren-Irsee, saw it as an excuse to pick up anyone he disapproved of from the lower echelons of society, including "asocial drinkers, grumblers, refractory parasites and workshy psychopaths," and send them either to concentration camps or for sterilization. Local administrators would refer vulnerable but perfectly healthy individuals to Pfannmüller, including single mothers and illegitimate children, to save the cost of their care.

As a schizophrenic inpatient designated *erbkrank,* Bühler was a person of interest to this new racial offensive. On October 19, 1937, Dr. Mathes wrote to Seitz in Offenburg requesting personal details about Bühler's relatives, "for the purposes of hereditary biology":

> It would be of particular interest to me to find out whether members of [Bühler's] family were sick with illness or were housed in an institution (health and nursing home, district nursing home, correctional center, penal institution, etc.), or if there was any known mental disorder, drunkenness, neglect, antisocial behavior in the family.

The asylum director enclosed a "genetic inventory" questionnaire. Seitz was to note any relevant details and then return the form to Emmendingen. There is no evidence that Seitz did this; he may have strug-

gled to find other close family members to report. In any case, he was transferred away from Offenburg the following month, leaving the question of Bühler's guardianship open once again. Town officials noted that the patient was now seventy-three and had no assets. They advised that the role "be taken over by the local office, so that larger administrative work does not develop." Cost, once again, was paramount.

13.

CLEANSING THE
TEMPLE OF ART

Early on the morning of Saturday, June 5, 1937, Hitler and Goebbels flew from Berlin to Munich. It was a sweltering day in Bavaria, and soon after the aircraft touched down, the propaganda minister went to his hotel for a few hours to rest.

Hitler loved these excursions. He had designated Munich the "capital of German art," and he liked to travel there every two to three weeks to inspect the giant redevelopment projects he had ordered for the city. The architect to whom he had entrusted these works, Paul Ludwig Troost, was now dead, but the practice continued under his widow, Gerdy. Hitler would drop by the Troost studio to speak with her and inspect the latest plans, then tour the construction sites. In between, he liked to relax in Munich's plentiful cafés and restaurants, where he would lecture his entourage on a range of pet themes with which they were now overfamiliar.

This June day followed the usual pattern. After their rest, Hitler and Goebbels began on Königsplatz with the Führerbau (Führer building), the neoclassical palace Hitler had commissioned to stand next to the Ehrentempel, the twin shrines to the sixteen Nazi "martyrs" killed in the Beer Hall Putsch. Then came lunch at his regular Schwabing restaurant, the Osteria Bavaria, an artists' favorite that reminded him of the happy days he had spent wandering the city before the war.

Guests were often invited to dine with him: The British aristocrat Unity Mitford was a regular, as was his personal photographer, Heinrich Hoffmann—usually a little tipsy by this time of day—and sometimes a favored painter or sculptor. Hitler would greet the restaurant's owner and the waitresses with a jovial "What's good today? Ravioli? If only you didn't make it so delicious. It's too tempting!" then install himself at his regular corner table. Always concerned with his waistline, he would scour the menu for lighter options, then order the ravioli anyway.

His main objective on this visit was the newly completed Haus der deutschen Kunst, which stood at the southern end of Munich's large central park, Englischer Garten. He had laid the building's foundation stone himself, in October 1933, during a giant propaganda festival dubbed the Tag der deutschen Kunst (Day of German art). Thousands of storm troopers and Hitler Youth had marched past the building site, where the Führer was welcomed by a body of masons clad in medieval costume as an orchestra played the overture to Wagner's *Die Meistersinger von Nürnberg* (The Mastersinger of Nuremberg). A lengthy, deeply kitsch parade of alleged Aryan culture had followed, in which the Nazis appropriated Europe's most celebrated artistic periods, from the classical Greek to the Gothic, the Baroque, and the Romantic, to create a glorious but fabricated German past. All this, the art magazine *Die Kunst* pointed out, was "in order to show clearly the new state's commitment to art, and to make public the truly 'fated' vocation and mission of the artistic metropolis of southern Germany." Speeches had been given. The Bavarian minister of culture, Hans Schemm, saluted Hitler as the "totality of artistic and political genius," and the dictator himself had announced: "We cannot think of a resurgence of the German people without a resurgence of German culture and, above all, German art."

Four years on, and the Haus der deutschen Kunst was just six weeks from opening. It would do this with an exhibition of regime-approved art titled the *Große deutsche Kunstausstellung* (Great German art exhibition), and Hitler intended to use the occasion for his most comprehensive cultural statement yet. Once again, Munich would submit to a sprawling Nazi pageant, the second Tag der deutschen Kunst.

When the lunch party at the Osteria Bavaria had broken up, Hitler, Goebbels and Hoffmann crossed the Schwabing to Prinzregenten-straße, the wide thoroughfare designed for military parades on which the new gallery stood. The building presented a monumental facade of twenty-two giant columns to the street, which had led Münchners to call it the *Bratwürstgalerie*, since it reminded them of sausages hanging outside a butcher's shop. But it was the preparations inside that Hitler had come to inspect. The curation of this vital first exhibition had been delegated to a panel of nine handpicked experts chaired by Adolf Ziegler, the president of the Reich Chamber of Fine Arts, and a painter of such exacting female nudes that he had earned the nickname "master of German pubic hair." Ziegler and the jurors, who included Gerdy Troost, had been asked to select the highlights of more than fifteen thousand artworks that had been submitted in a nationwide competition, but the judging process was not going well. The chairman had already complained several times to Goebbels that the jury was hard to manage.

In truth, Ziegler was in an impossible position, as no one really knew what, in Hitler's view, constituted good German art. Four years earlier, when the Nazis assumed power, Rosenberg, Schultze-Naumburg, and the *völkisch* reactionaries of the Kampfbund had thought that they knew, but Hitler, following his principle of divide and rule, had pitched them into a fight with the more modern aesthetic represented by Goebbels. The forward-looking wing of the party hoped Nazism could embrace a new kind of nationalist art, perhaps even Expressionism, much as Mussolini had given Futurism the blessing of the Fascist state in Italy. A vicious civil war had ensued, until Hitler had slapped both sides down at the party rally in Nuremberg in 1934. There was no place in Germany for modern art, he announced, and the "charlatan" avant-garde were mistaken if they thought the Third Reich could be befuddled by their chatter, but "even Jews" found the Teutonic revivalism promoted by Rosenberg and the *völkisch* movement "ridiculous":

[These artists] offer us railroad stations in original German Renaissance style, street signs and typewriter keyboards with genu-

ine Gothic letters ... perhaps they would like us to defend ourselves with shields and crossbows.

It was high time, he had said, that "these petrified backward-lookers" retire to the museums and cease to "spook about, molesting people and giving them the shudders."

No one had been much surprised by Hitler's attack on modernism: It would continue at the party rally the following year, where he would proclaim victory over the modernist "spoilers of our art," who were either fools or criminals and therefore belonged "in jail or in an insane asylum." More unexpected by far was the elimination of the *völkisch* faction that had supported him throughout his rise. It signaled the end for Schultze-Naumburg, whose relationship with Hitler had already begun to sour. Little more would be heard from the architect and his "comrades in struggle." The overall result was a vacuum in German arts policy, in which almost everything post-1910 could be dismissed or frowned upon, but no new direction was allowed to emerge. Art's only real purpose thereafter was as a political weapon, a tool for social control through "art-political" propaganda actions.

It had been clear to Ziegler and the jury that all sorts of art *wasn't* acceptable to Hitler, but no one really knew what *was*. Now they waited anxiously for the only verdict that really mattered. They had marked up their chosen works with red stickers, and some of these now hung on the gallery's white walls. Works with blue stickers, denoting possibles, lay piled up in the center of each room.

Hoffmann entered the gallery first, shortly after 4:00 P.M. The artist-in-chief was not far behind, and soon he began angrily to express his displeasure at the jury's selection, much of which was "catastrophic," Goebbels noted later, object lessons in art "horror." Hitler raged that he would not tolerate works being exhibited here that could mislead the people about his sense of art. In particular, he detested "unfinished pictures," by which he meant sketchy or impressionistic pieces, since it was the German way to "bring everything that was begun to a thorough conclusion." He identified several such paintings hanging next to each other, strode along the row, pivoted on his heel and walked back, order-

ing each of them to be removed with a jabbing finger: "And this! And this! And this! And this!" At one point, to the jury's horror, he personally took down several works by a group of Austrian artists. Out, too, went the painting of a tennis player by Leo von König, in which Hitler found "everything is only superficially smeared, neither a hand nor a face nor anything can be seen." Works like König's must never be shown in the Haus der deutschen Kunst, he commanded. Master builders and architects had worked for years to create this space. Every stone, every window, every door handle had been carefully considered. Then a painter like König came along with something that had evidently been rushed out "in two, at most three hours"! "I won't let that happen," he said. It was "an insolence" that anyone dared to send in such a painting at all. He replaced the tennis player with that of an SS man emerging from a dark background, in a faux Old Master style.

Troost tried to keep pace at his side throughout this tirade, valiantly defending the jury's choices. "In this picture you can feel that this painter wants something," she said. "[He] is trying to express something very particular about his mood!" That was not enough, Hitler retorted. It was not a question of desire, but of ability. If a painter wanted to express an idea then he had to have the skill to do it. Otherwise he must study for a further five years, then try again!

Troost continued bravely to argue the jury's case, but Hitler was adamant and at length she fainted. The rest of the jury slumped in misery, with Ziegler particularly crushed.

Hitler was still fuming the following day, when he and Goebbels took the train together to Regensburg. He would disband the jury, he said, even postpone the *Große deutsche Kunstausstellung* for another year, rather than open the gallery with such "crap."

FOR GOEBBELS, HITLER'S FURY at the Haus der deutschen Kunst was a spur and an opportunity. Despite the Nazi leader's long-established critique, National Socialism had failed to deal with modern art decisively. As he toured the disastrous *Große deutsche Kunstausstellung* preview, an idea to combine the Führer's rhetoric and government action was taking shape in his head. A great reckoning was long overdue.

Nineteen thirty-seven was a watershed for the National Socialist project, marking the end of the regime's first Four-Year Plan and the transition to the second. It was a time to take stock of what had been achieved, and to accelerate the program. Outwardly, Hitler's government was already a success: Germany, for so long the European basket case, was politically stable and economically reorganized. Thanks to the triumphant Berlin Olympics, staged in the summer of 1936, the country was respected, even envied, on the world stage: It was "back in the fold of nations," as the New York Times correspondent reported. What the newspaper and Allied governments didn't know at the time was that Hitler was already preparing for war. "I set the following task," he wrote in a secret memorandum that August. "I. The German armed forces must be operational within four years. II. The German economy must be fit for war within four years." Rearmament would progress even faster than this timetable implied. "The [military] upgrade continues," Goebbels told his diary in November 1936. "We put fabulous sums into it. In 1938 we will be completely finished. The confrontation with Bolshevism comes. Then we want to be ready."

Every aspect of German life was to be harnessed toward the conflict, including cultural policy, which would be used to sharpen the conceptions of Gemeinschaft, Kulturbolschewismus, and Volk, and to bind the people into closer, ever more obedient lines of battle. As Hitler declared in numerous speeches, art was Germany's social glue, its battle standard, its Promised Land, its claim to superiority, and its future legacy. It was a physical representation of the new Aryan soul. In the purifying of art as in the purifying of the race, no mercy could be shown.

The first skirmishes on the new cultural front had been made soon after the foreign visitors to the Berlin Olympics left the country. In the fall of 1936, the NSDAP closed part of the Kronprinzenpalais, the former palace on the Unter den Linden in Berlin which served as the modern wing of the Nationalgalerie. The upper floor of this building, which held the country's richest collection of Expressionist art, was shut to visitors on October 30. The following month, Goebbels eliminated at a stroke those bothersome intellectualizers of art, the critics. Art criticism was essentially "Jewish," he announced. It had "killed many German talents by praising unimportant artists and crushing

really gifted people." Henceforth, Germans would only be allowed to read purely descriptive "art reports," written by authorized art "directors," and regulated in the propaganda ministry's weekly cultural-political press conferences. But these measures were mere hors d'oeuvres to the idea that was gestating in his head as he toured Munich with Hitler. "Horrible examples of art Bolshevism have been brought to my attention," he wrote in his diary that day. "Now I am going to take action. . . . I want to organize an exhibition of the art of the time of decay in Berlin. So that people can see and learn to recognize it."

On his return to the capital, Goebbels picked up a slender, recently published volume, *Säuberung des Kunsttempels* (Cleansing the temple of art) by Wolfgang Willrich, a painter of dull, flaxen-haired heroes and heroines. Subtitled *Eine kunstpolitische Kampfschrift zur Gesundung deutscher Kunst im Geiste nordischer Art* (An art-political polemic for the recovery of German art in the spirit of Nordic style), the book was the product of a collaboration between Willrich and Walter Hansen, a former drawing teacher and long-standing bane of the intellectuals in his home city of Hamburg. Hansen had stockpiled examples of "degenerate" modern art and had given Willrich full access to the collection for his book, which picked up on Hitler's obsession with madness and disease in the avant-garde.

Art was meant to be "healthy," Willrich wrote, but it had been overtaken by unscrupulous charlatans peddling degenerate mischief. It was the duty of those who had "asserted their mental health" during the Weimar years to ensure that the temples of German art were "tidied up." He had created his book as a "weapon" to be used against "all those who try to pass off the pathological as a characteristic of genius" and who would like to allow "the spirit of fundamental negation" to rule over life and art. The specific targets of his assault were familiar: the leading lights of German modernism, many of whom had been inspired by psychiatric art and by Prinzhorn's collection. Klee, Schlemmer, and Kubin were among them, and Willrich even included a work by the Prinzhorn artist Paul Goesch. There were many things about these pieces and modern art in general that were "ready to be examined by medical doctors," Willrich wrote, before issuing the rallying cry:

May the degenerate be mercilessly suffocated in their own filth, so that the healthy and noble may prosper and rule, alone and soon and forever, in our German art!

Reading this book, Goebbels concluded that the task set by Willrich was one he was well placed to execute. He took soundings among his cultural allies in the Party, including Speer, and the Reich Commissioner for Artistic Design, Hans Schweitzer, and met some resistance, but decided to press on nevertheless. By the end of June he felt able to discuss his idea for a Berlin "shaming" exhibition over lunch with Hitler. The Führer approved the idea of *Entartete Kunst* (degenerate art) in principle, but seems to have suggested moving the event to Munich, where it could be staged as a direct confrontation with the regime-sanctioned *Große Deutsche Kunstausstellung*. Hitler and Goebbels spent some time choosing a suitable leader for the new project. Schweitzer, an NSDAP propaganda veteran, was an obvious candidate, but he had shown little appetite for an action against modernism so far, and Hitler didn't like his taste. Instead, they chose the man who was still licking his wounds after his humiliation in Munich, the president of the Reich Chamber of Fine Arts, Adolf Ziegler.

As a reward for the Goebbels initiative, Hitler treated him to a discourse on the proper thoughts to hold about art. "[Hitler] has great confidence in me," the propaganda minister purred in his diary. "I will not disappoint him. Generous, where appropriate, but rigid and stubborn when it comes to principles."

Goebbels briefed Ziegler the same afternoon. The following day, June 30, the propaganda minister signed a decree that would enable Ziegler to seize modern art from any museum or gallery in the Reich:

On the basis of an express authorization of the Führer, I hereby authorize the President of the Reich Chamber of Fine Arts, Professor Ziegler, Munich, to select and secure the works of German decay art [*Verfallskunst*] in German territorial and communal possession in the field of painting and sculpture since 1910, for the purpose of an exhibition. I ask you to give Professor Ziegler a

great deal of support during the inspection and selection of the works.

It was an affront to every curator in the land that their art collections could be ransacked on the judgment of Ziegler, a painter of modest talent and little renown. It was also an assault on the states and municipalities that owned the works, and on the education minister, Bernhard Rust, who was responsible for museums and galleries. But Goebbels had circumvented all political opposition with a "Führer order," and Rust did not dare challenge him. Instead, he responded with his own action against perceived "degeneracy," ordering the closure of the remainder of the Kronprinzenpalais at the start of July.

Armed with the Goebbels decree, Ziegler rapidly assembled a group of "experts" for an art confiscation commission. As well as Schweitzer, it consisted of Willrich and Hansen and two stalwarts of the Reich Chamber of Fine Arts, Walter Hoffmann and Hellmut Sachs. Rust added a pair of his own observers: the ministerial adviser Otto Kummer, and Klaus Graf von Baudissin, an SS officer who would become notorious for saying that the greatest work of art ever created was the *Stahlhelm,* the German soldier's distinctive steel helmet.

On July 1, 1937, the propaganda minister noted in his diary: "Ziegler authorization to confiscate the decay art given. He now drives off with his commission. We hope to make it in time for the Tag der deutschen Kunst. This will be a body blow."

AS THEY CLIMBED INTO their cars at the start of July, Ziegler and his companions had just two weeks to prepare Goebbels's show of degenerate art. They covered two and a half thousand miles over the next ten days, combing the country from north to south in a perverse whistle-stop gallery tour. On Sunday, July 4, they reached Hamburg; on Monday, it was Bremen, Hannover, and Wuppertal-Barmen; on Tuesday, Hagen, Essen, Krefeld, Düsseldorf, and Cologne. They arrived in each city without warning, flashed a copy of Goebbels's decree, hectored the frightened curators into submission, rifled their collections, and ordered them to hand the chosen works to a dispatch company, Wetsch of

Munich, who would ship them to the Bavarian capital. According to Goebbels's instructions, each "degenerate" artwork had to be accompanied by a report detailing how much it had cost the gallery, the date of the purchase, and the name of the individual who had bought it.

"Thank you for your efforts," the instructions concluded. "Heil Hitler!"

In Munich, the works were taken to the Hofgarten arcades, an exhibition space Gauleiter Adolf Wagner had requisitioned a five-minute walk from the Haus der deutschen Kunst. This venue, which formerly held the plaster cast collection of the Archaeological Institute, consisted of a series of long, gloomy rooms, which would provide a perfect contrast to the light-filled new gallery that would host the officially sanctioned art.

At 11:00 A.M. on Wednesday, July 7, Ziegler and his party arrived at the Kronprinzenpalais in Berlin. The Nationalgalerie's director, Eberhard Hanfstaengl, a cousin of Putzi Hanfstaengl, boldly told Ziegler that he viewed the art seizure action as an "execution," and announced that he would have nothing to do with it. Instead, the job of assisting the commissioners fell to Hanfstaengl's deputy, Paul Ortwin Rave. It was only day four, but Rave soon discovered that Ziegler had already fallen out with other members of his team, describing them as "idiots" and "gossips" with whom he didn't even care to have lunch. Willrich, the most zealous and excitable of the bunch, repeatedly made inflammatory comments, and at one point Ziegler and Kummer withdrew from the "unpleasant hustle and bustle" he provoked. They should make Willrich director of a degenerate art museum in Munich, Ziegler joked bleakly, so that the Reich Chamber of Fine Arts would be rid of him.

The commission took just three hours to identify the works they would strip from one of the world's great modern art collections. They began on the upper floor, with the controversial Expressionist galleries. These had been closed to the public for the past eight months, and a number of works were back with their private owners—a source of great irritation to Willrich, who couldn't find many of the pieces he wanted to seize. Even so, paintings by Schmidt-Rottluff, Kirchner, Pechstein, and Nolde were added to the confiscation list without de-

bate. Barlach was viewed as a "tragic case" and his sculptures were spared, though one of his drawings was chosen so that he was at least represented. The commissioners discussed Erich Heckel, especially his painting *Sylt*, which Schweitzer criticized for a "lack of aerial perspective," but Ziegler ruled that this transgression was not quite serious enough. There was general regret that Heckel's famous *Zeltbahn Madonna* had been returned. In the room devoted to Franz Marc and August Macke of Der Blaue Reiter, Ziegler remarked that although both had been killed fighting for their country, he had to make the selection purely on artistic grounds, and he arbitrarily ordered the right half of the space to be added to the list, including Marc's *Der Turm der blauen Pferde* (The tower of blue horses).

Some commissioners came armed with their own pet hatreds. Baudissin brought along a monograph on Max Beckmann to help him identify the painting *Die Barke* (The barque), but the work was no longer in the gallery, so a landscape and a still life by the artist were listed instead. In the storeroom, where they quickly added to the list anything that was not "pleasingly" painted, Willrich was excited to find Nolde's *Christus und die Sünderin (Christ and the adulteress)*, exclaiming that he had already written about it as a "work of shame," and now he was finally able to view the original. Ziegler himself seemed obsessed with Kokoschka and made a note of several works by the artist that were on loan to Vienna so that he could request them upon their return. Rave was alarmed to hear the commissioners' open expressions of contempt: When he asked them not to damage the pictures, one of the group announced, "They still long to burn them in Munich," to which a colleague responded that they "had not yet gathered enough of them together."

In general, Rave thought Ziegler was well informed about the art of the past thirty years, but for political expediency he had come to judge this material "with the eyes of the Führer." When Rave asked if he couldn't share his real views with Hitler, Ziegler said that he had tried and had even brought up the Führer's own painting career as an example, presumably of a struggling contemporary artist, but the dictator had only laughed and refused to accept the "north German art of Expressionism" as a valid form. Hitler wanted nothing but good crafts-

manship in Germany, Ziegler said, as this was the way to ensure a future artistic genius had every chance to develop. He had tried to explain this to Hanfstaengl, but the Nationalgalerie director wasn't interested, and now he would have to take the consequences. Hanfstaengl would soon be fired.

With time running out, Ziegler split the commission up in Berlin. Willrich would deal with the eastern part of Germany, including Magdeburg, Halle, and Breslau, while Hansen would go north, to Lübeck and Kiel. Ziegler would head west and south, taking in Mannheim, Karlsruhe, Munich, and Stuttgart. They would cover the whole country by July 14, earmarking more than seven hundred works for transportation to the *Entartete Kunst* show, including a number by the Prinzhorn artist Paul Goesch, which had been bought by Gustav Hartlaub for the Mannheim Kunsthalle.

Some gallery directors tried to resist the Ziegler commission's art confiscations by petitioning local party dignitaries. Others insisted that contracts were drawn up for the works that were taken, and insurance arrangements made. All such gestures would prove wholly futile.

WHILE THE CONFISCATION COMMISSION raced around Germany, the party leaders continued to plan for the great art festival in Munich. Having sacked Ziegler from the *Große deutsche Kunstausstellung,* Hitler had given the job to one of his oldest cronies, the photographer Heinrich Hoffmann. Hoffmann had endured enough of Hitler's lectures to be closely attuned to his likes and dislikes; he often acted as his art dealer, collecting pieces by favored nineteenth-century painters such as Eduard von Grützner, Carl Spitzweg, and Hans Makart. These high Romantic talents showed remarkable technique, though they had nothing new to say to a modern audience, and Hitler appeared to be governed by what they weren't as much as what they were. "I cannot abide slovenly painting," he told Hoffmann, "paintings in which you can't tell whether they're upside down or inside out, and on which the unfortunate frame-maker has to put hooks on all four sides, because he can't tell either!" The photographer tried faithfully to channel his boss's

taste, reediting the submissions so that Hitler "could take no possible exception." Goebbels, meanwhile, worked on the speeches and the radio broadcasts that would accompany the festival.

On Monday, July 12, Goebbels and Hitler were up early for a cold, wet drive to Munich. After lunch at Hitler's apartment, they went to inspect Hoffmann's selection at the Haus der deutschen Kunst. It was one of the Nazi leader's stipulations that everyone should be able to understand German art, and Hoffmann had done a thorough job of assuming the critical faculties of an SS layman. The exhibition now consisted of seventeen hundred works from which every attempt to portray the world as complex, difficult, morally ambiguous, ethnically diverse, ugly, or poor had been removed. What remained was propaganda, a glorification of land and blood and the *Nazizeit,* in which every *Mann* was a muscled hero, every *Fräulein* a sexless beauty, and every *Frau* had the state-prescribed quantity of at least four children. The Führer himself was a subject for several artists, one of whom had portrayed him as a mounted knight clad in silver armor, carrying a fluttering swastika flag. With so much craftsmanship and bounty, and so few troubling ideas, was it not a sheer pleasure to live in such a state?

The propaganda minister could barely contain his excitement: "It's become quite wonderful," he wrote. "The selected pictures are now also very beautiful, even better than the sculptures. There are not many, but especially selected. The Führer is very happy."

ON THE OTHER SIDE of Prinzregentenstraße, tensions were running high, as builders and exhibition managers worked round the clock in the race to get *Entartete Kunst* ready. Ziegler was in charge, but Willrich and Hansen provided the show's structure and many of its slogans—borrowed wholesale from Willrich's booklet—and extra personnel had been called in both to represent the interests of various branches of the regime and to help with the building work. There were frequent squabbles: One curator was overheard screaming that he would have an employee "arrested for sabotage." On Friday, July 16, the opening day of the festival, Goebbels went along to check on their progress and to root out pictures he deemed unsuitable. Hitler arrived half an hour later.

Ziegler took him on a tour, flanked by the propaganda minister and Hoffmann.

After the war, Hoffmann would claim that he objected to the inclusion of several artworks on the grounds that some in the party felt the exhibition went "much too far." "If Goebbels insists on having his exhibition of *Entartete Kunst*," he wrote, "he would be much better advised to concentrate his attack on artistic trash, and particularly on some of the trash which we ourselves are producing," since "at least a third" of the pictures submitted to the *Große deutsche Kunstausstellung* fitted this description. If this intervention really happened, Goebbels did not record it in his diaries. Instead, he briefly described his and Hitler's satisfaction:

It was the best thing I've ever seen. Outright insanity. We have no more concerns now.

14.

TO BE GERMAN
MEANS TO BE CLEAR

MUNICH WAS RESPLENDENT. MILLIONS OF REICHSMARKS had been spent to turn the city into a stage set of super-Wagnerian proportions, the backdrop for an occult ceremony of mass worship, the second Tag der deutschen Kunst. The station square alone was clad in 250 red, white, and black Nazi flags. A hundred and sixty pylons lined the streets, reaching forty feet into the bright blue sky, and each was crowned with a giant symbol of cultural vigor: a horse, a torchbearer, a Pegasus, an eagle, or a theater mask. At one end of Brienner Straße, an entire triumphal arch had been constructed, while Karolinenplatz was designated a "memorial for heroes" and encircled with a wall of Nazi flags. Every aspect of the streetscape was dictated: Every house with a street front was lit with eight to ten lights in Hitlerian red; every shopkeeper had been told which color to use in their windows. The effect was to transform the city into a vast, intimidating interior, with the new artistic temple at its heart.

For five days, from the welcome speeches at the Deutsches Museum on Friday, July 16, to the "Farewell Evening of the German Artists" at the Hofbräuhauskeller on Tuesday, July 20, a cast of National Socialist characters acted out their rituals, with Hitler in the starring role. There would be receptions for the Reich and for the city, concerts and performances, public dance events, press conferences and briefings. On Sun-

day afternoon, a giant carnival procession would snake its way through town, as it had in 1933: This time there were thirty floats, five hundred horsemen, and forty-five hundred men and women in historical costume who followed a five-mile route past the holiest shrines and monuments of Hitler's cult—the Führerbau, the twin Ehrentempel, and the Haus der deutschen Kunst itself. This parade, titled "Two Thousand Years of German Culture," was designed as a live presentation of the Nazi myth, an immortal expression of the German soul, which again looted the canon of Western history to claim Hitler's reign as the culmination of the glorious "Aryan" epochs of yore. Athena, the Greek goddess of wisdom, was portrayed here as a National Socialist, surrounded by the motifs of eagle, swastika, and torch. The might of Hitler's "New Era," meanwhile, was represented by the architectural models of buildings the Führer had commissioned or designed. Behind the floats, more than three thousand uniformed soldiers and paramilitaries would swing past, from the Wehrmacht, the SA, the SS, the National Socialist Motor Corps, and the Reich Labor Service.

The pageant was a work of cultural propaganda with a careful purpose: to delegitimize the individual. Personality and difference were subsumed in a tableau of massed ranks and martial charisma. Even the city wore fatigues. True Germans would lose themselves in this expression of the ethnic community of the *Volk* and pledge their hearts to their dark Siegfried, who scanned his regimented masses with paternal approval. "We ourselves as a whole people walk in the procession of German skill, German history," the program trumpeted. "Today we are not spectators, but a blood and cultural community."

Goebbels had worried about rain. He needn't have. At 9:00 A.M. on Sunday, the Haus der deutschen Kunst gleamed in brilliant sunshine as formations of SA and SS worked through their drills. The crowd pressed forward, "gripped," as the sculptor Arno Breker remembered, "by the hypnotic power with which this *völkisch* festival addressed ancient depths." At 11:00 A.M., Hitler climbed the red-carpeted steps to the gallery's giant portico, where he was hailed in a short speech by Gauleiter Wagner as the "greatest of living artists," before he swept beneath the stone imperial eagle into the building. He would address the nation from the gallery's Hall of Honor, a double-height room of

polished red marble, lit by enormous skylights, draped with a twenty-foot swastika, and packed with the invited elite: Wehrmacht generals, labor force leaders, approved artists. Another introduction, this time by Goebbels, eulogized Germany's "master builder," "the ideal combination of statesman and artist." Then Hitler climbed to the podium. His words would be transmitted by loudspeaker to the thirty thousand who stood outside, and over the airwaves to millions more who sat by their radios at home.

Those who witnessed Hitler's early speeches recalled their rhetorical power. This was his real gift. Each oration was shaped like an orchestral piece, with moments of piano, adagio, and fortissimo. He would begin in silence, standing at attention, before setting out in a quiet, almost humble voice. Gradually he would become animated, responding to the audience's applause, shifting from side to side, using his extensive repertoire of practiced gestures to emphasize the words. As the roars increased, so did his volume and tempo, and he began to thrust and parry like a swordsman. In the early years, he had remarkable vocal control; by 1937, the subtlety and humility had largely gone, and his tone had grown harsher, more like a bark. In the ears of Paul Ortwin Rave, seated in the Hall of Honor, the words sounded increasingly like a thunderstorm.

The opening of the Haus der deutschen Kunst represented a new beginning, Hitler said. From now on, the nation would be home to a "new and true German art" that had nothing to do with "so-called modern art." The very idea that art could be "modern" was ridiculous: Art was either valuable or worthless, immortal or transient; it could never go "out of date." He had read the failure of modern art in the response of the German people who, in their natural "healthy feeling," recognized it for the spawn of impudent presumption and frightening inadequacy it was. In particular, he scorned the modernists' interest in children's drawings, "primitive" art, and the work of the "retarded." Troost's great building was not for such "stumblebums," but for a new national art based in race and blood and German-ness. Since, he announced, "to be German means to be clear," it followed that the country's culture must also be logical, true, eternal. Jews, Bolsheviks, internationalists, and democrats, with the aid of "so-called art criti-

cism," had destroyed the "natural perceptions" of German art. With such incomprehensible, faddish ideas as Impressionism, Dadaism, Cubism, and Futurism, the cultural Bolsheviks had poisoned the supply of common, decent Aryan art represented by the masters who had gone before. Why had they done this? Because they were artistic "dwarfs" whose own "unnatural smearing and dabbling" did not measure up to their great German predecessors. This mattered because in the future the nation's cultural achievement would be far more important than anything in the political or economic sphere. There was no greater record of a people's highest right to life than its immortal culture.

"Drunk with victory," as Rave now saw him, Hitler moved to deliver his "bloated and scornful reckoning" with modernism. There appeared to be artists who had something wrong with their eyesight, he cried, since they depicted meadows as blue, sky as green, clouds as sulfur yellow. Anyone who painted in this way had to be either ill—in which case the medical authorities would prevent them from passing on their genetic diseases—or a fraudster, who should be dealt with by the criminal justice system. From now on, he forbade painters from using any colors other than those the eye perceived in the natural world. The naming of art movements would be banned, too, as would works of art that were not easy to understand and needed "a swollen instruction manual": Such "stupid or impudent nonsense" would no longer be allowed to reach the German people. Buzzwords such as "inner experience" or "meaningful empathy" were just "lying excuses" for products that were worthless because their creators lacked skill. The exploration of the primitive, too, was "a blatant impudence or a stupidity": Why would anyone want works that could have been made in the Stone Age? Portraying Germans in an unflattering manner was equally wrong: The new "type" of German was radiant, proud, a beacon of health and physical strength, but contemporary artists liked to portray them as "misshapen cripples and cretins, women who are abominations, men who are closer to animals than humans, children who [look like] a curse from God!"

As Hitler approached his denouement, the ranting reached a pitch that "had never before been heard in a political speech," according to Rave:

As if taken from his senses, he actually foamed with rage, dribbling from his mouth, so that even his entourage stared at him in horror. Was it a madman who bent in paroxysms, waving his hands in the air and drumming with his fists?

"From now on," Hitler shouted, "we will be leading a relentless war of cleansing . . . a relentless war of destruction against the last elements of our cultural decomposition!" Now, "all the mutually supportive and clinging cliques of chatterers, dilettantes, and art fraudsters will be dug up and eliminated!"

When the cacophony of applause had died away, the guests were invited to explore the new gallery, led by Hitler, Göring, and Ziegler. That afternoon, a motorcade delivered the Führer to a grandstand on Prinzregentenstraße, where, amid the shouted "Heils," he watched parade floats pass by in the Munich sunshine. Afterward, there were receptions to attend and glasses to raise to the festival's success. Goebbels was ecstatic. Munich was "like a singing island" that evening, he decided, and the parade had been "wonderful." The speech had been a "classic," the day "very holy." Most important, Hitler was "very happy."

AT FIVE O'CLOCK THE following afternoon, Goebbels's contribution to the Tag der deutschen Kunst opened at the Hofgarten arcades. Everything possible had been done to differentiate the "humiliation exhibition" from the art on display across the street. Where the Haus der deutschen Kunst was filled with natural light, the narrow, low-ceilinged rooms in the Hofgarten arcades were kept dim, with many of the windows covered. Where the paintings and sculptures in the *Große deutsche Kunstausstellung* were presented in acres of respectful white space, those in *Entartete Kunst* were bunched together, or even hung at crazy angles. It was part of the stagecraft that no senior regime figure would attend the event's inauguration. Instead, the show's opening was delegated to Ziegler, whose remarks were broadcast on all German radio stations that evening.

An angular man whose skinny limbs tended to protrude from the sleeves of his suits, Ziegler began by praising the festival and the magnifi-

cent temple of art that had been built across the street. Before the visitors went home, he said, he had a sad duty to perform: to show the people the dark elements that had dominated artistic creation in Germany before the coming of Hitler. These forces had not seen art as a natural and clear expression of life, but instead had cultivated everything "sick and degenerate," while conniving critics had praised their material as the highest revelation and the "most modern thing." "You see around us monstrosities of madness, of impudence, of inability, and degeneration," Ziegler told his audience. "What this show has to offer causes shock and disgust in all of us." On his tour of the country, he had been astonished to find that such works were still being exhibited. He and his team had gathered here just a fraction of the degenerate material they had found, since whole trains would not have been enough to carry all of the nation's "rubbish." He wanted to thank the German people, who, when they had been presented with the scrawlings of these "art Bolshevists" and "pigs," simply rejected the whole "swindle," and to thank the Führer, whom the people could unreservedly trust, and who knew which way German art must go. He concluded with an invitation: "Come and judge for yourselves!"

Tens of thousands of citizens took up Ziegler's offer in the following days. Rave, who was among them, reported that the "crowd was always tremendously large," and that thirty thousand people visited on the first Wednesday alone. Many were drawn there by the flyer that was tucked into the official *Große deutsche Kunstausstellung* program, encouraging the public to judge the two exhibitions together.

"Tormented Canvas—Mental decay—Sick fantasies—Mentally ill incompetents," the flyer read:

Awarded prizes by Jewish cliques, praised by literary figures . . . such were the products and producers of an "art" on which the state and national institutions unscrupulously squandered millions of the nation's wealth while German artists starved to death. . . .
Come and have a look! Judge for yourself!
Visit the exhibition *Entartete Kunst*
Admission free
Children prohibited

Free admission had the dual purpose of encouraging visitors and implying that, unlike the works in the *Große deutsche Kunstausstellung*, the art here was of no value. Forbidding children from entering, meanwhile, borrowed the same propaganda technique Otto Gebele von Waldstein had used at Mannheim Kunsthalle four years earlier: It gave *Entartete Kunst* an illicit feel, equating it with horror or pornography. The visitors' response was thus conditioned before they ever arrived at the Hofgarten arcades. Once there, they joined the crowd jostling to squeeze through the humble doorway, a tacit signal that they were now entering the world of the *Untermensch*. They were immediately confronted with a set of narrow stairs, which they climbed beneath the menacing gaze of Ludwig Gies's sculpture of Christ on the cross. The gallery space at the top of the stairs was jammed with art as well as people: Six hundred works had been crammed into nine narrow rooms. The walls were daubed with slogans from speeches by Hitler, Goebbels, and Rosenberg, juxtaposed with pronouncements of artists, critics, and intellectuals that seemed idiotic in their new context. In most cases, the purchase price was noted, along with a large red note stating that the work had been "paid for by the taxes of the working German people."

The first room was designed to offend the audience's religious sensibility, as the label "Insolent Mockery of the Divine Under Centrist Rule" made clear. The second room, "Revelation of the Jewish Racial Soul," was smaller: it included several works by Chagall, including the portrait of a rabbi that had once been paraded around Mannheim. In the third room, a whole wall had been given over to one of Hitler's favorite bugbears, Dada, and daubed with an alleged quotation from George Grosz that read, "Take Dada Seriously, It Pays!" By accident or design, the exhibitors had hung works by Klee and Kandinsky here, neither of whom had ever joined the movement. Elsewhere in the third room, slogans accused artists of sabotaging national defense, insulting war heroes and German womanhood, and holding up the "cretin and whore" as ideals. On the west side of the room hung Max Ernst's *Erschaffung der Eva* (Creation of Eve), which had been seized from Düsseldorf.

A fourth, smaller room mostly showed Die Brücke artists. Room five, the largest in the exhibition, exploited art's links with psychiatry.

Slogans on the walls here included "Crazy at Any Price," over a group of works by Kandinsky and Klee, hung in a deliberately absurd step pattern; "Madness Becomes Method," next to abstract works by Johannes Molzahn; and "Nature as Seen by Sick Minds," over a selection of landscapes and still lifes by Schmidt-Rotluff and Kirchner. Rooms six and seven contained works by the war heroes Marc and Macke, including *Der Turm der blauen Pferde,* though these would be removed later after complaints from the German Officers' Association. Two further rooms on the ground floor—which were barrel-vaulted and only thirteen feet wide—were not opened until Thursday, July 22, such was the time pressure Ziegler had been working under. These spaces would be hung with works by Klee, Barlach, Ernst, Mondrian, Dix, Kirchner, and Kokoschka, among others.

Ironically, the humiliation show was a far more engaging experience than the dull hush of the Haus der deutschen Kunst. Seventeen-year-old Peter Guenther traveled from Dresden that week to see the *Große deutsche Kunstausstellung,* which he found "disappointing and tiring," and was drawn by the flyer to visit the Hofgarten arcades the following day. No one asked his age. He noticed that people in the "approved" gallery whispered as if they were in church, but they talked loudly in *Entartete Kunst,* and even spoke to strangers. The crowds of people who ridiculed the art and proclaimed their dislike gave the young man the impression that it was a staged performance intended to promote an angry atmosphere. Over and over, he heard visitors reading aloud the purchase prices and laughing, or making loud, angry remarks and demanding "their" money back. Guenther, the son of an art critic, decided that most of the audience hadn't seen Expressionist works before and had probably come with the intention of disliking everything. He heard people remark that these "so-called artists" could neither draw nor paint, and that there must have been a "conspiracy" of dealers, curators, and critics, aimed at bamboozling the public. No one spoke up for the works or the artists represented, or attempted to challenge the condemnations.

Above all, Guenther was frightened. "I felt an overwhelming sense of claustrophobia," he remembered. He remained very quiet and avoided catching anyone's eye.

———

FROM THE FIRST DAYS, it was clear that *Entartete Kunst* was a hit, far more popular than the *Große deutsche Kunstausstellung*. More than a million visitors would shoulder their way through the overcrowded rooms of the Archaeological Institute by the end of August. As the Nazi press trumpeted the "artistic inferno," Hitler and Goebbels traveled to Bayreuth for the Wagner festival, a long-standing fixture of the regime's summer season. Hitler stayed as the guest of the family in the late composer's villa, the Haus Wahnfried. (Wagner had explained his villa's name, which means "mad peace," with an inscription over the door that read: "Here where my madness has found peace, let this place be named Wahnfried.") Basking in his victory, in the bosom of the Wagner clan, "Uncle Adolf" lavished approval and attention on Goebbels. "To the Führer at Haus Wahnfried, where I am also staying," the minister noted in his diary for Saturday, July 24. "Führer very nice . . . The exhibition *Entartete Kunst* is a huge success and a big blow." Here, between interminable operas, the pair discussed how to further exploit their confrontation with modern art.

Their first decision was that *Entartete Kunst* should come to Berlin in the autumn. Goebbels favored putting it on at the Kronprinzenpalais, where it would have a humiliating resonance. The Nationalgalerie should also be ordered to take a quarter of the works shown in the *Große deutsche Kunstausstellung*, which was to become an annual event. Eberhard Hanfstaengl should be sacked; Paul Ortwin Rave would be appointed director in his place.

Next, the two men decided that the confiscation of "degenerate" material must now be prosecuted systematically. Hitler gave Goebbels authority to seize all such works in German collections, and the propaganda minister telephoned Ziegler, telling him to "clean the museums." To perform this vast, secret campaign—which Rave later described as "rape," "looting," and "mutilation"—required a dramatic scaling-up of the confiscation commissions. The extreme nature of the purge, which he estimated would take three months, appealed to Goebbels. "This is how it must be done," he wrote. "Awaken the people's interest by means of great actions."

In mid-August, Rave was forced to look on in horror as a gang of anti-modern philistines, including Walter Hansen, rifled the National-galerie's priceless collection in a raid of "incomprehensible unscrupu-lousness." Apart from the personal insults and moral wrongs inflicted on the artists and institutions, he estimated that the damage to the gal-lery's inventory amounted to more than a million gold marks. Incalcu-lable harm was also done to the country's reputation. Goebbels had stipulated that "works of German degenerate art since 1910" were to be removed, but the commissioners also took works by foreign artists such as Cézanne, Van Gogh, and Munch, to whom, in an earlier life, Goeb-bels had once sent a congratulatory seventieth-birthday telegram. Han-sen reviled Van Gogh in particular for his supposed mental illness. He even wanted to confiscate the works of Grünewald, whom he called psychotic, and Rembrandt, who had painted Jewish ghettos, but in these cases he was overruled. The seized art was taken to a former gra-nary at 24a Köpenicker Straße, in the Kreuzberg district of east Berlin, which Ziegler had rented from the port authority.

On August 1, as reports continued to reach Berlin of vast numbers of visitors who had come to see the shaming art show, Goebbels noted in his diary that "[Hitler] is a fabulous man. All man and very real. He is very pleased about the success of *Entartete Kunst*." That day, they had an idea to "bang the advertising drum even more," as Goebbels put it. They would produce a guidebook to educate the wider German public about the threat posed by degenerate and insane modern art. To rein-force their point, the booklet would include works from the Prinzhorn collection.

15.

THE SACRED AND
THE INSANE

ALL OVER EUROPE, ARTISTS WERE ON THE RUN. BECKMANN left for the Netherlands the day after Hitler's speech at the Haus der deutschen Kunst: He would spend the next ten years in Amsterdam, trying to get a visa for the United States. Kokoschka was in Prague, where he painted *Self-Portrait of a Degenerate Artist,* his response to *Entartete Kunst,* which showed him sitting with arms folded while a man and a deer lurked in the forest behind him: the artist as fugitive. Ernst remained in Paris, where he would later be picked up by the Gestapo before fleeing to America with the help of Peggy Guggenheim. Klee and Kirchner were in Switzerland, where Klee produced hundreds of pieces that dealt with his fate. Kirchner, depressed, and fearful that German soldiers would eventually come for him, shot himself dead in the summer of 1938.

Those German modernists who hadn't fled lived in a state of internal exile, working little or furtively, in some cases under surveillance. Barlach was forbidden from exhibiting and was spied upon in his own house. He saw his public works being torn down one by one, and died in Rostock, stressed and plagued by illness, on October 24, 1938. Schlemmer, who had five paintings in the Munich *Entartete Kunst* show, withdrew with his family in September 1937 to a remote corner of the Black Forest. He went on to work with an advertising company in Stuttgart, then a lacquer manufacturer in Wuppertal. Schmidt-Rottluff,

Pechstein, Meidner, Hofer, Heckel, and Nolde were ordered to cease painting altogether. Nolde continued furtively: He abandoned oils, since the smell could betray him to the Gestapo, and instead embarked on a series of watercolors he called "Unpainted Pictures." By the war's end he had created more than thirteen hundred of these odorless images on small pieces of rice paper.

The Prinzhorn artists were unable to run or hide. They remained incarcerated in asylums across the Reich, derided by state propaganda as "useless eaters," "ballast existences," and "life unworthy of life." Between 1935 and 1937, the Rassenpolitisches Amt der NSDAP (NSDAP Office of Racial Policy) produced a series of silent 16 mm films with such titles as *Sünden der Väter* (Sins of the fathers) and *Alles Leben ist Kampf* (All life is a struggle), aimed at dehumanizing the mentally ill and increasing public support for eugenic solutions. *Erbkrank* (Hereditarily sick), from 1936, was a classic of the genre. It showed asylum inmates and people with physical disabilities enjoying apparently luxurious care at the expense of the state, while "normal" but poor children were filmed playing in the dirt. Captions drove home the message that the mentally ill were a burden the people could no longer afford to carry:

> Against all the laws of nature, the unhealthy are
> cared for disproportionately, while the healthy
> are neglected . . .
> Up to now this family has cost the state 62,300 RMs
> Chained to a bed for a lifetime . . .
> Should things go on like this?
> Should yet more distress be produced through
> casualness and irresponsibility?
> NO, NO, NEVER! . . .
> Otherwise our great nation and its culture will be
> destroyed.

Once again, German culture was the standard around which the racially healthy were expected to rally.

Hitler was so pleased with *Erbkrank* that he ordered a sequel, *Opfer der Vergangenheit* (Victims of the past), which would be shown in every cin-

ema in Germany. Other Office of Racial Policy initiatives included a magazine, *Neues Volk* (New people), which boasted three hundred thousand subscribers by 1938, and ran articles contrasting attractive "Aryans" with unflattering images of the mentally ill. "60,000 reichsmarks is what this person suffering from a hereditary defect costs the People's community during his lifetime," stated one *Neues Volk* advertisement, in which a smiling, white-jacketed orderly rests a sinister hand on the shoulder of a disabled man. "Fellow citizen, that is your money, too."

At the same time, the education system was indoctrinating children in the benefits of eradicating the "defective" from society. As Hitler had demanded in *Mein Kampf*, academic subjects in German schools had been downgraded in favor of relentless physical education. Girls were to become fecund mothers, and boys would be drilled into soldiers who were as "swift as a greyhound, as tough as leather, and as hard as Krupp steel," as the dictator put it. One new academic subject had been introduced, however: eugenics. Textbooks juxtaposed photographs of "degenerates" with "healthy," hard-bodied army recruits, and even math questions were retooled to deliver the regime's message. The following arithmetic problem dates from 1935:

> At the beginning of 1934 in the state of Baden a total of 6,400 people were in need of care, while 4,500 mentally ill persons, 2,000 hereditarily ill persons, and 1,500 young people were accommodated in care homes. Given that Baden has about 2,400,000 inhabitants,
>
> a) How many persons on average are in need of care per 1,000 inhabitants?
> b) How many reichsmarks minimum did these mentally ill persons cost the state?
> c) How many healthy families could live on this amount for 10 years?

It was as part of their racial education that a group from Freiburg's Ludendorff secondary school came to tour Emmendingen in January 1938. Afterward, each of the forty-two pupils was asked to write an

essay about the visit. The results show how well the propaganda worked and how public allegedly secret Nazi "solutions" for psychiatric patients had become.

A few of the Ludendorff students clearly hung on to a vestige of pre-Nazi morality, empathizing with the patients, writing that it was wrong to use the sick as "exhibits," or asking whether a reasonably healthy person might not go insane in such a place. Several were disappointed that the inmates did not look nearly as "repulsive and disgusting" as they had been led to believe. Most, though, followed their teacher's lead, describing how they had seen the "high point of horror," or "human ruins with bestial instincts," and comparing the inmates with animals. No one in the group questioned the necessity of racial legislation. Most surprising was the fact that a possible "euthanasia" action against the mentally ill was openly discussed, and every single pupil remembered to write that the principal argument for such a policy was to save public funds. One even specified that the money should be used "for the purpose of armament." Thirty-five of the forty-two pupils clearly supported the sentiment that the German people should be "freed from such evil appendages"—meaning the patients—and anticipated that asylum doctors would not be necessary for much longer. The teacher did have to correct one student, though, who failed to identify the Reich's preferred psychiatric treatment, writing "Hemlock, according to Hoche-Binding," on the paper in red ink.

Rumors of proposed "solutions" to the issue of psychiatric patients were a part of the discourse in late 1930s Germany. In the spring and summer of 1937, the SS organ *Das schwarze Korps* published articles that explicitly advocated the "mercy killing" of the mentally ill and disabled, while the director of the Eichberg asylum, Wilhelm Hinsen, recalled being told two or three times by a regional governor, as early as 1936 or 1937, that "it would be better if a law existed which made it possible to kill the mentally ill, since they were all ballast existences." Hinsen was also told at the end of 1936: "In the future they will only get SS doctors, who know better how to handle syringes." Unsurprisingly given this context, patient care continued to deteriorate. The relentless propaganda added to psychiatry's perennial recruitment problems. The nurses and orderlies who did sign up were often fascist or unsuitable,

while the system promoted doctors who were party members or at least supported eugenic goals. The attitude of Nazi medicine toward the mentally ill can be gleaned from the advice of Fritz Bernotat, a National Socialist who administered state hospitals in Hesse-Nassau. Addressing a meeting of institutional directors who complained about overcrowding, Bernotat said: "If you have too many patients in your institution, just beat them to death, then you will have space."

In 1937, two violent new "shock therapies" were rolled out in Emmendingen that held out the hope, as one psychiatrist explained, that schizophrenic patients "would not have to become long-term asylum inmates, and thereby costly ballast existences." These therapies were based on the assumption that by inducing convulsions, a subject could be "jolted" out of mental illness. In fact they were unscientific and inhumane. Insulin shock therapy involved injecting schizophrenic patients with high doses of the hormone, which reduced their blood sugar to such a critical level they fell into a coma. If the patient regained consciousness, he or she would sometimes have moments of lucidity and even feel "cured," but common side effects included headaches, disorientation, difficulty moving, extreme hunger, and even death. A course of treatment lasted months and involved anything from ten to sixty such "shocks." Cardiazol convulsive treatment was thought to work in a similar way. Doctors injected the patient with a cerebral stimulant known to induce epileptic fits. The drug caused massive anxiety, something like the terror of being thrown off a high building, and violent seizures that could stop a patient's heart, or cause them to break their own bones. Like all psychiatric treatments, insulin and cardiazol therapies were open to tremendous abuse in the hands of unsympathetic medical staff and were soon being used as a way of disciplining the disobedient or disturbed. In Emmendingen, 154 patients were treated with insulin or cardiazol in 1937. It is not known if Bühler was among them.

One way patients could try to escape the dangers of these treatments was to prove their ability to work. Nowhere in Baden was this more evident than in the Heidelberg clinic, which was now under the control of the Nazi psychiatrist Carl Schneider.

DILIGENT AND INTELLIGENT, WITH a neatly parted quiff of hair, Schneider was in many ways the worst sort of National Socialist: an ambitious character filled with an "uncritical sense of mission," as one of his successors at Heidelberg put it. He had backed eugenics at least since 1930, when he co-authored a paper arguing for a comprehensive, qualitative population policy in the sense of a "racial hygienic" re-arrangement of the entire economic and legal system. He keenly supported the Law for the Prevention of Genetically Diseased Offspring, claiming that it was a "responsible attempt before God to give a new era new people," and earmarked large numbers of his own patients for sterilization. He was also a pioneer in connecting Hermann Simon's idea of "work therapy" to eugenics.

Simon's original ideas about this form of therapy, in which patients were assigned a graduated range of tasks, had liberated many inmates from the listlessness of asylum life. In the punishing economic environment of the early 1930s, however, a patient's ability to perform useful labor increasingly became synonymous in doctors' minds with their overall health. Schneider would push the conflation of these two perceptions—ability to work and wellness—to its logical endpoint. He began with the Nazi idea of the *Volksgemeinschaft* as a "living community ethos of persons belonging to the state." Every individual could be judged by his or her ability to benefit or detract from that community, he believed. Therefore, all that was therapeutically possible should be done to encourage a patient to useful economic activity for the greater good. But if that failed, as it often would, the patient was proven to be socially useless, and useless patients, in Schneider's logic, should be removed from the gene pool.

Schneider applied his work therapy principles with great rigor, and the Heidelberg clinic's cellars soon became such hives of bookbinding, shoemaking, and carpentry that the local craft guilds complained to the government about the unfair competition. There was one form of patient activity, however, that he viewed as utterly without value: making art. He expounded his theories on this subject in a lengthy address he

planned to give on the occasion of the first anniversary of *Entartete Kunst*. The speech was never delivered, but it survives as the most comprehensive analysis of Nazi psychiatry's views about patient art, expressed by the man who was now in control of the Prinzhorn collection.

Schneider began by asserting the National Socialist idea that artistic ability was a product of genetics. Germans had known for centuries that the noble artist was the "highest perfection of what we are," with a responsibility to educate the race, philosophically and ideologically, and to lead it. In the nineteenth century, however, due to "racial shifts" in the national cultural leadership, insanity had become confused with the artistic process. This had led to the complete devaluation of art's noble purpose. What was to blame? "Progressive-rationalist recklessness," in the form of Marxists, liberals, and Jews, who had placed an "amazingly high valuation" on the art of the mentally ill. Freud was culpable, since psychoanalysis denied the racial superiority of the artist. So, too, was Prinzhorn, whose theory put all configuration on one level, whether it was a Rembrandt or a child's scribble, and opened the door to "art for every good-for-nothing," as anyone, however inartistic, could claim metaphysical authority for his need for expression. Even "many serious people" had been misled by Prinzhorn's worldview, Schneider wrote, which had helped create a time that was itself schizophrenic. Degenerate artists had tried to emulate the work of the mentally ill, which Prinzhorn and his kind had elevated "to so-called high art," while the ability to judge art had been withdrawn from the common people and given over to "experts" and connoisseurs. Jews and Marxists—whose agenda was the decline of German civilization—had promoted this material, thereby threatening the development of the Aryan race:

> Here lies the key to the fact that degenerate art, at the same moment, had to become truly sick art. For, as in all such cases, the outermost wing, i.e. the mentally ill, gradually also took over the leadership. The rest of the . . . degenerates, and especially the communist Jews, oriented themselves toward this.

From here, it was a short, social Darwinist hop to the conclusion that the genetically inferior degenerate painter had been able to pros-

per while the "healthy" artist was unable to make a living or reproduce, and that the race's artistic ability had thereby been driven toward genetic disaster. Luckily, a National Socialist solution was at hand. By preventing "degenerate" artists and patients from producing offspring, and by stopping "noble," "natural" traits from becoming mixed up with those that were "diseased," it would be possible to breed out degenerate art, and breed in German artistic talent.

Alarmingly for the collection in his care, Schneider agreed with Weygandt on the central question of whether psychiatric patients could produce art at all. This was impossible, he declared, since any artistic development in these cases was redirected toward their pathology. A professional such as himself could immediately tell the difference between a "mentally ill" work and one by a "healthy" individual, since the non-insane artist produced a degree of meaning, which "insane" art lacked. Worse still, the very existence of such material was evidence of medical malpractice. As the preservation of a healthy art was a prerequisite for the health of the people, a true German psychiatrist had only one option: to destroy the "didactic bogus evidence" that sought to derive the art of "degenerates and lunatics" from the same biological sources as the art of the healthy.

Schneider had already tested his theory himself and had achieved "admirable" results during a work therapy session with a schizophrenic female patient. "We did not keep the artist's pathological products," he boasted, "we destroyed them."

16.

THE GIRL WITH
THE BLUE HAIR

TWO MILLION VISITORS PASSED THROUGH THE CRAMPED SPACES of *Entartete Kunst* in Munich between July and November 1937. This immense success led Goebbels to extend the show several times, and to push back the Berlin opening. His vindictive wish that it should appear in the capital at the Kronprinzenpalais caused further delays, as Göring and Rust insisted that only upbeat events should be staged in such a prestigious venue. The propaganda minister eventually settled for the Haus der Kunst, a former embassy building next door to the Reichstag. The delays at least meant Goebbels had time to control every aspect of the exhibition, which he entirely recast for Berlin. He removed all the "ballast," as he called it, added art that had been produced in the capital, for local interest, and sharpened the image of the enemy so that it could now be read as a "political lecture" against the Jewish-Bolshevik racial foe and its destructive cultural program. The most significant change, however, was a new emphasis on madness.

In Munich, the show's organizers had used such pathologizing slogans as "Crazy at Any Price" and "Madness Becomes Method" to push Hitler's idea that the avant-garde had polluted art with insanity in order to bring about German cultural degradation. For Berlin, Goebbels hit upon a new technique to ram the message home. He would

present works from the Prinzhorn collection alongside those of the "degenerate" professional artists and ask the people to judge which appeared more insane. These visual juxtapositions would work equally well in the guidebook he and Hitler had dreamed up in Bayreuth in the summer. First, though, they needed to source appropriate comparative material, and so, that autumn, a young official named Hartmut Pistauer was dispatched to the Heidelberg clinic.

Pistauer knew the Munich edition of *Entartete Kunst* well. In the hectic July days before the exhibition's opening, he had been drafted from the Nazi student organization to help construct burlap-covered partitions and paint defamatory signs and captions on the walls of the Archaeological Institute. The young man's attitude impressed Goebbels enough that he was appointed exhibition director for Berlin. Pistauer was glad to play his part. He was such an enthusiastic National Socialist, in fact, that in the 1990s, when an enterprising art historian traced him to an apartment in Munich, Pistauer's wife met the visitor at the door with the words *Wir sind noch braun*—"We're still Nazis." Pistauer spent a fortnight in Heidelberg that autumn, digging through Prinzhorn's carefully catalogued artworks. He found some that were "amazingly similar" to those in Munich and recalled speaking in person to artist-patients in the clinic. He photographed anything that looked promising. Professor Schneider was helpful and "very interested" in his task, he remembered.

On January 22, the propaganda directorate in Berlin wrote to Heidelberg to agree on details for the shipment of a quantity of psychiatric works to the capital. More than a hundred paintings, drawings, and sculptures by at least twenty-six artists, including some of the most influential in the collection, were soon on their way. There were at least two Genzels, six Blankenhorns, and seventeen by Josef Schneller. Paul Goesch was unique in having his art sent to *Entartete Kunst* both as an example of professional degeneracy (to Munich) and of amateur madness (to Berlin). Bühler was represented in the shipment by at least five works, including a beautiful, brightly colored portrait of a blank-faced angel at play with a toy human. *Der Würgengel* may also have been sent to Berlin.

When it came to choosing professional art for the shaming show, Hitler and Goebbels personally picked out some works from the depot of confiscated art on Köpenicker Straße. They spent two hours going through the seized material. Hitler's verdict was devastating: "No picture finds mercy," Goebbels reported.

SATURDAY, FEBRUARY 26, 1938, was a day of glorious winter sunshine in the capital, and Goebbels took advantage of the weather to drive out to his villa on an island in Wannsee, where he played the racist card game Schwarzer Peter (Black Peter) with his children. Neither he nor Hitler would appear at the launch of the new edition of *Entartete Kunst* that afternoon. As at Munich, it was agreed that the senior leadership should not be seen in company with the degenerate art, although Goebbels had devoted a great deal of attention to it and had been unable to resist visiting the gallery several times during the show's construction.

At 4:00 P.M., lower-ranking party officials and their guests gathered in Room 12 of the Reichstag building. A portrait of Hitler had been placed at the front of the auditorium, adorned with laurels and flanked by Nazi flags, and as the audience took their seats, Beethoven's "Coriolan Overture" drifted across from an adjoining room, where the Berlin Landesorchester had been seated for the occasion. Speeches were made, praising the Führer and lambasting "degenerate" artists. A "triple-victory" "Sieg Heil!" was shouted, and national songs were sung. Then the guests trooped out of the Parliament building and across the road to the Haus der Kunst, which had been decked out with more Nazi flags. *Entartete Kunst* filled seventeen rooms across the building's three floors.

The atmosphere here was "festive," according to the *Deutsche Allgemeine Zeitung*'s correspondent. The reporters already knew what to expect: They had been thoroughly briefed by the new head of fine arts in Goebbels's ministry, the former *Völkischer Beobachter* critic Franz Hofmann, and handed an "Information Sheet for Editors," which emphasized the new tactic of comparing this art with that of the psychiatric inmates. The visitors were also given a copy of the new exhibition guide,

which would go on sale to the public for 30 pfennigs. It wasn't a cata-
logue as such, in that it didn't list all the pieces of art on display, but it
did contain many of the quotations and captions, as well as images of
some works, and corresponded closely to the layout of *Entartete Kunst*
from this point on. A quarter of its sixteen illustrated pages showed
Prinzhorn material alongside professional art, mirroring the juxtaposi-
tions in the exhibition. These were accompanied by a crowing, sarcastic
commentary stating that even these "sick" pieces were better than those
of the famous artists. The first pairing, of a work by Paul Klee and that
of an unidentified Prinzhorn artist, was captioned:

> Two "saints"!! The one above is called "The Saint of the Inner
> Light" and is by Paul Klee. The one below is by a schizophrenic
> from a lunatic asylum. That this "Saint Mary Magdalen and
> Child" nevertheless looks more human than Paul Klee's botched
> effort, which was intended to be taken entirely seriously, is highly
> revealing.

Two of the displayed Prinzhorn works were by Genzel. The first,
Mädchenkopf (Head of a girl), made from chewed bread, was shown next
to a sculpture by Eugen Hoffmann, a Communist from Dresden. The
caption here read:

> This head of a girl is the work of an incurably insane man in the
> psychiatric clinic in Heidelberg. That insane *non-artists* should
> produce such works is understandable ... This abortion [by
> Hoffmann], on the other hand, was seriously discussed as a work
> of art and included in many exhibitions in the past as a master-
> work.

The title of Hoffmann's "monstrosity" was *Mädchen mit blauem Haar*
(Girl with blue hair), and indeed, the guidebook scoffed, "its coiffure is
a resplendent pure sky blue." This was a clear transgression of Hitler's
ruling against non-realist colors.

The second Genzel sculpture was *Katze* (Cat), which was placed
next to a work by the Jewish artist Rudolph Haizmann:

When an incurable lunatic, and an amateur into the bargain, models a cat, this is how it looks. . . . But when Haizmann, praised in his day as a "sculptor of genius," takes it into his head to create a "fabulous beast" to adorn a fountain, the resulting monstrosity looks like this picture. The inferior work weighs several hundred pounds, by the way.

A later edition of the guide described Haizmann as "the Jew Haiz-mann," and the work as a "Jew creature."

The fourth comparison matched a portrait by the Prinzhorn artist Georg Birnbacher with a pair of works by Kokoschka:

Which of these three drawings is the work of an amateur, an in-mate of a lunatic asylum? You will be surprised: the one on the right above! The other two used to be regarded as master draw-ings by Kokoschka.

As at Munich, the exhibition and guidebook were divided into sec-tions, though these had been fine-tuned since the show's opening in Bavaria to better meet Goebbels's propaganda objectives. Artworks from Berlin galleries had also been added to generate local interest. There were nine different groups, dealing with such Hitlerian themes as the "collapse of sensitivity to form and color," the "shameless mock-ery" of religion, "Bolshevik" political art, treasonous anti-war art, "moral degeneracy," and "negro art" and the decline of "racial con-sciousness." The dictator's most vaunted targets were saved for the last three groupings, with number seven assaulting modern art's insane in-spiration. Artists had created a "highly specific intellectual ideal, namely, the idiot, the cretin, and the cripple," the exhibition organizers said:

Even where these "artists" have portrayed themselves or each other, the resulting faces and figures are markedly cretinous. [O]ne thing is certain: to the "moderns" represented here, a mindless, moronic face constituted a special creative stimulus. . . . Here are human figures that show more of a resemblance to go-rillas than to men.

Group eight targeted the Jews, particularly Otto Freundlich, whose sculpture *Großer Kopf* (Large head) had been sarcastically rechristened *Der Neue Mensch* (The new man) to give it an extra degenerate frisson: It also adorned the guidebook's cover. Lastly, the show's finale, group nine, lambasted all the movements within modern art, the so-called -isms, in a selection that, according to the guidebook, could only be entitled "Sheer Insanity." In this "chamber of horrors" there was no telling what was in the "sick brains" of the works' creators:

> In this "insanity group," visitors to the exhibition usually just shake their heads and smile. . . . But when we reflect that all these "works of art" have been removed not from the dusty corners of deserted studios but from the art collections and museums of the great German cities . . . then it is no laughing matter: then we can only choke back our fury that so decent a people as the Germans could ever have been so foully abused.

The newspapermen diligently trumpeted the Berlin opening of *Entartete Kunst* in the press, noting with admiration the comparison with the new psychiatric material. The *Frankfurter Zeitung*'s correspondent reported that the Prinzhorn pieces "each show a similar motif of representation [as] the exhibited work itself, so as to demonstrate that the product of the insane person is closer to real nature than the representation of the painter or sculptor concerned." The *Berliner Börsen-Zeitung* accused the professional artists of becoming ill on purpose: "The exhibition very cleverly juxtaposes works by real mentally ill people from the Heidelberg Psychiatric Clinic with the works of the intentionally insane," the reporter wrote. "They are indistinguishable . . . [in fact] the work of the intentionally insane is usually even more deformed." The critic Robert Scholz picked up on the juxtapositions as an "especially impressive" part of the show: "Simulated and real nonsense are indistinguishable here."

It was soon clear that Goebbels had another hit on his hands, as Berliners and foreigners hurried to see the exhibition that had caused such a sensation in Munich. Lines of visitors formed outside, and inside the rooms were full to bursting. The *Frankfurter Zeitung* reported that the

organizers had to designate a special exit, by way of a back staircase and a courtyard, "in order to divert the departing masses of visitors from the arriving ones." More than 50,000 came in the first two weeks, 150,000 in the first month, 200,000 by mid-April. The party did all it could to boost numbers, keeping the show open until 9:00 P.M., seven days a week, to give the workers a chance to see it.

Several eyewitnesses recorded that the atmosphere in Berlin was more somber than it had been in Bavaria, which was both the center of the *völkisch* reactionary tendency and the home of Nazism. Emil Stumpp, a press artist, visited the Haus der Kunst on a weekday—the show was crowded even then—and recorded that, though a small part of the audience reacted to the art with loud laughter, most people walked around with "stony faces." He was relieved to escape into the air outside. Felix Hartlaub, the son of the former Mannheim Kunsthalle director Gustav Hartlaub, found the exhibition "a real hell." "Audience deeply depressed," he wrote to his father. "Demonstrative indignation or cheerfulness very rare." In some cases, the pictures were openly appreciated, especially by young people, but there were many devout party members in the crowd, too. He also remarked on the presence of the Prinzhorn works. "In places," he noted, "juxtaposition with *Bildnerei der Geisteskranken*."

There was another significant innovation for the Berlin leg of *Entartete Kunst*: the show was designed to be portable. Where in Munich the pronouncements of Hitler and others had been painted directly on the walls, in Berlin they were carried on posters and placards that could easily be crated up and shipped to the next venue. On May 8, after a two-and-a-half-month run that had been extended several times, allowing more than half a million people to see it, *Entartete Kunst* was packed with great speed and sent to Leipzig, where it opened at the Grassi Museum five days later, complete with its complement of Prinzhorn material. Over the next eighteen months, it would tour all around the Reich, to Düsseldorf, Salzburg, Hamburg, Stettin, Weimar, Vienna, Frankfurt, and Chemnitz.

The exhibition always followed a similar layout, with the same Prinzhorn juxtapositions, and it was always greeted with jeering from the state-controlled press. In Leipzig, the *Tageszeitung* drew attention to

the "introduction of derangement into art . . . the worship of idiocy . . . and finally the perfection of madness," and celebrated the "relief and satisfaction that, as a nation, we have once and for all denounced such barbarity in cultural matters." In Düsseldorf, the *Remscheider General-Anzeiger* noted the "daubings of the incurable institutionally insane, who never before held a paintbrush in their hands." In Hamburg, the work of "mentally ill lay people" bore testament to the fact that "modern artists [had tried] to undercut the art of idiots." Newspaper readers were asked to compare the "products of idiots" with those of professionals and decide, "Who was an artist—who is mentally ill?" In Weimar, where "degenerate music" was included for the first time, the *Allgemeine Thüringische Landeszeitung* pointed out that "one often comes to the conclusion that the work of the so-called 'real' artist looks even crazier than that of the mentally ill."

Wherever it went, visitors flocked to see the chamber of modernist horrors. By the time it closed in Chemnitz on August 26, 1939, six days before the outbreak of the Second World War, *Entartete Kunst* was the most-visited art show in history.

AS THE EXHIBITION TOURED the Reich, Goebbels tried to work out what to do with the immense amount of confiscated art that had been stripped from German collections. A conscientious stocktaking of the east Berlin depot produced a six-volume inventory listing 16,500 works by 1,400 artists, seized from 101 museums in 14 cities. In the summer of 1938, the propaganda minister published the "Law on the Confiscation of the Products of *Entartete Kunst*," which divided the material into three groups. The first, most straightforward category consisted of foreign-owned works on loan, which would simply be returned. The second group was made up of state-owned works, which were either valuable, and could be exchanged abroad for "high-quality" German art or for hard currency, or should be preserved for educational or propaganda purposes. The final category consisted of art that was "absolutely worthless" and would be destroyed. Goebbels made clear that these categories would cover all cases.

Between the end of July and mid-September, the regime moved the

state-owned works with international value to Schloß Niederschön-
hausen, a three-story chateau on the northern outskirts of Berlin.
Eventually, 779 paintings and sculptures and 3,500 watercolors, draw-
ings, and graphics earmarked for foreign fire-sale would be stored here.
The treasure trove included art by Beckmann, Campendonk, Chagall,
Corinth, Dix, Grosz, Heckel, Kandinsky, Kirchner, Klee, Kokoschka,
Marc, Mondrian, Nolde, Pechstein, Rohlfs, and Schmidt-Rottluff.
Hermann Göring, who always had an eye for loot, secured thirteen con-
fiscated masterpieces from the chateau, by Cézanne, Van Gogh, Marc
(including *Der Turm der blauen Pferde*), Munch, and Signac.

A group of four hand-picked dealers were authorized to sell this
material. Some clients were given direct access to Schloß Niederschön-
hausen, but the most notorious sales went through the Swiss art dealer
Theodor Fischer. In October 1938, Fischer wrote to the Propaganda
Ministry to suggest that the best way to "liquidate" Germany's glut of
art would be an international auction. The first of these would take
place on June 30 the following year, at the Grand Hotel National in
Lucerne. One hundred and twenty-six works were offered for sale, and
dealers paid $21,000 for a Van Gogh self-portrait, $10,000 for a Pi-
casso harlequin painting, and a little over $9,000 for a Tahitian land-
scape by Gauguin. Chagall's *Winter, La maison bleue (The Blue House),* and
Rabbiner (Rabbi) were also sold. Prices on the whole were low, both be-
cause the art world was aware of the illicit nature of the sale and be-
cause everyone knew the money would be used to prop up Hitler's
regime. Fischer didn't help matters by showing obvious disdain for
much of the work on offer. Paintings by Dix, Klee, Kirchner, Nolde, and
Beckmann sold for insignificant sums. A second, poorly attended auc-
tion took place on August 26.

As the cream of Germany's modern art collections flooded the in-
ternational market, a great quantity of seized material judged "unsale-
able" remained in the Köpenicker Straße depot, and the head of the
Fine Arts Ministry, Franz Hofmann, was itching to dispose of it. In No-
vember 1938 he wrote to Goebbels to tell him that the building would
soon have to be cleared, since it was "urgently" required as a grain store,
and a "final decision" was required. There was no need to keep the art

for propaganda purposes, as *Entartete Kunst* was already abundantly supplied. Therefore, he stated:

I propose to burn this remainder at the stake in a symbolic propagandistic act and offer to hold a correspondingly spicy funeral oration. I ask for your consent.

Goebbels hesitated, responding that Ziegler's opinion would have to be asked. On January 19, 1939, Hofmann tried again, urging that the 12,167 pieces still in the depot were the "scum of degenerate art which can be safely burned." Three days later, he put the question to Goebbels once more: "I ask for permission, whether I may burn the remainder immediately, in order to free up the depot for the urgent need as Granary." This time, Goebbels agreed, responding simply: "Yes! Dr. G." The depot was cleared the following month. On March 20, 1,004 oil paintings and sculptures and 3,825 watercolors, drawings, and prints were burned in the courtyard of the main fire station in Berlin.

The final report on the exploitation of the products of "degenerate" art in Germany stated that most of the sixteen thousand confiscated works were "completely unusable," and that the majority had been destroyed or put into storage. Around three hundred paintings and sculptures and three thousand graphics had been sold internationally, for a total of "more than 10,000 pounds, approximately 45,000 dollars and around 80,000 Swiss francs." In addition to these foreign exchange receipts, swaps had been made to a value of 131,630 reichsmarks. The foreign currency generated was allocated to the rearmament program.

Goebbels claimed this as a great achievement. In fact, he and Hitler had caused irreparable damage to Germany's reputation as a world leader in the arts. The Nazis had liquidated one of the world's greatest national collections of painting and sculpture, a collection that would be worth many billions of dollars today. The amount they raised in return would barely cover the cost of two Panzer tanks.

PART FOUR

—

EUTHANASIE

Insanity is the great art.

— JEAN DUBUFFET,
1976

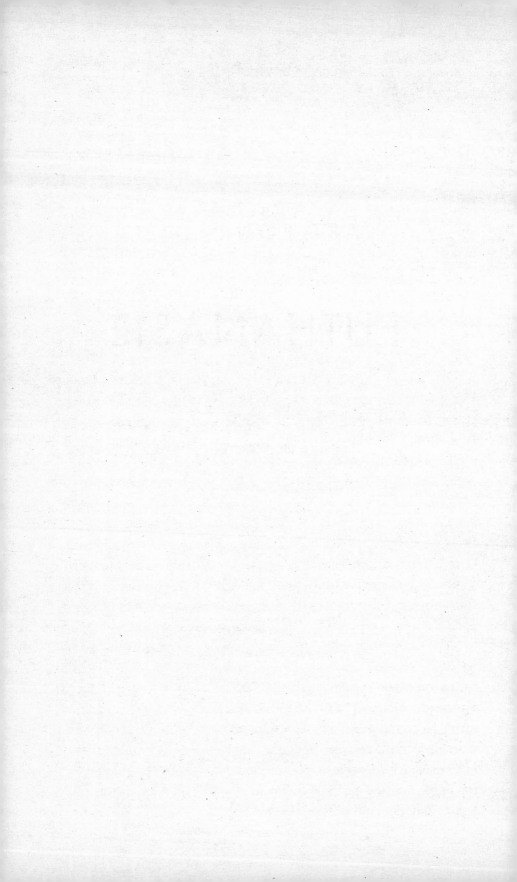

17.

FOXES WITH
WHITE COATS

ON FEBRUARY 20, 1939, A BOY WAS BORN IN THE SMALL village of Pomßen, fifteen miles southeast of Leipzig, to Richard Kretschmar, a farm laborer, and his wife, Lina. The Kretschmars named their son Gerhard, but they were far from delighted with their new addition, since the baby was severely disabled. He was blind, he was missing parts of his limbs, and he may have suffered from convulsions. Richard Kretschmar took him to the University Children's Clinic in Leipzig, where he was examined by the professor of pediatrics, Werner Catel. After hearing the bleak assessment that the boy would never be "normal," Kretschmar asked if he could be given a peaceful death. When Catel explained that this would be illegal, the family wrote to Hitler to ask for special permission for "the monster," as Richard described him, to be killed. Both Kretschmar parents were said to be ardent National Socialists.

This terrible request reached Hitler's private office in Berlin, the Kanzlei des Führers (KdF), where a senior administrator, Hans Hefelmann, picked it out from the two thousand or so private petitions that were made to the dictator every day. Hefelmann passed it up the chain of command, bringing it to the attention of his department head, Viktor Brack, and the KdF's overall chief, the SS colonel and Nazi "old fighter" Philipp Bouhler.

These men were well aware of Hitler's views on the matter of the disabled, which had changed little since *Mein Kampf*. In 1933, when the Führer was being advised on the Law for the Prevention of Genetically Diseased Offspring, he had aired his idea for a program of "involuntary euthanasia" to rid Germany of its burdensome patients. The idea was rejected then on the grounds that the public would find it unpalatable, but Hitler knew that war would weaken resistance, particularly from the churches, and make it "easier and smoother to carry out." After the war, Brack would tell the U.S. military court at Nuremberg what he understood of Hitler's position when the Kretschmar letter arrived:

> Ultimately, Hitler intended to eradicate those people who were kept in insane asylums and similar institutions and were no longer of any use to the Reich. These people were regarded as useless eaters, and Hitler was of the opinion that the extermination of these so-called useless eaters would give the opportunity to release more doctors, nurses, orderlies, and other facilities for the use of the Wehrmacht.

Gerhard Kretschmar seemed perfectly to fit Hitler's idea of a "useless eater," and when the KdF men informed him of the case, he leapt into action, summoning his personal physician, Karl Brandt, and ordering him to travel immediately to Leipzig to investigate. Brandt was to interview the doctors involved and find out whether Richard Kretschmar was telling the truth. If so, Brandt was to instruct the doctors to carry out "euthanasia" in Hitler's name. The parents were not to feel responsible or incriminated, Hitler told Brandt, and any legal proceedings were to be quashed on the Führer's authority.

Brandt hurried to Saxony, where he spoke with Catel and concluded that the baby "seemed to be an idiot." Next, he traveled to Pomßen to interview the parents. Then he pronounced that Gerhard should die. The baby was probably injected with a lethal dose of phenobarbital, and on July 25 he became the first official victim of Nazi Germany's policy of state killing. He was chosen no doubt because of his severe disability, and because the manner of the request meant Hitler's decision could be given a humanitarian, ad hoc gloss, when in fact the pro-

gram that emerged from Gerhard's murder had been under consideration for many years.

Hitler now ordered that the KdF handle all similar petitions, and Hefelmann was instructed to put together a secret working group on child euthanasia. It would include Brandt, and operate under the covert name of the Reich Committee for the Scientific Registering of Serious Hereditary and Congenital Illnesses. On August 18, 1939, at the behest of this committee, interior minister Frick circulated a confidential memo requiring German midwives to notify the authorities of newborns who suffered from certain conditions, including "idiocy and mongolism" (especially cases involving blindness and deafness); microencephaly; severe or progressive hydrocephalus; malformations of any kind, in particular absence of limbs, severe clefts of the head and spine; and paralysis, including spasticity. Berlin incentivized midwives with a payment of 2 reichsmarks for every name they supplied. Three doctors would make the decision of whether to kill a particular child: Catel; Hans Heinze, the director of Brandenburg-Görden asylum; and the pediatrician Ernst Wentzler. It was important for propaganda purposes that the decision-makers were medical professionals, though none of them ever examined the children whose deaths they ordered. Naturally, they all subscribed to the party ideology. Wentzler, who earned 240 reichsmarks a month for the extra work, recalled: "I had the feeling that my activity was something positive, and that I had made a small contribution to human progress."

The children who were sentenced to death were taken to one of thirty pediatric clinics around the Reich. The KdF instructed clinic personnel to carry out the killings using a variety of techniques, including overdoses and starvation, which could take days or weeks. German medics would eventually kill around six thousand children in this way. This was a small fraction, however, of the far wider mass murder program launched around the same time.

EARLIER THAT SUMMER, HITLER had summoned a group of high-ranking officials, including Reich health secretary Leonardo Conti, his private secretary Martin Bormann, and Hans Heinrich Lammers, the

head of the Reichskanzlei (the chancellor's office, as opposed to the KdF). He told them he was instructing Conti to start a program to end the "worthless lives of seriously ill mental patients." As Lammers recalled the meeting:

> [Hitler] took as examples the severe mental illnesses in which the patients could only be kept lying on sand or sawdust, because they perpetually dirtied themselves, cases in which these patients put their own excrement in their mouths as if it were food, and things similar. . . . He said that he thought it right that the worthless lives of such creatures should be ended, and that this would result in certain savings in terms of hospitals, doctors, and nursing staff.

In fact, there was no evidence that savings could be made, because Hitler had not ordered any financial analysis, and anyway the cutbacks meant spending on the psychiatric system was very low, but this was the excuse he used. It was a sign of their ambition and moral bankruptcy that when Bouhler and Brandt were informed of this development they moved to defend the murderous terrain they had staked out with the program to kill disabled children, rapidly maneuvering to elbow Conti aside, arguing that all aspects of "euthanasia" should be kept within the KdF. Hitler agreed, and ordered them to take charge.

Bouhler and Brandt conferred on how to implement their vast new commission. Because they needed to scale up their plans dramatically, they began to expand the pool of reliable Nazi doctors who could be trusted to sentence people to death. Carl Schneider of the Heidelberg clinic was one of those added to the original panel of child euthanasia "experts." Others included Hermann Pfannmüller of the Eglfing-Haar asylum and Werner Heyde of Würzburg. Bouhler set out his plan to a dozen such medical professionals in Berlin at the end of July. Hitler had been engaged with the problem of the mentally ill for many years, he told the doctors. Killing them would create space and free up hospital staff for the coming war. The operation had to be kept secret because of the likely reaction of the foreign press, and everyone involved would be protected from prosecution. As Heyde remembered:

[Bouhler] spoke of the fact that because of the necessary secrecy it was not feasible to carry out euthanasia in the individual institutions in which the patient in question lived. [He] also spoke of the fact that the execution had been conceived in such a way that an evaluation system should be set up, similar to the one in the work of Hoche-Binding.

The men from the KdF had chosen their doctors well. When Bouhler finished talking, the attendees immediately began to suggest their own ideas for classes of patients who could be "euthanized," and everyone invited to the Berlin meeting agreed voluntarily to participate in the program except the SS officer Max de Crinis, who had no moral objection but complained he was overcommitted elsewhere.

With their medical experts in place, the KdF turned to the method of killing. What was the quietest and most efficient way to murder large numbers of people? Various outlandish solutions were floated, including the staging of mass coach or train accidents. Eventually, the problem was put to the Kriminaltechnisches Institut (KTI), a support department of the security service, and in particular to the chemical analyst Albert Widmann. The Reich police chief, SS-Gruppenführer Arthur Nebe, in the presence of an official from the KdF, asked Widmann if the institute could manufacture large quantities of poison:

"For what? To kill people?"
"No."
"To kill animals?"
"No."
"Then what for?"
"To kill animals in human form: that means the mentally ill, whom one can no longer describe as human and for whom no recovery is in sight."

Widmann went away to think about it. After conducting experiments at the KTI, probably with animals, he concluded that carbon monoxide was the best poison, since it was both invisible and lethal. It could be pumped into psychiatric wards at night, he suggested, while

the patients slept. Though this delivery method would not in the end be used, the men from the KdF were persuaded that carbon monoxide would be an excellent killing agent and provided Widmann with an order to source fifty steel cylinders, which were to be filled with gas by the Ludwigshafen chemical conglomerate IG Farben. The procurement was to be done in the KTI's name in order not to arouse suspicion.

At the same time, the search was on for an institution that could serve as killing station. Dr. Egon Stähle, the enthusiastic senior officer of the Württemberg health service, provided the solution here, recommending Grafeneck castle, a home for disabled children in a remote part of the Swabian Jura. That autumn, various officials visited the establishment incognito. It seemed perfect. Built in the sixteenth century as a hunting lodge for the dukes of Württemberg, the castle stood on a steep artificial mound at the end of a secluded, wooded valley. It was isolated, and its clear sightlines offered sentries plenty of opportunity to spot unwanted visitors, yet it was only thirty miles from Stuttgart. There was even a train stop nearby, which served the famous stud farm at Marbach an der Lauter. The KdF organized the confiscation of the home from its owners and operators, the Samaritan Foundation, and relocated its residents. Local people were told that the building was to be repurposed as a hospital for infectious diseases.

The final major task was to recruit a unit of hardworking psychopaths to operate the new facility. Naturally, Bouhler and Brandt turned to the SS. The first man tapped to lead the team was Werner Kirchert, an adviser to the senior SS medical officer, Ernst Grawitz, who was also head of the German Red Cross. Grawitz explained the task to Kirchert. The killing had to be completely hidden from the outside world, he said, adding, without apparent irony, that the SS men employed at the castle would have to work undercover, to protect the organization's reputation: They could not wear uniforms and would be suspended for the duration of the activity. It was "not a pleasant task," Grawitz had to admit, but it had to be done, and life would be made very comfortable for the employees. They would have access to the radio, a library, and great quantities of alcohol. The money was extremely good, too—twice what Kirchert normally earned. It was even possible that their families could be housed with them.

After considering it for several days, Kirchert refused the job, as he thought the whole thing was impractical. Instead, he recommended his friend Horst Schumann, a thirty-three-year-old former storm trooper now working as a junior doctor in the Luftwaffe. Schumann accepted.

German troops crossed the border into Poland at 4:45 A.M. on September 1, 1939, triggering the Second World War. Two Führer orders were dated to that day, which officially marked the moment when involuntary "euthanasia" supplanted the time-consuming process of sterilization as the main method of combating degeneracy. The first order, the so-called "sterilization stop," declared that surgical procedures should now be pursued only where there was a particularly high risk of reproduction. (For various reasons, this order was ineffective, and sterilization would continue unofficially until 1945.) The second order, signed by Hitler the following month and backdated to September 1, was written on the Führer's private stationery, complete with the sovereign eagle emblazoned in gold in the upper left-hand corner. It stated:

> Reich Leader Bouhler and Dr. Brandt are charged with the responsibility to extend the powers of specific doctors in such a way that, after the most careful assessment of their condition, those suffering from illnesses deemed to be incurable may be granted a merciful death.

Hitler's regime was about to start something no state in history had attempted before: the industrialized mass murder of its own citizens.

RUMORS THAT A KILLING action was about to begin spread far and wide, despite the KdF's attempts to keep it secret. Hans Bürger-Prinz, the professor of psychiatry at Hamburg, recalled sitting with medical colleagues in the autumn of 1939 when a regional health official told them the city's sick would be picked up for "euthanasia." Such a program would be impossible to implement, Bürger-Prinz thought, telling the official: "Imagine doing that in practice!" Josef Schneider, a church finance officer in Rottenburg, remembered being told in October that "euthanasia was soon to begin." The anticipation was so great, and the

conditions in mental hospitals so dire, that staff had already started to jump the gun, administering overdoses to particularly difficult patients and logging their deaths as "general state of exhaustion" or "acute heart failure." At Emmendingen, an assistant named Dr. Theato entered the asylum at night, took a large quantity of morphine and hyoscine from the medicine chest, and injected three patients with lethal doses. By the time they were found the following morning, it was too late to save them. Theato, who had already received his call-up papers for the military, was nowhere to be found.

At the Eglfing-Haar asylum outside Munich, the institution's director, Hermann Pfannmüller, was entirely open about his killing program. That autumn, he explained his methods to a tour group who were being shown around the Heil- und Pflegeanstalt. Entering a "clean, well-kept" children's ward containing twenty or so children between the ages of one and five, Pfannmüller announced that, as a National Socialist, these "creatures" naturally represented only a burden upon the *Volkskörper*, the body of ethnic Germans. They did not kill such children with poison, injections and the like, he said, since that would only give the foreign press new propaganda material. "No: as you see, our method is much simpler and more natural." Assisted by a nurse who worked in the ward, he pulled one of the children out of bed, displaying the young patient around "like a dead hare," as one of the visitors, a schoolteacher named Ludwig Lehner, remembered. Then Pfannmüller announced with a cynical grin that "this one will last another two or three days." They did not suddenly withdraw food, he said, but reduced rations gradually. He made no secret of the fact that among the children to be murdered were several who were not mentally ill at all but were the children of Jewish parents. The image of the fat, grinning doctor holding the whimpering infant in his fleshy hand stayed with Lehner for years afterward.

Having found their method, staff, and a venue, Brandt and Bouhler moved to establish the substantial bureaucracy required by their program, which would later be known as Aktion T4, after the address of the villa at Tiergartenstraße 4, near the Berlin zoo, which became its headquarters. The Aktion T4 apparatus would include a number of front organizations whose names hinted at a philanthropic or charita-

ble purpose. Thus, the "Reich Working Party for Mental Asylums" was given the task of collating the names of potential victims, dealing with their personal effects, and overseeing the registry offices that would fake their causes of death. This group set an early target to "euthanize" patients in the ratio 1,000 : 10 : 5 : 1, meaning that for every thousand people in Germany, ten were classed as mentally ill, five were in institutions, and one of these would be killed. Given that psychiatric institutions held around 350,000 patients in 1939, Aktion T4 was setting out to murder 70,000 people. Additional front organizations created by the KdF included a "Community Foundation for the Care of Asylums," which would employ the personnel, run the buildings, acquire the gas, and exploit the gold teeth and jewelry stolen from the dead. The Community Patients' Transport Service Ltd., known by its German acronym, Gekrat, would bring patients to the killing centers in buses borrowed from the Reichspost, the national mail service. In April 1941, a "Central Accounting Office for Mental Asylums" would also be established to fraudulently collect maintenance payments for patients who were already dead.

On October 9, 1939, the Ministry of the Interior sent out a circular letter to psychiatric institutions, signed by Leonardo Conti, the Reich's top doctor, which announced that copies of two forms were being forwarded to them for the purpose of gathering economic data. One required details of the asylum itself, including its size, condition, number of beds, and type of construction. The other, more significant questionnaire, titled "Meldebogen 1" (Reporting form 1), demanded details for every patient who fell into the following categories:

1. Suffer from the following diseases and are not employed or are employed only for mechanical work:

Schizophrenia
Epilepsy
Senile dementia
Therapy-resistant paralysis and other lues diseases
Feeblemindedness of any cause

Encephalitis
Huntington's chorea and other incurable neurological states

2. Have been in institutions for at least 5 years
3. Are held as criminally insane persons
4. Do not possess German nationality or do not have German or related blood, stating race and nationality

The real purpose of this registration form was not made clear. At Emmendingen, the medical director, Dr. Mathes, had heard a rumor that the asylum was to be evacuated, since it was so close to the French border, and he spent the first weeks of the war trying to find new places for his fourteen hundred patients. As the forms arrived during this time, it seemed to him that the two things might be related. But it didn't really matter. Whatever their purpose, he had no choice but to make sure the forms were completed. He included one for Franz Karl Bühler, who fulfilled two of the stipulated criteria: He was diagnosed as schizophrenic and had lived in institutions for more than five years.

Mathes returned the forms to the program's Berlin headquarters, where they were photocopied and sent out to one of the medical "experts" for a verdict. The expert marked each patient with either a blue "–" or a red "+", or, in the few cases in which he couldn't decide, a question mark, sometimes with an added comment, such as "Worker?" As with the child euthanasia program, these medical men never met or examined the people they were sentencing, and they were not allowed to review their own patients. They were paid on a sliding scale: Those who appraised up to 500 files a month received 100 reichsmarks (worth around $725 in 2019), while those who assessed more than 3,500 a month were given 400 reichsmarks. The sheer quantity of life-and-death decisions being made by the most prolific reviewers would lead to numerous mistakes in which healthy individuals and good workers were added to the death lists.

The assessor returned the paperwork with his decisions one to two weeks later, and these were forwarded to a "senior reviewer," initially Herbert Linden of the Interior Ministry, for a final verdict in which a question mark was no longer an option. Next, the forms marked "+"

were given to the Gekrat transportation organization, who compiled lists of patients to be moved on particular dates. These lists were then passed to the regional interior ministries, who sent them out to the asylums with instructions that the named inmates should be prepared for transfer in the next few days. Medical staff were not told where they were to be taken, or why.

Bühler's form was marked with a red "+".

18.

CHOKING ANGEL

AROUND NOON ON TUESDAY, MARCH 5, 1940, TWO SLOW-
moving, long-snouted buses of the Reichspost approached Emmen-
dingen in convoy, led by a jeep-like staff car known as a *Personenkraftwagen,*
or PKW. These vehicles would soon be painted camouflage gray, and
the bus windows whitewashed so the public couldn't see inside, but in
these early days of Aktion T4 they still wore the red livery of the na-
tional mail service. The transport leader stepped out of the PKW with
his list, three photocopied sheets of neatly typed paper bearing
the names of fifty-four Emmendingen patients, in no apparent order,
with their dates and places of birth. The first name was that of Erich
Schmutzler, born at Meerane; the last belonged to Philipp Wahl, from
Weissenau. The youngest on the list was Magdalena Schlatterer,
who was just twenty-three. The oldest, at seventy-five, was Franz Karl
Bühler.

Dr. Mathes had been surprised to receive the first transport list
from the Karlsruhe regional office of the Ministry of the Interior. He
was still in the dark about what the "planned economic measures," as
they were called, really meant. All he and his staff had been told was
that the patients were to be taken to a different, unspecified institution.
One theory held that the authorities were preemptively relocating in-
mates who would be difficult to move quickly in the event of an emer-

gency: Since their medical files were to be sent with them, Mathes guessed that some sort of detailed examination was to take place at the new location. The only real certainty, given the Nazis' track record to date, was that the fate of the transportees would not be good, and Mathes had gone through the list, removing names where he could. They were mostly older patients, he observed, and only four were female. He had put a line through three women's names—scrawling *fleißige Arbeiterin* (industrious female worker) next to one—and similarly crossed off nine men. Schlatterer, Schmutzler, Wahl, and Bühler all remained.

The escort staff—SS men in civvies, and Nazi nurses known as "brown sisters"—would reveal nothing about their destination and instead exuded rudeness and contempt, even to the doctors. There were four employees to each bus: a driver and attendant, who both sat in the cab, and two large female nurses, who were "brutal and energetic in tone," as an eyewitness recalled. On a separate occasion, Emmendingen's priest, Pastor Oswald Haug, walked past the Gekrat crew while patients were being gathered, and saw them picnicking on the grass, chatting over sandwiches and cigarettes, unconcerned by the murders they were about to facilitate.

The state government in Karlsruhe had sent instructions along with the list telling Mathes how to prepare the inmates. "Restless" individuals were to be sedated for a journey that could last several hours. Patients were to be handed over with their own linen and clothes, but if they didn't own these, the institution should provide them on loan, and the Gekrat would see they were returned. Each transportee could take up to twenty-two pounds of luggage; any other personal effects should remain in the asylum. The patients must also have their name and transport number marked on their body, either written on their flesh—"like pigs," as one account put it—or on strips of plaster stuck to the back of their neck. The entire operation was to be conducted in the strictest secrecy: In particular, relatives were not to be told about the transfers.

The patients shuffled out, led and pushed by the nurses and by the white-coated men entrusted with their care. Some of the transportees were cheerful, looking forward to a rare drive in the countryside. Haug

remembered a group of teenage girls cheering and exulting as they waited to be loaded: "Pastor," they said, "we are allowed to go in a vehicle today!" Others reacted with suspicion and fear, shouting and resisting as they were forced aboard. One twenty-seven-year-old woman, a skillful embroiderer, knelt on the ground in front of Haug, hugging his knees, and imploring him: "The death vehicle is just outside the door! Help me, I do not want to die. Do whatever you want with me, but get me out!" It is impossible to know Bühler's state of mind as the old man was ushered up the vehicle steps, but Emmendingen had been his home for four decades, and the idea of leaving it for an unknown destination must have alarmed him. There was no escape. Those who resisted were shot up with drugs and carried onto the buses half asleep. Some were tied to their seats with leather restraints that had been fitted for the purpose, and the bus crews carried handcuffs to be used when fighting broke out, as it sometimes did. In one case, patients smashed the windows; another time, a driver was punched in the eye.

When the Gekrat team had finished lunch, the convoy carrying Bühler set off on the half-day drive to the Swabian Jura. The artist could have looked out through the clear glass at the mountains of the Black Forest, lit by the pale winter sun, as the bus followed the winding road, engine roaring, gears whining. The air would have grown colder as they climbed. The drivers liked to pull over for a break along the way, sometimes at the Marbach stud farm: An employee remembered that it was "unpleasant" to see the loaded buses parked there. Once a Gekrat vehicle suffered a punctured tire, and one of the patients offered to repair it, presumably unaware that he was shortening his life.

From Marbach, the passengers could make out Grafeneck castle high in the distance, lowering over the woods and fields and the stream from its promontory at the end of the valley. As they approached, they could see the fence of reinforced barbed wire that guarded the lower fields, and a sign that read: "Entry forbidden due to danger of epidemic." The loaded buses were too heavy to take the short, steep track that led directly up to the castle from the road, and instead the drivers turned in at the southern gate. There was a checkpoint here, staffed around the clock, with a guardhouse and a telephone so the sentries

Nazi propaganda, such as this advertisement for the magazine *Neues Volk,* targeted psychiatric patients. The words read: "It costs 60,000 reichsmarks to look after this genetically sick person over his lifetime. Comrade, that is your money, too."

Wilhelm Werner is the only psychiatric patient known to have documented his own sterilization by the Nazis. His work is now in the Prinzhorn Collection.

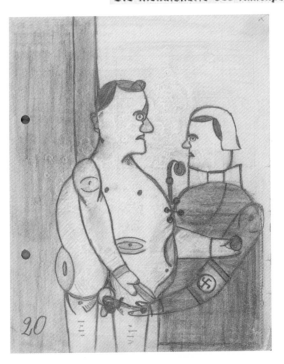

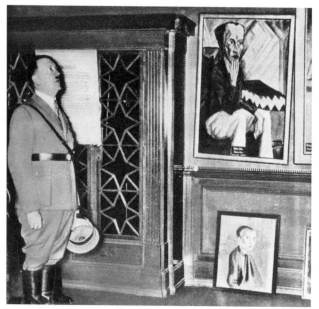

Hitler in Dresden in 1935, visiting one of the precursor exhibitions to the shows of "degenerate art" that would tour the Reich from 1937.

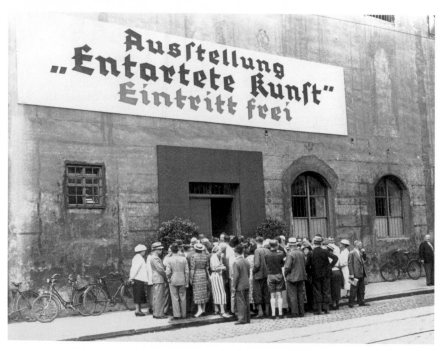

A crowd at the entrance to the Munich *Entartete Kunst* show, 1937. Overcrowding was deliberately engineered to present the artwork in the worst possible light.

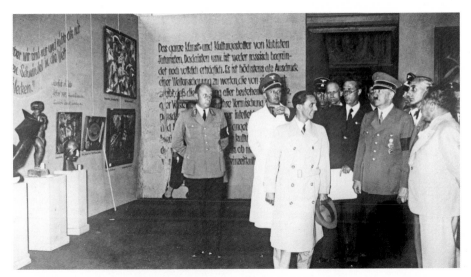

Hitler previewing *Entartete Kunst* in Munich in July 1937,
with Goebbels to his right (holding hat) and Adolf Ziegler and
Heinrich Hoffmann (in pale suit) to his left

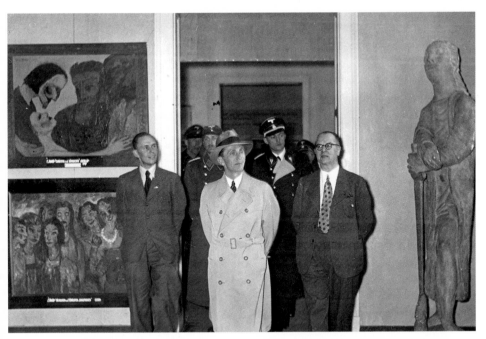

Goebbels inspecting the Berlin *Entartete Kunst* show in February 1938.
To his right is Hartmut Pistauer, the fanatical young curator who selected
Prinzhorn works for the exhibition.

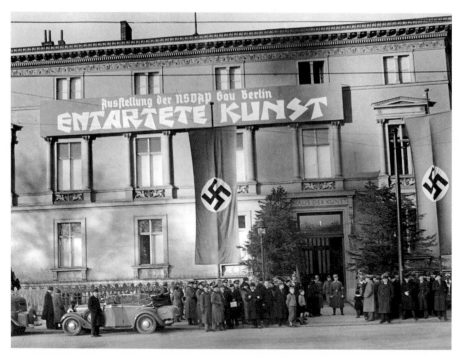

The *Entartete Kunst* exhibition opened in 1938 in Berlin at the Haus der Kunst. More than a hundred Prinzhorn works were sent to the capital for consideration.

© Scherl/Süddeutsche Zeitung Photo/Alamy Stock Photo

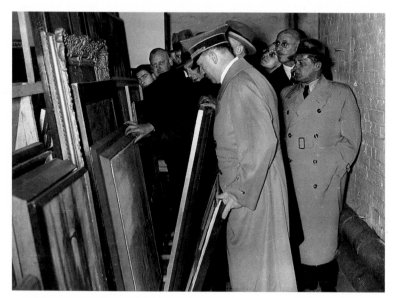

Hitler examines confiscated modern art at the depot in east Berlin, 1938. The German leader personally chose works to add to *Entartete Kunst*.

© bpk/Bayerische Staatsbibliothek/Archiv Heinrich Hoffmann

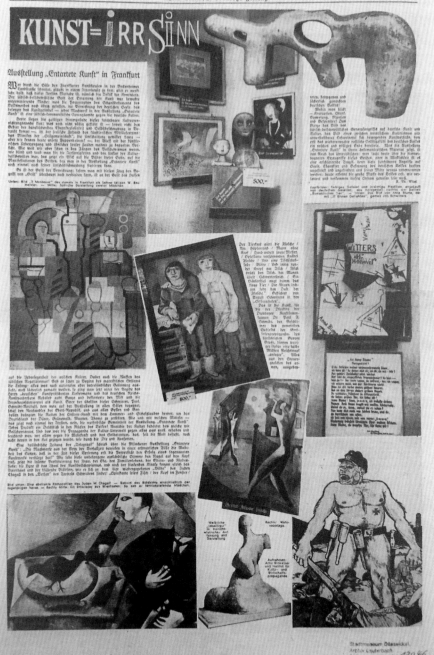

A Frankfurt newspaper report of the opening of *Entartete Kunst* in the city. The headline reads "Art = Madness." The top photograph shows a bust by the Prinzhorn artist Karl Genzel next to a larger sculpture by Eugen Hoffmann.

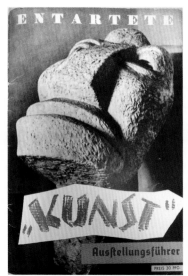
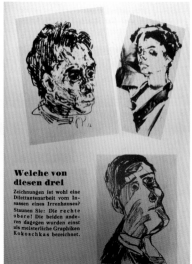

The guidebook contained several Prinzhorn images that were compared to those of professional artists. The caption on the right reads: "Which of these three drawings is the work of an amateur, an inmate of a lunatic asylum? You will be surprised: the one on the right above! The other two used to be regarded as master drawings by Kokoschka."

The "euthanasia" order, signed by Hitler, instructing Philipp Bouhler and Karl Brandt to give incurable patients a "merciful death." It was backdated to September 1, 1939.

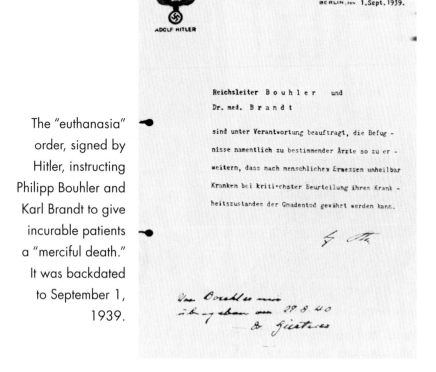

A page of the T4 transport list for Emmendingen, dated March 5, 1940. Bühler is number 15 on the list.

TRANSPORTLISTE

ANSTALT: Heil- und Pflegeanstalt Emmendingen.

Durchgeführt am: 5. III 40

Nr.	Name	Vorname	Transp.Nr.	Krank.Nr.	Geburtstag	Geburtsort
1.	Schmutzler	Erich				
2.	Duffner	Anton				
3.	Ebling	Peter				
4.	Frietsch	Erhard				
5.	Fischer	Karl				
6.	Gengenbach	Gottlieb				
7.	Haas	Michael				
8.	Hochheim	Gottfried				
9.	Huber	Josef				
10.	Walter	Otto				
11.	Kohl	Michael				
12.	Meier	Wilhelm				
13.	Tiefbrunn	Valentin				
14.	Wolfheim	Friedrich Israel				
15.	Bühler,	Franz Karl			28.8.64	Offenburg
16.	Huber	Emil				
17.	Wellasch	Erich	o			
18.						
19.	Noll	Anna Maria				
20.	Hofeler	Leo, Isr.				
21.	Scherle	Hermann	o.			
22.	Wurmser	Max, Isr.				
23.						

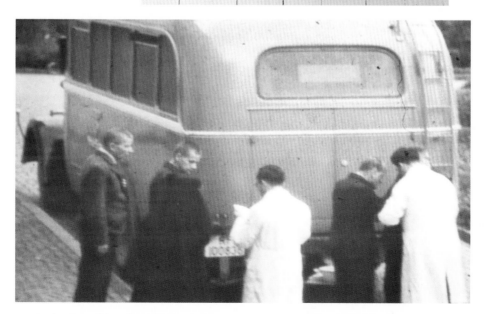

Medical staff load psychiatric patients on to a bus belonging to the Gekrat transportation service. It will take them to be killed.

Grafeneck Castle in the Swabian Jura hosted the first killing center.
More than ten thousand patients died here, including Bühler.

AUTHOR'S PHOTO

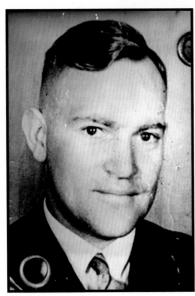

Grafeneck's former coach house
was turned into a prototype gas
chamber. A doctor, working in
the small room at the left-hand
end, released carbon monoxide
into the airtight chamber next
door, killing everyone inside.

COURTESY OF GEDENKSTÄTTE
GRAFENECK

Grafeneck's first gassing doctor,
Horst Schumann

COURTESY OF GEDENKSTÄTTE
GRAFENECK

could call ahead to warn the reception team. Once inside the grounds, where armed SS men patrolled with dogs, the buses bumped across the railway line, then climbed the gently sloping gravel road.

At the top of the hill stood a second checkpoint. Here, with night descending, the vehicles' headlamps would have picked out a flat, straight drive, lined with horse chestnut, ash, and sycamore trees. The buses advanced two hundred yards along this avenue before coming to a halt among a cluster of low-rise buildings. To the right was the bus garage, a roofless barn with two chimneys, a circular stable, and the old coach house. To the left was a barracks, two hundred feet long. In the distance, at the end of the drive, loomed the boxy outline of the castle.

As soon as the buses stopped, Grafeneck's SS nurses began to unload the patients, leading them into the barracks and into a giant dormitory with a hundred made-up beds in which no one ever slept. They were told to undress. They were measured, weighed, and photographed. Those with gold teeth were marked with an "X" on their backs. Then each naked patient was sent to a small room to be looked over by a doctor; at the time of Bühler's arrival, this was either Horst Schumann or his deputy, Günther Hennecke. The examination rarely lasted more than a minute: its only purpose was to establish a plausible cause of death and to rule out, for instance, appendicitis in an individual whose appendix had been removed. A very few patients—war veterans or good workers—were reprieved at this stage and told to dress and await transport to a different institution. Despite the pretense that this was some kind of hospital, anxiety in the dormitory was high. Some prayed, asking that they might come to their God. One man said he wanted to disappear in a puff of smoke, to which Schumann responded that his wish would soon be granted.

The staff now told the patients they were to be bathed. Doctors again jabbed restless individuals with a shot of morphine; even so, some had to be dragged to the next stage by force. The SS orderlies hung an old military coat about each victim's shoulders, then pushed Bühler and his fellow Emmendingers out into the freezing night, toward the old coach house. This single-story agricultural building contained three empty wagon bays, each thirteen feet by twenty, and a small room at the

southern end. Workmen had fitted the southernmost bay with a heavy iron door and made it look like a communal washroom, with shower-heads on the ceiling, wooden benches, and an extractor fan on the back wall. A pipe drilled with holes ran around the room at midriff height, and a small observation window had been fitted on the south side, allowing staff to see in from the small room next door.

The T4 nurses ushered the patients inside, took their greatcoats, and counted them again. Then they closed the door, as the doctor on duty—Schumann or his deputy—observed them through the window. For political purposes, Hitler had ordered that only a doctor could control the gas, to maintain the fiction that the killing was a medical procedure. When he was ready, the doctor turned a handwheel that opened a valve and allowed carbon monoxide to rush from the high-pressure steel bottles, along the pipe, and out through the holes. The carbon monoxide quickly filled the room.

As they heard the hissing noise, the patients thought the shower was about to start, but when no water emerged they began to panic. They screamed and tried to fight their way out. Then the gas began to take effect. They struggled to suck in air, collapsed, vomited, and defecated, staining the walls and floor with excrement. One horrified observer, Maximilian Friedrich Lindner, would tell a Frankfurt courtroom what he saw looking through the spy window of a similar death chamber at Hadamar in Hesse:

> Did I ever watch a gassing? Dear God, unfortunately, yes . . . In the chamber there were patients, naked people, some semi-collapsed, others with their mouths terribly wide open, their chests heaving . . . A few were lying on the ground. The spines of all the naked people protruded. Some sat on the bench with their mouth wide open, their eyes wide open, and breathing with difficulty.

Lindner turned away and hurried out before vomiting up everything in his stomach. He had never seen anything so gruesome, he said, and he could not believe that the victims died without pain. The T4 employees at Grafeneck were not so squeamish. Most would take their

turn to gawk at the dying patients. Schumann was known for his sarcastic running commentary. "They're already dropping," he would say.

After twenty minutes, when the doctor could no longer detect any movement in the chamber, he turned off the gas and switched on the ventilator fan to clear the carbon monoxide. Thirty to forty minutes later, the doors were opened and the "burners"—or "disinfectors," as they preferred to be called—moved in. These SS men were tasked with untangling the limbs of the corpses and loading them into the furnaces. It was a "very difficult and nerve-wracking job," a T4 "burner" named Nohel recalled, but they were given extra rations of schnapps to compensate. The bodies were first dragged to the "dead room" in the stable next door, where those marked with a cross had their gold teeth wrenched out. This wasn't easy, either: Nohel was once castigated for losing a tooth down a victim's throat. The extracted nuggets were taken to an office in the castle, where they were logged—as "bridge with three teeth," "single tooth," and so on—and dropped in a jar of formaldehyde, though this didn't prevent their rotting odor from distracting the secretaries as they typed. The precious metal was later sent off to be melted down into fine gold bars: The KdF could collect 60 pounds of it in a single month, and all T4 staff were entitled to cheap dental work using gold harvested from their victims.

From the "dead room," Bühler's corpse was dragged to the outbuilding with the chimneys, where it was placed in one of two mobile ovens made by J. A. Topf & Sons, who would later supply crematoria for the extermination camps in Poland. The Topf ovens had been designed with a large pan that made it easier to load corpses, and each could fit two or three bodies at a time. It took between sixty and ninety minutes to burn one load: An overweight body burned more quickly than a lean one, the "burners" observed, thanks to its high fat content. The ovens had to work day and night to get through all the corpses, so Grafeneck produced foul smoke almost continuously. At some stage, the roof of the cremation building was removed to allow the soot and fumes to escape, and the surrounding trees grew black with the residue. Even people who lived several miles away complained about the smell and the soot that clung to their houses.

After the burning, the charred remains were shoveled out of the

grate and any surviving pieces of bone were smashed up with a hammer or ground in a mill. The ash was dumped in a heap in another of the outbuildings.

With Bühler murdered and his body disposed of, all that remained for his killers to do was tie up the administrative loose ends. A "Condolence Department" at Grafeneck was responsible for notifying next of kin. In the absence of close family, Bühler's "consolation letter" was sent to his new guardian in Offenburg, Josef Schulz, on April 6, 1940. The sender's address was given as "Grafeneck Regional Nursing Home," and the letter was signed with an illegible scrawl.

> Dear Mr. Schulz!
>
> We hereby inform you that Mr. Karl Bühler, whose guardian you are listed as being in our medical records, had to be transferred to our institution on March 5, 1940, according to ministerial order of the Reich Defense Commissioner, and died here on April 4, 1940, due to myocardial weakness.
>
> On the instructions of the local police authority, the deceased had to be incinerated immediately in consideration of potential epidemic. We ask you to inform us to which cemetery the local police authority should send the urn containing the deceased's mortal remains. If we have not received any notification from you within 14 days, the urn will be buried elsewhere free of charge.
>
> We enclose two death certificates for any presentation to the authorities.
>
> Heil Hitler!

Almost every piece of information in this document was false. "Myocardial weakness" had been picked from a list of false but plausible causes of death drawn up by the doctors. The date of Bühler's demise

was put forward a month, so that Grafeneck could claim his living expenses from the local authority. (This fraud, repeated tens of thousands of times, provided valuable funding for Aktion T4.) Mention of an epidemic and the police aimed to dissuade the bereaved from asking awkward questions, such as why their relative's body had been cremated without their knowledge or consent. The narrow window in which to request the remains was designed to minimize the administrators' workload and postage costs.

Large numbers of relatives demanded urns nevertheless. Each of these was filled with a regulation seven pounds of ash from the heap—it didn't matter whose remains they were—and stamped with the death number that had been written on the victim when they were picked up by the Gekrat. The urns were driven to Stuttgart, Ulm, and other cities nearby to be dispatched, as the volume of shipments would have attracted attention at the local mail office. Even so, people were suspicious, particularly when death notices in local newspapers showed several patients from one area dying at the same time and place. To get around this problem, Berlin ordered the creation of a "Stakeout Department" in the castle, which mapped the birthplaces and hometowns of the victims with colored pins on wall charts, and alerted staff to potential clusters. If a particular village or suburb was due to receive several letters from the Condolence Department, the dates and locations on the death certificates were adjusted accordingly.

The SS men who lived and worked at Grafeneck performed their duties with enthusiasm and few apparent qualms. On the day Bühler was killed, a personal letter from the Grafeneck administrator Hans-Heinz Schütt was winging its way to his young stepbrother, Jürgen, who was about to be confirmed as a Christian. Without revealing Grafeneck's purpose, Schütt took the opportunity to explain his happiness and pride at working for the secret "special commando" unit, and how this work aligned with his religious faith and his belief in the Führer:

You have the great good fortune, dear Jürgen, to grow up in a time that no German has ever experienced before. . . . We are going into a great, new Germany with God's blessing, but with-

out the prayers of the clergy. One does not build a house with prayers, but by courage and, if necessary, by the sword.

There would only be one victor from the fortuitous conflict in which Germany was now engaged, Schütt wrote to his little brother. That victor would determine the future shape of Europe, indeed of the whole world. His name, of course, was "Adolf Hitler!"

19.

YOU WILL RIDE
ON THE GRAY BUS

I
N BÜHLER'S MASTERPIECE *DER WÜRGENGEL,* THE ARTIST POR-
trayed a choking man struggling on the ground, unable to breathe, as a
blank-faced angel of death prepares to finish him with a luminous
sword. It can be read as a portrait of the way he felt treated by the deity
and by life, and as an uncanny premonition of his death, which came as
he fought for breath on the floor of Hitler's prototype killing plant, a
doctor's hand on the gas tap. The government's propaganda stated that
he and his fellow victims were killed for economic reasons, because
Germany could no longer afford to keep them. In truth this brilliant
artist, this "master of the first rank," as Alfred Kubin described him, was
murdered in the service of another sort of art project: Hitler's *Gesamt-
kunstwerk,* his great and terrible design to refashion the Germans in ac-
cordance with his artistic vision, a stew of degeneracy theory, Wagnerian
myth, late-period Romanticism, and his own furious psychopathology.
The artist-dictator had set aside his pencils and paints to work
with humanity, and at the time of Bühler's death, this work was just
beginning.

As winter turned to spring, the KdF ordered Grafeneck to ramp up
its activities. The transport squadron would be given an additional bus,
which meant it could carry seventy-five people at once, and the gas
chamber was enlarged to fit them all. Other victims were shipped in by

train. At 8:00 A.M. on Thursday, March 7, a giant rail transport of 457 patients arrived at the little station at Marbach an der Lauter. Deep snow had fallen in the Swabian Jura, and it took the SS eight hours to unload them all. Egon Stähle, Leonardo Conti, and Karl Brandt came to oversee the operation, taking their turns at the gas chamber window, but there were too many to kill in a single day, so 138 women were temporarily housed in the nearby asylum at Zwiefalten. They were brought back at the start of April, when Stähle returned with a new group of dignitaries from Berlin who wanted to see the women die. Memorable on this occasion was a victim who screamed "We are all killed!" as the carbon monoxide began to take effect. Stähle's guests then observed the ovens, noting with surprise how much smoke was produced. Over the following weeks, a sort of gas tourism grew up in the Swabian Jura. Some visiting physicians were even invited to take part by performing the cursory final examinations.

They murdered 9,839 people at Grafeneck that year, including five Prinzhorn artists. The first of these was Mathäus Lorenz Seitz, an adventurer and French Foreign Legion veteran who had lived for two years with a pasha in Hyderabad. In 1921, Seitz was diagnosed as suffering from "delusions" and sent to Wiesloch asylum, where he spent the next two decades. He was killed at Grafeneck on or around February 29, 1940. Ernst Bernhardt was a former art teacher who drew an eerie self-portrait with a gallows over his head while at the Heidelberg clinic. After living for much of the 1930s in the asylum at Rastatt, he was taken to Grafeneck and killed in April 1940. Konstantin Klees loved to depict his full, well-groomed beard in yellow and green pencil and signed his designs "master baker, confectioner, and grocer." He was murdered on or after July 24. Grafeneck's gas chamber took two more artists in October: Johann Faulhaber, a shoemaker whose drawings bore a striking resemblance to work by Picasso and Kubin, and Josef Heinrich Grebing, the former chocolate salesman who had designed the beautiful "Air Ark" ocean liner for the skies.

. As Grafeneck scythed through the psychiatric population in southwest Germany, Berlin expanded the "euthanasia" program across the Reich, constructing new industrialized murder facilities based on the Swabian prototype in six strategic locations around Germany and Aus-

tria. These new centers were referred to by the letter codes B, Be, C, D, and E. Grafeneck took the letter A.

Killing station B was built in a converted prison in Brandenburg an der Havel, forty miles west of Berlin, and opened within days of Grafeneck, in January 1940. The SS "Death's Head" unit that staffed this plant was overseen by the ambitious young Austrian psychiatrist Irmfried Eberl, who would later command the Treblinka extermination camp. Nine thousand seven hundred and seventy-two patients would be murdered at Brandenburg, according to the official count, and at times there were so many corpses in the ovens that the flames that leapt from the top of the chimney were sixteen feet long. The operation produced a horrific smell of roasting human flesh that tended to settle over the city, but this problem was solved in the summer, when the cremation units were moved to a shed some miles away, where the corpses were delivered by a Reichspost van every day at 5:00 A.M. The body of the Prinzhorn artist Paul Goesch would have been burned here. A painter of bright watercolors with religious themes, Goesch was gassed at Brandenburg in August 1940, although killing-center staff wrote on his death certificate that he died in Austria in September, both to throw his relatives off and to fraudulently claim extra money for his upkeep.

In November, Eberl moved on to Bernburg, near Halle an der Saale, to establish killing center Be. Bernburg was unusual in that it was built in the wing of a functioning regional asylum whose staff had to be sworn to silence about the murders that were taking place on the premises. The hundred or so T4 employees who worked at Bernburg did little to ingratiate themselves with the deaconesses who ran the asylum, partying so late and so hard that the killing center was internally known as the *Nuttenstall,* or "whorehouse." Almost nine thousand patients would be killed at Bernburg, including the Prinzhorn artist Karl Ahrendt, who drew intricate, psychedelic patterns and brightly colored symbols. Ahrendt had once been a coachman and was committed in 1907 after marching around Berlin's Alexanderplatz in a general's uniform. He was in his late eighties when he was murdered, on or after March 18, 1941.

Killing center C was at Hartheim, a medieval castle outside Hitler's hometown of Linz, where operations began in January 1940. Of the six

murder facilities, Hartheim killed by far the largest number, at 18,269. The victims included Alois Dallmayr, who liked to draw androgynous figures with lots of curly hair, and was gassed here in August or September 1940, and Anton Fuchs, a woodcarver who probably died in February 1941.

In April 1940, Grafeneck's expert gas doctor, Horst Schumann, was recalled to Berlin, and his role at the castle was taken over by Ernst Baumhard, a newly graduated medic and enthusiastic party member. Schumann was sent to Pirna-Sonnenstein, near Dresden, where he opened killing center D. Among the 13,720 victims of this former fortress were a half dozen Prinzhorn artists, including four women. Gertrud Fleck and Johanna Melitta Arnold had both lived in the Pirna-Sonnenstein asylum for more than three decades. Fleck was an amiable patient who had a canary and loved to paint large, brightly colored flowers. She was transferred out of Pirna in November 1939 while the T4 men installed their equipment, and brought back a year later to be murdered. Arnold, a creator of rich, energetic pastel drawings, lived at Pirna until 1934; she returned to Pirna to die on July 18, 1941. Auguste Opel and Anna Margarete Kuskop, meanwhile, are represented in the Prinzhorn collection by a single drawing each: Opel by a ghostly, almost imperceptible townscape, Kuskop by a pastel portrait in which the subject's head is tilted slightly, eyes closed, as if absorbed in an inner retreat. This may be a likeness of a friend she met in the asylum system, Miss Alice, to whom Kuskop once wrote: "Above all, I ask you not to forget me." Opel was transported to Pirna on December 6, 1940; Kuskop on May 8, 1941. They were both gassed.

Wilhelm Werner, the artist who drew cartoonish pictures of his own sterilization, also died at Pirna-Sonnenstein. In theory, the procedure should have protected him from "euthanasia" since he was already unable to pass on his allegedly defective genes, but his care givers at Werneck were keen to be rid of him, noting on his T4 registration form that he was a "weak-minded chatterbox" with "a very primitive imagination." He was taken to Pirna on October 6, 1940.

By the end of that year, T4 had killed thirty-five thousand psychiatric patients and disabled children, and the decision was taken to close Grafeneck, which had far outstripped its initial target of killing 20 per-

cent of psychiatric inpatients in southwest Germany. At the start of December, young Dr. Baumhard invited his counterpart from Zwiefalten, Dr. Martha Fauser, to a "camaraderie evening" at Grafeneck to celebrate his unit's departure: The evening included an invitation to watch the gassing of a transport of women. The facility was shut down soon afterward and Baumhard went on vacation with his staff—or most of them, anyway: He had killed his chief nurse by shutting her in the gas chamber by accident.

In the new year, the Grafeneck team moved en masse to Hadamar, a village conveniently placed for the Wiesbaden-Limburg-Cologne motorway, to open station E. The gas chamber at Hadamar would kill ten thousand people in its eight months of operation. One of these was the Prinzhorn artist Peter Zeiher, a convicted murderer who protested his innocence and drew elaborate reconstructions of the crime scene to try to prove it. Another was Gustav Sievers, the artist who had inspired Max Ernst, and who liked to draw humorous, bosomy women riding to and fro on bicycles, or dancing with overpowered men.

IT WAS CLAIMED LATER that the population at large knew almost nothing about the covert action to exterminate German psychiatric patients. In reality, the vast killing enterprise was impossible to hide, and the perpetrators couldn't always be bothered to keep their activities secret. The awful truth is that, while some members of the public expressed grave concern, there was no widespread rejection of the policy for at least a year and a half, and many people supported it, or even benefited from it.

During the period of the killing factory's operation, Grafeneck provided a significant economic boost to its remote corner of the Swabian Jura. Garages in nearby villages were employed to service and repair the vehicles used by the Gekrat transport squadron, and T4 employees kept the castle farm working throughout, which meant regular business for the local butcher, among others, despite the signs warning of an epidemic. There was a close and symbiotic relationship, in fact, between the castle and the local people. Hans-Heinz Schütt ran daily errands to the nearby village of Münsingen, delivering milk and post and procur-

ing food and supplies. Schütt knew Münsingen well: His routine was to place orders he had been given by his SS colleagues with the grocer, the baker, the butcher, the bookstore, the garage, the plumber, the pharmacy, the greengrocer, and the hardware store, then breakfast at a local inn, before returning to pick up the goods. Schütt wasn't the only Grafeneck employee to enjoy close relations with the locals. Others picked up local women, and drank heavily in the inn at Marbach, where they were inclined to boast about their day jobs to the regulars. Sexual licentiousness seems to have gone hand in hand with mass murder: Even Viktor Brack, the KdF department head, was accused of taking part in orgies with his secretaries.

Given these indiscretions, it wasn't difficult to draw a connection between the comings and goings of the buses—filled with patients when they arrived, empty as they left—and the foul-smelling black smoke that emanated from the chimneys. The stench at Hartheim was so nauseating, one villager recalled, that when the workers returned home from the fields every evening they couldn't eat their food. The local people's disquiet eventually reached Christian Wirth, Hartheim's brutal personnel manager, who ordered them to a meeting in a bar, where, after telling them the smell was caused by the distillation of old and waste oils, he threatened to send anyone who spread rumors about human burnings to a concentration camp. Such threats did not stop the gossip. Schoolchildren who saw the buses roaring around Hadamar would whisper, "Here comes the *Mordkiste* [murder box] again," and insult each other with "You're so dumb, you're going to bake in the Hadamar oven!" Popular admonishments in Swabia included, "You too will go up the chimney!" and "You will ride on the gray bus!"

Even so, for twenty long months no branch of civil society—not the medical profession, not the legal system, not even the churches—tried in a concerted way to stop Aktion T4. This was partly a testament to Hitler's grip on the country, and partly thanks to the approval of a swathe of the German establishment: It was, after all, two senior members of the legal and psychiatric professions, in the form of Binding and Hoche, who had made the case for the annihilation of "life unworthy of life" in the first place. By the time National Socialist bullying and propaganda had done its work, many non-Nazis were at least resigned to

the program, if not openly supportive. What little resistance there was came from brave individuals acting alone, and this was easily quashed.

Emmendingen's director, Dr. Mathes, is a case study of a psychiatrist who opposed the policy. He said later that he only learned what was happening in the summer of 1940, a surprisingly late date given that hundreds of his charges had already been killed, and that Egon Stähle had explained the whole plan to a group of Württemberg asylum directors in mid-February. Mathes was horrified by his discovery, and subverted the operation as much as he could by asking relatives to remove vulnerable patients from the asylum, or at least take them out on the day their transfer was scheduled. He also took as many names off the transport lists as he could, although the T4 planners had built an element of doctor-led selection into the process, probably to implicate them in the killing. Mathes's behavior eventually earned him a rebuke from the senior medical officer in Baden, Ludwig Sprauer, who first threatened him—"You may be sent to Grafeneck yourself!"—and then put together a special transport of the patients he had tried to save. This seems to have broken Mathes. He took sick leave in November 1942 and later was granted retirement on the grounds that his behavior had been "unacceptable to the party." Like others who resisted, he was replaced by a willing member of the NSDAP.

Lothar Kreyssig, a conscientious district judge in Brandenburg, offered more effective resistance. When Kreyssig learned in the summer of 1940 that patients under his guardianship were being murdered, he sent an urgent report to the Reich minister of justice, Franz Gürtner, and forbade institutions in his jurisdiction to transport any more of their charges. Kreyssig was shown Hitler's authorization letter, but he argued correctly that such an order had no legal standing in the Reich, no matter who had signed it. (T4 officials knew this: A group of them, including Schneider at Heidelberg, had drawn up a law that would legitimate the action, but Hitler consistently refused to pass it on the grounds that he would then have to defend his policy publicly.) At length, Gürtner told Kreyssig: "If you cannot recognize the Führer's will as a legal basis, then you cannot remain a judge." Kreyssig was put on leave three months later and retired in 1942. Thereafter, the German judiciary ignored the murders.

Opposition from the churches was what Hitler feared most, but considering that half of T4's victims were taken from ecclesiastical or private care homes, their resistance was surpisingly slow and ineffectual. Once again, the significant interventions came from a few brave individuals, notably Emmendingen's pastor, Oswald Haug, who served a stint in Dachau for his criticisms, and the bishop of Münster, Clemens August Graf von Galen. On July 28, 1941, not long after Aktion T4 began operations in Westphalia, Galen lodged a complaint with the police, and when they did nothing, he took the matter to the pulpit of the Lambertikirche in Münster. There, on August 3, he delivered a fire-and-brimstone sermon attacking the murder program:

> If you establish and apply the principle that you can kill "unproductive" human beings, then woe betide us all when we become old and frail! If one is allowed to kill unproductive people, then woe betide the invalids who have used up, sacrificed, and lost their health and strength in the productive process. If one is allowed forcibly to remove one's unproductive fellow human beings, then woe betide loyal soldiers who return to the homeland seriously disabled, as cripples, as invalids.... Woe to mankind, woe to our German nation, if God's holy commandment "Thou shalt not kill!" ... is not only broken, but if this transgression is actually tolerated, and permitted to go unpunished.

Galen's sermon was widely disseminated: The Royal Air Force even dropped copies of it over Germany in a leafleting raid. At last, the open secret was a matter of public debate. The Nazis responded with alarm and repression. Those ordinary people found disseminating Galen's message were fired, sent to concentration camps, or even executed, while some in the regime called for Galen to be hanged. Warned by Goebbels that this could destroy support for the National Socialists in Westphalia, Hitler put off the confrontation, contenting himself with mob-style threats which he delivered to his entourage:

> I am quite sure that a man like the Bishop von Galen knows that after the war I shall extract retribution down to the last farthing.

And that if he does not succeed in the meanwhile in getting him-
self transferred to the Collegium Germanicum in Rome, he may
rest assured that in the balancing of our accounts no "t" will re-
main uncrossed, no "i" left undotted.

Nothing ever happened to the bishop, and three weeks after the ser-
mon, on August 24, Hitler ordered Brandt to halt the program. Galen's
intervention, combined with growing signs of popular dissent, may
have influenced this decision, but it was not the victory against the re-
gime's mass murder program that it appeared, since by this time Aktion
T4 had met the target set by the Reich Working Party for Mental Asy-
lums of killing 70,000 people. In regions where the program had begun
early, such as Baden, the planners had even secretly increased their goal,
and had killed more than half of the psychiatric patients in state institu-
tions. There had been 1,245 inmates at Emmendingen at the end of
1939: Between March 1940 and June 1941, 1,002 patients were picked
up from the asylum in nineteen transports and taken to the killing cen-
ters.

Neither did Hitler's "euthanasia-stop" order end the killing; it sim-
ply signaled a change of tactics. Asylum directors would be asked to
continue the program covertly, within their own walls, by starvation,
overdoses, or neglect, in a period known as "decentralized" or "wild"
euthanasia. Though murder in such cases is harder to establish, this
phase is estimated to have killed a further 130,000 people, including
several Prinzhorn artists. Joseph Schneller, the "schizophrenic master"
whose work had inspired Dalí, died of complications associated with
starvation in July 1943. Eva Bouterwek, a gifted painter of self-portraits,
died in Ueckermünde, a notorious killing institution during "wild eu-
thanasia," in April 1944. Karl Moser, who drew dark, heavy pencil works
punctured with small holes, was killed in Kaufbeuren, in Bavaria, by an
infection typically related to lack of food. He died on May 2, 1945, six
days before the Allies declared victory in Europe.

In the summer of 1941, around the time of his "euthanasia-stop"
order, Hitler turned his sights on the Jews. At the start of Aktion T4,
Jewish patients had been treated like the others, picked out on the basis
of their registration forms. In March or April 1940, Brandt and Bouhler,

in consultation with Hitler, introduced a new policy: From that moment, all those who registered as Jewish would be marked out for killing, irrespective of their diagnosis or their ability to work. This decision foreshadowed another, made in spring or summer of the following year, the so-called *Endlösung der europäischen Judenfrage* (the Final Solution to the European Jewish question). Aktion T4 had convinced Hitler that genocide was now feasible—that, as the historian Henry Friedlander put it, "ordinary men and women were willing to kill large numbers of innocent human beings," and that the bureaucracy would cooperate. The "euthanasia" program had acted as the test bed for Hitler's greater remodeling of the German race, and for the extermination of six million Jews and half a million Roma people.

This time, Hitler refused to sign a written authorization and instead gave the order verbally to the SS-Reichsführer, Heinrich Himmler. Himmler began the killing using paramilitary Einsatzgruppen units. In 1941, the death squads worked behind the Wehrmacht advance as it moved into Soviet territory, shooting en masse all the psychiatric patients and all the Jewish, Roma, and disabled people they could round up. But the SS and Sicherheitspolizei (security police) found this method to be labor-intensive, and they decided it would be more efficient to bring the victims to a central killing location, as Aktion T4 had done—although, given the complaints that arose around crematoria, it was no longer deemed advisable to carry out such operations inside Germany. Instead, the extermination of the Jews would take place in the conquered lands to the east. Brandt, Bouhler, and Brack now offered T4's expertise to the SS, and to Odilo Globocnik, the officer Himmler had tasked with killing the Jews in occupied Poland.

Globocnik's operation, "Aktion Reinhard," ran along similar lines to T4. The ideology of race-hate and degeneracy was the same; so, in the main, were the techniques and even the personnel, as the KdF contracted out its murder teams. At least ninety T4 staff members worked in the camps at Belzec, Sobibor, and Treblinka alone. Like the euthanasia centers, the Polish murder factories were designed to deceive: Where doctors and nurses had given the impression that Grafeneck was a hospital of sorts, Belzec, Sobibor, and Treblinka were introduced

to Jews as labor camps. In both actions, victims were lured into gas chambers disguised as showers. In both actions, their teeth and their bridgework were broken out of their mouths to be melted down. In both actions, their belongings were carefully collected and their corpses burned on-site in Topf ovens.

Of course, the scale of the horror in the east surpassed even that of T4: Aktion Reinhard would kill around two million Jews and an unknown number of Roma, and even Bouhler worried that "the absolute degradation and brutalization of the people involved" would mean his men were no longer capable of working inside the Reich. T4 veterans such as Christian Wirth, who was put in charge of a handful of Aktion Reinhard camps, developed an unrivaled reputation for brutality and ruthlessness. Gottlieb Hering, T4's commandant at Belzec, invented an "entertainment" in which he tied a Jewish man to his car with a rope and drove along while his dog ran behind, biting the prisoner. The T4 psychiatrist Irmfried Eberl was appointed commandant of Treblinka, where his ambition so far exceeded the capacity of the extermination camp's ovens that thousands of dying or dead prisoners lay strewn around the site, and the stench of rotting corpses could be detected six miles away.

Another gruesome connection between the "euthanasia" program and the "Final Solution" was medical research. In the summer of 1941, Horst Schumann, the doctor who oversaw Bühler's killing, was sent to Auschwitz; there he subjected Jewish prisoners to sterilization experiments using X-rays, which killed many of his subjects. In Heidelberg, the T4 assessor Carl Schneider ordered the brains of murdered patients to be sent to his histopathology lab for dissection. Beginning in the summer of 1943, Schneider ran an even more macabre research project into the causes of "idiocy." Fifty-two children were subjected to his investigations, at the end of which they were to be murdered to order in the "Children's Ward for Expert Care" at Eichberg and their body parts sent to Schneider for dissection. Due to the logistical difficulties imposed by the war, only twenty-one of the fifty-two victims were actually murdered, and three brains made it to his lab. In total, the brains of 187 "euthanased" patients were identified in the Heidelberg hospital after the war.

———

HANNAH ARENDT OBSERVED THAT totalitarian regimes explain the "total terror" that is their essence as a way to accelerate the people toward their goals. In the case of the Hitler cult, the industrialized extermination, combined with the rate at which new "Aryan" life was called forth, was intended to speed up the process of genetic selection and the cleansing of the *Volkskörper* into a better, purer race: *der Neue Mensch.* Art, as the qualitative manifestation of racial purity, was essential to that process, since only artists could envision the target image of the sunlit Nazi man—and the horrific consequences of faltering along the path. So, even as Hitler murdered his cultural-racial enemies by the million and called for ever more Germans to sacrifice their lives for a losing war, his regime continued to use Prinzhorn's art collection to point out the racial annihilation that faced the Aryans if they gave up the cause.

At the start of 1941, the Reich Propaganda Directorate (RPL) dusted off *Entartete Kunst,* which had lain in storage in Berlin for a year and a half, and sent it off to radicalize the eastern territories. It was a shrunken version of its former self: Where 700 works had been shown in Chemnitz on the eve of the war, only around 235 were now included, plus an unknown number of Prinzhorn pieces. The first stop on *Entartete Kunst*'s new tour was the Silesian town of Waldenburg (now Wałbrzych, in Poland), where it ran for two weeks from January 18, 1941, at the local branch office of the NSDAP. This new campaign was meant to satisfy party members in small towns who felt they were being left out; it was also meant to establish the idea of a final confrontation with the enemies of Germany, in this case the democracies of Britain and France. The RPL had adjusted its propaganda to present the art as an example of where the "degeneration and rot" of the enemy worldview inevitably led. According to the *Neues Tageblatt*—faithfully, we can assume, parroting Goebbels's line—viewing it would be enough to persuade anyone of the fact that democracy was the mortal enemy of National Socialism. The Prinzhorn works in particular showed how deep the disease had reached before the coming of Hitler:

Those [modern artists] who were active in some or other "ism" had clear brains, but they often drew, painted, and wrote poetry consciously like idiots, so it could happen that the insane actually competed with them. The exhibition shows a number of such [Prinzhorn] works, which . . . were taken completely seriously in the age of degenerate art.

There could be no deals struck with the purveyors of such material, the reporter dutifully noted; instead, there was only "life-and-death confrontation."

Eight thousand visitors came to see *Entartete Kunst* in Waldenburg, a tiny number compared with the crowds it had once drawn, but a significant proportion of the town's population. It likely traveled to other Silesian cities after that before turning west, arriving in Halle an der Saale at the start of April. Again, newspaper reports mentioned the presence of Prinzhorn material. The Halle show closed on April 20, after which *Entartete Kunst* probably continued to tour, but the next documented evidence of its whereabouts comes from mid-November, when the exhibition was sent back to the ministry in Berlin for the last time. Two hundred and thirty-five paintings, sculptures, watercolors, drawings, and graphics were returned, according to the inventory, but there was no mention of the Prinzhorn material, nor any subsequent record of the pieces that were with the exhibition in its later stages, such as Genzel's *Mädchenkopf.* These works are missing to this day, as is Bühler's *Der Würgengel.* They are believed to have been destroyed or stolen.

More than 3 million people visited *Entartete Kunst* during the five years it toured the Third Reich. Some 1.2 million saw it with the Prinzhorn works, and millions more had seen these works in the exhibition guide, which was printed in great quantities, and in the extensive newspaper coverage. Although its purpose was to defame rather than present art, *Entartete Kunst* remains the most-visited art exhibition of all time.

The retirement of *Entartete Kunst* did not mark the end of using "degenerate art" as a tool for legitimating Hitler's policies. In 1942, the

year the war turned against Germany, the idea was deployed once again to reinforce the message that this was a life-and-death struggle of cultural annihilation between the mad Jewish Bolsheviks and the noble Aryan West. As German divisions fought their bitterest battles against the Red Army, Himmler's office in Berlin produced a brochure entitled *Der Untermensch* (The subhuman), which used Schultze-Naumburg's now-familiar technique of juxtaposition to make its point: that Jewish cultural parasites were attacking German values like a "plague bacterium against the healthy human body," as the copy read. Photographs of alarmed "Aryans" contrasted with shifty-looking Jews and easterners; ugly, flinty-eyed Soviet women were compared with their lusty blond counterparts; and apple-cheeked German children were shown alongside bedridden, disabled Russians. If Germany were to be overrun by such degenerates, the result would be untold horror, a quote from Himmler explained:

> The leading heads of a people are bloodily butchered, which leads to economic, cultural, intellectual, spiritual, and physical slavery. The rest of the people, robbed of their own value by endless mixing of blood, is degenerated—and in the historically brief course of centuries at best it is still known that there was once such a people.

The evidence of cultural extermination was displayed on two double-page spreads given over to the *Entartete Kunst* and *Große deutsche Kunstausstellung* shows. Prominent for the degenerates once again was Otto Freundlich's sculpture *Großer Kopf*, which had appeared on the cover of the guidebook Hitler and Goebbels had dreamed up long before in Bayreuth. Other reprints from the guide included *Schwangere* (Pregnant woman) by Christoph Voll, and *Menschenpaar* (Couple) by Kirchner. Again the lie was trotted out that these sculptures represented a genetically inferior "subhuman" for which the artists yearned, while the Nazis would produce racial purity, illustrated by the gym-fit neoclassical nudes of Josef Thorack. By this time, the creators of the "degenerate" works included here had all paid for their affront to Hitler. Kirchner and Voll were already dead: Kirchner by his own hand,

Voll from cancer, an illness exacerbated, according to a friend, by the "psychological disruptions" to which the regime had subjected him. Freundlich, who was Jewish, had been interned by the Vichy regime in France, and released only because of the intervention of Picasso. In 1943 he would be rearrested and sent to the Majdanek extermination camp, where he was killed on the day he arrived.

Der Untermensch brought Nazi ideas about art and race to their most hysterical pitch. It harnessed the idea of degenerate art for National Socialism's Wagnerian finale, what Goebbels would describe in a 1943 speech as *totaler Krieg*, "total war," an apocalyptic conflict that would be more radical and destructive than anything the Germans had ever imagined. There could only be one winner in this last act: He who could exterminate his enemies the quickest.

20.

IN THE MADHOUSE

"GENIUSES CONSUME PEOPLE," GOEBBELS HAD WRITTEN, with some prescience, in his semi-autobiographical novel *Michael*. By the end of 1941, the "genius" of National Socialism was consuming people at an unprecedented rate, and the benefits for the faithful were not as tangible as they had once appeared. Far from being a "winner," Hitler was proving to be a disastrous military leader. The last years of his life were filled with catastrophic tactical errors, heinous crimes, and a growing mania for destruction.

When German troops were repulsed from Moscow in December, Hitler blamed everyone but himself and took personal charge of the armed forces. Increasingly, he withdrew into the troglodyte world of concrete bunkers with comic book names—Wolf's Lair, Werewolf, Wolf's Gorge—that served as his forward headquarters. He rarely visited the front, and made few public appearances. Instead, he directed his divisions from the world of charts and maps in the situation room. The dilettantism that had served him so well in politics now worked against him. He was a micromanaging commander-in-chief who trusted no one. He issued confusing, conflicting orders, and screamed betrayal and cowardice whenever his strategies led to disaster. The strain showed in his appearance: His face grew pastier, his shoulders more hunched,

his left hand shook, and he began to drag his foot. Always a hypochon-
driac, he was given cocktails of drugs by his personal physician, The-
odor Morell, known to the inner circle as "the Needle Chancellor" and
"Minister Injector." He couldn't sleep. Afraid of going to bed, he pushed
the evening meal with his staff later and later, until it began at 2:00 A.M.
and ended at 4:00.

As his failings mounted, Hitler clung ever tighter to his practiced,
artist-in-chief persona. It was what had elevated him, after all, above
the many higher-born, better-educated, and more capable people
around him. What was the wisdom of the Wehrmacht, the logic of the
military academy, of supply lines and troop movements, compared to
his vision for the new German era?

It was an unwritten law at his nocturnal dinners that guests were not
allowed to discuss events at the front or politics of any kind. Instead,
Hitler would lecture his companions—doctors, secretaries, adjutants,
press chiefs, and often a high-ranking visitor such as Goebbels, Himm-
ler, or Speer—on a range of subjects on which he considered himself
expert. Speer, who was made armaments minister in 1942, noted that
the Führer appeared "slightly unbalanced" during these conversations.
There were "painful spells of monologuing" as his captive audience
laughed at familiar jokes and feigned interest in the stories of his trou-
bled youth and the "days of struggle."

The "table talks," as they were known, were recorded, both at dinner
and in his situation conferences, by stenographers drafted from the
Reichstag. Sometimes, when Hitler thought he had made a particularly
brilliant point, he would address the note-takers directly. Speer felt
sorry for these "envoys from the populace," who were condemned to
witness the tragedy from front-row seats. He suspected they had envi-
sioned the Führer as a superior genius, as Goebbels had taught them,
and now they were shown the reality of life in the "madhouse."

As the horror in the east escalated and his troops committed atroc-
ity after atrocity, Hitler's need to define his mission in artistic terms
increased. On October 13, 1941, the day after the "Bloody Sunday" mas-
sacre in the Stanislawów ghetto in Poland, when between ten thousand
and twelve thousand Jewish civilians were stripped, shot, and pushed

into mass graves, he was found reiterating that "a war commander must have imagination and foresight . . . so it's not extraordinary that our people is at once a people of soldiers and artists." A week later, he was protesting that he would prefer to be a "builder" than a war leader, and asserting that "the power we today enjoy cannot be justified . . . except by the establishment and expansion of a mighty culture." On October 25, as Einsatzgruppen commandos in Odessa forced thousands of Jewish civilians into a series of barracks and then set the buildings on fire, he was complaining about the system of art academies. And on the night of January 25–26, 1942, five days after his ministers had agreed on details of the "Final Solution" at the Wannsee conference, he was announcing that "wars pass, only the works of culture never pass away. Hence my love of art."

There was little new in what Hitler said about art: Much of it would have been familiar to his childhood friend Kubizek. The academies had "nothing to tell me that's worth listening to," he explained to his followers that March, since the professors were in large part "failures," or "weary old men." Later that year, he was complaining that the "filthy Jews" had "succeeded in condemning nearly everything that was healthy in art as junk and trash." They had mocked such greats as Makart while advancing the works of true madmen. Those who created this stuff were either swindlers who should be in jail, lunatics who should be in asylums, or degenerates who must be sent to concentration camps "to be 're-educated' and taught the dignity of honest labor."

As Europe burned; as the dive-bombers screamed; as death squads dragged civilians from their homes, shot them, and pushed them into freshly dug pits; as patients were starved to death by their nurses; as psychiatrists picked out disabled children for murder so they could use their body parts for research; as cattle trucks carried terrified populations to their doom; as mothers, fathers, sons, and daughters were ushered naked into gas chambers; as "disinfectors" separated tens of thousands of stiffening corpses, wrenched out their gold teeth, and lugged them toward incinerators at Chelmno, Belzec, Sobibor, Treblinka, Majdanek, and Auschwitz-Birkenau—as these horrors unfolded, their architect sat at the dinner table and bored his guests with his secret, never-rusting love for art, which was the "truly stable pole in the flux of

all other phenomena," his "escape from confusion and distress," a source of "the eternal, magic strength."

At least once, this distraction was a blessing. On June 5, 1944, Goebbels and Hitler were discussing "problems of the theater and opera, film, literature and heaven knows what else," at the Berghof, his Bavarian mountain retreat. When, at ten o'clock, German intelligence began reporting the presence of an invasion fleet off Normandy, no one wanted to interrupt. Hitler and Goebbels moved on to discuss "film, opera, and theater matters," then sat in front of the fireplace until 2:00 A.M., "sharing memories," before going to bed. Hitler did not learn of the D-Day attack until he awoke late the following morning.

By this time, it was clear to Speer that a "departure from reality" was "spreading like a contagion" among the inner circle. It was not the burden of incessant murder that seemed to matter to Hitler so much as his personal failures. His rejection of reality multiplied with every defeat and took an increasingly pathological form. His girlfriend, Eva Braun, and his dog, Blondi, were the only living creatures "who aroused any flicker of human feeling in Hitler," Speer believed. At this time, he lived in a dream world filled, as his biographer Joachim Fest put it, with "more and more transparent fantasies fabricated from self-deception, distortion of reality, and delusion."

As well as Morell's medication—there were up to twenty injections a day, including psychoactive drugs such as heroin, and even commercial poisons—he used culture as a sedative and comfort. Sometimes, when he needed to sleep, he spent hours looking at books about painting or architecture. Toward the end, nothing seemed to distract him so much as his plans for Linz.

Linz! The thriving provincial city where it had all begun: where he had climbed in the hills overlooking the river, conjuring artistic dreams; where he had strolled the Landstraße, sneaking glimpses of his first love. How appealing it now seemed. As he told Speer, in one of numerous bouts of self-pity: "When I have ended the war victoriously, my life's task will be fulfilled, and I'll withdraw to the home of my old age, in Linz, across the Danube. Then my successor can worry about these problems." First, though, the city would be subjected to Hitler's "vision," the makeover he had first planned as a teenager wandering the

streets with Kubizek. He was determined that Linz should surpass Budapest as "the most beautiful city on the Danube," to prove that German artistic sensibility was superior to that of the Hungarians. The centerpiece of his plan was a giant art gallery, the Führermuseum, which he sketched in front of Speer. He would fill this building with the $400 million worth of paintings that had been bought or looted on his behalf. There would be spaces for his favorite high Romantic artists: Böcklin, Trübner, Leibl, Feuerbach, Menzel, Makart, Grützner, Defregger, Schwind, Spitzweg, Alt, and Waldmüller. Even Goebbels balked at the price of this scheme. "Linz costs us a lot of money," he wrote, "but it means so much to the Führer." The redevelopment would be Hitler's legacy, his gift to the German people, and his monument to himself. Within the complex, he drew his own mausoleum.

The plans for Linz increasingly diverted Hitler from the war Germany was now losing. He regularly spoke with his architect, Hermann Giesler, discussing the details of the design as he had once discussed the remodeling of Munich with Paul Ludwig Troost. Speer often found conversations about weapons production diverted toward Linz: "Between military meetings we then drew together, like colleagues, on the details of the plans. And in the hours when he was waiting for front reports, we talked about urban planning and architecture. This often happened in the times of his greatest tension, in the times of bitter disappointments." Martin Bormann, his personal secretary, was continually asked to check whether the art collection was safe in its storage depots in Munich and at Kremsmünster, Austria: whether the camouflage nets were in use, and whether the insurance was sufficient. In June 1943, the streets and squares around Kremsmünster were painted black as an extra deterrent to bombers. Eventually, when American planes came within range, he ordered that the art be moved out; most of it was shipped to a salt mine in Styria.

Like all Hitler's aides, Bormann was well aware that discussion of the Linz project was the best way to distract him. In the wake of the failed plot to assassinate him on July 20, 1944, Bormann told Giesler: "Talk to him about your plans, mainly Linz, that's what interests him most."

ON JANUARY 15, 1945, Hitler and his entourage climbed aboard the special train that would carry him back to the capital for the last time. There was no longer any need for him to be near the eastern or western fronts—by now you could reach all of them in a day from Berlin anyway. The train's blinds were firmly closed: He would not face the people to whom he had brought so much death and misery. Soon after reaching the city, intensifying air raids forced him to move into the maze of concrete rooms he had ordered to be constructed beneath the Reich Chancellery gardens. The Führer bunker was entirely self-sufficient, with its own diesel generators, heat, electricity, and water. Down here, in this world of artificial light and bare concrete, night and day lost their meaning. Iron doors guarded the few exits, and even his brief walks with Blondi brought him no more contact with nature than a tramp around a prison yard.

He took numerous works of art underground with him, including his old sketchbook filled with watercolors of Vienna and paintings that had previously hung in the Reich Chancellery. The entrance hall to his underground apartments was lined with classical landscapes, and a still life, probably by the Dutch artist Jan Davidsz. de Heem, hung in the small study where he took meals with his secretaries. The most powerful painting in the bunker was saved for his sitting room. Here he placed an iconic portrait of the Prussian king Frederick the Great, with large blue eyes and hangdog cheeks, to inspire him in his final act. In the dying days of the war, Hitler would borrow the guise of the lucky, art-loving monarch who had snatched victory from the jaws of defeat. "I think everything is lost," "Old Fritz" had written after the Battle of Kunersdorf. Instead, providence had delivered a miracle: The empress of Russia suddenly died, the tsar sued for peace, and Prussia was saved. Hitler liked to sit beneath the portrait in a sort of trance, frequently looking up to meet the king's gaze, hoping Old Fritz's luck would rub off. "In front of this picture I always get new strength when the bad news threatens to depress me," he told his chief of staff, Heinz Guderian. One night, when Goebbels had been summoned at midnight to

talk for five hours about his cultural plans, Hitler lamented the irony that he, "a man devoted to the arts," should be chosen by destiny to lead this most difficult of all wars for the Reich. "But such was also the case with Frederick the Great."

As a last German offensive failed in the west, the eastern front caved, and bombs reduced Berlin to rubble, Hitler demanded that the mock-up of Linz be brought to the capital. The architect Giesler and his model-maker worked around the clock to complete it. Finally, by the night of February 9, they had set it up in the spacious cellar beneath the Reich Chancellery, ready for Hitler to visit. Giesler remembered the moment they first went to see it there together:

> He stood for a long time, overwhelmed by the overall impression, only looking... Never before had I seen him consider a model so seriously, so enraptured and moved at the same time.

Hitler visited the model twice a day after that, often alone, to check the proportions, the details of the bridges. At times, members of the entourage were taken there, to have the design explained in enormous detail, as if it were "a promised land into which we would find entrance," as Giesler put it. The model represented a last manifestation of his power, a continuation of his ability to express his artistic "vision." His secretary Christa Schroeder observed that when he explained the Linz plans to her, he "forgot the war": "He then felt no more tiredness and explained to us for hours and hours all the details of the change he was planning for his hometown."

HITLER'S RETREAT INTO A world of architectural models was bizarre, but few moments in those last days were more surreal than the final performance of the Berlin Philharmonic. In early April, Goebbels ordered the musicians to be drafted into the People's Militia to defend the capital. Knowing this was pointless and a death sentence, Speer had all the players' cards removed from the Berlin draft board and instructed the orchestra's manager to schedule a series of concerts. He also arranged a coded warning: When he asked them to play Bruckner's

Romantic Symphony, it meant the end was near, and the musicians should flee Berlin.

The final concert was arranged for April 12 at the Philharmonic Hall. Electricity was tightly rationed at that time, but Speer had it switched on for the occasion. "Absurd, I know," he said later. "But I thought Berlin should see that lovely hall, miraculously still intact, just once more fully lit." The Bruckner piece was on the roster, as was Beethoven's Violin Concerto and the finale from the last opera in Wagner's Ring cycle, *Götterdämmerung,* the "twilight of the gods." Speer sat with the commander of the navy, Admiral Dönitz, in the dying moments of the Reich, while a full house watched the great orchestra recount the story in which Valhalla burns, along with Siegfried and his lover, Brünnhilde. As the guests filed out into the ruined streets, Speer saw children dressed in uniforms offering them cyanide capsules. Since Hitler had declared his intention to kill himself if the war was lost, suicide had become ever present, the only viable way out: Joseph and Magda Goebbels would soon kill all six of their children, and then themselves.

Everyone in the bunker now compared their plight to that of Wagner's characters. Would Hitler's death be like that of his mythic hero, Siegfried? A stab in the back, a funeral pyre, and a glorious blaze, heralding a new beginning? Bormann's wife, Gerda, thought so. "The monsters are storming the bridge of the Gods," she wrote to her husband. "The citadel of the Gods crumbles, and all seems lost; and then, suddenly a new citadel rises, more beautiful than ever before. . . . We are not the first to engage in mortal combat with the powers of the underworld, and that we feel impelled . . . to do so should give us a conviction of ultimate victory."

But it was too late for ultimate victory, or for victory of any sort. The fearless First World War corporal was now a wreck, a drug-addled neurotic who could no longer conceal his alarm when bombs shook the bunker. He felt the German people had let him down, that they deserved to be overtaken by the Slavic races. He had already issued a scorched-earth Nero Decree, ordering that the infrastructure of the entire country should be destroyed rather than fall into the hands of the Allies. Everyone was a traitor. He screamed at his generals, fired them,

and promised to execute every commander who disobeyed him. At one point, he even threatened to shoot his physician, Dr. Morell, thinking the doctor was trying to drug him with morphine so he could be shipped off to the Berghof. "Do you take me for a madman?" he railed.

On April 22, a storm that had been brewing for days broke. Told that a counteroffensive he had ordered with largely fictitious troops had not taken place, Hitler seemed to snap. For a full half-hour, he screamed at his remaining staff about the cowardice and faithlessness of the world. The army was corrupt and weak, his generals were liars—even the SS was lying to him. He had been surrounded by failures and traitors for years. He shook his fists. Tears ran down his cheeks. He was a child again, one whose exaggerated expectations had not been met. This was the end, he sobbed. He could no longer go on. The war was lost.

On April 29, at four in the morning, he dictated his last testaments. There were two of these documents. The first was a "private will" in which he left his art collection to the party, or, in case that should no longer exist, to the state, and set out his hope that the Linz project would be completed:

> The paintings in the collections which I have bought over the years have never been acquired for private purposes, but always exclusively for the creation of an art gallery in my native town of Linz. . . . It is my most heartfelt wish that this bequest be executed.

In the second "political" testament, he denied responsibility for the war and reprised the themes of cultural degeneracy and hatred for the Jews that had dominated his career. He had resolved to remain in Berlin and choose his own way to die, he said. He asked his commanders to tell their men he had preferred death to "cowardly withdrawal or even capitulation." Content to the last to waste other people's lives, he exhorted them to continue the fight.

When it came, Hitler's end was not so much Wagner as Hollywood B-movie. He would die with a revolver, some drugs, and a blonde in a bit part. Soon after midnight on April 30, he married Braun. Later that

day, he took lunch with his secretaries as usual, and when the meal was over he said his goodbyes. At 2:30 P.M., he retreated with Braun behind the doors of his study. Soon afterward, a single gunshot was heard against the drone of the diesel generator. It was another ten minutes before his valet dared open the door. He found the newlyweds slumped on the sofa, blood dripping from a bullet hole in Hitler's right temple. The strong, burnt-almond smell of cyanide filled the small room.

21.

LANDSCAPES OF
THE BRAIN

I T WAS 1962, AND MARIA RAVE-SCHWANK HAD BEEN WORKING AT
the Heidelberg clinic for almost a year when she asked her professor,
Walter von Baeyer, about the two large cupboards that stood in an an-
teroom off the institution's main lecture hall. As a trainee psychiatrist,
it was part of Rave-Schwank's job to assist in demonstrations to medi-
cal students, wheeling patients and pieces of apparatus in and out. She
liked the job on the whole, but couldn't stand the hours she had to
spend waiting in this side room. Inevitably, her attention was drawn to
the wooden cupboards, six feet high and as wide as they were tall, which
half filled the small space. What was inside? Why were they always
locked? No one seemed to know.

At length Rave-Schwank asked the professor, who told her the cup-
boards contained an old and famous collection of psychiatric art, and
where she might find the keys. Choosing a moment when the clinic was
quiet, she returned to the room in a state of some anticipation. The
paneled doors swung wide, releasing fine dust and a wash of stale air.
The cupboards were partitioned into compartments and drawers, all of
which were jam-packed with colorful and odd-looking materials. The
shelves at the top were so tight with cardboard folders that when she
tried to pull one out, an avalanche of others came with it. The folders
were marked with names and numbers, and contained strange draw-

ings, paintings, doodles, music, and writing, often in the old German script. One file was filled with cutouts from a pornographic magazine, she remembered: exciting girls with obscene and strong men coming to them. Elsewhere were wooden figurines, and even a small woman's jacket embroidered with illegible phrases. The work seemed immensely fragile, but even in this dilapidated state it drew Rave-Schwank in. It made her think of all the years the authors of this art must have spent alone with their insanity, exiled from the world, killing time. It was a pity everything was so badly stored, she thought, particularly when it was so delicate.

Baeyer agreed. Though he couldn't provide any funds, he would be glad if she could do as much as she could to save it. In the evenings and at weekends, she attacked the chaos, sorting through the artworks, cleaning away the dirt and the dust, and reading what she could about the collection's history. She found a space in the clinic's attic where the collection could be stored and a few of the pieces displayed. In time, she began to think about putting on an exhibition.

NEGLECTED AS THE PRINZHORN material was, the surprise of the postwar years was that it survived at all. Carl Schneider, who had destroyed psychiatric art as mercilessly as he had destroyed patients, had not damaged the famous collection in his care, probably because it might have been required for another propaganda show of "degenerate" material. Apart from a handful of important pieces that had disappeared during the final stages of *Entartete Kunst,* the collection had passed the war safely in storage in the Heidelberg clinic. After Hitler's demise, it would re-exert its influence, thanks in large part to the French artist Jean Dubuffet.

Dubuffet had been awestruck by his first encounter with *Bildnerei der Geisteskranken* as a young painter in the 1920s. "It showed me the way," he said, and made him realize that "all was permitted, all was possible." At the war's end he returned to Prinzhorn's themes with a new movement, Art Brut, or "raw art," which aimed to liberate the visual arts from the grip of the cultural establishment. He embarked on an epic journey of discovering, collecting, and publishing the work of psychiatric patients

and other non-professionals, and in September 1950 he traveled to Heidelberg, the culmination of a years-long voyage of artistic discovery. He spent two days at the clinic, exploring the contents of the purpose-built cupboards and making copious notes. He would use psychotic art—including the work of the Prinzhorn artists Heinrich Anton Müller and Adolf Wölfli—as inspiration for his own paintings of the human interior, which he described as "landscapes of the brain."

Thanks to Dubuffet and André Breton, his collaborator in Art Brut, knowledge of the Prinzhorn artists once again began to spread among the European avant-garde. In 1951, Dubuffet took his collection to New York, where it remained for a decade on the East Hampton estate of Jackson Pollock's close friend, the Abstract Expressionist Alfonso Ossorio. Some of the most illustrious names in American art came to see Art Brut here, including Pollock and Lee Krasner, Elaine and Willem de Kooning, and the critics Clement Greenberg and Harold Rosenberg. Pollock and Dubuffet never met, but they exchanged ideas via the collection and via Ossorio. Dubuffet also traveled to Chicago, where he set out his anti-establishment agenda in a famous lecture to the city's Arts Club. The theories he presented there sowed the seeds of another celebrated American art group, the Chicago Imagists.

In the 1960s, around the same time Rave-Schwank was making her own discovery in Heidelberg, Dubuffet's investigations inspired the tyro curator of the Kunsthalle Bern in Switzerland, Harald Szeemann, to create a show of "insane art." Szeemann was thirty years old in 1963 when he climbed into his Volkswagen Beetle and sped down the Rhine to Heidelberg. He borrowed more than two hundred drawings and twenty sculptures and carried them back to Switzerland, where he put them in a groundbreaking exhibition, *Bildnerei der Geisteskranken—Art Brut—Insania Píngens,* which constituted the Heidelberg collection's first public outing since *Entartete Kunst.* Szeemann's show was an international hit: It sparked another blossoming of interest in psychiatric art and led to new loan requests from the Prinzhorn collection. The revival even encouraged Springer to republish Prinzhorn's book, which would soon also appear in English and French editions.

In the 1970s, as collectors became more conscious of the many types

of creative expression that existed beyond the artistic mainstream, the British critic Roger Cardinal coined a new name for this kind of material: "Outsider Art." A "revolution in awareness" had taken place, Cardinal proclaimed, in which galleries sought to address this immense field of overlooked activity, including work categorized as psychiatric art, folk art, graffiti, and art by prison inmates. From 1989, Outsider Art would have its own international magazine, *Raw Vision,* and from 1993 New York would host an annual Outsider Art Fair. Reporting from the twenty-seventh edition of the fair in 2019, the *Art Newspaper* asserted that commercial interest had made this material a "hot commodity."

Prinzhorn was not the first person to take the art of psychiatric patients seriously, but he was the first to present its enormous diversity to a wide audience, to give patients "a presentation worthy of their talents," as Breton once remarked. The doctor's achievement was one of inclusion. He had taken work by the most marginalized group in German society and held it up for public regard—as high as that of the great artists of the past. The effect was to inspire new journeys of inner exploration, to expand the circle of permitted art-makers beyond the trained elite, and to broaden the definition of art in recognition that there were more kinds of creative expression than anyone had previously imagined.

HAVING BEGUN THE PROCESS of restoring the collection, Rave-Schwank left Heidelberg in 1972 to pursue her medical career, and the university hospital appointed its first professional curator, Inge Jádi. In 1980–1981, Jádi organized a large Prinzhorn touring show, which would travel around West Germany. In preparing for this exhibition she made a controversial decision: Instead of anonymizing the artist-patients—presenting the works with Prinzhorn's pseudonyms and case numbers—she would use their real identities. Jádi decided that the artists' stories should be told.

So began a long-running effort to uncover the real names and biographies of the artists in Prinzhorn's collection. This was often a difficult

task, partly because, in the case of Aktion T4 victims, patients' medical records had been sent with them on the transports and were still missing, partly because of a general reluctance in Germany to investigate the crimes of National Socialist psychiatry. While many of the ringleaders of the "euthanasia" action had either killed themselves (as Schneider, Bouhler, Conti, and Linden had done) or been tried and executed (Brandt and Brack), other, lower-profile perpetrators had served short sentences or were simply allowed to remain in their posts, for fear that the fledgling West German state would collapse under the strain of the new global conflict, the Cold War.

In the 1990s, medical historians made a breakthrough. Toward the end of the Second World War, T4's headquarters had been forced to move, first from Berlin to Hartheim, then to the Pfafferode asylum in Thuringia. At the same time, they had begun to destroy patient records to try to cover their tracks. But there was simply too much, and when the Red Army captured Thuringia in 1945 a mountain of material remained. These files eventually reached the East German state security service, the Stasi, and in the early 1990s, after German reunification, the federal government opened them up to the public. Historians who visited the Stasi archive in Berlin found three whole rooms filled with the medical records of people killed in the psychiatric Holocaust, thirty thousand files in all, each of which told the story of years spent in an institution followed by murder in the "euthanasia" action. Suddenly, there was almost too much information: As the medical historian Maike Rotzoll recalled, "You can't examine all that in one life." To narrow down their research area, they chose to look for names they already knew. One of the categories of victims they selected was the Prinzhorn artists.

The first sweep of the Stasi files, combined with research into the killing centers, revealed the fate of nineteen Prinzhorn artists who had been murdered in the "euthanasia" actions. This number grew over the next decade as more sources were discovered, particularly from the less well documented period of "decentralized euthanasia," when the perpetrators' intent was harder to establish. In 2020, the tally of Prinzhorn's artists thought to have been killed by the National Socialists stands at

thirty, with ten known to have been forcibly sterilized. These numbers may increase.

In 2001, as Jádi passed on the role of curator to the art historian Thomas Röske, the collection finally achieved something Prinzhorn had longed for but never realized: its own dedicated museum in Heidelberg, a few hundred yards from the old psychiatric clinic. Among its first exhibitions was *Todesursache: Euthanasie* (Cause of death: euthanasia), a showcase of the works and biographies of Prinzhorn artists killed by Hitler's regime.

EPILOGUE

I N RESEARCHING THIS BOOK I TRAVELED TO TWO VERY DIFFER-
ent places, on different sides of the Atlantic, to see two very different
kinds of art. Both types of work were created by self-taught artists, both
of whom had been diagnosed as mentally ill. Together, they represented
the opposing sides of the apocalyptic conflict that was fought over art
and heredity in mid-century Germany.

The first journey took me to Fort Belvoir, Virginia, a short drive
across the Potomac from Washington, D.C. After several months of
email exchanges, filling in questionnaires, and sending copies of IDs, I
was invited to this giant military facility to speak with the chief art cu-
rator of the U.S. Army, Sarah Forgey, and see some works from the col-
lection she oversees. Colonel F. Lee Reynolds of the U.S. Army Reserve
met me at the fort's heavily guarded entrance, then led me across the
base, past ranks of disused Humvees, to a utilitarian brick building
where Forgey awaited us. Passing through another layer of security, we
arrived in a giant four-acre climate-controlled storage facility which re-
minded me of IKEA, only here instead of flat-pack furniture the steel
racks held thousands of pieces of war art.

Hitler's watercolors were stored in a gunmetal-gray cabinet, but for
today's purposes they had been laid out across a pair of tables. There
were four in all, each enclosed by the same slim gilt frame in which their

former owner, Heinrich Hoffmann, had enshrined it. Before his capture by American soldiers in May 1945, Hoffmann had tried to hide these works in a castle outside Munich, but they were discovered and handed over to Captain Gordon Gilkey, the Oregonian artist President Roosevelt tasked with tracking down Nazi propaganda art. Gilkey sent the Hitler paintings to America along with around nine thousand other confiscated pieces. Almost all of this material had subsequently been returned, but a few hundred of the most inflammatory items remained in the United States, including these four watercolors.

The earliest of them, dated 1911 or 1912, shows a famous street corner close to the Mariahilf quarter of Vienna where Hitler lived. Next, from 1914, was a careful rendering of the Alter Hof, a Munich landmark, which Hitler had presented to Hoffmann on the photographer's fiftieth birthday. Both these earlier works appeared to be copies of postcards. The latter two paintings date from 1917: One shows a ruined village on the western front, with minutely rendered brickwork and substantial errors of perspective; the other is unusually dynamic, a hastily sketched war scene in which men hurry along a railway cutting under shellfire.

Forgey, an art historian by training, used adjectives such as "adequate" and "proficient" to describe Hitler's ability as an artist. "They don't show a tremendous amount of skill," she said. Without trying to diagnose him, I wondered what else they revealed about their author.

When the dictator's biographer Joachim Fest received one of Hitler's paintings from Albert Speer, he felt he could read certain character traits in it: a dependence on guidelines, reverence for the past, aloofness, pedantry, even his petit bourgeois taste. Forgey went further. The most obvious conclusions could be drawn from Hitler's figures, she said. I could see what she meant. In the Mariahilf street scene, he had proficiently copied out the image of a woman on a bill poster, but the only living person in the painting is a pedestrian in the distance who is so clumsily rendered she might be made of matchsticks. Life, in fact, was a real problem in Hitler's art. The more Forgey looked at the painting of the Alter Hof, she said, the more disturbing she found it: The water in the fountains of the stone courtyard had no hint of sparkle; no ripple of air stirred the leaves on the two trees. I was reminded of Ku-

bizek's description of his friend's painting, of how "the rapid catching of an atmosphere, of a certain mood ... freshness and liveliness ... was completely missing in Adolf's work."

It's difficult of course to divorce Hitler's watercolors from the knowledge of who he was and what he did: Even looking at these works at first feels ghoulish. The awful context never disappears, but it recedes, and then the overriding impression is of emptiness: There is very little here with which a viewer can engage. In this sense, Hitler's painting supports Arendt's theory of National Socialism—that it was defined by its banality and lack of empathy. The Nazis relied on the ability of people *not* to imagine themselves in someone else's shoes. The lack of a connection was very much the point.

ANOTHER CONTINENT, ANOTHER ARTIST. A century after Prinzhorn moved to Heidelberg, I followed his path across the town, from the steep-sloping streets beneath the Renaissance castle, through the medieval squares and cobbled alleys, to Voßstraße, the broad avenue lined with grand hospital buildings that stand back from the empty road. The psychiatry clinic seemed little changed from Prinzhorn's time, but for the addition of a 1998 memorial to the children killed for Schneider's research. A huddle of people—nurses or patients, I couldn't decide which—stood about the entrance, smoking furiously.

The new gallery housing the Prinzhorn collection lay a hundred yards up the road, in an old neurological lecture theater extended with glass and steel. Inside, a dozen visitors wandered around the generous space. I recognized a gang of small, angry Genzels in a glass vitrine, and on the walls some of the miracles Carl Lange found in his shoe insoles. Bühler's works were on display on a mezzanine level upstairs. I hunted out the crayon portrait on which he had written the date March 1919 and the words *Das Selbst* (The self).

Prinzhorn compared a similar Bühler work from this time with a late Van Gogh self-portrait, the only other image he could recall in which an individual seemed to be as inconsolably destroyed, or who looked at the observer with such burning tension. More recently, a curator at the Prinzhorn collection had connected *Das Selbst* with Edvard

Munch's *The Scream,* another powerful account of alienation at the dawn of the new industrial age, by another so-called degenerate. Bühler seemed entirely worthy of these comparisons. He had been in Emmendingen for almost two decades when he created this portrait. At the end of the First World War, he would have been near starving, and his condition meant he could barely speak. Yet *Das Selbst* is so powerful, so open and direct, it feels as though he is here in the room. His cheeks are emaciated, his hair thin, the eyes divergent black pools. But it is the gaping hole of the mouth that drew me in. Standing on the brink of that black, red-rimmed O, I felt the dizzying lure of the schizophrenic interior, and the questions he still provoked.

"What is this world?" the artist seems to say, and "Where do I fit in?"

ACKNOWLEDGMENTS

THIS BOOK COULD NOT HAVE BEEN WRITTEN WITHOUT THE GENEROUS support of the staff at the Sammlung Prinzhorn in Heidelberg, where the significant material relating to this story is kept. I am indebted to the collection's director, Thomas Röske, for his support and his patience, and for allowing me access to the archives; and particularly to Doris Noell-Rumpeltes. Doris, who died in February 2021, spent much of her career researching the Heidelberg artworks and the often obscure lives of the people who created them. Her knowledge of some of these artists, notably Else Blankenhorn, was unrivalled. In her last years, Doris helped me navigate the harder-to-access parts of Prinzhorn's papers, the archive, and the collection itself. It is with the deepest gratitude that I dedicate this book to her.

Others at the Sammlung Prinzhorn—Ingrid von Beyme, Sabine Hohnholtz, Torsten Kappenberg, Christine Piehler, and Ingrid Traschütz—welcomed and helped me in various ways, often through their own prolific writings, as did the former curators and employees Maria Rave-Schwank, Bettina Brand-Claussen, and Inge Jadí, who were restoring and researching the history of the collection long before I happened upon it.

I am lucky to have received advice and assistance from numerous other experts in Germany, including Maike Rotzoll, professor at the

Institute for the History and Ethics of Medicine at the University of Heidelberg; Christoph Zuschlag, professor of modern and contemporary art history at the University of Bonn; Gabriel Richter, chief medical officer at the Reichenau Centre for Psychiatry; Thomas Stöckle, head of the Grafeneck memorial site; and Martin Burst of the Emmendingen Centre for Psychiatry. I would also like to thank Dagmar Taylor for helping me with interviews and translations, and Natasha Abbas for trying to improve my German. In the UK, I sought help from the art historian Alison Price-Moir, of Hull University, and from Frank Rohricht, consultant psychiatrist at the East London NHS Foundation Trust: They have my gratitude. Though all of the above generously shared their specialist knowledge with me, any errors are my own.

There are at least four people without whom this project would never have begun. These are my superb agents, Stuart Krichevsky and Felicity Rubinstein, who always have a far better understanding of what might work than I do; and my fantastic publishers, Arabella Pike at William Collins and Hilary Redmon at Random House, whose faith allowed me to write the book and whose editing skills shaped it. Thanks must also go to the friends who advised and supported me during the writing process, among them Tomas Campbell, Ingrid Kari-Kari, Nick O'Toole, Toby Clements, Pascal Wyse, Sam Wollaston, Ian Katz, and Biddy Arnott; and to my family, Barbara English, Hugh English, and Harry, Arthur, and Eddie English. Most of all, I would like to thank Lucy Blincoe, for generally being fabulous.

NOTES

MY ACCOUNT OF THE LIFE OF FRANZ KARL BÜHLER AND his fellow artists is built on decades of research by staff at the university psychiatric clinic in Heidelberg, work that continues to this day under the current director of the Prinzhorn Collection, Thomas Röske. As well as an impressive exhibition space and an expanding repository of art, the collection is now an archive of primary and secondary sources for all things Prinzhorn, including copies of the medical files of individuals, the collector's own letters and writings (many of which remain unpublished), and other priceless artifacts from the 1920s and 1930s. An expanding list of Prinzhorn Collection publications, as well as Prinzhorn's own glorious *Bildnerei der Geisteskranken,* provide a wealth of information about the art, the people who created it, and their influence on the avant-garde. All of this material fed into the narrative.

There is an equally rich seam of literature dealing with Hitler's ideas about modernism and the cultural politics he pursued. This is often said to begin with Paul Ortwin Rave's *Kunstdiktatur im Dritten Reich* (1949), in which the former Nationalgalerie director recounts many of the events firsthand, and continues in the work of Hildegard Brenner, Henry Grosshans, Eric Michaud, Lynn Nicholas, Frederic Spotts, Jonathan Petropoulos, and Dana Arieli-Horowitz, to name a few. There are a range of primary sources, too, many written by Nazis or published during NSDAP rule, including *Mein Kampf,* the memoirs of Kubizek and of Heinrich Hoffmann, *Hitler's Table Talk,* and Goebbels's *Tagebücher.* To help navigate them, I turned to the biographies by Joachim Fest

(*Hitler*), Konrad Heiden (*The Fuehrer*), Ian Kershaw (published in two parts as *Hitler: Hubris* and *Hitler: Nemesis,* and then in a single abridged volume, *Hitler*), Richard Evans (*The Coming of the Third Reich*), and Brigitte Hamann (*Hitler's Vienna*), among others. I found no better authority on the degenerate art show than Christoph Zuschlag, whose encyclopedic *Entartete Kunst* (1995) provided more valuable source material than anyone barring Prinzhorn himself.

The "euthanasia" actions are overshadowed by the even greater horror of the "Final Solution," yet they deserve an important place in history, not least because they acted as a gangplank for the Holocaust, and were devised by psychiatrists, abetted by medics and care givers, and carried out by doctors on German soil, with insufficient popular resistance. The subject was still taboo in 1983, when Ernst Klee published his groundbreaking exposé, *"Euthanasie" im NS-Staat,* later revised as *"Euthanasie" im Dritten Reich.* Others have picked up Klee's baton, notably, in the case of Heidelberg, Maike Rotzoll and Gerrit Hohendorf, who have explored the connections between Carl Schneider, the murder programs, and the Prinzhorn artists, and helped the clinic to remember its past. Though Klee's work is unavailable in English, there are two substantial Anglophone accounts, by Henry Friedlander (*The Origins of the Nazi Genocide,* 1993), and Michael Burleigh (*Death and Deliverance,* 1994), which I have mined.

LANGUAGE

I have tried to avoid several dangers in writing about mental health. One is to perpetuate stigma through defining people by their diagnoses, seeing conditions as defects and not differences, and assuming that everyone is "suffering." At the same time, it would be wrong to underestimate the difficulty of living with schizophrenia, for example, in the early twentieth century, which meant lifelong incarceration in many cases, and sterilization or murder for hundreds of thousands. I have retained some of the terminology of the period, and in places quoted abusive or offensive language, to reflect the attitudes of the time and give a sense of the hostility the Prinzhorn artists faced.

I have used the German titles of various artworks, exhibitions, festivals, films, and buildings, as they seem to me to convey something more than a straightforward English translation, although this is also provided.

PREFACE

Conti's letter of October 9, the infamous registration forms known as "Meldebogen 1," and the "information sheet" attached to the circular, setting out

the categories of inpatient covered, appear in full in Klee's *"Euthanasie" im Drit-ten Reich*, pp. 90–93. The Grafeneck historian Thomas Stöckle has called this moment "the practical beginning of the collection of victims for euthanasia," in Thomas Stöckle and Eberhard Zacher, *"Euthanasie" im NS-Staat: Grafeneck im Jahr 1940*. The dispatch of the registration forms was done by region: Bran-denburg and Württemberg were the first states to receive them, according to Harald Jenner ("Quellen zur Geschichte der 'Euthanasie'—Verbrechen 1939–1945"), and Baden followed soon after. By the summer of 1940 they had been sent to all of the nearly one thousand institutions involved in Ak-tion T4.

My characterization of the work in the Prinzhorn collection, and its sig-nificance, is based on interviews with and readings of articles by Thomas Röske, Maria Rave-Schwank, Bettina Brand-Claussen, and Inge Jádi, as well as firsthand observation. Jádi has described the impact of the works in the most colorful terms. On first encountering them, she found that something "uncompromising, threatening emanated from many of the works," she wrote in "The Prinzhorn Collection and Its History." When she opened the artists' folders, "it was as if a dam broke . . . remarkable worlds opened up before me, drew me into their power; open spaces that took away my equi-librium, that made me dizzy. Only when I ceased fighting against these sen-sations and let myself flow with the stream did I become calmer."

Various observers have described pieces in the collection as messages from the isolated interior, or variations on that theme, including John MacGregor in his history of art's debt to madness, *The Discovery of the Art of the Insane*.

PART ONE: BILDNEREI

I. THE MAN WHO JUMPED IN THE CANAL

Apart from the substantial quantity of works by Bühler, the key primary source for his early biography are the few dozen scratchily written sheets of his Illenau medical file, which ended with his move to Emmendingen in April 1900. His notes from Emmendingen would have been sent with him to Grafeneck, and may have been destroyed. My re-creation of his early years comes largely from the patient history noted in his Illenau admissions ques-tionnaire. Ruth Kellar-Kempas wrote a brief but invaluable biography in the catalogue of a show of Bühler's works in Offenburg in 1993, *Franz Karl Bühler: Bilder aus der Prinzhorn-Sammlung*, which included an analysis of his work by

Bettina Brand-Claussen. A more recent, short biography by Monika Jagfeld can be found in Brand-Claussen, Röske, and Rotzoll (eds.), *Todesursache: Euthanasie*. After three years of reconstruction, part of the giant gate system Bühler took to Chicago stands once again as an entrance to the city park in Karlsruhe.

I am grateful to Frank Rohrich, consultant at the University of London Foundation Hospital, for helping me to try to understand schizophrenia. Heidelberg's own Emil Kraepelin is usually credited with naming the condition (as *dementia praecox*, or "premature imbecility") around 1896, though it was Eugen Bleuler who adjusted the description, with the help of Carl Jung, and gave it its modern name a decade later. The description of it as "a country, opposed to Reality, where reigned an implacable light" is from the *Autobiography of a Schizophrenic Girl*, by "Renée," aka Louisa Düss, cited in Louis A. Sass, *Madness and Modernism*.

The idea that Euphrosyne died early comes from *Bildnerei*, although Prinzhorn gives the date of her death as 1886, by which time Bühler was around twenty-two years old. The magnificent caricatures of the kaiser can be found in the balustrades at the Palais du Rhin, formerly the Kaiserpalast, where they have been photographed by the *Badische Zeitung* (https://www .badische-zeitung.de/der-kunstschmied-und-des-kaisers-bart--34451904 .html).

Wikipedia has an exhaustive list of "firsts" claimed to have been made at the 1893 World's Columbian Exhibition in Chicago; others include fluorescent lamps, penny-squashing machines, and an electric vehicle. The explosive growth rate of the city is documented in the Chicago Historical Society's *Electronic Encyclopedia of Chicago* (http://www.encyclopedia.chicagohistory.org /pages/962.html), which states that "Chicago soared from empty prairie and mud flats to world metropolis in a breathtakingly short sequence." The encyclopedia also contains photographs and souvenir maps of the fairground. There are numerous firsthand accounts of the Chicago World's Fair, including the one from the Bulgarian satirist and writer Aleko Konstantinov, who felt sorry for the moon, how "poor and pale" she seemed in comparison to the garlands of electric lightbulbs on display, in *To Chicago and Back*. The seamier side of Chicago was documented by Karen Abbott in *Sin in the Second City*.

The contemporary writer who said the world had changed less since the time of Jesus Christ was Charles Péguy, cited in Robert Hughes's *The Shock of the New*. Hughes also states that aerial perspective led to abstract art, although he placed this discovery in Paris in 1890, when visitors first climbed the Eiffel Tower.

The descriptions of Friedrichsberg's "elephant houses" and violent nurses come from Kai Sammet, "Habitus, Kapital und Spielräume." More details on the German psychiatric system at this time can be found in Eric J. Engstrom, *Clinical Psychiatry in Imperial Germany: A History of Psychiatric Practice,* and Monika Ankele, *Alltag und Aneignung in Psychiatrien um 1900.*

2. THE HYPNOSIS IN THE WOOD

There is no full-length biography of Prinzhorn at the time of writing, although Röske and Noell-Rumpeltes of the Sammlung Prinzhorn (Prinzhorn collection) hope to publish one soon. Primary sources for the doctor's life include his correspondence with friends and associates, much of which is now in the Heidelberg collection, and Prinzhorn's fragment of unpublished childhood memoir, "Lebensgeschichte," in which he gave a no-holds-barred criticism of his parents and his upbringing. The late Heidelberg professor of medicine Wolfgang Geinitz wrote two authoritative biographical essays, "Hans Prinzhorn. Das unstete Leben eines ewig Suchenden" (1987) and "Zur Biografie Hans Prinzhorns" (1992). I also borrowed from Röske's *Der Arzt als Künstler.* Useful overviews of Prinzhorn's life and career can be found in Marielène Weber's introduction to the French translation of *Bildnerei,* "L'homme, la collection, le livre," and in Silke Röckelein's *Hans Prinzhorn (1886–1933); Dokumentation mit Bild- und Textzeugnissen zum Leben und Werk.* He also left many books and articles, which are available at Heidelberg, including those for the magazine *Der Ring.*

Heidelberg survived the war almost unscathed, but anyone visiting Neue Schloßstraße 9 will find a modern house at the address where Prinzhorn once lived, surrounded by neo-Baroque mansions he would have recognized. Mark Twain's account of living in Heidelberg in 1878, including descriptions of its hotels and dueling fraternities, was published as *A Tramp Abroad* (https://www.gutenberg.org/files/119/119-h/119-h.htm). The English painter J. M. W. Turner also made several visits (https://sublimesites.co/2015/11/20/in-turners -footsteps-at-heidelberg-part-3/) to Heidelberg between 1833 and 1844 and produced dozens of sketches and watercolors, many of which are in the Tate Britain in London.

The poor physical state of the psychiatric clinic at the end of the war is revealed by a fundraising letter Karl Wilmanns wrote to German Americans in August 1919, which is in the archive of the Sammlung Prinzhorn in Heidelberg. The hospital, wrote Wilmanns, was "the birthplace of the modern study of mental diseases." The *Encyclopedia of Psychology* credits Kraepelin as

being the founder of modern scientific psychiatry, psychopharmacology, and psychiatric genetics. He was made professor of psychiatry at Heidelberg in 1890 and stayed thirteen years before moving to Munich. Jaspers is held in similarly high regard, for example by Louis A. Sass, though by 1919 he was in the process of moving from psychiatry toward philosophy. He published his own contribution to the debate about art and insanity, *Strindberg und van Gogh,* in the same year as Prinzhorn. The relationship between Jaspers and Prinzhorn has been set out by Röske in " 'Suchende Kierkegaard-Natur' und 'Enfant terrible': Karl Jaspers und Hans Prinzhorn."

Descriptions of the clinic's interior, including Prinzhorn's attic, are largely from my own visit, although certain aspects of the building have been remodeled.

David Lindsay Watson was evidently bowled over by Prinzhorn's charisma. He was a young psychologist at Antioch College when Prinzhorn arrived to deliver a guest lecture, "Nietzsche and the Twentieth Century," in 1929. The German spoke so powerfully that at least one student said he had "never heard anyone talk in that way" and was reduced to tears, Watson remembered. Watson's eulogy, "In the Teeth of All Formalism: A Tribute to Hans Prinzhorn," was published in *The Psychoanalytic Review* in October 1936, three years after Prinzhorn's death.

Prinzhorn's memories of his upbringing and parents are in his "Lebensgeschichte." Other details are from Geinitz and Weber. His Ph.D. thesis, on the architect and theoretician Gottfried Semper, considered "the psychological origin of the artistic activity" and thereby paved the way for his interest in the art of psychiatric patients.

Thomas Mann's satirical description of Munich as a place where "art with its rose-entwined sceptre holds smiling sway" is from "Gladius Dei," in *Death in Venice and Other Stories.* Another famous account of the Schwabing was given by the "Scandal Countess," Fanny zu Reventlow, in her novel *Herrn Dames Aufzeichnungen.* The Lovis Corinth quote is from Max Spindler's *Handbuch der bayerischen Geschichte,* cited in Kershaw.

Though Prinzhorn was deeply interested in the arts during his time in Munich and wrote some reviews of exhibitions, he does not appear to have been aware of Wassily Kandinsky or the forerunner Expressionist groups, who were not yet famous. He was probably more interested in music at this time, particularly Wagner.

The observation that Schwegerle represented Prinzhorn as "half Apollo, half Orpheus" is from Weber.

Rumors evidently swirled around the suicide of Prinzhorn's and Hoff-

man's singing teacher, whose death appears to have hit them very hard: According to Geinitz, "Hans Prinzhorn. Das unstete Leben eines ewig Suchenden," Prinzhorn spent several weeks afterward in a sanatorium. The fallout also had the effect of connecting Prinzhorn with the expensive and progressive Bellevue institution, run by Ludwig Binswanger. Binswanger may have shown him paintings by Else Blankenhorn even before he began his work at Heidelberg, according to Rotzoll and Röske in "Karl Wilmanns (1873–1945) und die Geburt der Sammlung Prinzhorn aus dem Krieg." The same source states that Prinzhorn met Wilmanns in a field hospital after graduating as a doctor in August 1917.

Prinzhorn wrote his somewhat glorified account of the Second Battle of the Marne to his sister, Käthe, on July 21, 1918, while recuperating from his injury. He began the letter: "I lie in a beautiful high-ceilinged room with a major handsome view out onto the Neroberg through the open window, between the firs even a bit of blue mountain to indicate the distance. Wonderful bed, best care and food, good condition except for a slight discomfort on the one leg—simply a wonderful existence. The wound is doing well."

The idea that Prinzhorn continued to mull over Wilmanns's offer after turning him down is supported by him writing, in the Magdeburger Zeitung in 1927, that the collection "had ignited, as it were, what I had carried in me half-finished in old studies on artistic creation or on the psychology of the creative process." This is cited in Röske, "Außerhalb der Kontinuität geschichtlicher Prozesse."

Brecht's description of spring 1919 as the fifth spring of the war is from his "Ballad of the Dead Soldier," cited by Carl Zuckmayer in Als wär's ein Stück von mir (1966), which is also the source of Zuckmayer's memories of the "crazy hunger" of those months. The impact of the food blockade is related by N. P. Howard in "The Social and Political Consequences of the Allied Food Blockade of Germany, 1918–19." The plight of German asylum inmates at this time, and data on the numbers who died from hunger, disease, and neglect, are from Burleigh, Death and Deliverance, as is the quote from Karl Bonhoeffer.

Karl Binding never got to see his eugenic collaboration with Alfred Hoche, Die Freigabe der Vernichtung lebensunwerten Lebens, since he died in April 1920, shortly before it was published. Translations are from Burleigh.

Prinzhorn wrote of his "deepest nihilism" at the end of the war in 1927 in "Die erdentrückbare Seele." He describes his entry into the clinic in 1918–1919 in a footnote in Bildnerei: "When the author, returning from military service, entered the clinic in the winter of 1918/1919, Prof. Wilmanns had

already chosen a few drawings by patients in the clinic and offered them for study. They included several notebooks and sheets which had already been separated from the medical histories for some time and which were kept in the teaching collection where they were arranged by diagnosis and accompanied by handwriting samples." He went on to add that Wilmanns was "most understanding," relieving the younger man of clinical work and granting him almost unlimited leave for study and extensive research trips.

Copies of different versions of the circular letters sent out by Prinzhorn and Wilmanns are in the Heidelberg archive. Prinzhorn wrote of the quick response to his shout-out in *Bildnerei*, describing it as "immediate and surprisingly good." Many details of Prinzhorn's collecting activity, including the correspondence with Dr. Hermkes at Eickelborn, can be found in Bettina Brand-Claussen's essay "The Collection of Works of Art in the Psychiatric Clinic, Heidelberg—from the Beginnings Until 1945," in *Beyond Reason: Art and Psychosis—Works from the Prinzhorn Collection* (1996). The Genzel quote, "otherwise there is going to be a fight," is from Prinzhorn's profile of the artist in *Bildnerei*.

Prinzhorn reported the statistical makeup of his collection as follows: "The majority of the pictures (about 75 percent) originate with patients who are schizophrenics. The remaining 25 percent are divided as follows: by manic-depressive patients, 7 to 8 percent; by psychopathologic patients, 5 to 6 percent; by paralytics, 4 percent; by imbeciles, 4 to 5 percent; and by epileptics, 3 to 4 percent. We cannot arrive at very precise figures because many diagnoses are lacking and others are very uncertain. Women drew 16 percent of the pictures."

Agnes Richter's *Jäckchen* (Jacket) has fascinated several modern artists and critics. Sources include Röske's "Agnes Richter's Jacket" and Monika Ankele's "Doing Culture / Doing Gender / Doing Identity." Brand-Claussen has written about Katharina Detzel in "Viel Lärm, wenig Bilder." References for other artists mentioned: Jakob Mohr in Beyme and Röske (eds.), *Dubuffets Liste*; Gustav Sievers and Joseph Schneller in Brand-Claussen, Röske, and Rotzoll (eds.), *Todesursache: Euthanasie*; Blankenhorn in Noell-Rumpeltes, "Else Blankenhorn—vom Projekt der Versöhnung des Unversöhnlichen"; Carl Lange in Röske, "Das Christusbild in der Schuheinlegesohle"; Josef Forster in Röske, Noell-Rumpeltes, and Brand-Claussen, *Durch die Luft gehen*.

Prinzhorn's overview of the literature on psychiatric art was published in the journal *Zeitschrift für die gesamte Neurologie und Psychiatrie* 53 (1919). It is summarized in Weber, "Prinzhorn." Paul Meunier's book *L'art chez les fous* was

published under the pseudonym Marcel Réja. Cesare Lombroso's book *Genio e follia* was first published in 1864. It appeared in English as *The Man of Genius* in 1889 (https://archive.org/stream/manofgenius00lombuoft#page/2/mode/2up).

Prinzhorn set out his idea for a substantial volume on the subject in the circular letter of January 1, 1920, writing: "Now that we have received some valuable contribution from all the institutions we have requested, our collection has become so abundant that we will soon be able to present an overall picture of the whole area in our museum and we have a large publication in preparation."

The idea that he "needed to gather as much information as possible from the artists themselves" is in Brand-Claussen, "Der Revolutionär für ewige Dinge und die Irrenkunst," who states that "the practice of questioning selected patients . . . was part and parcel of the initial collecting policy." Not all his subjects seemed to appreciate his interview technique. After interviewing August Klett at the Weinsberg asylum, Prinzhorn left behind a sheaf of papers. Klett found these documents, and added his own caricature of their meeting to them. The inquisitor is shown leaning back at a forty-five-degree angle, his scalp carpeted with two enormous tufts of hair, his large nose probing the sky. In the background, a perplexed figure, surely the artist, peeps out from behind a table. The patient captioned his sketch "Typisch Herren Doktoren!" (typical doctors).

3. A MEETING AT EMMENDINGEN

Prinzhorn recounted his meeting with Bühler in his profile of the artist "Pohl" in *Bildnerei*. Parts of my description of Emmendingen come from my visit in April 2018, when I was shown around the psychiatric facility by Martin Burst; other details come from former directors and employees. Karl Haardt, a director of the institution from 1894, cited in Monika Ankele's *Alltag und Aneignung in Psychiatrien um 1900*, describes how "in the south, from the plain, you can see the tower of the magnificent cathedral of Freiburg when the weather is fine. In the west a mountain range rises from the plain, the Kaiserstuhl. Behind it flows the Rhine." Mathes and Waßmer, *Die badische Heil- und Pflegeanstalt Emmendingen* (1930), gives many details of life at the asylum, including the storks on the roofs and a "choir of frogs" outside the director's house.

Bühler does not seem to have been violent. Prinzhorn remarked that

"Very seldom does his medical history note that he is irritable or momentarily violent against fellow patients who tease him."

4. DANGEROUS TO LOOK AT!

Prinzhorn's talent for networking and self-promotion are clear from his correspondence: He was in contact with many of the leading intellectual lights of the German-speaking world at that time, although not all remember him in their memoirs, or are half as complimentary as Watson. (See Binswanger's remarks to Freud in *Sigmund Freud—Ludwig Binswanger: Briefwechsel 1908–1938.*) Geinitz, "Zur Biografie Hans Prinzhorns," notes that a host of famous contacts were gleaned from Eva's father, "one of the star advocates of Berlin," who knew numerous cultural and political figures in the Reich capital, including Gerhart Hauptmann, the publisher Samuel Fischer, and the great industrialist and later foreign minister of the Weimar republic, Walther Rathenau. Prinzhorn struck up a lifelong friendship with Hauptmann at this time.

Weber, "Prinzhorn," notes that Prinzhorn wrote to Klages on September 7, 1920, to introduce himself and request an audience, and that this meeting "turned Prinzhorn into a Klages zealot." She adds that many of those who knew Klages, including Thomas Mann, found this incomprehensible. The strength of Prinzhorn's infatuation can be judged from the following lines, with which he dedicated one of his works to his mentor: "Midway along the path, fearful, I met you / You taught me to try every route / To first look inside myself / You will find yourself in the deepest part of my soul." My summary of Klages's philosophy is culled from several sources, including James L. Foy's introduction to *Artistry of the Mentally Ill*.

The close relationship between Fraenger and Prinzhorn is explored by Röske in "Außerhalb der Kontinuität geschichtlicher Prozesse," while Zuckmayer relates several of the Gemeinschaft's evenings, including Prinzhorn's singing the French fable *Aucassin et Nicolette*, in *Als wär's ein Stück von mir*. Prinzhorn wrote of *Dornbusch* and the attractive female lead (a "young juicy blond Jew") to his friend Käthe Knobloch on July 23, 1920. According to Karl-Ludwig Hofmann in Beyme and Röske (eds.), *Ungesehen und unerhört*, Prinzhorn was on the management board of the Gemeinschaft as early as February 1919; Fraenger borrowed works to present in his apartment, and invited Prinzhorn to give a lecture on January 4, 1921. In "Erforscher des 'Echten' Leben und Werk Hans Prinzhorns," Röske states that artists from

the Rih (https://de.wikipedia.org/wiki/Gruppe_Rih) group based in Karls-
ruhe may have heard about it, including Gustav Wolf (1887–1947).

My summary of modernism's interest in madness, which was heightened
by the war, is drawn from Raymond Williams's "When Was Modernism?"
(1987), Robert Hughes's *The Shock of the New*, and Louis Sass's *Madness and Mod-
ernism*, as well as MacGregor's *The Discovery of the Art of the Insane*.

The Die Brücke artist who suggested the group change its name to Van
Goghiana was Nolde, cited in MacGregor. Klee's excitement at seeing Van
Gogh in Germany for the first time can be found in Klee, Winston, and
Winston, *Paul Klee: His Life and Work in Documents*. His review of Der Blaue
Reiter three years later is in Paul Klee and Felix Klee, *The Diaries of Paul Klee
1898–1918*. Käthe Kollwitz's heartbreak can be read in *The Diary and Letters of
Kaethe Kollwitz*. Max Ernst's announcement of his own death and resurrection
is in Spies and Rewald, *Max Ernst: A Retrospective*. Hans Arp's reminiscence of
searching for an art to save mankind from furious madness is in Hughes, *The
Shock of the New*. The idea that this was a "schizophrenic age" was in general
circulation: James L. Foy writes in his introduction to *Artistry of the Mentally Ill*
that "Prinzhorn was saying that a schizophrenic age required a schizophrenic
art, indeed it demanded such an art to mirror its own loss of reality."

The different types of response to his collection are documented by
Prinzhorn in *Bildnerei*. Hölzel's "shaken to pieces" remark and "truly artistic
path" comments were reported to Prinzhorn by an acquaintance; he in-
cluded them in a letter to Käthe Knobloch on June 22, according to Ulrich
Röthke in "Bis zur Haltlosigkeit erschüttert," in Beyme and Röske (eds.),
Ungesehen und unerhört. Röthke is also the source of Hölzel's connection with
Klett and Frau von Zinowiew. Schlemmer's letter to Tutein can be found
in *The Letters and Diaries of Oskar Schlemmer*. Details of Baron Hyazinth von
Wieser's life and work and his influence on Schlemmer are documented
by Röske in "'Ganz losgelöst von allem Außen'—Oskar Schlemmer und
Hyazinth Freiherr von Wieser," in Beyme and Röske (eds.), *Ungesehen und
unerhört*.

Alfred Kubin visited the collection with his friend the neurologist Rob-
ert Laudenheimer on September 24, 1920, and wrote about it in the May
1922 issue of *Das Kunstblatt*. Brand-Claussen collates further details of this
encounter in "'. . . Lassen sich neben den besten Expressionisten sehen'";
she includes details of a meeting between Kubin and Prinzhorn, and the
exchange of pictures from his own collection with those in Heidelberg,
probably in autumn 1920. Brand-Claussen's "Drohender Zusammenstoß:

Alfred Kubins Freundschaftsbund mit der Kunst der Irren," in Beyme and Röske (eds.), *Ungesehen und unerhört,* describes Kubin as the "star witness" for the collection's artistic value, and gives the real names of the artists Kubin anonymized in *Das Kunstblatt.*

By 1920 there was a general move to pathologize modern art in Germany, as the art historian Wilhelm Valentiner wrote to Lübeck's museum director, Carl Georg Heise: "All sorts of doctors are now spreading out into the criticism of modern art" (cited in Brand-Claussen, "Häßlich, falsch, krank"). Weygandt's desire to call the police on Freud is told in Ernest Jones, *Life and Work of Sigmund Freud.* His "neuropathological collection," gathered at Friedrichsberg between 1905 and 1934, included skulls of Herero people, who had been colonized by Germany, which Weygandt purchased from private dealers between 1917 and 1925, according to a 2017 statement from the University Clinic Hamburg-Eppendorf (https://taz.de/Fund-in -Hamburger-Uni-Klinik/!5399183/). The University Clinic has recently tried to repatriate them. Weygandt's attempts to source Genzel sculptures from Eickelborn in 1922 are reported in Brand-Claussen, "Geschichte einer 'verruckten' Sammlung," which also cites Prinzhorn's letter of October 25, 1921, in which he writes that Weygandt "was already angry about our collection in May." "Kunst und Wahnsinn," Weygandt's comparison of the work of artists with schizophrenia and the "excrescences of modernism," was published on June 4, 1921, in *Die Woche.*

Immanuel Kant was one Enlightenment figure to develop the term "degeneration," in his 1777 essay "Von der verschiedenen Rassen der Menschen" (On the different races of people). Arthur de Gobineau's tract on Aryanism and race, *Essai sur l'inégalité des races humaines,* appeared in four volumes between 1853 and 1855. His biographer Michael Biddiss, in "Prophecy and Pragmatism: Gobineau's Confrontation with Tocqueville," *Historical Journal* 13, no. 4 (1970), called him the "father of racist ideology," and described the work as "a racial philosophy ... that surpasses even *Mein Kampf* in scope and sinister grandeur." Joachim Fest states that "Hitler simplified Gobineau's elaborate doctrine until it became demagogically usable and offered a set of plausible explanations for all the discontents, anxieties, and crises of the contemporary scene." Wagner's friendship with Gobineau is documented by Konrad Heiden in *The Fuehrer.* "Das Judenthum in der Musik" was originally published in 1850 in *Neue Zeitschrift für Musik.* Wagner extended it substantially and republished it in 1869. Alex Ross has noted (https://www.newyorker.com/culture/culture -desk/the-case-for-wagner-in-israel) that Wagner's slogan "The Jew is the

plastic demon of the decline of mankind" was used in the Nazi propaganda film *Der ewige Jude* (The eternal Jew).

Nordau's book *Entartung* was first published in German in 1892–1893, with an English edition in 1895. Shaw's response, "The Sanity of Art: An Exposure of the Current Nonsense About Artists Being Degenerate" was published in London in 1908. Wilde's response, that "all sane people are idiots" is cited in Richard Ellmann, *Oscar Wilde* (London, 1988).

I could not find the July 1921 letter stating that it can have a "clarifying effect in the chaos of current art" in the Heidelberg archive, but it is cited in Weber, "Prinzhorn."

5. THE SCHIZOPHRENIC MASTERS

Prinzhorn's growing disaffection with the Heidelberg clinic is apparent in his correspondence, notably with his friend Käthe Knobloch, which is in the Prinzhorn archive in Heidelberg. See, for instance, the letter to Knobloch of March 10, 1921, in which he describes himself as an "outsider" at the clinic, and an "unstable psychopath with hysterical traits." He told Knobloch the "book seemed dubious" on May 9, 1921, and that he was "a bundle of feelings of insufficiency" on June 17. At the end of June 1921, he met Jaspers for advice on "agonizing personal development issues," according to a letter of July 2, 1921, cited in Röske, "Suchende Kierkegaard-Natur." Jaspers warned him against reacting hastily "out of anger at the hospital's unpleasant atmosphere," and considerably strengthened his "courage to become independent at that time" (letter to Jaspers on May 23, 1927, also in Röske). His idea that the Heidelbergers disapproved of Klages is in Weber, "Prinzhorn," among other sources.

The boat trip with the Schroeders was related in a letter to Knobloch on July 16, 1921. The reflection that his own neurosis probably drew him to psychology in the first place is Mary Wigman's, cited in Geinitz, "Hans Prinzhorn," while Prinzhorn's remark that Erna "turns majestically away from me" was made in a letter to Knobloch on July 26, 1922.

The locations in which Prinzhorn could be found in his 1921–1922 travels are from Brand-Claussen, "Der Revolutionär für ewige Dinge und die Irrenkunst." The exchange of letters between Binswanger and Freud about him can be found in *Sigmund Freud—Ludwig Binswanger: Briefwechsel 1908–1938* (Frankfurt, 1992).

Prinzhorn seems to have been psychoanalyzed by Jung (Weber,

"Prinzhorn"), although Röske argues that this was likely short, so it did not constitute a full psychoanalysis as we know it today.

Prinzhorn's visit to the Bauhaus is recounted in Röske, "'Sie wissen nicht, was sie tun.'"

The date of May 4, 1922, for Prinzhorn to hold a copy in his hands for the first time is from Brand-Claussen, "Drohender Zusammenstoß: Alfred Kubins Freundschaftsbund mit der Kunst der Irren," in Beyme and Röske (eds.), *Ungesehen und unerhört*. The book's full title was *Bildnerei der Geisteskranken: Ein Beitrag zur Psychologie und Psychopathologie der Gestaltung* (Artistry of the mentally ill: A contribution to the psychology and psychopathology of configuration). It weighed 12 pounds 10 ounces. Ingeborg Baier Fraenger noted that Prinzhorn forgot to attribute the term *Bildnerei* to the Heidelberg scholar (Röske, "Außerhalb").

6. ADVENTURES IN NO-MAN'S-LAND

Prinzhorn's pleasure at the success of his book despite the general depression that had engulfed him is recounted in a letter to Knobloch on August 21, 1922 (in the Sammlung Prinzhorn archive). The book was reviewed in *Kunstwart und Kulturwart* 36, no. 1 (1922–1923). Emil Ludwig's appreciation is cited in Geinitz, "Hans Prinzhorn"; Oskar Pfister's is in *Imago* 9 (1923). Jaspers's remark was in the third edition of his *Allgemeine Psychopathologie* (General psychopathology), 1923, cited in Röske, "Suchende Kierkegaard-Natur."

Clara Malraux's recollections of Berlin cultural life in 1922 are in *Memoirs*, although she called him "Pringhorn." Sophie Taeuber's letter to Jean Arp is in Stefanie Poley, "'... und nicht mehr lassen mich diese Dinge los.'" *Bildnerei* was later found in Arp's library.

Lothar Schreyer's recollections of Paul Klee and his "wizard's kitchen" were published in *Erinnerungen an Sturm und Bauhaus* (Munich, 1956), cited in Klee, Winston, and Winston, *Paul Klee: His Life and Work in Documents*. James Smith Pierce's analysis of Klee's debt to the Prinzhorn collection was published in *Arts* in 1977; a more modern take is Gregor Wedekind's "Paul Klee und die *Bildnerei der Geisteskranken*," in Beyme and Röske (eds.), *Ungesehen und unerhört*. James Smith Pierce went on to identify even greater similarities between Klee and Karl Genzel in "Paul Klee and Karl Brendel."

For André Breton's biography and search for mad inspiration, see Peter Bürger, "The Lure of Madness." Breton's claim that "Les champs magnétiques" showed "the unrevealed and yet revealable portion of our being" is cited in Polizzotti, *Revolution of the Mind*.

Biographical sources for Ernst include Werner Spies's *Max Ernst Collagen*, Patrick Waldberg's *Max Ernst*, and Ernst's own "Notes pour une biographie." A visit by Ernst to the collection at Heidelberg was "highly likely," according to MacGregor in *The Discovery of the Art of the Insane*.

For relations between the Éluards and Ernst, see McNab, *Ghost Ships*. Éluard gave his opinion that *Bildnerei* was "le plus beau livre d'images qui soit, c'est certainement . . . cela vaut mieux que n'importe quel tableau," in a letter of March 5, 1928, in Éluard and Scheler, *Lettres à Joë Bousquet*. André Masson's quote is from a letter to *Le Monde* titled "Une précision d'André Masson sur l'art brut," published on October 6, 1971. Breton wrote that Prinzhorn had given the artists a "presentation worthy of their talents" in 1948 in "Freedom to Roam Abroad," in Breton, Taylor, and Polizzotti, *Surrealism and Painting*. On the difficulties of "automatic painting," see Max Morise, "Les yeux enchantés," in *La révolution surréaliste*, December 1, 1924. The notion that Masson's *dessin automatique* was inspired by an unnamed Prinzhorn patient is in Gisela Steinlechner's "Underhand: André Masson's Automatic Drawings," in Beyme and Röske (eds.), *Surrealismus und Wahnsinn*.

August Natterer's biographical details are from *Bildnerei*. Breton's list of notable Prinzhorn artists also included Hermann Behle, Joseph Schneller, and Adolf Wölfli. The idea that Surrealism used Natterer's "collapse in meaning" to mirror that caused by the war is from Röske, "August Natterer," in *Raw Vision* 51 (2005). For a comprehensive analysis of Ernst's borrowing from Natterer, see Röske, "Max Ernst's Encounter with Artistry of the Mentally Ill," in Beyme and Röske (eds.), *Surrealismus und Wahnsinn*.

Antonin Artaud's 1925 "Letter to the Medical Directors of Lunatic Asylums" is in *Antonin Artaud: Collected Works—Volume One*. Salvador Dalí's statement "The only difference between myself and a madman . . . is that I am not mad" is in George A. Cevasco, "Dalí's Christianized Surrealism." Dalí would finally meet Freud in London in July 1938, when the Spaniard was thirty-four and the Austrian eighty-one. Freud was initially unimpressed, but afterward wrote (to Stefan Zweig, cited in *Letters of Sigmund Freud 1873–1939*, London, 1970), "I was inclined to look upon the surrealists—who have apparently chosen me as their patron saint—as absolute (let us say 95 percent, like alcohol), cranks. That young Spaniard, however, with his candid and fanatical eyes, and his undeniable technical mastery, has made me reconsider my opinion."

For Lange and Schneller's influence on Dalí, see Peter Gorsen, "Salvador Dalí's Imagined World of Madness." Dalí wrote his paranoid interpretation of Millet's painting in the 1930s, but it was not published until 1963, as *Le mythe tragique de l'Angélus de Millet*.

Stefanie Poley, in "'... und nicht mehr lassen mich diese Dinge los,'" suggested that Picasso's 1926 *Tête de Femme* was inspired by Heinrich Anton Müller, although Röske questioned this in an interview with the author.

According to MacGregor, in *The Discovery of the Art of the Insane,* Dubuffet was given a copy of *Bildnerei* shortly after its publication by his friend the Swiss writer Paul Budry. MacGregor is also the source of Dubuffet's remarks about *Bildnerei*'s impact on art: "Prinzhorn's book struck me very strongly when I was young. It showed me the way and was a liberating influence. I realized that all was permitted, all was possible. I wasn't the only one. Interest in art of the insane and the rejection of established culture was very much 'in the air' in the 1920s. The book had an enormous influence on modern art."

Richard Lindner's tribute to Prinzhorn is in Beyme, "'The Most Important Artistic Experience of My Life.'" Hans Bellmer is quoted by Wolfgang Rothe in "Zur Vorgeschichte Prinzhorns." Koga Harue is in Croissant, "Koga Harues 'Endloser Flug.'" Hugo Ball, "the turning point of two epochs," is in Ball and Burkhard, *Der Künstler und die Zeitkrankheit.*

PART TWO: ENTARTUNG

7. PLEASANT LITTLE PICTURES

Details of Hitler's life in Landsberg are partly from Kershaw, *Hitler,* who asserts that he typed the drafts of the first volume himself. King, *The Trial of Adolf Hitler,* notes that he typed with two fingers on a new Remington machine given to him by Helen Bechstein, sitting at a small varnished table provided by the warden. Hitler told Hans Frank that this was his "university paid for by the state," cited in Kershaw. The prison psychologist Alois Maria Ott's reflections were given in an interview with *Der Spiegel* in "Von guter Selbstzucht und Beherrschung" on April 17, 1989, and are cited in Roger Moorhouse, *His Struggle.* The Nazi leader's shift from believing he was a herald or "drummer" to thinking he was the messiah is recorded in Kershaw, *Hubris.*

I used the 1943 Ralph Manheim translation of *Mein Kampf.* The phrase "usual morning glass of wine" is from Kershaw, *Hitler,* who has details of the complex domestic arrangements of Alois Schicklgruber, aka Hitler's father. For Hitler's self-conception as an "artist-genius," see Birgit Schwarz, *Geniewahn.* Palmer et al., *A History of the Modern World,* gives details of the idea of genius in Romantic philosophy: "The idea of original or creative genius was

in fact another of the most fundamental romantic beliefs. A genius was a
dynamic spirit that no rules could hem in, one that no analysis or classifica-
tion could ever fully explain. Genius, it was thought, made its own rules and
law. The genius might be that of the individual person, such as the artist,
writer, or Napoleonic mover of the world. It might be the genius or spirit of
an age, or it might be the genius of a people or nation, the Volksgeist of
Herder, an inherent national character making each people grow in its own
distinctive way, which could be known only by a study of its history; romanti-
cism thus merged in many places with new forms of nationalism." *Idee und
Gestalt* is from Michaud, *The Cult of Art in Nazi Germany,* who says it appeared
again and again in Nazi literature. Michaud writes: "What National Social-
ism sought to highlight in both of its models, art and Christianity, was a
process that was able to lead from idea to form. It was this process, placed
under the direction of a Führer who presented himself as both the German
Christ and the artist of Germany, that was designated by the expression 'cre-
ative work.'" According to Arieli-Horowitz, *Romanticism of Steel: Art and Politics
in Nazi Germany* (an English version, *Painting Totality,* is available online at
https://www.ourboox.com/books/painting-totality-nazi-leaders-and-politics
-of-culture/), the greatest influence on Hitler's worldview was not a painter,
but the composer Wagner. Hitler proposed himself as Wagner's twentieth-
century counterpart.

 In *Hitler and the Artists,* Henry Grosshans has traced Hitler's personality
traits to his idea of an artistic temperament. An English version of Thomas
Mann's essay "Bruder Hitler" was published as "That Man Is My Brother" in
Esquire in March 1939. Speer's analysis that he was "always and with his whole
heart an artist" is in Spotts, *Hitler and the Power of Aesthetics.* I have also used
Spotts's summary of Joachim Fest, asking repeatedly whether politics ever
meant anything more to him than rhetoric, histrionic processions, parades
and party rallies, or the spectacle aspects of war. The idea that art can be
passed down through the *Volkskörper* over generations is in Day, "Paul
Schultze-Naumburg: An Intellectual Biography." Hitler's unchanging views
have been noticed by many biographers, who sometimes call him a "fossil."
Speer's line that he remained arrested in the time of his youth is from *Inside
the Third Reich.*

 The account of Hitler's upbringing is based on *Mein Kampf,* informed by
several more reliable sources, including Kershaw, *Hitler;* Fest, *Hitler;* Hamann,
Hitler's Vienna; and Kubizek, *The Young Hitler I Knew.* Although Kubizek's recol-
lections were originally commissioned by the Nazi party, his memoir is a
more credible source than was once thought. Kubizek notes how odd it was

that the fifty-year-old Führer would carry out ideas dreamed up by the fifteen-year-old: "Indeed, the plans which that unknown boy had drawn up for the rebuilding of his home town of Linz are identical to the last detail with the town planning scheme which was inaugurated after 1938."

Kokoschka's view of the academy is in Hamann, as is the detail of the examination. "At odds with myself" is in *Mein Kampf*. Dr. Bloch's views of Hitler were published in two parts in *Collier's Weekly* in March 1931 (http:// www.ihr.org/jhr/v14/v14n3p27_bloch.html). Given the circumstances, he was remarkably generous about the boy who would become Nazi leader, and clearly astonished by the affection the boy showed for his mother, which he described as his "most striking feature." It was Bloch who remembered Hitler sketching his mother on her deathbed to preserve a last impression. The "only person on earth he had really loved" is the view of Kubizek. The neighbor who offered to help him get a job at the post office was called Presemayer (Hamann).

The Schönbrunn Palace museum and Vienna University have collaborated to produce a vibrant virtual exhibition of Habsburg Vienna at https:// ww1.habsburger.net/en. It includes a section on "The Metropolis as Melting Pot," which describes the makeup of the city at the time Hitler lived there. The description of it as a "Babylon of Peoples" is in Kershaw.

Hitler met Kubizek off the train on February 22, 1908. According to Hamann, their room was just a hundred square feet, and the first thing that struck Kubizek were Hitler's sketches, which lay around "on the table, on the bed, everywhere."

Hamann describes Vienna's "filthy, overcrowded homeless shelters," including the one at Meidling, in detail: Many people would spend the freezing nights on the pavement in front of these buildings to at least have a chance to get into the shelter the following night. She also describes the relationship with Hanisch.

Hitler took the train to Munich on May 24, 1913, "carrying a light, black suitcase containing all his possessions" (Kershaw), in the company of a friend from the Men's Home, Rudolf Häusler. Kershaw states that, despite the fact that Munich was a vibrant hub of modern art at this time, "in Munich as in Vienna, the avant-garde passed him by." That he was more at home with the classical art on display in the Pinakothek and the Schack is reported by Birgit Schwarz in *Geniewahn*.

Hitler's early war experience was undoubtedly terrible. He was assigned to the newly formed List Regiment, and after four days of combat, this fight-

ing force was reduced from 3,600 to 611 men. He said later that this forced him to realize "that life is a constant horrible struggle" (Kershaw, *Hitler*).

For more on the proximity of Hitler and Churchill at the start of 1916, see Jones, "Churchill and Hitler." The two leaders would never be in such close proximity again.

For the effect of the gas attack on Hitler in October 1918 and his days as an invalid at Pasewalk, see Kershaw, *Hitler,* and Fritz Redlich, *Hitler.* Redlich, a senior psychiatrist at Yale, describes the second attack of blindness as a "psychogenic (more specifically, hysterical) reaction." Karl Wilmanns's remarks about the incident are recorded by Ruth Wilmanns Lidz in "Ein erfülltes Leben." Wilmanns Lidz writes: "The records of this must have been destroyed later, although at that time not only my father was well aware of this. The Nazis later said that he had been blinded by gas. From a medical point of view, however, this does not seem possible, since he could not have regained his sight overnight."

The Goebbels quote, "He comes from architecture and painting," is cited in Schwarz.

8. DINNER WITH THE BRUCKMANNS

Hitler's transformation in Landsberg is remarked upon by many biographers. Fest, *Hitler,* puts it like this: He became "a man of strict law and order [who] veiled his revolutionary intentions with untiring protestations of how well he was determined to behave and how dearly he cherished tradition." The makeup of Elsa Bruckmann's salon is documented in Wolfgang Martynkewicz's *Salon Deutschland: Geist und Macht 1900–1945,* in which he describes Hitler's presence at these gatherings as a "type of demon." Houston Stewart Chamberlain's life and notorious works are outlined in Zuschlag, *Entartete Kunst,* who notes that Kaiser Wilhelm II had been as much a fan of the racist Englishman as Hitler later became. Elsa Bruckmann's observations about Hitler in Landsberg (that he was "plain and chivalrous and bright-eyed") are in Volker Ullrich, *Hitler: Ascent 1889–1939.* "Monkey in a zoo" and "house boy" can be found in Martha Schad, *Sie liebten den Führer.*

As well as Schultze-Naumburg's own writings, my main sources for the architect's relationship with Hitler are Lara Day, "Paul Schultze-Naumburg: An Intellectual Biography" and Norbert Borrmann, *Paul Schultze-Naumburg 1869–1949.* Day, it is worth noting, believes it is wrong to think of Schultze-Naumburg and his ilk as simple reactionaries against modernism. The Nazis

proposed a radical new social model by which the deficits in "modernism" could be overcome, and this was, some argue, in no way reactionary, but modern itself.

Schultze-Naumburg's polemic about the flat roof is in Kai K. Gutschow, "The Anti-Mediterranean in the Literature of Modern Architecture." Schultze-Naumburg recorded his astonishment at his first dinner with Hitler in "Lebenserinnerungen, Deutschlands Schicksal und Adolf Hitler," cited in Borrmann.

Sources for the various meanings and uses of art for Hitler are as follows. Art as an escape: In Landsberg he had drawn up plans for his wildest architectural flights of fancy, the massive Great Hall and Arch of the Triumph, which one day he hoped to build in Berlin. Art as sophistication: this veneer was not very deep, as on a visit to the Nationalgalerie, Putzi Hanfstaengl recalled him holding forth on the subject of Michelangelo's genius while standing next to a Carvaggio, having misunderstood the painting's caption. Art as a bridge to the people: in Zuschlag, "Chamber of Horrors of Art," among others (the party's founding manifesto of February 1920 included a demand to take "legal action against those tendencies in art and literature that have a disruptive influence upon the life of our Volk"). Art as a "higher political purpose": from Peter Paret, An Artist Against the Third Reich, who states that "Hitler's emphasis on the 'cultural state' in his enumeration of the main political forces in world history again points to his association of art and politics. No doubt, the bonding of culture and the state was a rhetorical device. It gave his message of power politics an impressive idealistic sheen." Art as a way of measuring cultural health and achievement: In 1936, at the Kulturtagung of the NSDAP in Nuremberg, according to Day, he announced that "the only truly immortal talent within [the field of] human endeavour and achievement is art."

On Hitler's buy-in to the concept of degeneracy: Arieli-Horowitz, Romanticism of Steel, intriguingly states that the Nazis fine-tuned the theory, identifying three types of degeneration: individual, collective, and racial. That Prinzhorn's book "could well have served as a catalyst" for Hitler's views on madness and art is stated by Sander Gilman in "The Mad Man as Artist."

Hanfstaengl's verdict that Mein Kampf was "really frightful stuff" is in Hanfstaengl's memoir Unheard Witness (1957), later released as Hitler: The Missing Years. Mussolini's view that it was "a boring tome" is in Antony Beevor, The Second World War (2012). Strasser's view that it was a "veritable chaos of banalities" is in Kershaw, Hubris. Paret argues that these stylistic shortcomings

didn't matter much. He notes: "Germans could welcome or at least tolerate these fantasies on the course of world history. Once taken as fact or as metaphoric summaries of basic historical phenomena, Hitler's shopworn but for that reason familiar racial delusions coalesced into a consequential sequence, stretching from past to present and future."

The Goebbels quote "Is this really Christ . . ." is from Goebbels's *Tagebücher*, cited in Kershaw, *Hitler*.

9. GLIMPSES OF A TRANSCENDENTAL WORLD

The "Golden Twenties" are described by Heiden, who lived through them, in Heiden, *The Fuehrer*. According to Geinitz, "Hans Prinzhorn," Prinzhorn's time in Dresden with Wigman was a high point in his life. Geinitz also describes his time at the sanatorium in Wiesbaden surrounded by "hysterical jellyfish."

Prinzhorn's study of the art of prison inmates, *Bildnerei der Gefangenen: Studie zur bildnerischen Gestaltung Ungeübter*, was published in Berlin in 1926. The friend at Emmendingen to whom he wrote to inquire about Bühler on December 12, 1926, was the parapsychologist Gerda Walther. This letter is in the Sammlung Prinzhorn archive.

Details of the numerous upgrades to the Emmendingen asylum in the late 1920s, and the growth in patient numbers, derive from Mathes and Waßmer, *Die badische Heil- und Pflegeanstalt Emmendingen 1930*, and from Richter, "Geschichte der ehemaligen Heil- und Pflegeanstalt Emmendingen." Hermann Simon's therapies are discussed in Burleigh, *Death and Deliverance*. According to Mathes, where in 1924 only the able-bodied in Emmendingen were chosen to work—around 40 percent of the population—by 1930, 80–85 percent of male patients and 70–75 percent of female patients were occupied with some form of employment. Mathes described Emmendingen as "exemplary and progressive."

Grebing's pleasure at his inclusion in *Bildnerei* is cited in Torsten Kappenburg, "Josef Heinrich Grebing—'ein fürchterliches Gefängnis—diese Heil- & Pflegeanstaltschaft—ich war nervenkrank,'" in Brand-Claussen, Röske, and Rotzoll (eds.), *Todesursache*. The upgraded assessment of Genzel's work is cited in Brand-Claussen, "Der Revolutionär für ewige Dinge und die Irrenkunst"; details of his escape bid are in Brand-Claussen, "'KnochenWeltMuseumTheater.' Holzskulpturen von Karl Genzel aus der Prinzhorn-Sammlung," in *Kunst & Wahn*. Details from Natterer's notes are in Jádi and Brand-Claussen, *August Natterer: Die Beweiskraft der Bilder: Leben und Werk: Deu-*

tungen. The autopsy suggested the cause of death to be inflammation of the aorta, a late vascular disease of syphilis. Paul Goesch's post-*Bildnerei* life is documented in Sabine Hohnholz, "Die Farbe muß sich wohl fühlen im Pinsel," in Brand-Claussen, Röske, and Rotzoll (eds.), *Todesursache*. The value of 70,000 marks at this time is hard to assess since June 1923 was a period of hyperinflation, but it was not much. That month there were between 57,000 and 193,500 marks to the U.S. dollar, according to online sources (http://marcuse.faculty.history.ucsb.edu/projects/currency.htm).

Franz Huber founded Graphische Werkstätte Franz Huber, latterly Druckerei Huber, in 1929, which published the local magazine *Ortenauer Rundschau* (Ortenau review). His recollections of Bühler as a young man were published as "Franz Bühler. Das Genie im schizophrenen Künstler." The report of the Offenburg county fair is from the *Badische Presse* 47, no. 459 (morning edition of October 3, 1931), 3.

The "refreshing" review of *Psychotherapy* was by Arnold Eiloart, "Psychotherapy: Its Nature, Its Assumptions, Its Limitations: A Search for Essentials by Hans Prinzhorn," *British Medical Journal* 2, No. 3751 (November 26, 1932): 971. Geinitz, "Zur Biografie Hans Prinzhorns," notes that "among his colleagues the book found little recognition, sometimes even harsh criticism," and that Klages "objected to the language and style, but also believed that the title promised something different: in fact, it was a critique of psychopathology."

Details of Prinzhorn's American trip are from Watson, "In the Teeth of All Formalism," and Geinitz, "Hans Prinzhorn," who notes that he did not become a Navajo representative, "for reasons that neither the Home Office in Washington nor the current tribal representatives of the Navajos could tell me."

10. ART AND RACE

Detailed election results for the period are available in "Historical Exhibition Presented by the German Bundestag," on the website of the Bundestag (https://www.bundestag.de/resource/blob/189774/7c6dd629f4afff7bf4f962 a45c110b5f/elections_weimar_republic-data.pdf). Hanfstaengl's observed "coffee-house tirades" etc. are described in Kershaw, *Hubris*. The Hitler speech exalting Wagner was made on October 28, 1925; his remarks about artists "clearing up this garbage" were made on January 26, 1928. All can be found in Arieli-Horowitz, *Romanticism of Steel*, which states that "the connection between modernism in art and madness appears in many variations in

Hitler's speeches; it shows that Hitler's beliefs on the subject were well developed and also a not insignificant degree of obsession."

The Kampfbund für deutsche Kultur was called the Gesellschaft für deutsche Kultur when it was founded in January 1928; it was renamed in February the following year. Rosenberg's quote about its purpose, "to arouse the conscience," is from Paret, *An Artist Against the Third Reich*. The declaration of war on the "swamp culture" of the Weimar Republic is in Borrmann. Zuschlag, in *Entartete Kunst*, lists the membership of the Kampfbund, as does the *Historisches Lexicon Bayerns* (https://www.historisches-lexikon-bayerns.de/Lexikon/Kampfbund_f%C3%BCr_deutsche_Kultur_(KfdK),_1928-1934).

Schultze-Naumburg had been a member of the *völkisch* group Deutsche Nationale Volkspartei from 1918, and was in contact with the race theorists Günther, Darré, and Bartels (Day, "Paul Schultze-Naumburg: An Intellectual Biography"). Rave in particular identifies Günther as the origin of the National Socialist doctrine of visual arts, which, he says, "culminated in the demand that every figural artistic representation correspond to the canon of Nordic racial theory."

The Nazi theory that the "uniqueness of the artist faded away" in the face of the *Volksgemeinschaft*, and that art showed the "spiritual direction" in which the Germans were headed, is from Michaud, *The Cult of Art in Nazi Germany*.

For Weygandt's diagnoses of professional art, and his previous uses of these photographs, see Brand-Claussen, "Häßlich, falsch, krank," citing Wilhelm Weygandt, "Zur Frage der pathologischen Kunst" (1925). Evidence that Weygandt was an "enthusiastic supporter" of Nazi cultural policy, despite being a member of the German Democratic Party until 1933, when he tried to join the NSDAP but was refused, can be found on German Wikipedia (https://de.wikipedia.org/wiki/Wilhelm_Weygandt). According to Röske, in "Expressionismus und Psychiatrie," only a few artists tried to stand up to Weygandt.

Schultze-Naumburg's appeal for National Socialism not to ignore the "instrument of art" appeared in *Kampf um die Kunst*, 1932. Paul Westheim, in "Rassenbiologische Ästhetik," summarized Schultze-Naumburg as follows: "The foundation of artistic creation is not the spirit, but the corporeal. And because, according to the proponents of racial ideology, the corporeal is the product of specific immutable racial genetic material, level and worth of artistic creation is entirely dependent on the racial disposition of its creator. If proof can be found, that the artist can express only and nothing but this racially determined corporeal, individual artistic accomplishment remains; but art is merely the medium utilized by race" (translation from Day). The ar-

chitect's identification of the "explicitly pathological," and Hitler's apprecia-
tion of him as an art pedagogue, is from the ex-Nazi official Hans Severus
Ziegler, *Adolf Hitler aus dem Erleben dargestellt,* who wrote that "in his lectures
[Schultze-Naumburg] demonstrated—by his words and a projector—the
disturbing similarity of some of the expunged images with physical deformi-
ties and cretins from the madhouse, whose photographs he presented along-
side the paintings of degenerate artists to facilitate a comparison" (cited in
Day).

Details of the election in Thuringia are in Kershaw, *Hitler.* The legisla-
tion "Wider die Negerkultur für das deutsche Volkstum" has been described
by Dina Kashapova as the first "directive art political legal text of the NS"
(Day).

Schultze-Naumburg's Weimar school was called Künstlerische Lehran-
stalten.

The Bauhaus had left Weimar in 1925 for Dessau, where it would remain
open until 1932 before briefly reappearing in Berlin.

Details of the first Nazi art "purge" and the destruction of Schlemmer's
murals are in Zuschlag, *Entartete Kunst,* and in Day. After painting over the
murals, Schultze-Naumburg wrote Schlemmer a facetious letter, explaining:
"I could not imagine that you yourself considered these exercises as perma-
nent works of art." The leading cultural figures who protested Schultze-
Naumburg's actions in Weimar included Kurt Weill, Alfred Doeblin, Max
Pechstein, and Carl Zuckmayer. The Schlemmer quote, "That terrible
thing . . ." is in *The Letters and Diaries of Oskar Schlemmer.*

More on Bettina Feistel-Rohmeder's racialized art ideas and the Ger-
man Art Society can be found in Joan Cinefelter, *Artists for the Reich,* who ex-
plains how the *völkisch* art movement predated the Nazis. She states that
Feistel-Rohmeder "argued that race determined biological form and psy-
chological content. Art was an expression of both racial biology and psychol-
ogy. Thus, artistic creations were physical manifestations of the race and its
mental universe."

There are several accounts of Schultze-Naumburg's lectures on behalf of
the Kampfbund. Paul Ortwin Rave's is from *Kunstdiktatur im Dritten Reich.* The
security unit of storm troopers is in Day. A correspondent of *B.Z. am Mittag*
described in "'Kunst und Rasse': ein Vortrag von Professor Schultze-
Naumburg," May 2, 1936, how, "tracing the development of the arts over the
centuries, [the lecturer] arrived in modernity and the National Socialist
revolution, which ended the degeneration of the artistic and spiritual real-
ism, brought about by liberalism." In *Kulturbolschewismus* (1932), Paul Renner

noted that he "shaped the selection and comparison of his photographs to suggest evidence of the moderns' degeneracy and the way in which he let the 'NS stewards' restore quiet in the most brutal manner." Peter Meyer, in "Schlagringe und Schultze-Naumburg gegen moderne Kunst," *Das Werk* 18, no. 4 (1931), described Panizza's interjection and the SA response. Day cites Hans Eckstein corroborating the incident's brutality and the use of "brass knuckles." In an article based on the lectures "Der Kampf um die Kunst," in *Der Hammer* 31 (1932), Schultze-Naumburg wrote that "the battle of life and death rages in German art, just as in the political theater." Bettina Feistel-Rohmeder's report "Der Kampf um die Kunst" appeared first in *Deutsche Kunstkorrespondenz* 44 (1931).

The friend from his student days with whom Prinzhorn had an affair was Dory Falck. According to Geinitz, in "Hans Prinzhorn," the relationship descended into "endless grueling arguments"; he was especially upset when she left him for a monied rival. The reference in an early draft of *Bildnerei* to Tolstoy is in Röske, "Hans Prinzhorn—ein 'Sinnender' in der Weimarer Republik," in *Wahn Welt Bild*. His decision to enter politics—his sense of "impending doom," and of the period being like that of late Rome—is drawn from Röske, *Der Arzt als Künstler*.

The four published articles for *Der Ring* are: "Über den Nationalsozialismus," *Der Ring* 3 (1930): 884–885; "Zur Problematik des nationalen Radikalismus. Über den Nationalsozialismus II," *Der Ring* 4 (1931): 573–577; "Moralische Verpflichtungen. Über den Nationalsozialismus III," *Der Ring* 5 (1932): 88–90; and "Psychologisches zum Führertum. Über den Nationalsozialismus IV," *Der Ring* 5 (1932): 769–770. A fifth, unpublished article is in the Prinzhorn archive in Heidelberg. Klages's January 1931 letter criticizing his attitude to the pro-Nazi youth is cited in Röske, "Hans Prinzhorn—ein 'Sinnender' in der Weimarer Republik," and Prinzhorn's idea, after seeing Hitler at close quarters, that he was "a constitutional monarch" is in Röske, *Der Arzt als Künstler*.

Martynkewicz, *Salon Deutschland: Geist und Macht 1900–1945*, states that "Hugo Bruckmann was certainly familiar with these articles." Martynkewicz also cites Prinzhorn's letter to Hitler, reported to Bruckmann in correspondence of July 21, 1932. Weber summarized the relationship with the NSDAP thus: "An interview with [Rosenberg] convinced him that collaboration is impossible. After one last attempt to save his project—a letter to Hitler, of which we do not know what happened—he gives it up."

Röske sums up the fourth *Ring* article in *Der Arzt als Künstler*: "The fourth *Ring* article in the series, from November 1932, which contains seven 'guiding

principles' under the heading 'Psychological aspects of leadership,' seems to respond with complete confidence to the riots preceding the elections since July of that year. Now 'there should be no one outside the party who would wish Hitler and his people to take over governmental power even from the point of view of the least evil,' he says; Hitler is denied to be a 'legitimate Führer'; and a paragraph even ends with the word 'catastrophic exit' and a threatening dash. At the same time, however, the text makes one consider (as it did in 1923) how much easier it was for a Mussolini, for reasons of time, social conditions, temperament; and finally, it says that in order to avoid such slander, 'the popular power of the movement should not be valued less': The grumbler already shows possible reconciliation on the distant horizon."

I found Hitler's copy of Prinzhorn's *Persönlichkeitspsychologie* in the Library of Congress in Washington, D.C., among Hitler's personal book collection, which was sent to America at the end of the war. The dedication reads: "At Christmas 1932 for Adolf Hitler from Elsa Bruckmann." The responses to the *Ring* articles are collated in *Der Arzt als Künstler*.

Thirty-six Prinzhorn works were shown in Paris at the *Exposition des artistes malades* at the Galerie Max Bine in May–June 1929, according to Beyme, "Asylum Art as the 'True Avant-Garde?'" in *Surrealismus und Wahnsinn*. Brand-Claussen, "Der Revolutionär für ewige Dinge und die Irrenkunst," informs us that anywhere from 150 to 330 works were shown at the art association exhibitions, which were organized by Heidelberg professors Wilhelm Mayer-Gross and Hans Gruhle. Among the towns and cities the collection toured were Ulm, Basel, Geneva, Darmstadt, Mannheim, Heidelberg, Munich, Kassel, and Leipzig. The quotes from Gruhle are taken from his essay "Die Kunst der Geisteskranken" in the exhibition guide for Ulm, which is in the Heidelberg archive.

Feistel-Rohmeder's review of the Munich Prinzhorn show was first published as "Kunst der Geisteskranken" in *Deutsche Kunstkorrespondenz* 48 (1931), and later in *Im Terror des Kunstbolschewismus* (1938).

Gruhle's reference to Weygandt and the "unpleasant press discussions" he provoked was written in a letter on March 14, cited in Brand-Claussen, "Häßlich, falsch, krank." The review of the *Neue Leipziger Zeitung* is reported in Brand-Claussen, "Der Revolutionär für ewige Dinge und die Irrenkunst."

II. A CULTURAL REVOLUTION

Details of Hitler's appointment as chancellor are largely drawn from Kershaw, *Hitler,* and Richard Evans's *The Coming of the Third Reich,* in particular the

chapter "Hitler's Cultural Revolution." Barr wrote three articles on the National Socialist art phenomenon while on a sabbatical year in Europe: this one is cited in Lynn Nicholas, *The Rape of Europa*.

Hitler's 1930 assurance to Goebbels is from Brenner, *Art in the Political Power Struggle of 1933 and 1934*. His "Enabling Act" speech of March 23 is in Domarus and Hitler, *Hitler*.

The idea that Nazis did not need orders but "worked toward" the Führer is from Kershaw, *Hitler*. Alfred H. Barr was on a sabbatical from the Museum of Modern Art in New York when he went to a meeting of the Kampfbund. He wrote three articles about Nazi cultural policy, which were deemed controversial at the time. These quotes from the Barr papers are cited in Nicholas, *The Rape of Europa*.

Rüdiger's article "From the German Artistic Kingdom of the Jewish Nation" was published in *Völkischer Beobachter* on February 25, 1933.

The demands of the Führerrat der Vereinigten Deutschen Kunst- und Kulturverbände from March 5, 1933, are in Zuschlag, *Entartete Kunst*. I have not quoted them verbatim.

Details of the founding of the Propaganda Ministry and Goebbels's appointment are from Evans, *The Coming of the Third Reich*. According to Arieli-Horowitz, *Romanticism of Steel*, the eponymous hero of *Michael: Ein deutsches Schicksal*, which was eventually published in 1929, had clear stands on issues of culture, which were largely those of Goebbels, and although his feelings about modern art were ambivalent, he did not reject avant-garde movements. He admired Van Gogh as a "star" and "the most modern of the moderns." Goebbels's approval in 1924 of Van Gogh, Nolde, and Barlach is cited in Paret, *An Artist Against the Third Reich*. Nine years later he was more confused, writing in his diary, "Is Nolde a Bolshevik or a painter? Theme for a dissertation." The anecdote in which Goebbels is ashamed of the Noldes in his apartment is in Arieli-Horowitz and elsewhere.

Schultze-Naumburg's view of Goebbels as an "angry snake" is in Borrmann. Goebbels's ideas about the *Volk* and technology are in Evans.

Barlach's fears about the coming Nazi takeover were recorded in a letter to Hugo Sieker on January 26, 1933 (in Ernst Barlach, *Die Briefe*). The account of the Klees' response to Hitler's takeover of power are from Klee, Winston, and Winston, *Paul Klee: His Life and Work in Documents,* and from "An Interview with Felix Klee," in Sabine Rewald, *Paul Klee: The Berggruen Klee Collection in the Metropolitan Museum of Art* (New York, 1988). Details of artists' expulsions from their academies and teaching positions are in Zuschlag, "Chambers of Horrors"; Grosshans, *Hitler and the Artists;* and Nicholas, *The*

Rape of Europa. The statistic that thirty directors were removed from galleries and museums is in Evans.

The account of Gustav Hartlaub's experiences at the Mannheim Kunsthalle is largely from Zuschlag, "Die Ausstellung 'Kulturbolschewistische Bilder' in Mannheim 1933," and Zuschlag, *Entartete Kunst*. Despite the anti-Semitic nature of Gebele von Waldstein's attack, Hartlaub was not Jewish.

There are minor discrepancies in accounts of the incident with the Chagall painting: Some say it was shown in a jewelry shop, or a cigar shop, or a bookshop—it may have moved between several Mannheim shop windows.

The origin of the works by psychiatric patients put on display at the small *Mannheimer Schreckenskammer,* show at Erlangen is unknown, but the man responsible for the exhibition, Hermann Müller, was a doctor of psychiatry and medicine according to Zuschlag (*Entartete Kunst*). Children's drawings were also included, to defame the professional artists. Franz Hofmann's call for a "book burning" for art, and for artists to be sent to Dachau, was published in the *Völkischer Beobachter* on August 16, 1933.

It is worth briefly setting out the story of the Berlin students' attempts to defend German Expressionist artists—including Barlach, Heckel, Kirchner, Schmidt-Rottluff, and Nolde—against the Kampfbund in the summer of 1933, which is documented comprehensively by Brenner. The pro-modernist faction was led by Otto Andreas Schreiber, a Nazi student leader who represented Berlin art schools, and who called Rosenberg's Kampfbund an "organization of cantankerous daubers." A successful mass meeting held at Humboldt University on June 29, 1933, led to brief optimism that arts policy would be liberalized, and on July 22, an exhibition of "thirty German artists" opened at the Ferdinand Möller Gallery in the capital. Rosenberg responded to Schreiber by denouncing him and vilifying Barlach and Nolde, while Walter Hansen, later an initiator of the *Entartete Kunst* shows, described their action as an "act of sabotage." Interior minister Frick shut the Ferdinand Möller exhibition down three days after it opened, and Schreiber was expelled by the National Socialist Students Association.

Details of the community of cultural refugees in Hollywood are in Evans, as is Gerhart Hauptmann's admission of cowardice.

The attacks on Karl Wilmanns and his family are recalled by Ruth Wilmanns Lidz in "Ein erfülltes Leben." Her brilliant career in America was documented in her obituary in the *New York Times,* "Ruth W. Lidz, 85, Yale Professor, Dies," *New York Times,* October 13, 1995.

Prinzhorn's last months are covered in detail by Geinitz, "Hans

Prinzhorn" and "Zur Biografie Hans Prinzhorns." The final exchange of letters between him and Klages are in the Prinzhorn archive. His cause of death was a pulmonary embolism caused by typhoid. Watson's eulogizing remarks are from "In the Teeth of All Formalism."

PART THREE: BILDERSTURM

12. THE SCULPTOR OF GERMANY

The decline of the German psychiatric system in the early 1930s has been captured by Burleigh in *Death and Deliverance*. The buildup to the first eugenics legislation, including promotion of the idea that a tidal wave of "useless individuals" was overwhelming Germany, and detail of the Prussian Health Council's draft legislation, which was never passed, can be found in Mark B. Adams, *The Wellborn Science*.

Hitler's agreement with the idea that art could establish a model of the future German is reinforced by a 1935 Nuremberg speech, in which he stated that "art, precisely because it is the most direct and faithful emanation of the Volksgeist, constitutes the force that unconsciously models the mass of the people," cited in Michaud, *The Cult of Art in Nazi Germany*. Schultze-Naumburg explained the same philosophy as follows: "The most elevated 'mission' of art was to provide 'goals' . . . to render visible 'the image to be attained,' and to fashion the future image of the race," cited in Day, "Paul Schultze-Naumburg: An Intellectual Biography."

Goebbels's line that "only under the hand of an artist can a people be shaped from the masses" is in Michaud. The *Kladderadatsch* cartoon, by Oskar Garvens, was published on December 12, 1933.

Frick's figures for the number of Germans suffering genetic "defects" are given in Robert N. Proctor, *Racial Hygiene: Medicine Under the Nazis*. Details of the "Law for the Prevention of Genetically Diseased Offspring," including the number of denouncements from the medical profession, are in Friedlander, *The Origins of the Nazi Genocide*. The patient who tried to castrate himself with a breadknife is in Burleigh, *Death and Deliverance*.

Wilhelm Werner's biography was researched and recounted by Röske and Rotzoll in "Doppeltes Opfer," after his pictures reached the Prinzhorn collection in two groups, in 2008 and 2010. His sterilization would not have taken the form of castration, but he used amputated testicles as a motif for emasculation.

The statistic that 2,500 people in the Freiburg-Emmendingen area were sterilized is from Gabriel Richter, "Chronik der Heil- und Pflegeanstalt Emmendingen (1913–1949)," in Richter (ed.), *Die Fahrt ins Graue(n)*.

The correspondence between Mathes and Bühler's guardians is in the Prinzhorn archive. The letter from Mathes to Wilfried Seitz was written on November 7, 1935. Seitz (b. Mannheim, 1899) was a church financial officer in Offenburg until 1937; Hauke Marahrens, *Praktizierte Staatskirchenhoheit im Nationalsozialismus* (Göttingen, 2014).

The eugenic dragnet launched in 1936 is addressed in Burleigh, *Death and Deliverance,* which also details how Hermann Pfannmüller worked. Note that though concentration camps were extremely violent places in 1936, they were not yet extermination camps.

13. CLEANSING THE TEMPLE OF ART

Goebbels noted the flight to Munich with Hitler in his diary, June 5 and 6 (*Tagebücher*). The account of what the Führer liked to do on these trips is drawn largely from Speer, a veteran of many such visits, in *Inside the Third Reich.*

Michaud, *The Cult of Art in Nazi Germany,* describes the first Tag der deutschen Kunst, in 1933, including the speech by Hans Schemm. Hitler's aim in creating the Haus der deutschen Kunst, according to Michaud, was to summon "the genius of the race to manifest its eternity in the present day through concrete productions . . . and to draw the German people there so that . . . it would at last awaken to its eternal creative essence."

Olaf Peters, "Genesis, Conception and Consequences," in Peters (ed.), *Degenerate Art,* lists some of the nine jurors: In addition to Troost and Ziegler, they included the sculptors Karl Albiker, Joseph Wackerle, and Arno Breker, as well as the painters Conrad Hommel and Rudolf Hermann Eisenmenger, and Hans Schweitzer of the Reichskulturkammer, who, according to Rave (*Kunstdiktatur im Dritten Reich*), published not very penetrating caricatures in the *völkisch* press under the Old Norse pseudonym Mjölnir (Hammer). Nicholas, *The Rape of Europa,* states that Troost was "only too aware of what was not acceptable, but still not quite sure what was."

Marlies Schmidt reconstructs Hitler's viewing in detail in "Die Große Deutsche Kunstausstellung 1937" using various contemporary sources, including those of Eisenmenger, "Erlebte Vorarbeiten zur Eröffnung des Hauses der Deutschen Kunst." Schmidt writes that Hitler's furious "perfor-

mance" was widely reported in the Nazi press, implying that Hitler and
Goebbels thought there was an advantage to him being seen to behave in
such a way.

Gerdy Troost's "swoon" is recorded in Rave. Hitler's threat to "disband
the jury" is from Goebbels's *Tagebücher*, June 7.

Hitler's slapping down of both factions of the party over their art ideas,
"molesting people and giving them the shudders," is in Brenner, who also
records the demise of Schultze-Naumburg's influence, and the sense that art
in Germany was becoming little more than a political weapon, "without
fixed aims, without political theory or principles, without educational pro-
gram or ideology."

The *New York Times* pronounced that Hitler's Germany was "back in the
fold of nations" in "Olympics Leave Glow of Pride in the Reich," August 14,
1936. The secret memorandum that was being written the same month is
cited in Zuschlag, *Entartete Kunst,* as is Goebbels's diary entry of November 15,
1936.

The closure of the Kronprinzenpalais's upper floor is in Rave, *Kunstdik-
tatur im Dritten Reich,* and Alfred Werner, "Hitler's Kampf against Modern
Art."

Rave describes the art of Wolfgang Willrich, the author of *Säuberung
des Kunsttempels,* as "boring, flaxen blond noble-race heads of noble women
and heroes." The volume is available online at https://digi.ub.uni-heidelberg
.de/diglit/willrich1937/0148/scroll. Goebbels's diary entry of June 11 reads:
"Yesterday ... Reading: Willrich 'Cleansing the Temple of Art.' It is also
necessary and I will carry it out." On June 30, he noted that the previous day
he had "lunch at the Führer's ... Degenerate Art exhibition approved. Prob-
ably Munich. I have the authority to confiscate the relevant pieces in all the
museums." Later in the lunch, he noted, "Führer talks to me in detail about
art. Goes his way with certainty."

Many of the details of the confiscation commission's race around Ger-
many, including the Führer order Goebbels gave to Ziegler on June 30, are in
Zuschlag, *Entartete Kunst.* Rave wrote a detailed firsthand account of the com-
mission's visit to the Kronprinzenpalais in *Kunstdiktatur im Dritten Reich.*

Heinrich Hoffmann, by all accounts a bumptious character inclined to
alcoholism, recorded his experience of curating the *Große deutsche Kunstausstel-
lung* in his memoir, *Hitler Was My Friend.* He includes a story in which he tried
to sneak modern art into the exhibition, devoting one gallery "to the mod-
erns" as a "surprise" for Hitler. The result was disastrous:

When we entered it together, I confess my heart was beating a bit rapidly. Hitler looked at a picture by a well-known Munich artist. Then he turned to me. "Who hung this one?" he asked and his tone was not exactly friendly.

"I did, Herr Hitler!"

"And that one?"

"Yes, Herr Hitler—I chose them all!"

"Take the whole damned lot away," he rasped and stomped angrily out of the room; and that was the end of my attempt to curry Hitler's appreciation for modern art!

Horrified descriptions of Hoffmann's edit of the *Große deutsche Kunstausstellung* are everywhere. Nicholas is typical in writing that it was a "stultifying display carefully limited to idealized German peasant families, commercial art nudes, and heroic war scenes." Goebbels, of course, took a contrary view in his *Tagebücher* entry for July 12.

My description of the installation of the degenerate art show is based largely on Zuschlag, *Entartete Kunst*. Hitler's preview visit was captured in three photographs.

14. TO BE GERMAN MEANS TO BE CLEAR

Stefan Schweizer describes the transformation of Munich, and Nazi attempts to legitimize their theories of race and *Volksgemeinschaft* by turning cities into stage sets, in "Unserer Weltanschauung sichtbaren Ausdruck geben." Peter Guenther gave a firsthand account of the tableau in "Three Days in Munich." Michaud, *The Cult of Art in Nazi Germany*, describes the remarkable kitsch of the Tag der deutschen Kunst parade, in which neoclassical figures were drawn along by horses covered in swastikas, in turn led by men in Teutonic costumes. Quotations from the program are cited in Marlies Schmidt, "Die *Große deutsche Kunstausstellung* 1937." Photographs of the day can be found online in the German national archives (www.bild.bundesarchiv.de).

My descriptions of the day's speeches (Hitler's lasted ninety minutes) are taken from Domarus and Hitler, *Hitler;* Schmidt, "Die '*Große deutsche Kunstausstellung*' 1937"; Hanfstaengl, *Hitler, the Missing Years;* Rave, *Kunstdiktatur im Dritten Reich;* Luttichau, "Crazy at Any Price" (for Ziegler); and Alfred Werner, "Hitler's Kampf against Modern Art."

According to Arieli-Horowitz, *Romanticism of Steel*, on July 18, 1937, Goeb-

bels told the *Völkischer Beobachter:* "National Socialism had successfully held up against the danger that the fight against cultural Bolshevism would lead to the extreme opposite of national kitsch of the Biedermeier variety, which is petit bourgeois and lacking all novel form." He also said that "[Hitler's] whole creation is a sign of artistic views. His policy is built according to truly classic forms. The artistic leadership of his state places him according to his essence and character as the first of all German artists." In fact, kitsch was exactly where Hitler's artistic vision led. Alfred Werner cites a poem, a take-off on Goethe, about the Haus der deutschen Kunst, which ran as follows: "That high-roofed columned mansion, long ago, today with Blood and Soil is all aglow, and Ziegler's naked wenches moon at you, O Art, poor thing, what have they done to you!"

The figure of thirty thousand is based on Munich newspaper reports, according to Rave. The Munich leg of *Entartete Kunst* would receive two million visitors to the *Große deutsche Kunstausstellung's* 420,000, according to official reports. Zuschlag, *Entartete Kunst,* accepts that these numbers are broadly accurate.

Details of the *Entartete Kunst* show itself are from Zuschlag, *Entartete Kunst,* and from Stefanie Barron, *"Degenerate Art,"* which re-creates the entire exhibition, room by room, work by work, and which includes Peter Guenther's account of his visit as a seventeen-year-old. Several of my translations are from this book. The *Entartete Kunst* flyer is available in various sources, including online at Alamy.de.

Among the slogans daubed on the walls was Hitler's pronouncement at the party rally in 1935: "It is not the mission of art to wallow in filth for filth's sake, to paint the human being only in a state of putrefaction, to draw cretins as symbols of motherhood, or to present deformed idiots as representatives of manly strength."

Hitler and Goebbels's visit to the Wagner festival, and their brainstorming of new ways to exploit the "degenerate" concept, is documented in Goebbels's *Tagebücher.* The account of a new Nazi commission rifling the Nationalgalerie is in Rave, *Kunstdiktatur.*

15. THE SACRED AND THE INSANE

The résumé of attempts by modern artists to escape Hitler are culled from numerous sources, including Grosshans, *Hitler and the Artists;* Wikipedia; max-ernst.com; paulklee.net; kirchnermuseum.ch; and Petropoulos, *Artists Under*

Hitler. Petropoulos makes the counterargument that several artists tried to seek accommodation with the regime in its early years, and argues that modernism did not entirely stop under Hitler, but "continued on, despite the often hostile environment." He does state, however, that the German émigré community during the Third Reich represented "the greatest assemblage of cultural talent ever to leave a country." The story of Nolde's persecution by the regime, despite being a long-standing member of the NSDAP, and his odorless miniatures, is in Emil Nolde and Werner Haftmann, *Emil Nolde: Unpainted Pictures.* Haftmann argues in this volume that emigration had a considerable influence on the development of modern art, as German ideas spread all over the world.

For more on Nazi eugenic propaganda, see Burleigh, *Death and Deliverance,* which includes a chapter devoted to the "killing films of the Third Reich." The eugenicists' infiltration of the education system was widespread. In some areas, teachers were co-opted into the scheme: They would ask pupils to draw their family trees as a way to identify branches of alleged "hereditarily ill" relatives. The arithmetic "problem" is cited in Richter, "Chronik der Heil- und Pflegeanstalt Emmendingen," in Richter (ed.), *Die Fahrt ins Graue(n).* Klee gives an account of the Freiburg school outing to Emmendingen and of the essays the students wrote afterward in *"Euthanasie" im NS-Staat.* He also cites Wilhelm Hinsen, who resigned as director of Eichberg at the start of 1938 and was a witness in the postwar trial of Eichberg personnel. Bernotat's announcement that directors should "beat [patients] to death" is in Friedlander, "Registering the Handicapped in Nazi Germany."

Burleigh, *Death and Deliverance,* has details of the violent "shock therapies"; it was Fritz Ast, the director of Eglfing-Haar, who made the comment that these treatments would prevent patients from becoming "costly ballast existences." The statistics for those treated at Emmendingen are from Richter, "Chronik." Klee reports on the hunger punishment and short rations in *"Euthanasie" im Dritten Reich.*

Among sources for Schneider, I have largely drawn on Maike Rotzoll, Bettina Brand-Claussen, and Gerrit Hohendorf, "Carl Schneider, die Bildersammlung, die Künstler und der Mord," in Fuchs et al. (eds.), *Wahn Welt Bild* (2002), and Rotzoll and Hohendorf's "Murdering the Sick in the Name of Progress?," in which the authors cite Werner Janzarik, a professor of psychiatry at Heidelberg in the 1970s and 1980s, describing his predecessor as a "petit bourgeois sort of scholar, uncertain in matters of good taste." Schneider's art speech, "Entartete Kunst und Irrenkunst," was due to be

given July 19, 1938, but never delivered. It was published in *Archiv für Psychiatrie und Nervenkrankheiten* in 1939.

16. THE GIRL WITH THE BLUE HAIR

The resistance of Göring and Rust to using the Kronprinzenpalais for *Entartete Kunst* in Berlin derives from Rave, cited in Zuschlag, *Entartete Kunst*. That the introduction of Prinzhorn works was the most significant change is supported by the press handout, "Information Sheet for Editors," in Annegret Janda and Jörn Grabowski, *Kunst in Deutschland 1905–1937* and Klee's *"Euthanasie" im Dritten Reich*. It is not clear whose idea it was to include the Heidelberg material. Possible candidates include Goebbels, Schneider, Pistauer, Fritz Kaiser (the Propaganda Ministry functionary charged with producing the guidebook), and Hitler himself. Pistauer's recollections of his visit were given to Zuschlag almost five decades after the event, on March 10, 1990; this short, remarkable interview is in *Entartete Kunst*.

Details of the shipment of Prinzhorn works to Berlin are contained in a letter of January 22 from Wilhelm Niederste-Ostholt, chairman of the Advisory Council of the Institute for German Cultural and Economic Propaganda, and also director of the Reich Propaganda Directorate in Munich (see Brand-Claussen, "Häßlich, falsch, krank"). The source for which works were sent comes from analysis of the so-called Leipzig list, an inventory of seventy to eighty works sent back to Heidelberg at the end of the Leipzig *Entartete Kunst* show, which is in the Prinzhorn archive. Numerous other works were not returned; one or two can be seen in press photographs of the subsequent exhibitions.

Goebbels and Hitler visited the depot filled with "degenerate" art on January 14; Goebbels wrote it up in his *Tagebücher* the following day. The propaganda minister's activities on February 26 are recorded in his diaries. He evidently had full control of the Berlin show—Pistauer stated that he had been to see it several times—despite not being there at the opening.

Deutsche Allgemeine Zeitung reported on the opening in its February 27 edition.

Fritz Kaiser's full exhibition guidebook to *Entartete Kunst* is reprinted in Barron's *"Degenerate Art,"* with English translations. It was closely coordinated with the physical show, which followed the same layout as the guide at Berlin and subsequent stations.

The responses of the government-controlled press to Berlin and later legs of the show are cited in Zuschlag, *Entartete Kunst,* as are the reactions of

Emil Stupp. Felix Hartlaub's letter to his father is in *Felix Hartlaub in seinen Briefen.*

Entartete Kunst opened on Friday, May 13, 1938, in Leipzig. Subsequent venues and dates were: Düsseldorf (June 18–August 7, 1938), Salzburg (September 4–October 2, 1938), Hamburg (November 11–December 30, 1938), Stettin (January 11–February 5, 1939), Weimar (March 23–April 24, 1939), Vienna (May 6–June 18, 1939), Frankfurt (June 30–July 30, 1939), and Chemnitz (August 11–September 10, 1939). On its later tour it is known to have been shown at Waldenburg (now Walbrzych, in Poland), from January 18 to February 2, 1941, and at Halle an der Salle from April 5 to April 20, 1941.

The only known complete copy of the inventory of the more than 16,000 "degenerate" artworks that were confiscated by the Nazis is held by the V&A Museum in London. It can be read online at https://www.vam.ac.uk/articles/explore-entartete-kunst-the-nazis-inventory-of-degenerate-art#?c=&m=&s=&cv=&xywh=-1924%2C-303%2C7927%2C6044. Two other copies of an earlier version of Volume 1 (A–G) are known to have survived the war, and these are now held by the German Federal Archives in Berlin (R55/20744, R55/20745) (https://www.bundesarchiv.de/EN/Navigation/Home/home.html).

The atmosphere at the sale in the Grand Hotel National in Lucerne was "stifling," according to the French journal *Beaux Arts,* cited in Nicholas, *The Rape of Europa.* For Alfred Hentzen, it represented a moment when the German government had reached a degree of shamelessness and cultural decay unparalleled in the history of art. For further details of the auction, see Zuschlag; Rave, *Kunstdiktatur im Dritten Reich;* Grosshans, *Hitler and the Artists;* and Nicholas, *The Rape of Europa.*

Franz Hofmann's letters urging the burning of the rest of the material, and Goebbels's responses, are cited in Zuschlag. The "final report" on the exploitation of "degenerate" art was submitted in the summer of 1941, though this was not the end of the affair: There remained around five thousand works, and there was no clarity about what to do with them. Some were destroyed, some were stolen by the likes of Hermann Göring, and some were given to art dealers to sell on the black market or added to personal collections that would come to light decades later. In February 2012, German prosecutors found the collection of the Nazi art dealer Hildebrand Gurlitt in the Schwabing apartment of Gurlitt's son, Cornelius: There were 1,406 artworks worth approximately $1.3 billion. During Goebbels's whole action, according to Olaf Peters ("Genesis, Conception and Consequences," in Pe-

ters [ed.], *Degenerate Art*), nearly 22,000 works were confiscated, of which around a quarter were destroyed, representing "a terrible loss and destruction of German culture that in some cases has yet to be compensated today."

I have estimated the value of the degenerate art program to the German war effort as being roughly equivalent to "the cost of two Panzer tanks" from various online sources, including Lawrence H. Officer, "Exchange Rates Between the United States Dollar and Forty-one Currencies," http://www.measuringworth.com. Zuschlag, in *Entartete Kunst,* cites evidence that some of this money went to the Ministry of Education to compensate individual museums.

PART FOUR: EUTHANASIE

17. FOXES WITH WHITE COATS

Gerhard Kretschmar's name was first published by Ulf Schmidt in his 2007 biography, *Karl Brandt: The Nazi Doctor*. In older sources, such as Klee and Burleigh, the family is called "Knauer" or is anonymized, but the tragic details of his life and death are largely the same.

Brandt revealed how familiar Hitler's inner circle were with his ideas about euthanasia at the doctors' trial at Nuremberg. After the end of the Polish campaign, Brandt was called to a meeting with Hitler at Obersalzburg, where he was told that "insane persons" who were in such a condition that they could no longer take any conscious part in life were about to be given "relief through death." But this was far from the first inkling of Hitler's desire to kill psychiatric patients, Brandt continued, since "in his book, *Mein Kampf,* Hitler had already referred to it in certain chapters, and the [sterilization] is a proof that Hitler had definitely concerned himself with such problems earlier" (IWM, Medical Trial, Case 1, in Burleigh, *Death and Deliverance;* Nuremberg trial documents at https://nuremberg.law.harvard.edu). Hitler's 1933 musings over whether or not to murder psychiatric patients was recalled by Hans Heinrich Lammers, the head of the Reich Chancellery. Brack's statement that Hitler intended to "eradicate those people who were kept in insane asylums" was also made at the Nuremberg doctors' trial, cited in Thomas Stöckle and Eberhard Zacher, *"Euthanasie" im NS-Staat*.

A copy of the August 18 memo requiring midwives to notify them of babies born with certain conditions can be found in Klee, *"Euthanasie" im NS-Staat*. Their fee, 2 RM, was worth approximately $100 in 2020.

According to Burleigh, Hitler's meeting with high-ranking officials, in

which he told them Conti was to lead the killing program, was held before July 1939. Lammers's account of the meeting is from the Nuremberg doctors' trial, cited in Burleigh. The fallacy of the economic justification is in Friedlander, *The Origins of Nazi Genocide*.

Among the eminent team of would-be referees invited to Berlin in July were Maximilian de Crinis of Berlin; Carl Schneider; Berthold Kihn of Jena; and Werner Heyde of Würzburg. The core group included Catel, Heinze, Wentzler, and the asylum directors Pfannmüller of Eglfing-Haar, Paul Nitsche of Sonnenstein near Pirna, and Wilhelm Bender of Berlin-Buch. Heyde's recollection of what Bouhler said is in Klee, *"Euthanasie" im NS-Staat*.

Widmann recalled his interview with Arthur Nebe under interrogation in 1960 (Burleigh, *Death and Deliverance*). IG Farben, the company that supplied the killing carbon monoxide, was a conglomerate of six chemical companies, some of which have long since become household names: BASF, Bayer, and Agfa.

The first trial killings by gas took place in Brandenburg in January 1940. Independently of the "euthanasia measures" beginning in the Reich, mass killings of mentally ill persons were already taking place from September 1939 until the beginning of 1940 in occupied and then incorporated Poland (Danzig–West Prussia, Wartheland), and also of patients from Pomeranian and East Prussian institutions.

After the sterilization-stop order of September 1, 1939, the practice continued in an unofficial manner, albeit at a lower rate, until 1945, according to Klee, who estimates the total number sterilized at between 200,000 and 350,000. Many people were sterilized for political reasons, as whoever was against Hitler was judged to be feebleminded.

The creeping murder rate inside German asylums was bolstered by official instructions in certain regions, such as Saxony, where all psychiatric institutions were told to eliminate restless patients with overdoses even before the war (Klee). The murderous antics of Dr. Theato at Emmendingen were recalled by Mathes in "Die sogenannten 'planwirtschaftlichen Maßnahmen' aus Sicht des Ärztlichen Direktors."

The horrified account of a visit to Eglfing-Haar by Ludwig Lehner is cited in Burleigh, *Death and Deliverance*.

Brandt and Bouhler's killing operation moved into the Tiergartenstraße 4 villa that later gave it its name in April 1940. Before that, from December 1, 1939, the KdF leased three or four rooms in an office building, the Columbushaus, on Potsdamer Platz.

For more about the "Meldebogen 1" reporting form, see notes to the Pro-

logue. Mathes stated later, in "Die sogenannten 'planwirtschaftlichen Maßnahmen,'" that his medical board thought the questionnaire "would be used either for scientific statistical purposes or for the preparation of a proper accommodation for the sick in the case of evacuation." It wasn't until the following spring that they learned about the program in more detail, he stated, and even then it wasn't clear. He was surprised that only one institution was ever named in the transfers, which led him to believe it must be some sort of processing center. He discovered his patients' real fate via their bereaved relatives.

18. CHOKING ANGEL

Much of my reconstruction of Aktion T4's operation in Baden and Württemberg is derived from a conversation with Thomas Stöckle, the historian who has worked for many years at the killing station memorial; from Stöckle's book with Eberhard Zacher, *"Euthanasie" im NS-Staat;* and from Gabriel Richter, formerly a doctor at Emmendingen, editor of *Die Fahrt ins Graue(n)*. Dr. Richter also gave me a copy of the transport list bearing Bühler's name; other primary sources are published in Robert Poitrot, *Die Ermordeten waren schuldig?* Poitrot was the head neurologist of the French occupation zone in 1945.

Mathes, in "Die sogenannten 'planwirtschaftlichen Maßnahmen,'" recalled that the removal of patients "started surprisingly and overwhelmingly for us." The rudeness and brutality of the Gekrat staff is attested to by various eyewitnesses in Klee, *"Euthanasie" im NS-Staat.* Oswald Haug's recollections are published in "Nazizeit—Verfolgung der Kirche" in Richter (ed.), *Die Fahrt ins Graue(n):* In them, he recalls a visit from a woman who asked if he knew what was happening to the transportees. Her husband had been at a government meeting in Berlin, she explained, where it was openly stated that the patients were to go to Grafeneck to be gassed. An official had explained that the country need have no fear about the procurement of raw materials during the war, since, for every "unworthy life" that was extinguished, the Reich could gain a lot of fat to make floor wax, while glue could be extracted from their bones.

"Like pigs" is taken from Alfred Döblin's account of the murders, written as early as 1946, "Fahrt ins Blauen," which is republished in Richter (ed.), *Die Fahrt ins Graue(n).* The driver who reported being punched was named Mayrhuber and worked at Hartheim; the "unpleasant" experience of seeing the buses was recalled by Wilhelm Traub of the Marbach stud farm; the

puncture-repairing patient was recalled by Hartheim driver Franz Hödl. All are cited in Klee, *"Euthanasie" im NS-Staat*. Descriptions of Grafeneck's geography are from my own visit, in April 2018.

Stöckle notes that Dr. Baumhard arrived at Grafeneck in April 1940, meaning that Dr. Schumann or Dr. Hennecke would have examined and murdered Bühler in March. At the examination, around 2 percent of transported individuals were reprieved, commonly war veterans, foreign nationals, or particularly good workers.

The coach house that held the gas chamber has since been demolished, but there are a handful of photographs of it. Stöckle describes the aftermath of the gassing thus: "The bodies of the dead and the ground were stained with stools, menstrual blood and vomit, some corpses were clawed together and had to be separated by force."

Maximilian Friedrich Lindner's testimony of what he saw through the Hadamar spy window was given in a Frankfurt courtroom in 1947. It is cited in Friedlander, *The Origins of Nazi Genocide*.

There is no testimony from a "burner" at Grafeneck, as none stood trial after the war; Nohel worked at Hartheim.

The entitlement of all T4 staff to cheap dental work is from Burleigh, *Death and Deliverance*.

A copy of Bühler's "consolation letter" is in the Prinzhorn archive. According to Stöckle, the Stakeout Department was created at Grafeneck in the spring of 1940, on the orders of Berlin. Hans-Heinz Schütt's letter expressing pride in his work is cited in Burleigh, *Death and Deliverance*.

19. YOU WILL RIDE ON THE GRAY BUS

Thomas Mann's lament that Hitler no longer used pencils and paints but humanity as his canvas is from Arieli-Horowitz, *Romanticism of Steel*, citing "Bruder Hitler."

Details of the train shipment unloaded at Marbach are in Klee, *"Euthanasie" im NS-Staat*. According to the T4 nurse Zielke, "The sick were taken from the destination station by bus to Grafeneck and killed on their arrival." The details of Stähle, Conti, and Brandt watching the murders, and of a growing "gas tourism," are in Klee, *"Euthanasie" im Dritten Reich*. It was Otto Mauthe, the senior medical officer in Württemberg, who heard the words "We are all killed!"

Much of what is known about the lives and deaths of the Prinzhorn art-

ists killed in the "euthanasia" programs has been published in Brand-Claussen, Röske, and Rotzoll (eds.), *Todesursache: Euthanasie,* the catalogue for a Prinzhorn collection show of the same name, which includes a large number of their artworks. For Werner, whose works came later to the collection, see Werner, *Wilhelm Werner.*

The story of the expansion of the T4 program across the Reich is in the main drawn from Klee, *"Euthanasie" im NS-Staat;* Friedlander; and Burleigh, *Death and Deliverance,* as well as Stöckle, who dates the last killing to December 13, 1940, three days after Baumhard invited Martha Fauser to his "camaraderie evening."

In "'Euthanasie' im Nationalsozialismus," Gerrit Hohendorf summarizes the population's response as follows: "Despite all the secrecy measures, there was considerable concern among the population about the murders. However, there was no general rejection of the killing of patients in the population. Apart from personal protests, there were also individuals who approved, and agreed with the idea that it was a release."

Richter, in an interview with the author, explained that all asylum directors were given some leeway: In later months, there were typically ninety patients on each transport list, of whom seventy-five would be taken, so the medical staff could "save" around fifteen. It was a way of making them complicit. In Richter's view, Mathes's actions went beyond that.

In 1940, by a strange coincidence, Mathes bumped into the psychiatrist Alfred Hoche, co-author of *Die Freigabe der Vernichtung des lebensunwerten Lebens,* in a streetcar in Baden-Baden. The T4 transports were still in progress, and Hoche had recently received the ashes of a relative who had been killed in the program. He told Mathes he "strongly disapproved" of the measures being taken, and supported the Emmendingen director's attempts to sabotage it.

The account of the resistance of Lothar Kreyssig is based on Klee, *"Euthanasie" im NS-Staat.* The extract from Bishop von Galen's sermon is in Burleigh, *Death and Deliverance.* Hitler's threat to Galen is recorded in *Hitler's Table Talk.*

Statistics for the numbers of people taken from Emmendingen to be killed are in Richter, "Chronik der Heil- und Pflegeanstalt Emmendingen (1913–1949)," in Richter (ed.), *Die Fahrt ins Graue(n).* These were not all inpatients at the asylum; some seem to have been brought to Emmendingen for pickup.

Hitler evidently thought it had been a mistake to give written orders for the euthanasia program, and he refused to put his signature on a piece of

paper authorizing the killing of the Jews. However, it is inconceivable, according to Friedlander, that such a radical move would have been made without consulting him.

Carl Schneider's activities, including having children killed to order, are documented in Maike Rotzoll and Gerrit Hohendorf, "Murdering the Sick in the Name of Progress?"

The last showings of the degenerate art exhibition are from Zuschlag, *Entartete Kunst*. The *Neues Tageblatt* review appeared in the edition of January 31, 1941. As to the fate of the Prinzhorn works that were with the show until the end, they may have been deemed not to have any value, unlike the professional works (which were returned), and therefore simply been discarded, though some suspect they have survived in private hands and will surface again.

Zuschlag, in "An Educational Exhibition," states that the show was seen by "more than 3.2 million people," according to official figures.

Olaf Peters, in "Genesis, Conception and Consequences" (in Peters [ed.], *Degenerate Art*) documents a "brutal, scorning return to the theme of 'degenerate art' during the war," in which it was used to support the policy of extermination. This is the source of the details surrounding *Der Untermensch*'s publication. *Der Untermensch* is available online at https://archive.org/details/SS-Hauptamt-Der-Untermensch. Details of Freundlich's fate are from Wikipedia.

20. IN THE MADHOUSE

The quote from *Michael*, "Geniuses consume people," is cited in *Goebbels*, by Peter Longerich et al. My portrait of Hitler's disastrous leadership from 1942 is partly drawn from Fest, *Hitler*; Kershaw, *Nemesis*; Speer, *Inside the Third Reich*; and from *Hitler's Table Talk*. His obsession with art toward the end has been documented by Spotts in *Hitler and the Power of Aesthetics*, and by Schwarz in *Geniewahn*. Schwarz does a remarkable job of establishing which artworks hung in which rooms in the Führerbunker and of analyzing the significance of the portrait of "Old Fritz" and the Linz model.

Speer's account of the last performance of the Berlin Philharmonic was given to Gitta Sereny, who published it in *Albert Speer: His Battle with Truth*. Gerda Bormann's comparison of the end to Wagner are cited in Kershaw, *Hitler*.

The Hitler testaments are in the personal papers of Adolf Hitler, in the

U.S. National Archives. I found them online at https://catalog.archives.gov
/id/6883511.

The trashiness of Hitler's final scene is Fest's insight. He states that:
"Even his death, trivial and botched though it may seem, reflected both as-
pects of the era that he admired and once again represented: something of its
sonorous splendor, as expressed in the *Götterdämmerung* motifs of the staging,
but also something of its trashiness, when he lay dead on the bunker sofa like
a ruined gambler of the opera-hat era beside his newly wedded mistress."

21. LANDSCAPES OF THE BRAIN

Maria Rave-Schwank told me the story of her first encounter with the
Prinzhorn collection, and her decision to try to restore it, which is generally
regarded as the moment that marks its postwar rebirth.

Of the numerous Prinzhorn artists who escaped Hitler's murder pro-
grams, we know the fate of two. Josef Forster, the former upholsterer who
aspired to become an *Edelmensch* and travel through the air at great speed, was
spared thanks to his quick-thinking sister, who also had a nephew in psychi-
atric care. In 1940, she was told that the nephew was being transferred, and
soon afterward the family received a condolence letter informing them he
had died and been immediately cremated. She found this suspicious, and
asked that her brother be released from the Karthaus Prüll asylum in Re-
gensburg, where he lived. Forster was let out on June 15, 1941, at age sixty-
three, and lived for another eight years. His sister had acted just in time:
Aktion T4 would kill 641 patients at Karthaus Prüll by the end of the sum-
mer. A second Prinzhorn artist, Alfred Seidl, was moved from the same asy-
lum by his brother, who relocated him to a safe municipal care facility across
town. He lived until 1953, by which time he was in his seventies. The names
of other artist-patients who outlived the Third Reich are not yet known.

Details of Dubuffet's visit to the Prinzhorn collection are in Baptiste
Brun, "Ein unumgänglicher Besuch," in Beyme and Röske (eds.), *Dubuffets
Liste*. Afterward, on September 23, 1950, Dubuffet wrote to Pierre Matisse:
"I was able to see at leisure, in the best conditions, in Heidelberg, the won-
derful collection of Dr. Prinzhorn, which I had, for so many years, longed to
visit" (Archives de la Fondation Dubuffet). As Dubuffet told MacGregor: "I
had the idea of doing research on the art of the insane. I was so excited by
the pictures in Prinzhorn, and I felt it might be possible to discover more"
(cited in *The Discovery of the Art of the Insane*).

In 2013, the show *Angels, Demons, and Savages: Pollock, Ossorio, Dubuffet* at the Phillips Collection traced the influence of Dubuffet on the Abstract Expressionists. (See, for example, Philip Kennicott, "'Angels, Demons, and Savages: Pollock, Ossorio, Dubuffet' Review," *Washington Post*, February 8, 2013.) Peter Selz has more details of his intervention in Chicago in "Surrealism and the Chicago Imagists of the 1950s." Szeemann's role in relaunching the Prinzhorn collection was the subject of a 2005 show in Heidelberg, *Bern 1963: Harald Szeemann Invents the Prinzhorn Collection*.

An explanation of what Roger Cardinal meant by Outsider Art can be found in John Maizel's *Raw Creation: Outsider Art and Beyond*. Linda Yablonsky's article "The Outsider Art Fair: A Victim of Its Own Success?" was published on the website of the *Art Newspaper* on January 19, 2019 (https://www.theart newspaper.com/blog/has-the-outsider-art-fair-become-a-victim-of-its -own-success).

In an interview, Maike Rotzoll explained the reemergence of the medical files that had been lost to the Soviet zone, and described a visit to the archives, with three rooms filled with records.

The latest figure of thirty artists thought to have been killed and ten forcibly sterilized were given to me by Sabine Hohnholz of the Sammlung Prinzhorn.

SELECTED
BIBLIOGRAPHY

Abbott, Karen. *Sin in the Second City: Madams, Ministers, Playboys, and the Battle for America's Soul.* New York, 2008.

Adams, Mark B. (ed.). *The Wellborn Science: Eugenics in Germany, France, Brazil, and Russia.* New York, 1990.

Alexander, Franz, and Sheldon T. Selesnick. *The History of Psychiatry: An Evaluation of Psychiatric Thought and Practice from Prehistoric Times to the Present.* New York, 1974.

Ankele, Monika. *Alltag und Aneignung in Psychiatrien um 1900: Selbstzeugnisse von Frauen aus der Sammlung Prinzhorn.* Vienna, 2009.

Ankele, Monika. "Doing Culture / Doing Gender / Doing Identity. Von den Möglichkeiten praxistheoretischer Ansätze für die Frauenbiografieforschung am Beispiel eines mit Texten bestickten Jäckschens aus dem Jahre 1895." In: Susanne Blumesberger and Ilse Korotin (eds.), *Frauenbiografieforschung. Theoretische Diskurse und methodologische Konzepte.* Vienna, 2012.

Arieli-Horowitz, Dana. *Romanticism of Steel: Art and Politics in Nazi Germany.* Jerusalem, 1999.

Arndt, Karl. "Die Münchener Architekturszene 1933/34 als ästhetisch-politisches Konfliktfeld." In: Elke Fröhlich-Broszat and Anton Grossmann (eds.), *Herrschaft und Gesellschaft im Konflikt, Part 2.* Berlin, 2018.

Artaud, Antonin. *Antonin Artaud: Collected Works—Volume One.* Trans. Victor Corti. London, 1968.

Ball, Hugo, and Hans Burkhard Schlichting (ed.). *Der Künstler und die Zeitkrankheit: ausgewählte Schriften.* Frankfurt, 1988.

Barlach, Ernst, and Friedrich Dross. *Die Briefe.* Munich, 1969.

Barr, Alfred H. *Fantastic Art, Dada, Surrealism.* New York, 1936.

Barron, Stephanie (ed.). *"Degenerate Art": The Fate of the Avant-Garde in Nazi Germany.* Los Angeles, 1991.

Bauduin, Tessel. "Fantastic Art, Barr, Surrealism." *Journal of Art Historiography* 17 (December 2017).

Bauduin, Tessel. [Review of *Surrealism and Madness.*] *Papers of Surrealism* 8 (Spring 2010).

Becker, Annette. "The Avant-Garde, Madness and the Great War." *Journal of Contemporary History* 35, no. 1 (2000): 71–84.

Beevor, Anthony. *Berlin: The Downfall 1945.* London, 2002.

Beevor, Anthony. *The Second World War.* London, 2012.

Beringer, Kurt. "Experimentelle Psychosen durch Mescalin. Vortrag, Gehalten auf der Südwestdeutschen Psychiaterversammlung in Erlangen 1922." *Zeitschrift für die gesamte Neurologie und Psychiatrie* 84, no. 1 (1923): 426–433.

"Beschreibung der Hamburger Irren-Anstalt Friedrichsberg." In: *Erinnerungsschrift zur Feier des 25 jährigen Bestehens der Irren-Anstalt Friedrichsberg.* Hamburg, 1889.

Beveridge, Allan. "A Disquieting Feeling of Strangeness? The Art of the Mentally Ill." *Journal of the Royal Society of Medicine* 94, no. 11 (2001): 595–599.

Beyme, Ingrid von. "'The Most Important Artistic Experience of My Life': Richard Lindner und die Sammlung Prinzhorn." In: Ingrid von Beyme and Thomas Röske (eds.), *Ungesehen und unerhört.* Heidelberg, 2013.

Beyme, Ingrid von, and Thomas Röske (eds.). *Dubuffets Liste. Ein Kommentar zur Sammlung Prinzhorn von 1950.* Heidelberg, 2015.

Beyme, Ingrid von, and Thomas Röske (eds.). *Surrealismus und Wahnsinn.* Heidelberg, 2005.

Beyme, Ingrid von, and Thomas Röske (eds.). *Ungesehen und unerhört.* Heidelberg, 2013.

Beyond Reason: Art and Psychosis—Works from the Prinzhorn Collection. Hayward Gallery. London, 1996.

Binding, Karl, and Alfred Hoche. *Die Freigabe der Vernichtung des lebensunwerten Lebens: Ihr Maß und Ihre Form.* Leipzig, 1920.

Bloch, Eduard. "My Patient, Hitler: A Memoir of Hitler's Jewish Physician." Institute for Historical Review, http://www.ihr.org/jhr/v14/v14n3p27_bloch.html. Originally published in *Collier's,* 1941.

Borrmann, Norbert. *Paul Schultze-Naumburg, 1869–1949: Maler. Publizist. Architekt: Vom Kulturreformer der Jahrhundertwende zum Kulturpolitiker im Dritten Reich.* Essen, 1989.

Brand-Claussen, Bettina. "Der Revolutionär für ewige Dinge und die Irren-kunst." In: *Kritische Berichte* 24 (1996).

Brand-Claussen, Bettina. "Die 'Irren' und die 'Entarteten': Die Rolle der Prinzhorn-Sammlung im Nationalsozialismus." In: Roman Buxbaum (ed.), *Von einer Wellt zu'r Andern: Kunst von Aussenseitern im Dialog*. Cologne, 1990.

Brand-Claussen, Bettina. "Geschichte einer 'verruckten' Sammlung." *Vernissage* 7, no. 1 (2001).

Brand-Claussen, Bettina. "'Häßlich, falsch, krank.' 'Irrenkunst' und 'irre Kunst' zwischen Wilhelm Weygandt und Carl Schneider." In: Christoph Mundt, Gerrit Hohendorf, and Maike Rotzoll (eds.), *Psychiatrische Forschung und NS-'Euthanasie': Beiträge zu einer Gedenkveranstaltung an der Psychiatrischen Universitätsklinik Heidelberg*. Heidelberg, 2001.

Brand-Claussen, Bettina. "'. . . Lassen sich neben den besten Expressionisten sehen.'" In: Herwig Guratzsch, Thomas Röske, and Susanne Augat (eds.), *Expressionismus und Wahnsinn*. Munich, 2003.

Brand-Claussen, Bettina. "Viel Lärm, wenig Bilder." In: Bettina Brand-Claussen et al. (eds.), *Irre ist weiblich: Künstlerische Interventionen von Frauen in der Psychiatrie um 1900*. Heidelberg, 2009.

Brand-Claussen, Bettina. "The Witch's Head Landscape: A Pictorial Illusion from the Prinzhorn Collection." *American Imago* 58, no. 1 (Spring 2001).

Brand-Claussen, Bettina, et al. *Irre ist weiblich: Künstlerische Interventionen von Frauen in der Psychiatrie um 1900*. Heidelberg, 2004.

Brand-Claussen, Bettina, Thomas Röske, and Maike Rotzoll (eds.). *Todesursache: Euthanasie: Verdeckte Morde in der NS-Zeit*. Heidelberg, 2012.

Brenner, Hildegard. "Art in the Political Power Struggle of 1933 and 1934." In: Hajo Holborn (ed.) and Ralph Manheim (trans.), *Republic to Reich: The Making of the Nazi Revolution*. New York, 1972.

Brenson, Michael. "The Need to Communicate in a World That Does Not Listen." *New York Times*, June 23, 1985.

Breton, André. "The Art of the Insane: Freedom to Roam Abroad" (1948). In: André Breton, Simon Watson Taylor, and Mark Polizzotti, *Surrealism and Painting*. Boston, 2002.

Breton, André. "The Manifesto of Surrealism" (1924). In: André Breton, Richard Seaver, and Helen R. Lane, *Manifestoes of Surrealism*. Ann Arbor, MI, 1969.

Breton, André, et al. *La révolution surréaliste*. Paris, 1924–1929.

Brugger, Ingried, Peter Gorsen, Patricia Allderidge, and Verena Traeger. *Kunst und Wahn*. Vienna, 1997.

Bürger, Peter. "The Lure of Madness: On the Problem of a 'Surrealist Aes-

thetic.'" In: Thomas Röske and Ingrid von Beyme (eds.), *Surrealismus und Wahnsinn*. Heidelberg, 2009.

Burleigh, Michael. *Death and Deliverance*. London, 2002.

Burleigh, Michael. *The Third Reich: A New History*. New York, 2001.

Cevasco, George A. "Dalí's Christianized Surrealism." *Studies: An Irish Quarterly Review* 45, no. 180 (1956): 437–442.

Chamberlain, Houston Stewart. *Foundations of the 19th Century*. New York, 2006.

Cinefelter, Joan L. *Artists for the Reich: Culture and Race from Weimar to Nazi Germany*. New York, 2005.

Croissant, Doris. "Koga Harue's Endloser Flug: Eine japanische Interpretation des Wunder-Hirthen von August Natterer." In: Ingrid von Beyme and Thomas Röske (eds.), *Ungesehen und Unerhört*. Heidelberg, 2013.

Dalí, Salvador. *Le mythe tragique de l'Angélus de Millet: interprétation "paranoïaque-critique."* Paris, 2011.

Day, Lara. "Paul Schultze-Naumburg: An Intellectual Biography." Ph.D. diss, University of Edinburgh, 2014.

Domarus, Max, and Adolf Hitler. *Hitler: Speeches and Proclamations 1932–1945: The Chronicle of a Dictatorship*. Würzburg, 1997.

Dross, Friedrich (ed.). *Ernst Barlach, die Briefe*. Munich, 1969.

Dubuffet, Jean. *Biographie au pas de course*. Paris, 2001.

Dunlop, Ian. *The Shock of the New: Seven Historic Exhibitions of Modern Art*. London, 1972.

Eisenmenger, Rudolf Hermann. "Erlebte Vorarbeiten zur Eröffnung des Hauses der Deutschen Kunst." In: Marlies Schmidt, "Die *Große deutsche Kunstausstellung 1937* im Haus der Deutschen Kunst zu München. Rekonstruktion und Analyse." Ph.D. diss, University of Halle, 2010.

Éluard, P., and L. Scheler. *Lettres à Joë Bousquet*. Paris, 1973.

Engstrom, Eric J. *Clinical Psychiatry in Imperial Germany: A History of Psychiatric Practice*. Ithaca, NY, 2003.

Ernst, Max. "An Informal Life of M.E. (As Told by Himself to a Young Friend)." In: *Max Ernst*, ed. William S. Liebermann. New York, 1961.

Ernst, Max. "Notes pour une biographie." In: Max Ernst, *Écritures*. Paris, 1970.

Ernst, Waltraud. *Work, Psychiatry and Society, c. 1750–2010*. Manchester, 2016.

Evans, Richard J. *The Coming of the Third Reich*. London, 2008.

Feistel-Rohmeder, Bettina. *Im Terror des Kunstbolschewismus: Urkundensammlung des "Deutschen Kunstberichtes" aus den Jahren 1927–1933*. Bondelum, Germany, 2005.

Fest, Joachim C. *Albert Speer: Conversations with Hitler's Architect*. Hoboken, NJ, 2007.

Fest, Joachim C. *Hitler: A Career* (film). 1977.

Fest, Joachim C., Richard Winston, and Adolf Hitler. *Hitler.* Translated by Richard and Clara Winston. London, 1974.

Fischer, E. [Review of Prinzhorn.] *Zeitschrift für Morphologie und Anthropologie* 2, no. 1 (1923).

Foster, Hal. "Blinded Insights: On the Modernist Reception of the Art of the Mentally Ill." *October* 97 (2001): 3–30.

Foster, Hal. *Prosthetic Gods.* Cambridge, MA, 2006.

Franciscono, Marcel. *Paul Klee: His Work and Thought.* Chicago, 1991.

Franz Karl Bühler (1864–1940) — Bilder aus der Prinzhorn-Sammlung. Offenburg, 1993.

Freud, Sigmund (ed.). *Internationale Zeitschrift für Psychoanalyse* VII, no. 4 (1921).

Freud, Sigmund, Gerhard Fichtner, and Ludwig Binswanger. *Sigmund Freud— Ludwig Binswanger: Briefwechsel 1908–1938.* Frankfurt, 1992.

Friedlander, Henry. *The Origins of the Nazi Genocide from Euthanasia to the Final Solution.* Chapel Hill, NC, 1996.

Friedlander, Henry. "Registering the Handicapped in Nazi Germany: A Case Study." *Jewish History* 11, no. 2 (1997): 89–98.

Fuchs, Thomas, et al. (eds.). *Wahn Welt Bild: Die Sammlung Prinzhorn; Beiträge zur Museumseröffnung.* Berlin, 2002.

Gassert, Philipp, and Daniel S. Mattern. *The Hitler Library: A Bibliography.* Westport, CT, 2001.

Geinitz, Wolfgang. "Hans Prinzhorn. Das unstete Leben eines ewig Suchenden." *Hestia,* 1986–1987.

Geinitz, Wolfgang. "Zur Biografie Hans Prinzhorns." In: W. Pöldinger (ed.), *Kulturelle Psychiatrie und Psychologie.* Karlsruhe, 1992.

Gercke, Hans, and Inge Jarchov. *Die Prinzhorn-Sammlung: Bilder, Skulpturen, Texte aus psychiatrischen Anstalten (ca. 1890–1920).* Königstein, 1980.

Gilman, Sander. *Difference and Pathology: Stereotypes of Sexuality, Race, and Madness.* Ithaca, NY, 2010.

Gilman, Sander. "The Mad Man as Artist: Medicine, History and Degenerate Art." *Journal of Contemporary History* 20, no. 4 (1985): 575–597.

Gobineau, Joseph Arthur, comte de. *The Moral and Intellectual Diversity of Races, with Particular Reference to Their Respective Influence in the Civil and Political History of Mankind.* Philadelphia, 1856.

Goebbels, Joseph. *Die Tagebücher von Joseph Goebbels,* Part 1, vols. 4 and 5. Ed. Elke Fröhlich. Munich, 2000.

Goffman, Erving. *Asylums: Essays on the Social Situation of Mental Patients and Other Inmates.* New York, 1961.

Gorsen, Peter. "Salvador Dalí's Imagined World of Madness in Comparison to

Hans Prinzhorn's Artistry of the Mentally Ill: Approaching the Issue." In: Ingrid von Beyme and Thomas Röske (eds.), *Surrealismus und Wahnsinn*. Heidelberg, 2005.

Grosshans, Henry. *Hitler and the Artists*. New York, 1983.

Gruhle, Hans. "Die Kunst der Geisteskranken." Sammlung Prinzhorn.

Guenther, Peter. "Three Days in Munich." In: Stephanie Barron (ed.), *"Degenerate Art": The Fate of the Avant-Garde in Nazi Germany*. Los Angeles, 1991.

Guratzsch, Herwig, Thomas Röske, and Susanne Augat (eds.). *Expressionismus und Wahnsinn*. Munich, 2003.

Gutschow, Kai K. "The Anti-Mediterranean in the Literature of Modern Architecture." In: M. Sabatino and J. Lejeune (eds.), *Modern Architecture and the Mediterranean: Vernacular Dialogues and Contested Identities*. London, 2010.

Haftmann, Werner. *Painting in the Twentieth Century*. London, 1965.

Hamann, Brigitte. *Hitler's Vienna: A Portrait of the Tyrant as a Young Man*. London, 2010.

Hanfstaengl, Ernst. *Hitler: The Missing Years*. New York, 1994.

Hanisch, Reinhold. "I Was Hitler's Buddy." *New Republic*, April 5, 12, and 19, 1939.

Harris, James C. "The Würgengel." *Archives of General Psychiatry*, vol. 63, October 2006.

Hartlaub, Felix, et al. *Felix Hartlaub in seinen Briefen*. Tübingen, 1958.

Hauner, Milan. *Hitler: A Chronology of His Life and Time*. Houndmills, 2008.

Heiden, Konrad. *The Fuehrer*. Translated by Ralph Manheim. London, 1999.

Heynen, Robert. "4 Bodies and Minds: Art and the Politics of Degeneration." *Degeneration and Revolution*, January 2015.

Hinz, Berthold. *Art in the Third Reich*. New York, 1979.

Hitler, Adolf. *Hitler's Second Book: The Unpublished Sequel to Mein Kampf*. Ed. Gerhard L. Weinberg and Krista Smith. New York, 2015.

Hitler, Adolf. *Hitler's Table Talk, 1941–1944*. Ed. Hugh Redwald Trevor-Roper. Oxford, 1988.

Hitler, Adolf. *Mein Kampf*. Ed. Ralph Manheim. London, 1994.

Hitler, Adolf. *The Speeches of Adolf Hitler, April 1922–August 1939: An English Translation of Representative Passages*. Ed. and trans. Norman Hepburn Baynes. New York, 1981.

Hitler, Adolf, Max Domarus, and Patrick Romane. *The Essential Hitler: Speeches and Commentary*. Wauconda, IL, 2007.

Hitler, Adolf, and Billy F. Price. *Adolf Hitler, the Unknown Artist*. Houston, 1984.

Hoffmann, Heinrich. *Hitler Was My Friend*. Barnsley, 2014.

Hohendorf, Gerrit. "'Euthanasie' im Nationalsozialismus—Die medizinische Vernichtung der Anstaltspatienten." In: Bettina Brand-Claussen, Thomas

Röske, and Maike Rotzoll (eds.), *Todesursache: Euthanasie: Verdeckte Morde in der NS-Zeit.* Heidelberg, 2012.

Holborn, Hajo, and Ralph Manheim. *Republic to Reich: The Making of the Nazi Revolution: Ten Essays.* New York, 1972.

Howard, N. P. "The Social and Political Consequences of the Allied Food Blockade of Germany, 1918–19." *German History* 11, no. 2 (April 1993): 161–188.

Huber, Franz. "Franz Bühler: Das Genie im schizophrenen Künstler." In: Otto Kähni and Franz Huber (eds.), *Offenburg: Aus der Geschichte einer Reichsstadt.* Offenburg, 1951.

Hughes, Robert. *The Shock of the New.* New York, 2013.

Jádi, Inge. "The Prinzhorn Collection and Its History." In: Krannert Art Museum et al., *The Prinzhorn Collection: Selected Work from the Prinzhorn Collection of the Art of the Mentally Ill.* Champaign, IL, 1984.

Jádi, Inge, and Bettina Brand-Claussen. *August Natterer: Die Beweiskraft der Bilder: Leben und Werk: Deutungen.* Heidelberg, 2001.

Janda, Annegret, and Jörn Grabowski. *Kunst in Deutschland 1905–1937: Die verlorene Sammlung der Nationalgalerie im ehemaligen Kronprinzenpalais; Dokumentation.* Berlin, 1992.

Jenner, Harald. "Quellen zur Geschichte der 'Euthanasie'—Verbrechen 1939–1945 in deutschen und österreichischen Archiven. Ein Inventar." Federal Archives Berlin, accessed November 8, 2020. https://www.bundesarchiv.de /geschichte_euthanasie/Inventar_euth_doe.pdf.

Jewell, Edward Alden. "Exhibition Opens of Fantastic Art." *New York Times,* December 9, 1936.

Jones, Ernest. *Life and Work of Sigmund Freud.* Aylesbury, UK, 1974.

Jones, Nigel. "Churchill and Hitler: At Arms, at Easels." *History Today* 64, no. 5 (May 2014).

Kallert, Thomas W., Juan E. Mezzich, and John Monahan. *Coercive Treatment in Psychiatry: Clinical, Legal and Ethical Aspects.* Chichester, UK, 2012.

Kellar-Kempas, Ruth. "Franz Karl Bühler, eine Biographie." In: *Franz Karl Bühler: Bilder aus der Prinzhorn-Sammlung.* Offenburg, 1993.

Kershaw, Ian. *Hitler, 1889–1936: Hubris.* London, 2001.

Kershaw, Ian. *Hitler, 1936–1945: Nemesis.* London, 2001.

Kershaw, Ian. *Hitler.* London, 2009.

King, David. *The Trial of Adolf Hitler.* New York, 2017.

Klee, Ernst. *"Euthanasie" im NS-Staat: Die 'Vernichtung lebensunwerten Lebens.'* Frankfurt, 1994.

Klee, Ernst. *"Euthanasie" im Dritten Reich: Die 'Vernichtung lebensunwerten Lebens.'* Frankfurt, 2010.

Klee, Felix, R. Winston, and C. Winston. *Paul Klee: His Life and Work in Documents*. New York, 1962.

Klee, Paul, and Felix Klee. *The Diaries of Paul Klee 1898–1918*. Los Angeles, 1964.

Kollwitz, Käthe. *The Diary and Letters of Kaethe Kollwitz*. Evanston, IL, 1988.

Krämer, Steffen. "Entartung in der Kunst: Die Verbindung von Psychopathologie und moderner Kunst von der Mitte des 19. Jahrhunderts bis zum Nationalsozialismus." *Kunstgeschichte*, https://ia800603.us.archive.org/25/items /B-001-004-339/Kr%25C3%25A4mer_-_Entartung_in_der_Kunst.pdf.

Krannert Art Museum et al. *The Prinzhorn Collection: Selected Work from the Prinzhorn Collection of the Art of the Mentally Ill*. Champaign, IL, 1984.

Kubin, Alfred. "Die Kunst der Irren." *Das Kunstblatt* 6, no. 5 (May 1922).

Kubizek, August. *The Young Hitler I Knew*. London, 2006.

Kunstwart und Kulturwart 36, no. 1 (1922–1923) [Review of *Bildnerei der Geisteskranken*]. https://digi.ub.uni-heidelberg.de/diglit/kunstwart_kulturwart36_1/0276.

Kurzmeyer, Roman. "Evokationen des Wunderbaren." In: *Heinrich Anton Müller, 1869–1930: Katalog der Maschinen, Zeichnungen und Schriften*. Basel, 1994.

Langbehn, Julius. *Rembrandt as Educator*. London, 2017.

Leader, Darian. *What Is Madness?* London, 2012.

Lehmann-Haupt, Hellmut. *Art Under a Dictatorship*. New York, 1954.

Lingis, Alphonso. "The Outsiders." *Qui Parle* 17, no. 1 (2008): 199–221.

Longerich, Peter, et al. *Goebbels: A Biography*. New York, 2015.

Luchsinger, Katrin. *Die Vergessenskurve: Werke aus psychiatrischen Kliniken in der Schweiz um 1900: Eine kulturanalytische Studie*. Zürich, 2016.

Luttichau, Mario-Andreas von. "'Crazy at Any Price': The Pathologizing of Modernism in the Run-up to the '*Entartete Kunst*' Exhibition in Munich in 1937." In: Ronald S. Lauder et al., *Degenerate Art: The Attack on Modern Art in Nazi Germany, 1937*. Munich, 2014.

MacGregor, John M. *The Discovery of the Art of the Insane*. Princeton, NJ, 1992.

Maizel, John. *Raw Creation: Outsider Art and Beyond*. London, 2000.

Malraux, Clara. *Memoirs*. London, 1967.

Mann, Thomas. "Gladius Dei." In: *Death in Venice and Other Stories*. London, 2001.

Mann, Thomas. "That Man Is My Brother." *Esquire* (March 1939).

Mann, Thomas. *Tagebücher 1937–1939*. Frankfurt, 1981.

Martynkewicz, Wolfgang. *Salon Deutschland—Geist und Macht 1900–1945*. Berlin, 2011.

Mathes, Viktor. "Die sogenannten 'planwirtschaftlichen Maßnahmen' aus Sicht des ärztlichen Direktors." In: Gabriel Richter (ed.), *Die Fahrt ins Graue(n): Die Heil-und Pflegeanstalt Emmendingen 1933–1945 und danach*. Emmendingen, 2005.

Mathes, Viktor, and Otto Waßmer. *Die badische Heil- und Pflegeanstalt Emmendingen*. Düsseldorf, 1930.

McNab, Robert. *Ghost Ships: A Surrealist Love Triangle.* New Haven, CT, 2004.

Michaud, Éric. *The Cult of Art in Nazi Germany.* Stanford, CA, 2004.

Moorhouse, Roger. *His Struggle: Hitler in Landsberg Prison, 1924.* London, 2018.

Mosse, George L. *Nazi Culture: Intellectual, Cultural and Social Life in the Third Reich.* London, 1966.

Murray, Henry. *Analysis of the Personality of Adolph Hitler.* Washington, DC, 1943.

Neuburger, Mary. "To Chicago and Back: Aleko Konstantinov, Rose Oil, and the Smell of Modernity." *Slavic Review* 65, no. 3 (2006): 427–445.

Nicholas, Lynn H. *The Rape of Europa: The Fate of Europe's Treasures in the Third Reich and the Second World War.* New York, 1994.

Noell-Rumpeltes, Doris. "Else Blankenhorn—vom Projekt der Versöhnung des Unversöhnlichen." In: Susanne Augat, Herwig Guratzsch, and Thomas Röske (eds.), *Expressionismus und Wahnsinn.* Schleswig, 2003.

Nolde, Emil, and Werner Haftmann. *Emil Nolde: Unpainted Pictures.* New York, 1965.

Noll, Richard. *The Encyclopedia of Schizophrenia and Other Psychotic Disorders.* New York, 2007.

Nordau, Max. *Degeneration.* London, 1898.

Palmer, R. R., Joel Colton, and Lloyd S. Kramer. *A History of the Modern World.* Boston, 2007.

Paret, Peter. *An Artist Against the Third Reich: Ernst Barlach, 1933–1938.* New York, 2003.

Peters, Olaf (ed.). *Degenerate Art: The Attack on Modern Art in Nazi Germany, 1937.* Munich, 2014.

Petropoulos, Jonathan. *Artists Under Hitler: Collaboration and Survival in Nazi Germany.* New Haven, CT, 2015.

Pfister, Oskar. [Review of Prinzhorn's *Bildnerei der Geisteskranken*.] *Imago* 9 (1923): 503–506.

Pierce, James Smith. "Paul Klee and Baron Weltz." *Arts* (New York), 1977.

Pierce, James Smith. "Paul Klee and Karl Brendel." *Art International* 22 (1978/79): 4, 8–10, 18–19.

Poitrot, Robert. *Die Ermordeten waren schuldig? Dokumente der Direction de la Santé Publique der französischen Militärregierung.* Baden-Baden, 1945.

Poley, Stefanie. "'… und nicht mehr lassen mich diese Dinge los': Prinzhorns Buch 'Die *Bildnerei der Geisteskranken*' und seine Wirkung in der modernen Kunst." In: Hans Gercke and Inge Jarchov (eds.), *Die Prinzhorn-Sammlung: Bilder, Skulpturen, Texte aus psychiatrischen Anstalten (ca. 1890–1920).* Königstein, 1980.

Polizzotti, Mark. *Revolution of the Mind: The Life of André Breton.* Boston, 2010.

Prinzhorn, Hans. *Artistry of the Mentally Ill: A Contribution to the Psychology and Psychopa-*

thology of Configuration. Translated by Eric von Brockdorff. With an introduction by James L. Foy. New York, 1972.

Prinzhorn, Hans. *Bildnerei der Geisteskranken: Ein Beitrag zur Psychologie und Psychopathologie der Gestaltung.* Berlin, 1922.

Prinzhorn, Hans. "Das bildnerische Schaffen der Geisteskranken." *Zeitschrift für die gesamte Neurologie und Psychiatrie* 52 (1919).

Prinzhorn, Hans. "Die erdentrückbare Seele." *Der Leuchter* 8 (1927).

Prinzhorn, Hans. "Genius and Madness." *Parnassus* 2, no. 1 (1930).

Prinzhorn, Hans. "Lebenserinnerungen." Fragment of biography in Prinzhorn Archive.

Prinzhorn, Hans. *Psychotherapy; Its Nature—Its Assumptions—Its Limitations, a Search for Essentials.* Trans. Arnold Eiloart. London, 1932.

Prinzhorn, Hans. "Über den Nationalsozialismus." *Der Ring,* various issues, 1930–1933.

Proctor, Robert N. *Racial Hygiene: Medicine Under the Nazis.* Cambridge, MA, 2002.

Quinn, Edward, and Max Ernst. *Max Ernst.* Cologne, 1997.

Rave, Paul Ortwin. *Kunstdiktatur im Dritten Reich.* Berlin, 1987.

Redlich, Fritz C. *Hitler: Diagnosis of a Destructive Prophet.* Oxford, 2001.

Richter, Gabriel (ed.). *Die Fahrt ins Graue(n): Die Heil- und Pflegeanstalt Emmendingen 1933–1945 und danach.* Emmendingen, 2005.

Richter, Gabriel. "Geschichte der ehemaligen Heil- und Pflegeanstalt Emmendingen." In: Hans-Jörg Jenne und Gerhard A. Auer (eds.), *Geschichte der Stadt Emmendingen,* vol. 2, *Vom Anfang des 19. Jahrhunderts bis 1945.* Emmendingen, 2011.

Röckelein, Silke. *Hans Prinzhorn (1886–1933); Dokumentation mit Bild- und Textzeugnissen zum Leben und Werk.* Hemer, 2003.

Roelcke, Volker, Gerrit Hohendorf, and Maike Rotzoll. "Psychiatric Research and 'Euthanasia': The Case of the Psychiatric Department at the University of Heidelberg, 1941–1945." *History of Psychiatry* 20, no. 4 (December 5, 1994): 517–532.

Rosenberg, Harold. *Discovering the Present: Three Decades in Art, Culture, and Politics.* Chicago, 1985.

Röske, Thomas. "Agnes Richter's Jacket." *Epidemiology and Psychiatric Sciences* 23 (2014).

Röske, Thomas. "Anstaltskunst und Euthanasie im Nationalsozialismus." In: Carola S. Rudnick (ed.), *Bildfreiheiten: Paul Goesch und Gustav Sievers—Künstler und Opfer in der NS-Psychiatrie.* Luneburg, 2013.

Röske, Thomas. "August Natterer, Visionary Artist." *Raw Vison* 51 (Summer 2005).

Röske, Thomas. "Außerhalb der Kontinuität geschichtlicher Prozesse." In: Susanne Himmelheber and Karl-Ludwig Hofmann (eds.), *Neue Kunst—lebendige Wissenschaft: Wilhelm Fraenger und sein Heidelberger Kreis 1910–1937.* Heidelberg, 2004.

Röske, Thomas. "Das Christusbild in der Schuheinlegesohle: religiöse Vorstellungen in Bildwerken von Insassen psychiatrischer Anstalten um 1900." In: *Kunst und Kirche: Ökumenische Zeitschrift für zeitgenössische Kunst und Architektur 76,* no. 3 (2013).

Röske, Thomas. *Der Arzt als Künstler: Ästhetik und Psychotherapie bei Hans Prinzhorn (1886–1933).* Bielefeld, 1995.

Röske, Thomas. "Erforscher des 'Echten' Leben und Werk Hans Prinzhorns (1886–1933)." In: *Der Schlüssel: Blätter der Heimat für die Stadt Hemer 47.* Hemer, Germany, 2002.

Röske, Thomas. "Ernst Kris und die Kunst der Geisteskranken." In: Steffen Krüger and Thomas Röske (eds.), *Im Dienste des Ich: Ernst Kris heute.* Vienna, 2013.

Röske, Thomas. "Expressionismus und Psychiatrie." In: Herwig Guratzsch (ed.), *Expressionismus und Wahnsinn.* Munich, 2005.

Röske, Thomas. "Inspiration and Unreachable Paradigm—L'art des fous and Surrealism." In: Thomas Röske and Ingrid von Beyme (eds.), *Surrealismus und Wahnsinn.* Heidelberg, 2009.

Röske, Thomas. "Schizophrenie und Kulturkritik: Eine kritische Lektüre von Hans Prinzhorns 'Bildnerei der Geisteskranken.'" In: Ingried Brugger, Peter Gorsen, and Klaus Albrecht Schröder (eds.), *Kunst und Wahn.* Cologne, 1997.

Röske, Thomas. "'Sie wissen nicht, was sie tun'—Hans Prinzhorn spricht am Bauhaus über 'Irrenkunst.'" In: Peter Bernard (ed.), *Bauhaus Vorträge: Gastredner am Weimarer Bauhaus 1919–1925.* Berlin, 2017.

Röske, Thomas. "'Suchende Kierkegaard-Natur' und 'Enfant terrible': Karl Jaspers und Hans Prinzhorn." In: Monica Meyer-Bohlen, Matthias Bormuth (eds.), *Wahrheit ist was uns verbindet: Philosophie, Kunst, Krankheit.* Bremen, 2008.

Röske, Thomas, and Ingrid von Beyme (eds.). *Surrealismus und Wahnsinn.* Heidelberg, 2009.

Röske, Thomas, and Bettina Brand-Claussen. "Kunst und Wahnsinn: Das Museum Sammlung Prinzhorn in Heidelberg." *Museum Aktuell* 150 (August 2008).

Röske, Thomas, Doris Noell-Rumpeltes, and Bettina Brand-Claussen. *Durch die Luft gehen: Josef Forster, die Anstalt und die Kunst.* Heidelberg, 2011.

Röske, Thomas, and Maike Rotzoll. "Doppeltes Opfer. Wilhelm Werner, der 'Siegeszug der Sterelation' und der Krankenmord im Nationalsozialismus."

In: Stefanie Westermann, Richard Kühl, and Tim Ohnhäuser (eds.), NS-*"Euthanasie" und Erinnerung: Vergangenheitsaufarbeitung, Gedenkformen, Betroffenenperspektiven.* Berlin, 2011.

Rothe, Wolfgang. "Zur vorgeschichte Prinzhorns." In: *Bildnerei der Geisteskranken aus der Prinzhorn-Sammlung,* exhibition catalogue. Heidelberg, 1967.

Rotzoll, Maike, et al. "The First National Socialist Extermination Crime: The T4 Program and Its Victims." *International Journal of Mental Health* 35, no. 3 (2006): 17–29.

Rotzoll, Maike, and Gerrit Hohendorf. "Murdering the Sick in the Name of Progress?" In: Paul Weindling (ed.), *From Clinic to Concentration Camp.* London, 2017.

Rotzoll, Maike, and Thomas Röske. "Karl Wilmanns (1873–1945) und die Geburt der Sammlung Prinzhorn aus dem Krieg." In: Ingo Runde (ed.), *Die Universität Heidelberg und ihre Professoren während des Ersten Weltkriegs.* Heidelberg, 2017.

Ryback, Timothy. *Hitler's Private Library: The Books That Shaped His Life.* New York, 2008.

Sammet, Kai. "Habitus, Kapital und Spielräume." *Gesnerus* (2005).

Sass, Louis A. *Madness and Modernism: Insanity in the Light of Modern Art, Literature, and Thought.* New York, 1992.

Schad, Martha. *Sie liebten den Führer.* Munich, 2009.

Schlemmer, Oskar. *The Letters and Diaries of Oskar Schlemmer.* Ed. Tut Schlemmer. Trans. Krishna Winston. Middletown, CT, 1972.

Schlemmer, Oskar. *Oskar Schlemmer: Idealist der Form: Briefe, Tagebücher, Schriften 1912–1943.* Ed. Andreas Hüneke. Leipzig, 1990.

Schmidt, Marlies. "Die *Große deutsche Kunstausstellung* 1937 im Haus der Deutschen Kunst zu München. Rekonstruktion und Analyse." Ph.D. diss, University of Halle, 2010.

Schmidt, Ulf. *Karl Brandt: The Nazi Doctor.* London, 2007.

Schmied, Wieland. "Prinzhorn und die Kunst des 20. Jahrhunderts." In: Franz Tenigl (ed.), *Klages, Prinzhorn und die Persönlichkeitspsychologie.* Bonn, 1987.

Schmiedebach, Heinz-Peter, and Stefan Priebe. "Social Psychiatry in Germany in the Twentieth Century: Ideas and Models." *Medical History* 48, no. 4 (2004): 449–472.

Schneider, Carl. "*Entartete Kunst* und Irrenkunst." *Archiv für Psychiatrie und Nervenkrankheiten* 110, no. 1 (1939): 135–164.

Schultze-Naumburg, Paul. *Kampf um die Kunst.* Munich, 1932.

Schultze-Naumburg, Paul. *Kunst und Rasse.* Munich, 1928.

Schwarz, Birgit. *Geniewahn: Hitler und die Kunst.* Cologne/Vienna, 2011.

Schweizer, Stefan. "'Unserer Weltanschauung sichtbaren Ausdruck geben': Nationalsozialistische Geschichtsbilder in historischen Festzügen zum 'Tag der deutschen Kunst.'" *Journal für Kunstgeschichte* 14, no. 2 (2010): 111–114.

Selz, Peter. "Surrealism and the Chicago Imagists of the 1950s: A Comparison and Contrast." *Art Journal* 45, no. 4 (1985): 303–306.

Sereny, Gitta. *Albert Speer: His Battle with Truth.* London, 2017.

Speer, Albert. *Inside the Third Reich: Memoirs.* Trans. Richard and Clara Winston. New York, 1970.

Spies, Werner. *Max Ernst Collagen, Inventar und Widerspruch.* Cologne, 1988.

Spies, Werner, and Sabine Rewald (eds.). *Max Ernst: A Retrospective.* New York, 2005.

Spotts, Frederic. *Hitler and the Power of Aesthetics.* London, 2001.

Steinkamp, Maike. *Das unerwünschte Erbe: Die Rezeption "entarteter" Kunst in Kunstkritik, Ausstellungen und Museen der Sowjetischen Besatzungszone und der frühen DDR.* Berlin, 2012.

Stöckle, Thomas, and Eberhard Zacher. *"Euthanasie" im NS-Staat: Grafeneck im Jahr 1940.* Tübingen, 1999.

Torrey, E. Fuller, and Robert H. Yolken. "Psychiatric Genocide: Nazi Attempts to Eradicate Schizophrenia." *Schizophrenia Bulletin* 36, no. 1 (2010): 26–32.

Trevor-Roper, Hugh. *Blitzkrieg to Defeat: Hitler's War Directives, 1939–1945.* New York, 1973.

Twain, Mark. *A Tramp Abroad.* New York, 1923.

Ullrich, Volker. *Hitler: Ascent 1889–1939.* Trans. Jefferson Chase. London, 2016.

Victor, George. *Hitler: The Pathology of Evil.* Dulles, VA, 1998.

Wagner, Richard. *Judaism in Music.* London, 1966.

Waldberg, Patrick. *Max Ernst.* Munich, 1976.

Watson, David L. "In the Teeth of All Formalism: A Tribute to Hans Prinzhorn." *Psychoanalytic Review* 23 (1936): 353–362.

Weber, Marielène. "Prinzhorn: L'homme, la collection, le livre." In: Hans Prinzhorn, *Expressions de la folie: dessins, peintures, sculptures d'asile.* Paris, 1984.

Weber-Jasper, Elisabeth. "Wilhelm Weygandt: Psychiatrie zwischen erkenntnistheoretischem Idealismus und Rassenhygiene." Anhandlungen zur Geschichte der Medezin und der Naturwissenschaften, vol. 76. Husum, Germany, 1996.

Werner, Alfred. "Hitler's Kampf against Modern Art: A Retrospect." *The Antioch Review* 26, no. 1 (1966): 56.

Werner, Wilhelm. *Wilhelm Werner: Sterelationszeichnungen.* Ed. Thomas Röske, Maike Rotzoll, Brian Currid, and Peter Cross. Heidelberg, 2014.

West, Shearer. *The Visual Arts in Germany 1890–1940: Utopia and Despair.* Manchester, 2000.

Westheim, Paul. "Rassenbiologische Ästhetik." *Zeitschrift für freie deutsche Forschung* nos. 1/2 (1938).

Weygandt, Wilhelm. "Kunst und Wahnsinn." *Die Woche* 23, no. 22 (1921): 483–485.

Weygandt, Wilhelm. "Zur Frage der pathologischen Kunst." *Zeitschrift für die gesamte Neurologie und Psychiatrie* 94, nos. 2/3 (1924): 421–429.

Williams, Raymond. "When Was Modernism?" Lecture, University of Bristol, 1987.

Willrich, Wolfgang. *Säuberung des Kunsttempels—Eine kunstpolitische Kampfschrift zur Gesundung deutscher Kunst im Geiste nordischer Zeit.* Munich, 1937.

Wilmanns Lidz, Ruth. "Ein erfülltes Leben." In: Ludger M. Hermanns (ed.), *Psychoanalyse in Selbstdarstellungen II.* Tübingen, 1994.

Zacharias, Kyllikki. *Das Wunder in der Schuheinlegesohle: Werke aus der Sammlung Prinzhorn.* Berlin, 2014.

Zegher, Catherine de. *The Prinzhorn Collection: Traces upon the Wunderblock.* New York, 2000.

Ziegler, Adolf. "Rede zur Eröffnung der Ausstellung 'Entartete Kunst.'" 1937.

Ziegler, Hans Severus. *Adolf Hitler aus dem Erleben dargestellt.* 3rd ed. Göttingen, 1965.

Zuckmayer, Carl. *Als wär's ein Stück von mir.* Frankfurt, 1986.

Zuschlag, Christoph. "'Chambers of Horrors of Art' and 'Degenerate Art': On Censorship in the Visual Arts in Nazi Germany." In: Elizabeth C. Childs (ed.), *Suspended License: Censorship and the Visual Arts.* Seattle, 1997.

Zuschlag, Christoph. "Die Ausstellung 'Kulturbolschewistische Bilder' in Mannheim 1933." In: Eugen Blume and Dieter Scholz (eds.), *Überbrückt: ästhetische Moderne und Nationalsozialismus; Kunsthistoriker und Künstler 1925–1937.* Cologne, 1999.

Zuschlag, Christoph. "Die Dresdner Ausstellung *Entartete Kunst.*" In: Holger Starke (ed.), *Geschichte der Stadt Dresden,* vol. 3, *Von der Reichsgründung bis zur Gegenwart.* Stuttgart, 2006.

Zuschlag, Christoph. "An Educational Exhibition: The Precursors to Entartete Kunst and Its Individual Venues." In: Stephanie Barron (ed.), *"Degenerate Art": The Fate of the Avant-Garde in Nazi Germany.* Los Angeles, 1991.

Zuschlag, Christoph. *Entartete Kunst: Ausstellungsstrategien im Nazi-Deutschland.* Worms, 1995.

INDEX

works in *Entartete Kunst* from, 151,
161, 162–65, 166–67, 204–5
prison inmates, art by, 82, 221
Propaganda Ministry, 109, 110, 114,
134, 168
see also Goebbels, Joseph
Prussian Academy of Arts, 111
psychiatry
Nazi, patient art as viewed in,
157–59
Nazi's eugenic goals and, 155–56
Prinzhorn's criticism of, 48, 50
psychoanalysis, 54, 55, 81–82, 87, 158
Psychotherapy (Prinzhorn), 87, 99
Pudowkin, Vsevolod, 95

R
race mixing, 41–42, 77, 91, 123
racial hierarchy, of Gobineau, 41–42
racial hygiene, *see* eugenics and racial
hygiene; "euthanasia" actions;
sterilization, forced
racial theories, 253
Nazi art theory and, 75–76, 90–98
of Schultze-Naumburg, 91–95
Rassengefühl (racial feeling), 94
Rassenkunde (racial science), 123
Rassenpolitisches Amt der NSDAP
(NSDAP Office of Racial Policy),
153–54
Rave, Paul Ortwin, 97, 137, 138, 144,
145–46, 147, 150–51
Rave-Schwank, Maria, 218–19, 220,
221
Raw Vision, 221
Reich Committee for the Scientific
Registering of Serious Hereditary
and Congenital Illnesses, 175
Reich Labor Service, 143, 144
Reich Propaganda Directorate
(RPL), 204
Reichstag, 105, 106, 160, 162, 209
Reich Working Party for Mental
Asylums, 201
Remarque, Erich Maria, 95, 114

Rembrandt, 52, 113, 151, 158
Remscheider General-Anzeiger, 167
révolution surréaliste, La, 56
Richter, Agnes, 23
Ring, Der, 99, 100, 101
Rohlfs, Christian, 113, 168
Roma, killing of, 202, 203
Romanticism, 13, 193
artist-genius concept in, 65,
246–47n
arts and, 72, 77, 129, 139, 212
Rosenberg, Alfred, 90, 96, 97, 100,
110, 114, 130, 148
Rosenberg, Harold, 220
Röske, Thomas, 223
Rottenmünster asylum, 85
Rotzoll, Maike, 222
Rubens, Peter Paul, 69
Rüdiger, Wilhelm, 107–8
Rust, Bernhard, 136, 160

S
SA, *see* Sturmabteilung
Sachs, Hellmut, 136
Samaritan Foundation, 178
"Sanity of Art, The" (Shaw), 43
Säuberung des Kunsttempels (Cleansing
the temple of art; Willrich),
134–35
Schemm, Hans, 129
Schiele, Egon, 68
schizophrenia, schizophrenic art,
xviii–xix, 5, 8, 13, 23, 24, 36, 41, 48,
92, 159
creativity and, 26, 31
"euthanasia" actions and, xv–xvi,
181–82
forced sterilization and, 123, 124
habitual prejudices about, 102–3
profiles of ten "schizophrenic
masters" in Prinzhorn's *Bildnerei*,
47, 49–50, 57
shock therapies for, 156
see also mental illness, mentally ill
people

ABOUT THE AUTHOR

CHARLIE ENGLISH is the author of two critically acclaimed works of nonfiction, *The Storied City* (published in the UK as *The Book Smugglers of Timbuktu*) and *The Snow Tourist*. He formerly worked as a journalist at *The Guardian,* where he was head of international news. He lives in London with his family.

charlieenglish.net

Facebook.com/charlieenglishwriter

Twitter: @charlieenglish

Instagram: @charlieenglish1

ABOUT THE TYPE

This book was set in Requiem, a typeface designed by the Hoefler Type Foundry. It is a modern typeface inspired by inscriptional capitals in Ludovico Vicentino degli Arrighi's 1523 writing manual, *Il modo de temperare le penne.* An original lowercase, a set of figures, and an italic in the chancery style that Arrighi (fl. 1522) helped popularize were created to make this adaptation of a classical design into a complete font family.